D0662794

Domesticating HISTORY

The Political Origins
of America's House Museums

Patricia West

Smithsonian Institution Press
Washington ▪ London

Copy editor: Joanne Reams
Production editor: Deborah L. Sanders
Designer: Linda McKnight

Library of Congress Cataloging-in-Publication Data

West, Patricia, 1958–
 Domesticating history : the political origins of America's
house museums / Patricia West.
 p. cm.
 Includes bibliographical references and index.
 ISBN 1-56098-811-8 (cloth : alk. paper)
 ISBN 1-56098-836-3 (paper : alk. paper)
 1. Historical museums—United States—History.
2. Dwellings—United States—Conservation and restoration—
History. 3. Mount Vernon (Va. : Estate) 4. Orchard House
Museum (Concord, Mass.) 5. Monticello (Va.) 6. Booker T.
Washington National Monument (Va.) I. Title.
E159.W48 1999
973—dc21 98-52073

British Library Cataloguing-in-Publication Data available

Manufactured in the United States of America
06 05 04 03 02 01 00 99 5 4 3 2 1

♾ The paper used in this publication meets the minimum require-
ments of the American National Standard for Information
Sciences—Permanence of Paper for Printed Library Materials
ANSI Z39.48-1984.

For Chloe,
this book begins with the words "once upon a time . . ."

Contents

Acknowledgments

I welcome the opportunity to recognize those who have offered their generous support for this project.

For research assistance I would like to thank John P. Riley and Sara Huggins of the Mount Vernon Ladies' Association, Marcia Moss and Joyce Woodman of the Concord Free Public Library, Ann Clifford and Lorna Condon of the Society for the Preservation of New England Antiquities, Jayne Gordon (former director of the Orchard House museum), Ann Lucas, Zanne Macdonald, Kate von ter Stegge, and Anna Koester of the Research Department at Monticello, Sharon Higgins Nealy of the Springfield (Missouri) Public Library, John F. Furlong of the Missouri Historical Society, Dr. Roy Hill of St. Augustine's College, Alice Hanalt and Bill Gwaltney of Booker T. Washington National Monument, Linda J. Evans of the Chicago Historical Society, William C. Leubke and Stacey Gibbons Moore of the Virginia State Archives, Barbara Griffin of the University of Richmond, Margie Spurlock of Royal Crown Cola, James S. Rush Jr. of the National Archives, Jeanne Roberts of the Historical Society of Pennsylvania, and Virginia Roney and Bettye Daniels, who shared important insights into the life of their father, Sidney J. Phillips, and lent research materials and photographs.

I would also like to thank scholars who have read the manuscript and/or offered guidance: Barbara Melosh, Karen Blair, Barry Mackintosh, Robert Wesser, Douglas Ambrose, Richard Dalfiume, Merrill Peterson, Judith

Mitchell, Jim Lindgren, Harvey Green, Sally Webster, Gail Lee Dubrow, and Page Putnam Miller.

The Spencer Foundation, the National Endowment for the Humanities, the International Center for Jefferson Studies, and the Society for the Preservation of New England Antiquities provided material aid. Blackwell Publishers granted permission to reproduce portions of my article, "Gender Politics and the 'Invention of Tradition'," *Gender and History* 6 (November 1994): 456–67. Deborah Sanders, Duke Johns, and Joanne Reams (copy editor extraordinaire) ferried the manuscript through its final phase at Smithsonian Institution Press.

I am very much obliged to kind friends Carol and Frank Curran, Sarah Elbert, Michael Henderson, Liselle LaFrance, Annie Rody-Wright, Dorothy Tristman, and Sylvie and Thor Wickstrom.

There is a special cohort to whom I am particularly indebted. I would like to acknowledge my good fortune at having for an acquisitions editor Mark Hirsch, whose intelligence and enthusiasm kept the work moving always onward and upward. Lawrence Wittner and Robyn Rosen were valued friends and advisers throughout.

Above all I would like to thank G. J. Barker-Benfield, who has read this book almost as many times as I have, an act of heroism and affection for which I will always be grateful.

Finally, all of my accomplishments are directly traceable to the influence of my parents, Frank and Pat West, and to the support of Frank, Rose, and Tyler West. And then there is that small but significant person whose arrival slowed my work down in the most delightful ways imaginable, to whom this book is dedicated, with love.

Introduction

When a house becomes a museum, its function changes radically. That function is shaped by the exigencies of the period in which the museum is founded, in particular by the political issues so meaningful to those defining its public role.

This study examines the establishment of four individual house museums: Mount Vernon, Orchard House (the home of Louisa May Alcott), Monticello, and Booker T. Washington National Monument. I have selected these cases to generate a chronological narrative of the first hundred years of the house museum in America—Mount Vernon and Monticello as the genre's flagships, and Orchard House and Booker T. Washington National Monument for what they can tell us about the crucial issues of gender and social diversity. Each museum is the subject of a chapter, introduced by an overview describing the context for its establishment in relation to the larger movement.

Following the chapter introduction, the institutional origin of each museum is analyzed historically. Chapter 1 demonstrates the extent to which the nature of the antebellum movement to preserve Mount Vernon by the Mount Vernon Ladies' Association of the Union was determined by the fact that that Union was on the verge of disintegration. Chapter 2 takes up the history of the founding of Orchard House in the context of the "new immigration" and the volatile issue of women's suffrage. Monticello is the subject of Chapter 3,

which describes the pivotal moment at which women's traditional activity as house museum founders was being transformed by the culture of Progressivism and the increasing interest of men in the political utility of popular history. Chapter 4, examining Booker T. Washington National Monument, closes this account of the first hundred years of the house museum movement by marking the entrance of the federal government into the creation of an "official" historical canon, pressed into existence by urgent political issues.

When investigated closely, the activities of house museum founders reveal them to be unclassifiable as either politically detached antiquarians or blue-blooded proponents of social control. This counters on one hand the conservative suggestion that house museums were founded strictly to memorialize a glorious past separable from politics, and, on the other hand, the temptation to see the distorted history often found there in conspiratorial terms. Although connoisseurs as well as xenophobes have their places in the history of this large movement, overall the story is far more complex. The first hundred years of the house museum movement illuminates this and other important historical themes, among them the role of women voluntarists in the founding of house museums and the changes in that role brought about by professionalization and the growing participation of the state.[1]

In sum, house museums are products as well as purveyors of history. This has been obscured, however, by the frequency with which the actual histories of house museums have been superseded by vague, mollifying "creation myths," which give conventional form to early missions and institutional self-conceptions. Analyzing house museums in terms of the various entanglements from which they were deduced reveals them to be agents of American cultural politics, not the politically aloof, neutral institutions received knowledge has supposed them to be. Their founders may have wished them to be "shrines," either to the romantic patriotism enshrouding their institutional origins or to the scientized professional standards that emerged in the early part of this century, but house museums are and always have been about politics. If we lose sight of this and accept the house museum's "creation myth," we risk casting period rooms and museum missions in the agendas of their founders. And many of them had reasons of their own for avoiding, for example, the subjects of George Washington's slaves on the eve of the Civil War, Louisa May Alcott's feminism as women's suffrage was being debated, Thomas Jefferson's radicalism while Progressives expanded the power of the state, or an incisive interpretation of Booker T. Washington in the passionate days of the Civil Rights movement. House museum founders and combative

members of Congress alike have recognized the power of history to shape culture and social action. The house museum's mission should be forged consciously and scrupulously in the land of the living using that keen device, historical perspective.

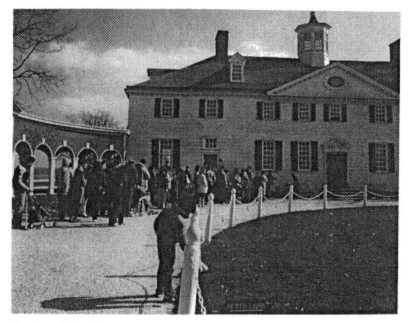

Tourists at Mount Vernon. COURTESY OF THE MOUNT VERNON LADIES' ASSOCIATION.

Chapter

Inventing a House Undivided

Antebellum Cultural Politics and the Enshrinement of Mount Vernon

When Mount Vernon was founded as a house museum in the middle of the nineteenth century, it appeared on the cultural landscape as an innovation, yet the institutional concept of the American house museum had roots in a combination of widely established European and American precedents: the idea of a collection of objects worthy of study born in the elite "cabinet," a belief in the benefits of popular access to exhibits drawn from the European "Great Expositions," the nationalistic phenomenon of period rooms, and the concept of a historically oriented membership organization from American historical societies.[1] Most distinctive, however, was the fact that these museums were preserved "homes" and that the early house museum movement was dominated by women enmeshed in the "cult of domesticity."[2]

Mount Vernon's establishment, therefore, reflected the primacy of the iconographic, sacralized home popularly envisioned as the heart of mid-nineteenth-century America. The "inculcation of home religion" was often proposed as "the ultimate answer to matters in the public sphere," including social heterogeneity, political conflict, and the effects of the disestablishment of religion.[3] Churchlike, mystical, and character-shaping, the home of mid-century American ideology reflected the era's millennialism, which stressed the endless perfectibility of social institutions through evangelism, imparted largely by women as agents of revival ministers.[4] One highly public manifestation of this "domestic religion" was the nineteenth-century house museum.[5]

▪ The Politics of Home: Cultural Context for Mount Vernon and the Early House Museum Movement

The early house museum movement arose in the context of a burgeoning "aesthetic moralism" promulgating faith in the power of properly designed homes to mold character and stabilize the American Republic. Popular architectural plan books, in particular Andrew Jackson Downing's *The Architecture of Country Houses* (1850), associated house form and decoration with the cultivation of middle-class standards of refined taste and the "moral uplift" of a nation in transition from "rudeness to civility."[6] Plan books explained the coded meanings of decorative and architectural forms, as did other authoritative media such as *Godey's Lady's Book*, which published more than four hundred house plans across the middle of the nineteenth century.[7] Popular literature, Harriet Beecher Stowe's *Uncle Tom's Cabin* (1852) for example, displayed the vivid mid-nineteenth-century faith in the moral power of the home environment.[8] No one exemplified this belief more than Stowe's sister, Catharine Beecher, whose design for the ideal home was a multipurpose home, school, and church.[9] Beecher "began with the premise that the home was a perfect vehicle for national unity because it was a universally experienced institution" through which women could refine an increasingly heterogeneous republic. Thus Beecher helped define the "parlor as cultural podium," a notion embodied in the public parlors of house museums like Mount Vernon.[10]

As we shall see, the history of the founding of Mount Vernon as a museum reveals that the preservation of historic "shrines" was appealing to conservative as well as activist women because it was consistent with women's private, domestic role and because it was part of a wider pattern of nineteenth-century social reform. If women reformers could use domestic imagery, proposing to "tidy up our country's house," in order to vindicate their entrance into the public realm on behalf of "home protection," the literal "tidying up" of Washington's house was clearly within the proper bounds of woman's "sphere."[11] Justification for women's activity in the establishment of house museums was often framed in terms of female civic responsibility "to strengthen and fortify the conservative elements of the nation's life," as this statement of purpose by the Mount Vernon Ladies' Association (MVLA) suggests: "We say that in this Association of republican women, there dwells a power which is a lever to lift up and move that great and necessary, ay, vital force of a free state, popular sympathy with public benefactors!"[12]

Lori D. Ginzberg argues that the development of antebellum women's associations based on women's wish to exert their moral influence on the public

realm was connected to the advent of "universal" white manhood suffrage. Women's "benevolence" was posited as one stabilizing source of authority in a society no longer governed solely by property holders. As fears mounted in the 1850s that officials elected by the new mass of voters might not be able to forestall war, such questions became more ponderous. One Mount Vernon founder argued that it was "woman's mission" to "do something to regenerate the corrupted politics of the country by reviving, by the green shades and flowing streams of Mount Vernon, those great principles of Christian polity."[13]

Traditionally, civic virtue had been understood to have been based on the republican independent household. When white manhood suffrage detached property holding and home ownership from the right to vote, symbolic "homes" found a still more important place in political rhetoric. A more inclusive and mobile electorate voted in record numbers in the "log cabin" campaign of 1840, presumably expressing a belief in the influence of a virtuous native birthplace on male political character. The same iconography of "God, home, and country" was a manifestation of the "civil religion" that would prove to be a major feature of the discourse surrounding the establishment of house museums in general and Mount Vernon in particular.[14] By claiming to provide the "rootless" populace with a shared ancestral home and sacred heritage, the house museum found a permanent niche in American political culture.

Add to electoral expansion the commercial revolution, mass immigration, growing class stratification, and the gnawing controversy over slavery aggravated by territorial extension, and the stridency with which conservative cultural prescriptions were advocated at midcentury becomes understandable. Notable among such responses was the cult of George Washington, which reached its apogee in the anxious decade preceding the Civil War. From the wellsprings of the "cult of domesticity" and popular deification of Washington, the historic house museum movement drew its first devotees.[15]

An audience for house museums already existed by the middle of the nineteenth century; tourism was thriving. Visits to the new prisons and asylums, to places of "sublime" natural beauty, and to rural cemeteries, as well as pilgrimages to sites with hallowed historical associations, were becoming more and more popular.[16] House museum founders often decried the unsupervised crowds who already visited the prospective museum, usually to the detriment of the property and the dismay of its owner. Such complaints echoed reactions to the notoriously democratic scene at Andrew Jackson's inauguration, when undisciplined masses tumbled through the White House.[17] Advocates for the preservation of historic houses as museums argued that the creation of a new institution dedicated to the protection and display of a revered historic house

would meet the recreational and inspirational needs of nineteenth-century tourists, while exerting a much-needed refining and uplifting influence.

Such arguments were the underpinning for the creation of a museum at Hasbrouck House (Washington's military headquarters at Newburgh, New York), which preceded the more influential movement to preserve Mount Vernon. Linked to the latter effort in its commemoration of Washington, the Hasbrouck House museum was opened July 4, 1850.[18] The history of its preservation began in the late 1830s, when a local committee headed by Washington Irving advocated making the Hasbrouck House a shrine to George Washington. The committee obtained a charter from the state legislature, though the house remained the mortgaged property of a descendant of the builder. The legislators assigned to review the project anticipated its political utility:

> If our love of country is excited when we read the biography of our revolutionary heroes, or the history of revolutionary events, how much more still the flames of patriotism burn in our bosoms when we tread the ground where was shed the blood of our fathers, or when we move among the stones where were conceived and consummated their noble achievements. . . . No traveller who touches upon the shores of Orange County will hesitate to make a pilgrimage to this beautiful spot, associated as it is with so many delightful reminiscences of our early history. And if he have an American heart in his bosom, he will feel himself to be a better man; his patriotism will kindle with deeper emotion; his aspirations for his country's good will ascend from a more devout mind, for having visited "Headquarters of Washington."[19]

In the late 1840s, the state loan commissioner was called upon to foreclose the mortgage on the property. Rather than putting it up for sale, Commissioner Andrew Caldwell organized an appeal to the state legislature for its public purchase. Caldwell won the support of Governor Hamilton Fish, who dedicated a portion of his 1850 annual address to the cause, proclaiming "there are associations connected with this venerable edifice which rise above considerations of dollars and cents." The context for unprecedented state sponsorship of the memorial was now the threat of civil war, forestalled by the "Great Compromise" of the same year.[20] Shifting the justification from the site's power to induce patriotism to its role in the maintenance of the increasingly fragile Union, the legislature asserted "it will be good for our citizens in these days when we hear the sound of disunion reiterated from every part of the country . . . to chasten their minds by reviewing the history of our revolution-

ary struggle."[21] The bill was passed, allotting more than eight thousand dollars for the house and land and six hundred for a flagpole and a flag sporting the immortalized words of Daniel Webster, uttered in the famous 1830 nullification debate and repeated on behalf of "the Great Compromise": "Liberty and Union, now and forever, one and inseparable." A crowd of ten thousand enthusiasts celebrated the opening of the memorial, singing an ode, "Freeman Pause, This Ground Is Holy." General Winfield Scott, emblem of national victory over Mexico, raised the flag.[22]

▪ *A Southern Matron's Jeremiad*

The significance of Mount Vernon to the early house museum movement cannot be overstated. It would be a prototype in several key respects: It was a public history museum conceived of by a women's organization, it was a re-created domestic environment memorializing a mythologized white male political figure, and its institutional persona was devised in response to the political context of its establishment. The story of the founding of Mount Vernon in the stormy decade preceding the Civil War has been told and retold, enveloped in romantic narrative lore.[23] Legend has it that on a moonlit night late in 1853, a steamboat moving down the Potomac River sounded its bell to honor George Washington's beloved Mount Vernon, rousing a distinguished Southern matron from her cabin in the boat. She walked to the deck at the tolling and was appalled by the deterioration of the plantation so rich in associations with Washington's political and domestic virtue. It seemed to her that the fate of the nation mirrored that of Mount Vernon, and at that moment Louisa Bird Cunningham conceived of the notion that a group of Southern women should unite to rescue the home and tomb of Washington and establish it as a "shrine." By passing the idea along to her invalid daughter, Ann Pamela, she ignited a nationwide movement of patriotic women. It has often been said that the Mount Vernon Ladies' Association of the Union rose above cataclysmic sectional politics in a manner that the country's men were unable to emulate, saving Mount Vernon out of pure benevolence. The historian's tale of the MVLA's Mount Vernon, a product of the political and cultural crisis of the 1850s, is even more intriguing.

Mount Vernon had been the object of patriotic tourists for decades before its founding as a museum.[24] The great orator Edward Everett, speaking on behalf of the MVLA, described the "vast numbers" of "tourists and pilgrims" who generally "conducted themselves with the decorum that belongs to the place." Yet, he added, "in addition to the civil and well-bred, there are enough

of an opposite description to inflict serious injury on the grounds and to cause the greatest annoyance to its inmates. . . . It is quite natural that the People should wish to visit Mount Vernon, but if they insist on doing it in numbers that put to flight all ideas of private property, they ought to be willing to acquire a right to do so. They ought to possess themselves legally of the property, and not insist upon using it illegally."[25] In keeping with the widely ambivalent response to Jacksonian democracy, Everett simultaneously suggested that popular behavior could be reformed through the creation of a museum and that the establishment of such an institution was the result of the irresistible democratic insistence of the people.

There had been unsuccessful efforts to convince the federal government to purchase the crumbling Mount Vernon, owned by John Augustine Washington, a relation of limited means. Despite the rather ornate suggestion that state purchase would preclude "some Turk or other foreigner" from obtaining Mount Vernon to "exact tribute" in the form of admission fees, a petition early in 1846 to the U.S. government to buy the estate for $100,000 failed in large part because of congressional concern that the "expected war" with Mexico would soon strain the Treasury. Likewise, an 1853 petition to the state of Virginia was rejected because the price (now $200,000) was considered exorbitant. When John Washington once again offered Mount Vernon to the United States late in 1853, key members of Congress balked, predicting with some acuity that if government were to enter the business of preserving sites with historical associations the process would snowball.[26] Worrisome rumors circulated that the financially strapped John Washington had been approached by "speculators" wishing to turn Mount Vernon into a resort hotel.[27]

It was the possibility that "Northern Capitalists" were about to intercept the "sacred" property that motivated Louisa Bird Cunningham and her daughter to appeal for help to "the Southern Ladies."[28] The "rescue" of Mount Vernon may have been the elder Cunningham's idea, but it was her daughter who made the project her lifework. Born in 1816 and raised at Rosemont, the Cunninghams' South Carolina upcountry plantation, Ann Pamela Cunningham claimed prestigious lineage. Her mother, of the Pennsylvania Birds and the Alexandria Daltons, had ancestors close to the Washington family. Her father, Robert Cunningham, had distinguished himself in the military, law, and politics (tutored by John C. Calhoun, though the two later diverged over the nullification issue). His ancestors had been loyalists during the Revolution, however, which according to Ann Pamela Cunningham's biographer "haunted" her "throughout her life."[29] By all indications prepared to be a classic Southern belle, the elite Cunningham was educated at a school patterned

after Emma Willard's, and she drew the attention of beaux until a riding accident in her late teens turned the tide of her life.[30] She never married; her "invalidism" was her most commented upon characteristic, and it was in these terms that she defined herself. It was also the cause of a debilitating addiction to laudanum, an alcohol-based tincture of opium, which began before the war and worsened to the end of her life.[31] Cunningham was in regular treatment with the Philadelphia physician Hugo Hodge, best known for his specialization in "women's diseases." She was under his care when she received the letter from her mother proposing the protection of Mount Vernon by an organization of Southern women.[32]

Cunningham had already shown a vivid interest in history and enough of a feminist consciousness to spur her bold venture into the public realm. Judith Mitchell describes a telling incident in 1845, when Cunningham published a revisionist history of her notoriously Tory forebears, arousing criticism so severe that her brother nearly dueled to preserved her honor. When the reviewer responded that he had been unaware that the history had been written by a "lady" and tendered his apologies, the duel was averted. Ann Pamela, however, was unappeased because the withdrawal of the criticism was based on her gender. "Mind," she sternly argued, "has no sex." A woman would be "puerile in mind and feeling to wish or expect that her sex should effect the real merits of the production or the nature of the criticism it provokes."[33] In the wake of this incident, Cunningham undertook another historical project, gathering materials for Elizabeth Ellet's three-volume *The Women of the American Revolution* (1848, 1850).[34]

Cunningham's own lifework would be in defense of the memory of the greatest Revolutionary War leader. In December 1853, Cunningham issued her "Appeal to the Ladies of the South," published first in the *Charlestown Mercury* and reproduced shortly afterward in other southern newspapers. Signing herself anonymously as "A Southern Matron," Cunningham called for Southern women to take action to rescue the home and tomb of Washington from desecration by "the speculator and the wordling."[35] She set forth a public role for the republican woman based on her participation in the American Revolution as "a vestal" guarding the "fire of liberty," linking patriotic action to preserve Mount Vernon to the threat of civil war: "Should there ever again be times to try men's souls there will be found among you, as of old, heroines superior to fear and selfish consideration, acting for country and its honour!"

A foreboding sense that the potential sale of Mount Vernon symbolized a cultural and economic (if not military) assault on the South pervaded Cun-

ningham's first appeal. In fact, Virginia's expanding commercial links to the North and land speculation there by Northerners were flashpoints for political and cultural conflict between traditional "centripetal forces pulling to the South" and "centrifugal forces pulling Northward."[36] Cunningham contrasted the South, "a region of warm, generous, enthusiastic hearts, where lingers . . . some chivalric feeling yet untouched by the material spirit so rapidly overshadowing the morals of our beloved land," to a region unnamed but clearly the North, where "love of money and speculation alone seem to survive." Cunningham asked: "Ladies of the South! Can you stand with closed souls and purses . . . , suffer Mount Vernon, with all its sacred associations, to become . . . the seat of manufacturers and manufactories? Noise and smoke, and the busy hum of men, destroying all sanctity and repose around the tomb of your own world of wonder! . . . Never! Forbid it, shades of the dead! That pilgrims to the shrine of pure patriotism should find it forgotten, surrounded by blackening smoke and deafening machinery!—where money, only money, enters the thoughts; and gold, only gold, moves the heart or nerves the arm!"

The creeping tide of Northern culture threatening the South in general and Mount Vernon in particular could not, according to the "Southern Matron," be averted by a direct appeal to the federal government, which, she implied, was increasingly under the sway of the same Northern money-grubbers: "Oh! who that have a spark of patriotism but must mourn such degeneracy, when they see who fill our legislative halls, who crowd our metropolis! who can restrain a pang of shame when they behold the annual rush thither of jobbers and bounty-seekers of office, aspirants and trucklers of party; corruptors and corrupted, all collecting like a flock of vultures to their prey."

Cunningham's argument that women needed to shore up the public realm because of the decay of male virtue was in the grand tradition of nineteenth-century women's benevolence.[37] But her jeremiad had a uniquely regional flavor, calling on "southern feelings of honour" to move women to "furnish a shrine where at least the mothers of the land and their innocent children might make their offering." Rooting public feminine action in a defense of traditional Southern culture and "the cult of Southern womanhood" was an effective strategy for justifying what may have otherwise seemed just the kind of violation of rigidly defined sex roles many Southerners identified with Northern culture.[38] Ironically, it was the germ of Cunningham's emphasis on "true womanhood" that would eventually be the basis for future claims that the MVLA had risen above sectional politics.

Cunningham fortified her earnest public appeal with a letter to Eleanor Washington, wife of John Augustine Washington, begging for time for "the

Southern Ladies" to raise the purchase money before Mount Vernon was sold to either "Capitalists," or "even Congress should she apply at last."[39] Despite the activities of a loose coalition of women in Virginia and Georgia who had formed an embryonic Mount Vernon association, the Washingtons wished to sell the house only to the United States or to the state of Virginia. Though he reported that Cunningham's efforts were "gratifying to the family of Him," and he praised "our enthusiastic countrywomen of the South, so highly prized for quiet home virtues," John Washington cited "practical difficulties" in Cunningham's plan.[40]

Cunningham had suggested that Southern women organize to solicit contributions to be sent to individual state governors throughout the South, who would in turn give the money to the Virginia governor to make the purchase, "that the property be conveyed to the President of the United States and the Governor of Virginia to be preserved and improved."[41] The women organizing to effect this were undaunted by John Washington's negative reaction, and the movement slowly grew in Virginia, Georgia, and Alabama. By early 1854, the "Southern Matron" publicly admitted the first scheme was "impracticable," setting forth a new organization with "a central head for each state and association."[42]

The new plan soon caused problems, the solutions for which coalesced Cunningham's leadership and expanded her organization. Confusion over lines of authority had to be firmly resolved, and it became clear that some mode by which to insulate the MVLA from ever-pressing sectional tension (manifested early on in the form of conflicts over whether the United States or Virginia should be designated to hold the property's title) had to be speedily formulated. But first and foremost, Southern women's reticence to enter the "public sphere" had to be overcome.

Allies were scattered around the South. Cunningham warmly referred to a "gallant editor" of an Alabama newspaper who came to the defense of the MVLA, explicating the propriety of womanly participation in the "rescue" of Mount Vernon. He said, "Wherever there is pure sentiment, there is woman's sphere; wherever good may be done, wherever noble and virtuous thoughts may be inspired, there lies a duty for woman to perform, whether it lead beyond her household or not. . . . To rescue the home of Washington from spoliation is the peculiar business of a woman . . . and any man who should condemn her for the act deserves to die where there is no gentle voice to soothe his passing moments."[43]

Octavia Walton LeVert wrote that the cause "comes yet within the legitimate sphere of womanly enterprise." She went on: "And you, women of such

timorous nature that . . . you peep in and out of the world of action without venturing from your homes, learn (and be not frightened at the disclosure) that in this great world you have your social duties, as imperative to your country as the political battles of your husbands and your brothers."[44] Others called women to action by identifying the threat to Mount Vernon with the vices of unreformed men, asking "shall it be converted to a card room, a billiard room?"[45]

Although Cunningham intended the "rescue" of Mount Vernon to be a Southern endeavor, within the year Northern women began to show interest. By this time the difficulty of raising two hundred thousand dollars from Southern women alone must have become as painfully obvious as the boiling over of sectional hostilities with the signing of the Kansas–Nebraska Act earlier in the year. In November 1854, Cunningham issued a third appeal, shifting the emphasis from "southern honour" to the ability of women to rise above and perhaps even ameliorate political conflict: "We neither desire nor intend sectionality. We feel none towards those whose patriotism knows no North, South, East, or West. If ever in the future period of our national history, the Union should ever be in serious danger, political storms rocking it to its base, or rendering it in twain, there will be such a moral grandeur (perhaps an assuaging influence we cannot now estimate) in the mere fact that the tomb of Washington rests secure under the flag of his native state, enshrined in the devotional reverence of the wives, mothers, and daughters of the Union."[46]

Cunningham's new openness to the participation of Northern women was not shared by all of the Mount Vernon enthusiasts; for example, her mother flatly asserted "Let it be all South," adding "I still hope there is too much patriotism at the South to wish to be mixed up with the North in such a cause." Likewise, disagreement was voiced in the family of Civil War diarist Mary Boykin Chesnut, though in this case it was the younger woman who argued that there should be no obligation to include their "Northern sisters."[47]

It was a critical moment. Cunningham strove to include Northern women without alienating "the Southern Ladies" who made up the association. In an appeal written early in 1855 to "the Daughters of Washington," she attempted to unite all American women who could claim to be "true-hearted descendants of our noble revolutionary Mother." Her overture to the North began with a defense of the South. The Southern Matron "felt she could not call upon you for aid in what seemed peculiarly southern obligations the south could fulfill whilst there were so many [i.e. in the North] who seemed to have forgotten Washington and His counsels, asperse the region in which he was born and buried!"

This said, Cunningham conceded that "many noble and patriotic" Northern women "loved the common Father as we do." "The door has been thrown open," she said, "and the first offer made by a worthy descendant of the Pilgrim Fathers." Cunningham repeated the phrase she used in the late-1854 appeal, "publicly announcing that we neither desire nor intend sectionality," emphasizing that "Woman, in her higher or better nature retained a sacred reverence for the Memory of Washington."[48]

As Cunningham was establishing a focus on transcendent femininity as a vehicle for finessing sectionalism, troubles were brewing on exactly that front. The Philadelphia committee readied to "flood the State with publications" with the erroneous information that the United States would hold the title to Mount Vernon. When Cunningham informed them that Virginia was to do so, "they dropped the whole like a hot potato" and then later "threatened to get up a delegation . . . to ask Congress to buy it."[49] In addition, the Virginia state committee organized itself in a manner Cunningham perceived as insubordinate, undermining her new goal of Unionwide cooperation by publicizing itself as the predominant state committee and placing too much emphasis on the fact that "the native State of Washington" should own Mount Vernon.[50] Cunningham acted vehemently and swiftly to reorganize the committee by nullifying their proceedings, alienating some members but clearly establishing herself as the principal officer. The most visible dissenter was Mrs. John H. Gilmer, who immediately resigned from the committee in the wake of tense correspondence between Cunningham and her husband in which he warned that expanding the effort to include Northern women was "an unholy alliance" that would "tarnish the soil of Virginia with the polluted breath of northern fanaticism."[51]

The primary device Cunningham used to resolve these problems was bold and utterly political: The organization would acquire a legislative charter setting forth a clear line of authority, creating the official Mount Vernon Ladies' Association of the Union. Cunningham hoped that the existence of an independent chartered body would solidify her leadership of the newly national organization, rooting it in the South while assuring skittish potential Northern donors that they were not, in fact, giving money directly to the state of Virginia.[52] Solidly in the grain of antebellum women's benevolent associations generally, the MVLA immersed itself in politics and sought male support while claiming that the sphere of women's moral activity was above male commercial and political interests.[53] Cunningham credited John McPherson Berrien of Georgia, a former senator and U.S. attorney general under Jackson, with the idea of the charter and with its initial form, which he had suggested

to her would "satisfy all sectional feeling."[54] When Berrien died in the midst of drafting the charter, the task was assumed by staunch Unionist James Louis Petigru of Charleston, who supposedly urged that the phrase "of the Union" be added to the Mount Vernon Association.[55] The bill was carried to the Virginia legislature on March 15, 1856, by Richmond attorney O. W. Langfitt who, in his words, "interpolated the word 'Lady' in the title."[56] Thus Cunningham would take the reins of "The Mount Vernon Ladies' Association of the Union."

A key figure in the effort to obtain the 1856 charter was the celebrated actress Anna Cora Ogden Mowatt, who was recently married to William Foushee Ritchie, heir to the powerful Virginia Democratic political machine of the early republic known as the "Richmond Junto." Despite her colorful career, of which some in Richmond disapproved, Ritchie's place in society was secured both by her Ogden heritage and by her marriage. She was a Swedenborgian, and her dedication to Mount Vernon was based in part on the fact that she believed that Washington's spirit "still hovered closely about the fields, gardens, and rooms he had loved," and also by her enthusiasm for the preservation of Stratford-upon-Avon.[57] Mrs. Ritchie's charming "cottage" on Ninth Street was the site of many an evening gathering, replete with good port and turtle soup, on behalf of the MVLA in general and the passage of the charter in particular. Its unprecedented nature made the garnering of male support crucial. Heavy lobbying, employing whatever means "woman's sphere" brought forth, characterized the weeks before the introduction of the bill. Ritchie reported: "I have been electioneering, and very successfully. Night before last I gave a musical soiree, and desired my husband to invite as many of the Senators and members of the legislature as the house would hold. . . . Everyone declared he had a delightful evening. The music was excellent, and the supper good. Then came the grand coup. As the Ladies began to retire, Mrs. Pellet commenced the subject with [former] Governor Floyd, and I soon managed to make it general. Governor Floyd pledged himself to pass our bill and at once—so did all the other members and Senators present."[58]

Troubles lay ahead, however, as disgruntled former Virginia committee members stalled the bill at week's end by leaking to influential legislators that there was internal discord over the charter. With Cunningham confined to her sickbed, her reformed committee decided at an emergency meeting after church on Sunday that they should act immediately to press their allies to restore the bill. Anna Ritchie was instrumental both in flushing out the opposition and in asserting Cunningham as the organization's unalloyed chief, leading the committee in a descent upon Floyd and Langfitt as they were rising

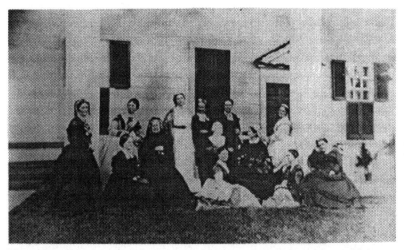

The Mount Vernon Ladies' Association of the Union's 1870 "Grand Council." Ann Pamela Cunningham is seated to the right of the bust of George Washington.
COURTESY OF THE MOUNT VERNON LADIES' ASSOCIATION.

from their Sunday dinner at the Exchange Hotel. The committee, with male escorts, was present in both the House and Senate when the bill passed the next day, March 19, 1856.[59]

"Victory, Victory, beloved friend and fellow worker!" wrote the triumphant Ritchie to Cunningham.[60] The celebration would be short lived. John Washington abruptly withdrew the estate from sale out of pique at some aspects of the charter. Still smarting from the vigorous public criticism of his asking price for Mount Vernon, which had crescendoed whenever the U.S. and Virginia legislatures considered proposals for its purchase, he considered the charter's stipulation that the MVLA would purchase the estate and turn it over to Virginia a kind of humiliation. Washington had long asserted that he would sell Mount Vernon only to the United States or Virginia; he therefore wanted himself to be explicitly named as the conveyor of the property to state custody. When another round of fierce public outcry arose against Washington, Cunningham rushed to his defense, realizing that the MVLA's success lay in overcoming his essential resistance.[61]

Cunningham wrote a retrospective account of her dramatic visit to Mount Vernon in June 1856 to convince John Washington to reconsider. As had Ritchie in her superb soirees, Cunningham claimed to have deployed orthodox "womanly persuasion" on behalf of her cause. The particular resource she

called upon was the heady amalgam of sentimental fiction and evangelical re-ligion, which had made a convention of the scene featuring a vulnerable but morally superior woman set against a powerful, resistant man.[62] Cunning-ham's spiritual fervor dramatized by her visibly weak physical condition per-vaded the account. Proudly she described the signs that her supplications had succeeded: Washington's "quivering lips, a moist eye, and a heart too full for him to speak." Thus she placed this decisive moment in the MVLA's history firmly in the sentimental tradition.[63] Cunningham left believing him to have been utterly converted.

Over the next few years, as the MVLA worked toward a revised legislative charter, Cunningham would continue to nurse John Washington's vulnerable commitment. For example, she forwarded to his attention a newspaper article in which she supplied "a proper rebuke" to critics of his asking price by assert-ing that they were nothing but a band of "abolitionists" playing into the hands of "speculators."[64] Though often confined to her sickbed and even to a "dark-ened room," she maintained a careful correspondence with Washington, still having faith in the power of his conversion. In reality, he had written to William Ritchie shortly after Cunningham's visit that even if the ladies were able to purchase Mount Vernon, their "languid mismanagement" would cause care of the estate to revert to the state of Virginia anyhow, topping it off with the assertion that the MVLA plan was "simply preposterous."[65]

Nonetheless, the 1856 legislative charter had initiated a portentous trans-formation in the MVLA. Though Cunningham had hoped that the charter would be an emblem of the segregation of the MVLA from politics, in fact dealings with the legislature had identified her organization with the Ritchie wing of the split Virginia Democratic Party, the implications of which would soon be realized. The day after the charter was passed, the MVLA's ties to this faction, now headed by Gov. Henry A. Wise, were tightened by the appoint-ment of his wife to the vice-presidency. The "ladies" would continue to invoke the Ritchie name whenever they found themselves "among democrats."[66] Though the ideology of benevolent femininity would continue to supply the MVLA with a claim to political neutrality, the intensification of sectional conflict as they sought their revised charter would thrust the now-Unionwide organization further and more explicitly into the arena of male politics. And although Cunningham would write to John Washington that making a na-tional project of the purchase of Mount Vernon would assuage "the absorbing and deteriorating influence of sectional strife," in fact the MVLA would find itself wound into the tangled skein of antebellum politics.

▪ *"To Commence a New Era in Our Political Life":*
The MVLA and Antebellum Sectional Discord

Although Cunningham's original "Appeal to the Ladies of the South" called for spontaneous, grass-roots action, her firm response to the Philadelphia and Virginia committees' difficulties represented a desire for authority over the blossoming movement. The 1856 charter had established the MVLA's structure and Cunningham's leadership, but the primary instrument of its exercise was the detailed hierarchy she devised for the organization's national expansion. Cunningham handpicked a company of "vice-regents," one for each state in which interest in Mount Vernon's "rescue" had arisen. In general, they had certain qualities in common, most notably wealth, status, and distinguished Revolutionary ancestry. Cunningham had great faith in the power of uniting this select "sisterhood": "Their broad and liberal patriotism in this day of sectional prejudice and party strife, crowns them with a greater glory than any advantageous circumstance of birth or fortune. We recognize in this association a bond of Union and political regeneration. With such a spirit ruling the association, who will say it is not destined to commence a new Era in our political life as a Nation."[67]

Ratcheting up her argument that women's benevolence could influence a public sphere gone awry, Cunningham acknowledged the "birth and fortune" aspects of her "sisterhood" but claimed that its virtue lay in the fact that it was an elite capable of rising above sectional discord. In the context of disenchantment with antebellum politics, the suggestion that a kind of aristocracy, related by blood to the Founding Fathers, should resume its guidance of the off-course ship of state was a conservative one; the assertion that this elite should be composed of women was an interesting political commentary to say the least, in fact justifying public action by generally conservative women.

Some of the elect "sisterhood," Anna Ritchie and Octavia LeVert for example, had become interested in the preservation of historic houses as a result of their European travel, the former in Stratford-upon-Avon and the latter in the home of Ariosto.[68] Some were figureheads, such as the elderly Mrs. Mary Chesnut of South Carolina (mother-in-law of the Civil War diarist), who had been personally acquainted with George Washington. Others were activists. Mary Morris Hamilton of New York (granddaughter of Alexander Hamilton and niece of Gouverneur Morris) raised about a fifth of the purchase price. The "vice-regents," who reported directly to Cunningham, the "regent," were responsible for the appointment of trustworthy "lady managers" for towns,

villages, or counties in their state and for the publication of regular reports and appeals in key newspapers.[69]

As the MVLA was consolidating, others outside the organization began to take notice. The potential of Mount Vernon to be a rallying point for national unity was popularized by Edward Everett, who began giving fund-raising orations on behalf of the MVLA in 1856. The enormously popular orator, now remembered as the other speaker at Gettysburg in 1863, carried the MVLA's message throughout the North, no doubt legitimizing the previously Southern movement in the eyes of the Union.[70] Everett delivered his speech, "The Character of Washington," 137 times across the country between 1856 and 1860, investing the proceeds and donating the profits to the MVLA. Everett's gift amounted to nearly seventy thousand dollars, more than one-quarter of the purchase price.[71]

Everett's address reveals much about his perspective on the potential power of a public Mount Vernon. The Unionist orator hoped that a heightened reverence for such a shrine to Washington would inspire the kind of political moderation that could stave off civil war.[72] According to Everett, Washington's leadership was distinguished by his extraordinarily "calm and well-balanced" temperament; Everett believed his "pure example" could bring back the "blessings of national harmony."[73] With characteristic flourish, he exclaimed: "Sooner let the days of colonial vassalage return; rather let the Frenchman and savage again run the boundary with the firebrand and scalping-knife, from the St. Lawrence to the Mississippi, than that sister states should be arrayed against each other, or brother's hands be imbrued in brother's blood."[74]

Everett couched his call for accord in terms of the conflicted colonial and revolutionary circumstances out of which George Washington had led America into the Union. In describing Mount Vernon itself, he emphasized the contrast between the grandeur of Marlborough's Blenheim Palace (which was, nevertheless, "but a dismal mausoleum") with the homeyness of Washington's "modest" Mount Vernon, the "abode of George Washington and Martha his beloved, his loving, his faithful wife." At Mount Vernon, Washington lived "in nobled simplicity," and "the latest generations of the grateful children of America will make this pilgrimage to it as to a shrine."[75]

Everett's other venture on behalf of the MVLA was a series of weekly reports written for the *New York Ledger*, in payment for which he accepted a gift of ten thousand dollars to the Mount Vernon fund, as well as the additional monies raised from the publicity generated by the series.[76] Everett detailed the unregulated access to Mount Vernon induced by private ownership; how-

ever devoted John Washington might be to his family estate, he simply did not have the resources to properly see to its protection. Echoing a Jacksonian-era argument positing the need for a via media between democracy and mob rule, Everett proposed that a balance be struck between public access to Mount Vernon and restrictions against relic-seeking "pilgrims" who would plunder it.

Further, he warned that Mount Vernon had become the object of base "pecuniary speculation." Since its protection had been "neglected by Congress" and "not performed by Virginia," Everett supported the "purchase of the estate by a voluntary association coextensive with the Union" with "members from every part of the country." Everett implied that Mount Vernon, administered by women and therefore detached from government, would nonetheless be associated with the Union, operating as a kind of Unionist "Trojan House" in Virginia. The women of America, he said, "have undertaken this noble work" and were "determined to make their appeal to the heart of the country."[77]

George Forgie has linked Everett's enormous popularity to a cultural context that celebrated "so-called feminine, specifically maternal, values" against the "masculine characteristics" that had supposedly driven the post-Jacksonian nation to the breaking point, which would certainly place Everett in the same camp with Cunningham in diagnosing the nation's ills. She met Everett in March 1856, when she invited him to speak for the MVLA in Richmond. In what was perhaps Cunningham's introduction to the vehemence of the public with regard to sectional matters, negative publicity led to the cancellation of the talk when news of Everett's speech protesting the caning of Charles Sumner by South Carolina congressman Preston Brooks linked him with the antislavery movement.[78]

As Everett was touring the North, the Southern wing of the MVLA was going forth with its own interpretation of the application of Mount Vernon's inspirational power to sectional conflict. To many Southerners, Cunningham included, protecting the Union meant that the North should honor the fact that the Constitution recognized slavery. The assault on the values of the Founding Fathers, they argued, was therefore coming from the North, with the South holding its own as the true heir to the American Revolution.[79] Thus the Northern and Southern wings of the MVLA could celebrate the memory of George Washington as a vehicle for national unity in apparent agreement, while below the surface taking vastly different stances.

Nothing embodied the bifurcation of the MVLA along these lines more vividly than the fact that while Everett was speaking for the MVLA, so was a distinguished cousin of Cunningham's, the renowned fire-eater and "orator of secession," William Lowndes Yancy.[80] Though Yancy dedicated his oratorical

life to the defeat of compromise on the slavery issue, he perceived himself to be a defender of the will of the Founding Fathers, saying that the fire-eaters supported the original tenets of the Union, based on a constitutional right to hold slaves.[81] In contrast with Everett's circumspect speeches, Yancy's were intended to inflame sectional confrontation. An observer characterized his manner of expression, tinged with "ferocious sarcasm," as having the force of a southern hurricane, "tearing, uprooting, demolishing, and scattering all in its path."[82]

Everett and Yancy agreed on one subject in addition to Mount Vernon, however; they both rejected the controversial Kansas–Nebraska Act, Everett because he felt national expansion would serve only to threaten the Union, and Yancy because he renounced the idea that slavery could be legislated against under the Constitution.[83] The otherwise vastly divergent views of Everett and Yancy suggest that for a time the Northern and Southern wings of the MVLA developed independently. But as the Kansas–Nebraska Act began to polarize the nation, the MVLA found its collective fortunes swept up in the storm of reaction that sheared the Virginia Democratic Party into two factions, creating a natural political opposition for the MVLA. This was the tempestuous context for the MVLA's pursuit of a revised legislative charter.

The Kansas–Nebraska Act had been engineered by Stephen Douglass to address problems arising from the gradual population of the western territories by U.S. citizens. The ratio of nonslave states to slaveholding states had reached a tense political equilibrium; the question of whether slavery would be permitted in the territories and in the derivative states had beset national politics. Douglass's compromise principle, "popular sovereignty," whereby territorial elections would determine whether slavery would be permitted, met with a range of disapproval in both the North and South, as the opinions of Yancy and Everett demonstrate. Yet as a means by which to absorb large areas of western territory into statehood while adhering to democratic principle, popular sovereignty seemed viable to many. The Kansas–Nebraska Act became law in May 1854.

Rather than assuaging sectional discord, however, the fruits of the Kansas–Nebraska Act over the next few years brought the nation to the doorstep of war. Antislavery and proslavery adherents rushed to populate what would become known as "Bleeding Kansas." In the territorial election, masses of proslavery voters came from neighboring areas to establish a legislature that would forge the wildly debatable proslavery Lecompton Constitution in September 1857. The referendum the legislators devised allowed voters

to choose only between protecting slavery where it existed in the territory or allowing its extension.[84] The controversy split the national Democratic Party and hardened sectional alignments, obstructing political solutions. Further, earlier in the year the Dred Scott decision, in which the Supreme Court determined that Congress lacked the power to bar slavery from the territories, had in effect nullified the Missouri Compromise.

As the MVLA prepared to introduce its revised charter to the Virginia legislature early in 1858, the Kansas controversy had brought into high relief the differences between factions led by the distinguished U.S. senator R. M. T. Hunter and his adversary, Gov. Henry Wise (aligned with the heirs to the Ritchie machine). The rivalry was "enmeshed with the elusive elements of class, family, and regional pride": Hunter was one of the richest slaveholders in Congress, while Wise was a middling farmer with a diversified crop worked by a small number of slaves.[85] The clash, which dominated Virginia politics until nothing less than civil war overshadowed it, had its roots in Hunter's support of John Calhoun in the nullification crisis, in opposition to Thomas Ritchie of the "Richmond Junto." Further, the insurgent Wise made no secret of his desire for Hunter's Senate seat nor of his resentment of the deference accorded the old-line leader.[86]

Given this long history, the Wise–Hunter split over the Lecompton Constitution took on mammoth proportions. Hunter, who felt that the extension of slavery was necessary for the South to maintain power in the Union, endorsed the Lecompton Constitution. Wise argued that Lecompton was a fraud because there had been no referendum on whether slavery should be abolished. Both men shaped their public stances in hopes of achieving a place on the national Democratic ticket in 1860, Hunter expressing a more popular Southern perspective and Wise, though in the national spotlight, finding himself on the defensive in the South.[87]

The *Richmond Enquirer*, organ of the Ritchie Democrats, attempted damage control by questioning the legality of the Lecompton Constitution and saying that the whole Kansas question had "given enough trouble to the country" over an area essentially unsuitable to slavery.[88] It was the ability of the august *Enquirer* to lend credence to Wise's political maneuvers that had led the Hunter faction to sponsor Roger Pryor's establishment of a rival newspaper, the *Richmond South*, early in 1857 "to frustrate Wise's ambition and dilute his strength." This only tightened Wise's connection to William Ritchie's *Enquirer*, in which Wise acquired an interest in mid-1858.[89] Few of Wise's public acts were "unaffected by his rivalry with Hunter," which by 1857 had turned

Virginia politics "absolutely lethal."[90] His enthusiastic support of the Mount Vernon crusade was certainly no exception; the debate over Cunningham's plan was played out colorfully in the pages of the *Enquirer* and the *South*.

Wise had been provoked to support the Mount Vernon cause in response to an attack on his 1856 Fourth of July oration at Lexington, Massachusetts. Asserting that George Washington had been a true Southerner and a slaveholder, "no Northern iceberg which repelled by coldness," Wise less than subtly identified himself with Washington as a forceful leader unafraid to carry out policies that would incur "malice and uncharitableness." Wise was promptly pilloried for reducing Washington to "the level of his own passionate and brutal nature." His rejoinder was to reinforce his identification with Washington by cloaking himself in his support of the MVLA.[91]

The MVLA, unwittingly drawn into the web of Virginia politics, introduced the revised charter for the consideration of the state legislature on January 12, 1858. It was still essentially the 1856 charter drafted by James Petigru, reworded to suit John Washington. Perhaps Cunningham's choice of Petigru was based on longtime acquaintance, since both Cunningham's father and Petigru were Unionist leaders in the bitterly divisive nullification crisis that racked Charleston in the 1830s. Petigru, remembered primarily as a staunch Unionist throughout the Civil War, was a distinguished jurist who extended and protected the legal rights of women in marriage and "helped redefine the legal status of corporations," paving the way for a later decision that interpreted corporations as legal "persons." This decision was crucial for the history of women's public activity, for as Ginzberg demonstrates, when women were denied rights as individuals they created chartered corporate entities that could claim a full range of legal rights.[92] Thus either personal acquaintance or compelling interest prompted Petigru's engagement with the MVLA.

The appointment of a committee to review the MVLA charter was not the only business for the legislature on that January day. A motion was put forth and overwhelmingly endorsed to recommend that the U.S. Congress "speedily admit Kansas as a state under the Lecompton constitution."[93] Both items drew the attention of the two rival Richmond Democratic newspapers, the Wise–Ritchie *Enquirer* and the Hunter–Pryor *South*. Pryor, characterized as "one of the principal southern hotheads, widely famed as a duelist," had a fascinating career that spanned being the officer in charge of firing on federal supply boats from Fort Sumter, to being associate counsel for Theodore Tilton in the Beecher scandal, to accepting a position on the New York State Supreme Court.[94] The highpoint of Pryor's journalistic career was probably the coining of the famous "house divided" metaphor, for which Lincoln cred-

ited him.[95] Pryor's pugnacious enthusiasm for the Lecompton Constitution and his scathing attack on the MVLA clarified the extent to which the two issues were now identified with the Wise–Hunter conflict.

In the weeks following the introduction of the MVLA charter, Cunningham and Anna Ritchie lobbied the legislators, or "made friends," as Cunningham saw it. She explained that "this aroused the ire of Mr. Pryor," who "was a Hunter man," and since the Ritchies were "of the Wise party," the charter "became a political matter."[96] Pryor wrote an editorial mocking the MVLA's efforts as one of patriotism's "most eccentric manifestations." The MVLA was vulnerable to Pryor's criticism because of the method by which they planned to acquire Mount Vernon under terms dictated by John Washington, with Virginia as the actual purchaser to be reimbursed by the MVLA. Pryor implied that the MVLA was simply insolvent and applying for direct state purchase of Mount Vernon, forfeiting the chivalry due women who remained in their sphere:

> Although we have ever regarded the enterprise as the vagary of an amiable enthusiasm, we were indisposed to resist it so long as it appealed only to the sympathies of individuals and was promoted by the exertions of voluntary champions. Indeed, we have a word of hearty applause for the ladies who have devoted themselves with so much zeal to a lofty but impracticable object; and while they were content to forward their scheme by their own persuasive influence and the eloquence of an Everett and a Yancy, we refused to touch the beautiful bubble which fascinates the public eye by the reflection of the generous and graceful impulses of those who bequeathed it into existence. But since the "Mount Vernon Association" proposes to come before the Legislature in *forma pauperis,* and to solicit pecuniary assistance from the public treasury, we are absolved from these obligations of chivalric forbearance, and may presume to treat its pretensions with as little delicacy as is due to the application of a railway corporation.[97]

Pryor went on to argue that the MVLA was attempting to drag Virginia into paying an exorbitant price for Mount Vernon and that the debt caused by the MVLA's inability to raise the necessary funds for purchase and upkeep would drain the state treasury. In a subsequent editorial, Pryor criticized any legislator who would fall prey to "the subtle arts of female persuasion," warning that if Virginia facilitated the acquisition of Mount Vernon for the MVLA, "the barrier will be broken down, and every praiseworthy project of plunder will insist upon a share of the spoils."[98]

Cunningham knew her bill was seriously threatened by Pryor's critique,

and she was asked to "answer it immediately." She described the process of composing her response: "I took laudanum, put my feet in mustard water, wrapped my head in hot cloths till my face was purple and I dictated it to Mrs. Pellet."[99] The "Southern Matron" responded directly to Pryor's condescensions, saying "we would pass over its inaccuracies, even as we do its (such!) compliments, but for the effects on the opinion of the masses." She retorted that, although the MVLA coffers had been diminished by the financial crisis of late 1857, after the initial purchase of Mount Vernon was facilitated by the state to meet the terms of John Washington, the MVLA would in fact be in a position to "relieve the state from the care and expenses of its protection." Yet she did not dispense with the idea that the state had a responsibility to posterity to assist with the preservation of Mount Vernon. There were those, Cunningham argued, who had seen the Revolution itself (that is to say, George Washington's own dream) as "as a 'vagary,' a mistaken 'enthusiasm,' a 'bubble'": "We hope, for the honor and credit of the Old Dominion, that there are none such in the present General Assembly, guardians *in this matter* of her reputation for all time. On their decision now, in reference to the sacred ashes of the Father of His Country, *the world, for all time, will sit in judgment.*"[100] Pryor, in opposing the MVLA, was repudiating both George Washington and the American Revolution. Cunningham felt that "the bully Pryor, who had killed so many in duels, had met his match and got a castigation he could not revenge." Yet the pressure against the MVLA was unremitting from the Pryor camp, who had, Cunningham said, put "spies upon all of our movements."[101]

The next public attack came in early February, as the MVLA was planning ceremonies celebrating the unveiling of the Crawford equestrian statue of Washington in Richmond on the twenty-second, Washington's Birthday. Cunningham and Ritchie had arranged for the inauguration dinner that night to be succeeded the following morning by a ceremony at which the MVLA would formally thank Edward Everett and William Lowndes Yancy for their support by giving them George Washington's walking cane and spyglass, respectively. This was to be followed by the delivery of Everett's renowned oration, "The Character of Washington." Pryor seized the opportunity to revive public sentiment against Everett for his sympathies with Sumner in the Preston Brooks caning incident of 1856. He claimed that Everett, the "Knight Commander of the Mount Vernon Association," deserved "the execration rather than the courtesies of the South" for his "overt act of identity with the Abolitionists."[102] In a subsequent edition of the *South,* he printed a letter to the editor raising the issue once again by a tongue-in-cheek reference to the unfortunate parallel between the controversy and the particular object to be

offered to Everett by the MVLA as a token of thanks: "I bow my head to this infliction from Massachusetts' 'matchless orator and patriot,' and would for the sake of relieving the dull monotony of this oft-repeated oration, suggest that, while presenting Mr. Everett with the cane of Washington, there be confided to his care a cane for his friend Sumner, who has not been able to walk alone since Mr. Brooks castigated him in the Senate chamber. The speeches appropriate to such an occasion would be extremely racy."[103]

Washington's Birthday was overcast, with "leaden clouds; not a ray of sunshine smiled through the falling flakes of a most dispiriting snow storm." The formal inauguration of the statue was held at midday. With characteristic faith in the name of Washington to effect peace, the MVLA placed the unlikely duo of Gov. Henry Wise and Sen. R. M. T. Hunter on the dais. The opening address by Grand Past Master of the Virginia Masons Robert G. Scott lobbied the leaders of Virginia on behalf of the Mount Vernon bill still under consideration by the legislature: "Gloriously have you, my good and old and beloved brothers of Virginia, come in with your aid, proffered to a scheme, which, I here predict, will save Mount Vernon, as the holy resting place of Washington, for generations to come." At this point in the speech, Cunningham made a well-timed entrance in a carriage, which was drawn up near the speaker. He turned toward it, saying, "And most appropriately have we here our lovely countrywoman, the Southern Matron, whose constant toil and labor for this great cause, has worn down her frame and borne her almost to the grave. In this work of love and patriotism, rely, my brethren, on your own strong will and resources."[104]

Following a benediction and an ode, Henry Wise rose to introduce Hunter's speech by positing that the "magic name" of Washington would "touch the chord of union and clasp us hand in hand, and bind us heart to heart, in the kindred heirship of one Patriotic Father." Hunter took his own tack, emphasizing Washington's political virtue, his forbearance and lack of personal ambition, for example. He hoped the "yonder expressive bronze" would "continue to speak its lessons of virtue and wisdom" to the ambitious man who might "in his eagerness for fame, find that he is in danger to prefer the prizes of ambition to goodness." If this was a jab at Wise, whose reputation for opportunism was a serious political encumbrance, it was at least indirect, and the best the MVLA could have hoped for as a display of unity. But, unfortunately for the cause of the MVLA bill, the influential senator also referred to the statue as the discharge of the state's "last duty" to Washington's memory.[105]

The inauguration dinner that night at the new Custom House was far less

civil. It was probably lucky that, while Hunter attended, Wise sent word that he was indisposed. Everett and Yancy were there, however, as were an array of similarly incompatible Northern and Southern politicians and ideologues. The tables were prettily set and garnished, the room was lavish with bright festooning and men in splendid uniforms, and a large, five-pointed star formed overhead of brilliant gas jets had "an exceedingly striking effect."[106] It was only "when the cloth was cleared away" and the postprandial speeches and toasts bearing the unmistakable imprimatur of the debate over the Lecompton Constitution began that the drama of the evening's events outshone the decorative effects.

Sen. James Mason of Virginia delivered a pointedly pro-South address, arguing that "the Union that we intend to preserve, if we are allowed to do so, is a union under the Constitution and no other," referring to the constitutional recognition of slavery, and, presumably, the Dred Scott decision. After some of the guests attempted mollifying toasts, M. R. H. Garnett presented the provocative "The South first, the South last, and the South at all times," after which it might be said that all hell broke loose. Balm was sought in the sedate Everett's response, but even he was feeling surly, concluding that the Washington statue's "brazen arm shall point the unerring road to the welfare of the country more surely than any arm of living flesh and a fiercer thunder than that of the elements shall clothe the neck of the monumental war horse, and strike terror to the hearts of the enemies of the Constitution and the Union." Gov. Alexander Holley of Connecticut followed up in the spirit of Daniel Webster, saying "The Union of these states, indissolubly one and the same, now and forever." More thrusts and parries ensued, with several of the Unionists invoking Mount Vernon as a symbol of conciliation, until at last Yancy rose and stunned his audience by saying that at Mount Vernon there were "to be learned other lessons than we have heard":

> Aye, it is written in the blue vault of the heavens that cover us, "there must be no trampling down of the Constitutional rights of any section of this Union.". . . And then if [my] voice might have any influence with my brethren of the South it would be to exort them, that if the sons of the North heed not the virtues of the father of his country, but, rather, choose to imitate the conduct of his foes, do you, too, as Washington and his compeers did, with firm reliance on Divine Providence pledge to each other your lives, fortunes, and sacred honor in imitation of their illustrious example. "If this be treason, make the most of it."[107]

One can only imagine the hush that must have fallen over the dinner crowd, in particular the mortification of the friends of the supposedly neutral MVLA.

The party broke up almost immediately, knowing that the next morning would bring many of them together again.

The theme of the Tuesday morning ceremony, at which Everett and Yancy were to be formally thanked by the MVLA, shifted not surprisingly and one cannot help but think deliberately away from politics in favor of exhortations of feminine virtue, a subject upon which all could apparently agree. Governor Wise presided, surrounded by dignitaries "whose white heads and benevolent countenances gave great interest to the general grouping."[108] George W. Mumford represented the MVLA, referring reverently to the Revolutionary Fathers' efforts to make the Union perpetual, in contrast to their fractious "sons," whose sectional "mutterings" should "be hushed." The "daughters," however, were to be praised for their busy forging of "other links" to build "a bond of affection that ought not to be broken." Everett was then given Washington's cane (thanks to Pryor now linked to the Sumner incident) with the words "should any rude band be raised to destroy the liberties of this people, or the Union . . . let your eloquent voice be raised." Then with no apparent sense of irony (given his speech of the previous evening), Yancy was given the spyglass Washington had used in the Revolution, requesting that if he were to see "the approaches of the sappers and miners of the Constitution," that his similarly "eloquent voice" be raised "to rouse the people to a sense of the danger." Yancy's acceptance speech was tame, relatively speaking, emphasizing the duty of man to assist the MVLA "as a knight in the age of chivalry." Everett gave his "Character of Washington" oration, and the festivities closed with tempers no doubt worn woefully thin at the MVLA's effort to unite near-warring parties under its aegis.

These events must have been fresh in the minds of Virginia legislators when they were called upon to vote on the Mount Vernon bill on March 12. The bill failed, twenty-nine to fifty-seven.[109] Cunningham attributed the vote to Pryor's "log-rolling," but his arguments pointing to the fiscal risk that would have been incurred if Virginia had made the purchase and held the title also may have been effective.[110] After the failure of the bill, Cunningham wrote to Washington, pleading that he reconsider his insistence that Virginia purchase Mount Vernon. Washington responded immediately, finally realizing that "neither Virginia nor the United States wish to acquire the place" and agreeing to allow the MVLA to hold the title.[111] With the issue of Virginia's involvement removed, the charter passed the House of Delegates less than a week later, and the Senate on March 22, 1858.[112]

After recovering her strength, Cunningham gathered herself to begin the daunting task of raising the remainder of the funds necessary to purchase Mount Vernon. She dropped the pseudonym "Southern Matron," signing her

"baptismal name" for the first time to a public appeal in July 1858. Not surprisingly, considering the events surrounding the passage of the revised charter, Cunningham expanded on the MVLA's established rhetorical orientation criticizing the men's commercial and political world while elevating the healing influence of women's benevolence, a theme that would become even more salient as the nation drifted closer to war. Cunningham blamed the deterioration of Mount Vernon on "the broken pledges of Congress and the apathy of [Washington's] mother state," the "murmurs of Mammon," and "angry waves of sectional strife and bitterness." In contrast, "devoted woman alone triumphs when the common homestead can be procured as a common heritage for the estranged children of a common father, the spell of whose memory will yet have the power to reunite them around his hallowed sepulchre." Taking one step further, she asserted, "Our country can be saved, one and indissoluble, forever—for *woman* has become her guardian spirit."[113]

The resonance of Cunningham's argument celebrating the healing power of women's influence drew a steady flow of donations from schools, state legislatures, and Masons, along with monies from theatrical performances and balls. Currier and Ives issued a series of Mount Vernon views, with a narrative by Benson Lossing describing the MVLA's mission.[114] The editors of *Godey's Lady's Book* received subscriptions "to secure to the women of America this sacred spot."[115] The *Ladies' Repository* revived the anxiety that Mount Vernon could become a "scene of bacchanalian orgies" or a "gambler's den."[116] The *Home Journal* offered an explanation for the widespread popularity of the Mount Vernon campaign: The public wanted "less to gaze upon the oft-repeated battlefields and occasions of state and great event, than to have a nearer look at the domestic daily life of the Great Chieftain."[117]

Yet the MVLA's success was predicated on the ability of its advocates to gloss over issues that might strike the chord of sectional disharmony. For example, Susan Fenimore Cooper's *Letter to the Children of America* (1859) made the "great moral power" of Mount Vernon the justification for its conversion into a public institution designed to illustrate above all that "good men love their homes."[118] Since the prewar North preferred to see Washington as the patriarch of a virtuous "home" rather than as a slaveholder, Cooper's polemic is replete with exacting censorship of that rather notable fact. The following is her carefully crafted description of pre-Revolutionary Mount Vernon, in which Washington resembles a New England farmer and the activity of slaves is hidden behind the passive voice:

> The farms were thoroughly worked. George Washington was a wise, industrious, thrifty farmer; he was not a man to be content with meagre re-

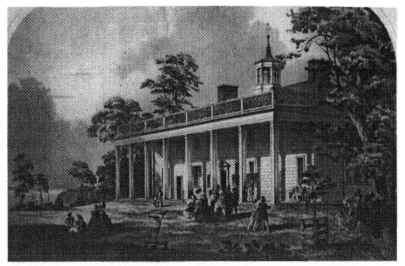

Lithograph of the east view of Mount Vernon, published in 1859 by N. S. Bennett to help the MVLA raise funds to purchase the estate. COURTESY OF THE MOUNT VERNON LADIES' ASSOCIATION.

turns from the soil; he spared no pains to bring the very best crops from his fields. . . . It would not be easy, dear children, to imagine a more happy, a more honorably peaceful way of life, than that led at Mount Vernon during those quiet years; the active usefulness, the manly exercises without—the generous hospitalities, the neighborly charities, the happy family circle within—these gave Colonel Washington what his heart most enjoyed.[119]

Though it was true that Washington experimented with advanced agricultural methods, he did so using the labor of hundreds of slaves.[120] Northern repression of Washington's slaveholding was not unique to the MVLA campaign. When Henry Adams reflected on his childhood visit to Mount Vernon, he wondered why he "never thought to ask himself or his father how to deal with the moral problem that deduced George Washington from the sum of all wickedness," that is from the "Slave Power."[121] The MVLA's reinforcement of the tendency of Northerners to ignore the historical reality of slavery at Mount Vernon was part of the effort to immunize it from contemporary political debate: Again and again they asserted that the MVLA was above sectional conflict.

Certainly Cooper's fund-raising appeal was directed to a Northern audience, and it therefore replaced the historically accurate image of Mount Vernon as a plantation with one sidestepping sectional flashpoints, focusing in-

stead on the various dimensions of the "moral power" of Mount Vernon as national "home," the basis for womanly participation in the cause: "Children of America! We come to you to-day, affectionately inviting you to take part in a great act of national homage to the memory, to the principles, to the character of George Washington. . . . Let this work become, on our part, a public act of veneration for virtue—of respect for love of country in its highest form, pure, true, and conscientious—of loyalty to the Union, the vital principle of our national existence. Let it become, for each of us, a public pledge of respect for the Christian home, with all its happy blessings, its sacred restraints."[122]

As it became clear that the political or military Washington could be used as a cudgel by either side in the sectional debate, the MVLA increasingly proffered Mount Vernon not only as a vehicle for the influence of transcendent womanhood but also as an explicit celebration of domesticity as an agent of national moral regeneration. This cultural motif was characteristic of the 1850s, an era in which the idealized domestic scene was often a rhetorical "countervailing model against the excesses of politicians."[123] For conservative women profoundly worried about what they perceived to be a decline in political virtue, the house museum was the ideal way to extend their values into the public realm. An MVLA vice-regent argued that although women ought not to "transcend their heaven appointed limits" to "mingle in public affairs," the prevention of the "revolting tragedies now of almost daily occurrence must depend far more on the women of the country than is generally supposed." "Woman's Mission" was to do what she could within her sphere to raise republican sons—"Christian statesmen"—and the rescue of Mount Vernon was clearly a contribution to the rehabilitation of "the corrupted politics of the country."[124]

Proponents of the MVLA argued that Mount Vernon and womanhood were transpolitical, sacred forces. Cunningham called the "inceptive formation and ultimate organization of a great Society of WOMEN" a "singular and striking event" in the nation's history, "which, in the Divine economy, overruling human government, and in the dispensation of God's providence" formed "a sort of a ratchet in the wheel of the nation's progress."[125] The MVLA would use its "moral power to strengthen and fortify the conservative elements of the nation's life."[126]

Squeezed between Southern vice-regents anxious about the "dreadful prospect of a Black Republican President" and Northerners warning of "abolitionist" opposition to the MVLA, Cunningham's rhetoric of neutrality became more and more emphatic.[127] Despite her effort to mold a serene MVLA by emphasizing its ideological disposition, the organization continued to be jolted by sectional squabbles. Philosophically, Cunningham claimed the

MVLA was "a bond of union and political regeneration," while in practical terms she heeded advice that the association should "be careful to exclude every political feeling or influence." So although she argued that the MVLA's influence on the political realm would be profound, a calculated effort to avoid politics was in fact under way.[128]

Meanwhile, Cunningham dealt with pressing problems. For example, early in 1859, one Mount Vernon activist from Boston, endeavoring "to make the cause fashionable," met with difficulty "inducing people to entertain themselves without regard to politics." With a stern but apparently overlooked warning that Cunningham should "burn these letters," the activist said: "I know very well there is an undercurrent . . . of opposition to every Southern proposition because of the dread of slavery connected with it The subscription has been very different from what it would have been could we have stated positively that nothing but free white labor would be allowed on the estate. You see that all the abolitionists have declined to do anything on the grounds that they have but one duty, and that is to abolish slavery. This sounds very absurd to you, doubtless, and it certainly does to me, yet, in trying to raise money for Mount Vernon, we must calmly take all the elements of success and failure into consideration."[129] Cunningham's apparent policy not to alienate the South by promising the North that only "free white labor" would be hired at Mount Vernon continued to dog the MVLA. Early in 1860 Northern supporters, among them the famous writer Lydia Sigourney, were uneasy about it, and the Connecticut vice-regent implored Cunningham to "please enable us to satisfy our constituency on this point."[130]

It was in the unsettled wake of the John Brown raid that the MVLA finally took possession of Mount Vernon in February 1860. Cunningham exclaimed that the MVLA had proven that "Woman, in her appropriate sphere, on her heavenly appointed mission, has dared to undertake that from which Man shrank appalled, and has triumphed where he failed!"[131] Their first act was to invite members of the House and Senate to take the excursion boat from Washington for a trip to Mount Vernon for dedicatory ceremonies in March. Not surprisingly, "an absorbing and prolonged debate in both Houses prevented many from being present."[132] At the ceremony, Rep. John Cochrane of New York emphasized the transcendent nature of the MVLA. He declared "a new epoch in the history of our country—the development of a period when . . . from the retirement of domestic life, the female has emerged to her proud work, her lofty mission to rescue perishing memories, to build up decayed monuments, to gather . . . the sunshine of heaven with which to make glad the dark places of our land."[133]

He could not have known how soon hopes would be dashed that Mount

Vernon would inspire, in his words, "actors in the present scene to retain the glorious accomplishment" of George Washington, "the Union of the American States."

▪ *"One National Spot": Mount Vernon in the Civil War Years*

When the MVLA acquired Mount Vernon, it was too late to exercise its wished-for power to strengthen the bond between the states; within the year John Cochrane's "conciliatory manifesto" (written with Andrew Johnson and designed to forestall war) would fail and Ann Pamela Cunningham's home state of South Carolina would secede.[134] The MVLA, and women generally, did not stand aloof from the dramatic political developments that prefaced the Civil War. Roger Pryor's wife, Sarah, recalled: "Thoroughly alarmed, the women of Washington thronged to the galleries of the House and Senate Chambers. From morning until the hour of adjournment we would sit, spellbound, as one after another drew the lurid picture of disunion and war. Our social lines were now strictly drawn between North and South."[135]

The issue of popular sovereignty had driven the nail into the coffin of sectional compromise, splitting the Democratic Party and paving the way for Tennessee vice-regent Mary Rutledge Fogg's worst nightmare to be realized, the election of the "Black Republican," Abraham Lincoln.[136]

Jefferson Davis was sworn in under a statue of Washington, laying claim in his inaugural address to the legacy of the American Revolution.[137] Though South Carolina led the secession movement, the home state of Mount Vernon was perceived to be the linchpin in its success.[138] On April 10, from the piazza of the Charleston Hotel, Roger Pryor gave the most famous speech of his career, alarming moderates by announcing that Virginia, "the mother of Presidents," would join the Confederacy "in less than an hour by Shrewsbury clock" if war were to begin at Fort Sumter.[139] Less than a week later, the old nemesis of the MVLA was given the opportunity to fire the first shot against the Union enclave, an honor Pryor dispensed to the aged fire-eater Edmund Ruffin.[140] And by the end of the month, Washington's "mother" state had indeed seceded.

Cunningham, though a moderate, was sympathetic to her native South. Her longstanding view of politicians seemed confirmed; they were "unequal to the exigency of the times and all may be lost before they comprehend the nature and extent of the danger." Tensions were high when Cunningham made her way home to Rosemont early in 1861, stopping in Charleston where the ill-fated Fort Sumter stood in the harbor. "Excited and indignant feelings"

overcame her as she condemned the North's Maj. Robert Anderson for actions taken to hold the contested fort, which she argued would make inevitable "immediate civil war."[141]

Fortunately for Cunningham, her family's plantation was spared direct exposure to war, but with her father recently dead, her mother elderly, and her brothers off to war, the management of Rosemont was on her shoulders. She complained that in her father's declining years the cotton plantation went to "rack and ruin," left in the hands of "negroes careless and wasteful" and a "faithless" overseer. She said she "had neither friend, relative, nor capable neighbor to look to," yet she eventually managed to make a significant profit, investing it in Confederate bonds.[142]

In the midst of this Cunningham had to endure sharp public and personal attacks for her moderate views, causing her much "wear and tear of heart." Her mother, in particular, was an enthusiastic secessionist, urging her daughter to resign from the MVLA out of loyalty to the Confederacy. Cunningham said, "She calls me a Northerner because I mourn over the past and present."[143] Yet Cunningham had already taken a political risk by coming back to Rosemont, given her wish to remain publicly neutral for the sake of Mount Vernon. When a South Carolina newspaper publicized the return of the MVLA's regent to South Carolina as evidence of her support of secession, Cunningham was horrified. It was, "under any circumstances, most improper and indelicate to draw a lady into the political arena; how much more so to do it in connection with an Association formed to have joint ownership of the grave of the Father of all—no matter how the country is divided! . . . For South Carolina to throw such a firebrand into our woman's camp was worse than a blunder, it was a crime!"[144]

Her friends consoled her by saying "that the paper had no circulation beyond the State, and that the political excitement would be so absorbing that this item would probably be overlooked," but they were wrong; her return to Rosemont would indeed be commented upon in the North, and in the long run, her refusal to take part in the war effort, due to her position as keeper of "the one National spot left in the country" would draw notice in the South.[145] Thus she faced criticism from both sides: Some Southerners questioned her allegiance, a Philadelphia paper charged that Cunningham would use Mount Vernon to "damage the free States and assist the armed traitors of the South," and Northern MVLA vice-regents reported that she was regarded as "a rabid secessionist."[146]

Cunningham's political moderation was the manifestation of an ardent wish that the Union could continue, yet in practical terms she emphasized that

only by adherence to the "principles" of Washington, which would preclude Northern "factional injustice," could the Union be preserved. She blamed Douglass for splitting the Democratic Party and compelling the South to believe that "her safety depended on separation alone." Secession, she argued, was legal, and the North's "aggressiveness" and "violations of the Constitution" were to blame for the war. She said, "While I never wished for secession, when it came I joined fate with the South as was but right."[147]

The fact that Cunningham also placed MVLA funds in Confederate bonds belied her desire to remain utterly neutral as regent.[148] But she doggedly clung to the idea that, as an association of women, the MVLA could claim that "no sectional differences should effect our position." "We must bide the storm," she said, "and then the officers will meet and pledge themselves to continue to carry out the purposes for which we are a chartered body, and show to the world that we, at least, have profited by the counsels of Washington."[149]

Yet the Civil War was on, and Mount Vernon stood squarely in its path. Though Cunningham did not "apprehend any molestation" of public buildings by the Southern army ("because it is almost entirely composed of gentlemen"), she knew that Mount Vernon needed protection.[150] Her first hire was Upton Herbert, a Virginian distantly related to the Washington family. But now Cunningham had to counterbalance her appointment of a Southerner with one that would satisfy the already uneasy Northern vice-regents.[151] The husband of Mary Goodrich, the Connecticut vice-regent most vocal in pressuring Cunningham to declare that only "free white labor" would be employed at Mount Vernon, arranged for Sarah Tracy, a dignified and capable Emma Willard graduate, to take charge of Mount Vernon while Cunningham was at Rosemont.[152] With faith in the sacred aura of true womanhood, Cunningham was certain that "the presence of a lady" (and, more concretely, of representatives from both the North and the South) at Mount Vernon would "insure respect toward the place from both contending parties."[153] As an unmarried woman, Tracy observed the proprieties by engaging a series of chaperones to live at Mount Vernon, while Herbert managed the stabilization of the crumbling estate.

Tracy's first task was to publicly defend Cunningham and the MVLA from charges of political involvement and incompetence. Besieged by inquiries about Cunningham's politics, she was advised to focus on Mount Vernon's envelopment in "woman's sphere": "Women are intended for the ornament and blessing of life, at once the stimulant and the reward of virtue. Of course, therefore, the Mount Vernon Association—and especially its accomplished Regent—must instinctively shrink from all participation in the disorder and disunion by which the present time is characterized."[154]

Despite the hope that this reasoning would deflect the fallout of war, nettlesome rumors came thick and fast: that slave labor was being employed at Mount Vernon, that Upton Herbert was linked to "some fugitive slave question," that Cunningham was a secessionist.[155] A report circulated early in 1861, that the body of George Washington had been removed from Mount Vernon and spirited away to the Virginia mountains, met with Tracy's firm response asserting the competence of the MVLA to protect the "sacred" Mount Vernon in its charge:

> Never, since first laid in this, his chosen resting place, have the remains of our Great Father reposed more quietly and peacefully than now, when all the outer world is distracted by warlike thoughts and deeds. And the public, the owners of this noble possession, need fear no molestation of this one national spot belonging alike to North and South. Over it there can be no dispute! No individual or individuals has the right, and surely none can have the inclination, to disturb this sacred deposit Mount Vernon is safe under the guardianship of the Ladies of the Mount Vernon Association of the Union.[156]

Along with her formidable public relations duties, Tracy initially spent a good deal of her time shopping for furnishings to make the shabby house somewhat presentable, though admitting she was "frightened at the idea of daring to choose carpet and oilcloth for Mount Vernon."[157]

It soon became clear that the rhetorical distancing of Mount Vernon from war was one thing, its physical proximity another.[158] While Emma Willard and others in Tracy's Northern circle were forming soldiers' aid societies, Tracy was in Virginia between opposing armies, praying that "God will forgive the ring leaders and provokers of such evil, both sides."[159] Sometimes within earshot of battles, plagued by food shortages, isolation, and persistent illness, Tracy and Herbert painstakingly attended to the crumbling house and to the tasks necessary to opening it as a museum. Though life at Mount Vernon during the war sometimes seemed "beautiful and peaceful," Tracy was seldom free of the awareness that "at so short a distance from us men's passions are driving them to all that is wicked and horrible."[160]

Soon the war began to close in; the Mount Vernon steamboat, upon which Tracy relied for delivering supplies and fee-paying visitors, was seized by the Union for troop transport. For a time mail service to Mount Vernon was cut off, and there were rumors that the Union army was considering using Mount Vernon to quarter troops. It was precisely this sort of exigency that transformed Tracy's task from upholding the sacredness of "woman's sphere," from

being a mere "presence of a lady," to actually entering the male realm. She went directly to General Winfield Scott in Washington, from whom she requested and received assurance that Mount Vernon would not be further disturbed. She took the opportunity to proclaim that soldiers wishing to visit Mount Vernon would not be permitted to do so in uniform, nor could they bring their weapons.[161]

Tracy had subsequent encounters with authority over practical problems, apparently handling them with considerable aplomb. By the spring of 1862 the steamboat had been returned, and along with it the income of twenty-five cents per passenger. When the post and supply lines were reestablished through Alexandria, Tracy stepped up repairs and purchases for the mansion, and, to raise additional cash, she initiated the sale of flower bouquets and photographs of Mount Vernon, popular with the visiting soldiers through whom knowledge of the newly established museum would be disseminated.[162] The war's effects on the MVLA reflected its general impact on women's voluntarism, for what began as faith in the power of "woman's sphere" to protect the "shrine" from war resulted in a vivid public demonstration of the range of women's pragmatism and efficiency under duress.[163]

There was little Tracy could do, however, about the fact that the war had seriously disabled the MVLA from fulfilling its mandate to "rescue" Mount Vernon. Its finances were bleak, its institutional hands had been tied by war and internal dissent, and its regent was at her plantation in the Confederacy, unable to communicate with her Northern associates. Under these circumstances, New York vice-regent Mary Morris Hamilton and Edward Everett attempted a coup. By this time Everett's relationship with Cunningham was strained severely. He argued that the war was an act of self-defense by the North, and Cunningham, of course, felt the opposite was true.[164] Early in 1864, when Hamilton consulted Everett about her concern that the MVLA was fiscally moribund, he confessed that he had always hoped that Mount Vernon would become the property of the United States, and, in a perhaps ill-chosen turn of phrase, that the time would be right for the MVLA to "cede" it.[165] Hamilton called a meeting of the vice-regents (over Sarah Tracy's objections, noting that Cunningham and the Southern vice-regents could not attend because of the war) and made a motion for the proposed cession. Tracy was greatly relieved when the motion was not adopted. By the end of 1865 Hamilton had resigned her lifetime appointment. Everett had died early that year, and though upon his death the MVLA passed a resolution praising him as its "unfailing friend," there was evidence that some had not forgiven him for the events of the previous year.[166]

At the end of the war, mutual forgiveness would be necessary when the

deeply riven MVLA reconstituted itself. Women and their associations, North and South, had been transformed by the experience of war; the MVLA was no exception. Though their faith in the power of women's moral influence appeared undiminished, an emphasis on sheer competence, progress, and political adroitness was on the rise. This new era in the MVLA's history began on an ominous note, when Ann Pamela Cunningham arrived at Mount Vernon to take her place, at long last, as regent in situ in December 1867.

※ Mount Vernon's Reconstruction

The postwar years brought the first real opportunity for the MVLA to begin reconstructing Washington's estate. Unfortunately, after enduring years of hardship, Sarah Tracy immediately tendered her resignation because of a conflict with the regent, which some attributed to Cunningham's irascibility stemming from her laudanum addiction.[167] In 1868 Cunningham mustered the strength to engage in a "bitter, abusive" political fight to wrangle from Congress compensation for the receipts lost by the Union's seizure of the Mount Vernon steamboat, estimated to be the substantial sum of seven thousand dollars. Despite her ill health, Cunningham lobbied Congress ("I writhed under the necessity of sending for Sumner, but I did it—and did not hold back my hand when he held out his") and even the distracted President Johnson himself, finally achieving the passage of the indemnity bill early in 1869.[168]

War-born animosity lingered in this period; Cunningham had obviously felt repelled by the necessity to associate with Charles Sumner, and she attributed the haltingly slow passage of the steamboat reimbursement bill to resistance on "sectional grounds."[169] Indeed, Cunningham found herself attacked for "living on and by the Association, as an idle and penniless representative of a Southern family."[170]

It was true that Cunningham's fortunes were declining in almost every respect. In the early 1870s her personal relationships with the vice-regents were shaky, her autocratic methods of running the association were drawing sharp criticism from without and within, and, most painful of all, Rosemont was failing, as was her aged mother's health. By 1871 Cunningham had "rescued" Mount Vernon but wrote sadly of her own family's failed ancestral plantation, "our home is no home for us any more."[171] Late in 1873 Louisa Bird Cunningham, originator of the notion that had spurred the "Southern Matron" to call for the "rescue" of Mount Vernon, was dead, and her daughter made what would be her final pilgrimage to Rosemont.

The context for her return was not only the death of her mother but also the

dramatic escalation of tensions between the regent and her association. Cunningham was forced to resign in the summer of 1874.[172] Her letter of resignation celebrated the now-public Mount Vernon as women's "worthy tribute to public integrity and private virtue." She summarized the MVLA's self-definition, of which she was the author, and set forth both a critique and an agenda, which would be echoed by historic preservationists for decades to follow:

> Ladies, the home of Washington is in your charge—see to it that you keep it the home of Washington. Let no irreverent hand change it; no vandal hands desecrate it with the fingers of progress. . . . Let one spot in this grand country of ours be saved from change. Upon you rests this duty. . . . When the Centennial comes, bringing with it its thousands from the ends of the earth, to whom the home of Washington will be the place of places in our country, let them see that, though we slay our forests, remove our dead, pull down our churches, remove from home to home, till the hearthstone seems to have no resting place in America, let them see that we know how to care for the home of our hero.[173]

Cunningham could not have known that not only would her MVLA succeed in its mission, it would also spawn an entire cultural phenomenon: Mount Vernon became the model for the late-nineteenth- and early-twentieth-century house museum movement. John Cochrane's declaration that the purchase of Mount Vernon by the MVLA signaled "a new epoch in the history of our country," when women would take up the "lofty mission to rescue perishing memories," had been prophetic. Women would indeed organize to "rescue" the deteriorating former homes of historical figures, transmuting once-private houses into democratically accessible exemplars of domesticity, which offered cultural solutions to public, political problems. Linking their cause to Cunningham's, women's preservation groups often referred to their projects reverentially as "second only to Mount Vernon." The Ladies' Hermitage Association, which helped preserve the home of Andrew Jackson; Mary Galt's Association for the Preservation of Virginia Antiquities; the National Association of Colored Women, in its effort to preserve Frederick Douglass's Cedar Hill; and the Louisa May Alcott Memorial Association, among others, self-consciously emulated the MVLA.[174]

To women preservationists, the success of the MVLA confirmed that the rescue of "sacred" historic houses was within the proper, domestically based "sphere" of woman's activity. Yet to the historian it reveals the extent to which women's associations in general and the house museum movement in particular were enmeshed in the political realm. The far-from-delicate process of

founding Mount Vernon as a museum blurred the distinction between male and female worlds, enabling women to develop a unique dimension of public life. Yet the MVLA did what it could to repress historical memory of the profound political entanglements through which it passed, emphasizing instead the values it held most dear: the power of Mount Vernon to proclaim women's transcendent benevolence and the sacredness of Washington's memory as means to preserve the virtue of the American Republic. The notion of presenting a historically accurate picture of plantation life could not have been further from the MVLA's agenda, lending a particular ideological cast to Mount Vernon and its institutional progeny. Women's primary role in the creation of house museums was, for the moment, a fascinating feature of American cultural politics.

The Orchard House museum. COURTESY OF THE LOUISA MAY ALCOTT MEMORIAL ASSOCIATION.

Chapter

Gender Politics and the Orchard House Museum

Orchard House, the family home of Louisa May Alcott in Concord, Massachusettts, was founded as a museum early in the twentieth century. In many ways, it was Mount Vernon's institutional progeny. Yet the years between the establishment of Mount Vernon and Orchard House as museums were marked by dramatic changes in the nature of women's relationship to the public sphere, much of which was reflected in their activity as purveyors of history exhibits. This context is crucial to our understanding of the way in which Orchard House was perceived by its founders in the Louisa May Alcott Memorial Association.

■ *From Mount Vernon to Orchard House: The Polemics*
of the Period Room Exhibit in the Era of Reform

During the Civil War and in the postbellum period, women built on Mount Vernon's legacy, producing history exhibits featuring domestic scenes in service of particular social agendas and aligning historic preservation with their conventional roles as reformers. While the MVLA ferried Mount Vernon through the dangerous years of the Civil War, women's reform networks also worked on behalf of soldiers, raising funds and supplies for the U.S. Sanitary Commission. Their work is pertinent to the house museum movement in two ways. The commission's success helped to initiate the co-opting of the functions of women's voluntary organizations by an expanding government, a

trend that would ultimately contribute to the "professionalization" of museum work. Secondly, the commission's popular fund-raising device, the Sanitary Fair, held in many Northern cities from 1863 to the war's end, reinforced the emerging pattern of women's history-focused voluntarism.[1] Historical exhibits, including "colonial kitchen" recreations and "relic rooms," were among the most popular features of the fairs, furthering women's claim that creating polemical displays of historical objects (especially domestic interiors) was within their appropriate "sphere" of moral responsibility. As with the Mount Vernon project, the massive scope of the fairs honed women's organizational skills and heightened their awareness of what they could accomplish collectively. By making a direct contribution to the mobilization of popular ideological and political boosterism for the Union cause, the exhibits at the Sanitary Fairs were a persuasive illustration of the power of history to influence the public realm. With Mount Vernon, the Sanitary Fair exhibits and period rooms would provide the groundwork for the late-nineteenth-century historic house museum movement.[2]

The purpose of the Sanitary Fair, to generate support and personal sacrifice for the war, was well served by the democratic ideals of exhibit planners, who demonstrated a faith in "the superiority of popular institutions for preserving the balance of forces in a nation."[3] It was hoped that the fairs would be "inspired from the higher classes, but animate, include, and win the sympathies and interest of all classes."[4] The "curiosity shops" of the Sanitary Fairs appealed to a popular audience by exhibiting, for example, "a bit of the cherry tree George Washington chopped down with his hatchet," or "relics" from the frigate *Constitution.*[5]

The success of the exhibits led fair organizers to call repeatedly for the establishment of permanent museums of American history. It was argued that the New York fair's "curiosity shop" could have been "the nucleus of a great Metropolitan Museum," with its "memorials of social life," such as antique clothing and "relics of our forefathers."[6] The organizers of the Great Central Fair in Philadelphia declared:

> One of the most singular and least expected results produced by the Sanitary Fairs, has been the exhibition of large collections of objects, interesting from their association with famous people, or with events of historical importance, in this country. Museums filled with such curiosities exist in every capital in Europe, and by means of them many important events in history are strikingly illustrated. This taste, which is a modern one, would seem to be prevalent here, if, in the absence of any great national collection

of historical relics, we are to judge by the richness, variety, and number of those brought together by these Fairs from private sources.[7]

The fairs' popular "colonial kitchens" used the period room to support the patriotic goals of the commission by evoking national loyalty to a mythologized American past.[8] For example, the New York Metropolitan Fair's romantic "Knickerbocker Kitchen" featured a living display of colonial lineage in the form of "certain ladies whose ancestors figured in the chronicles of the Niew Nederlandts," along with an idyllic memorial to colonial domestic prowess: "festoons of dried apples, rows of dip-candles, seed-corn, and bright red peppers; the deep window-seats, and windows with little panes, the generous fire-place with a fire of blazing logs."[9]

The living counterpoint to the distinguished "colonial dames" sat tucked away in a corner of the exhibit. "In the chimney-corner sat Chloe and Caesar, respectable people of color, the one busy with knitting, the other 'on hospitable cares intent,' scraped his fiddle for the beguilement of visitors. Sometimes, for more boisterous amusement, there came in a real Virginia darky, all ebony and ivory, who could dance a 'breakdown' with all the vigor and splendor of embellishment of an age that is passing away. But this was only upon festive occasions. The regular ornaments of the fireside were Caesar and Chloe, and one or two pickaninnies that played upon the hearth."[10] The social order of the past was thus rendered serene, and "people of color" deemed worthy of defending and deserving of freedom if in their place. This display of humble black domesticity recalled Stowe's *Uncle Tom's Cabin* and may have been a critique of the New York antiblack draft riots of the previous year, or a reassuring vision of race relations given the potential in Lincoln's Emancipation Proclamation. In any case, the effectiveness and popularity of this history exhibit prompted the fair's organizers to conclude proudly that "the need for a great national museum" was partially met by this "eighteenth-century fireside of the Knickerbocker Kitchen," which "gave as perfect an illustration of 1776, as this generation is likely to get, at least in the way of a museum."[11]

In popularizing the period room, the Sanitary Fairs were linked to women voluntarists' involvement in the house museum movement (as well as the establishment of period rooms in art museums).[12] Like the MVLA, the women who created the "colonial kitchens" had found their experiment in public expression gratifying. Mary Livermore said that behind the "unparalleled success" of the Chicago fair was "a great uprising of the women of the Northwest, in signification of their devotion to the cause of our beloved and imperiled country."[13] With this base of support fortified, the historic house museum

movement underwent a slow but steady expansion in the postbellum years. History became more popular than ever, especially as economic upheaval and increased heterogeneity fueled middle-class interest in a mythologized American past that was stable, virtuous, and above all, culturally uniform. Historical societies more than doubled in number between 1870 and 1890, many of them acquiring historic houses in which to headquarter their activities.[14] In the South, women's groups moved directly from relief work to memorializations, bridging the colonial and Confederate eras "as a means to shape their contemporary world."[15]

The commercial boom of the postwar period contributed to a gradual but as yet incomplete shift from the presentation of house museums as churchlike "shrines" to their use as a particular kind of model home. Consumers were showing a keen interest in the new mass-produced home fashions, which by 1876 were beginning to become "colonial" in formal derivation. Thus along with the new department store furniture showrooms, photomechanical illustrations of historic interiors in mass market magazines, and books featuring detailed descriptions of famous houses, historic house museums would gradually become sources of decorating ideas. The availability of reproduction "colonial" furniture was rendering such museums highly imitable.[16] With the acceptance of a certain theatricality in home decoration that would have seemed "insincere" in earlier decades, antique collecting was becoming more popular.[17]

No single event in this period did more to mobilize interest in public or private period rooms than the 1876 Philadelphia Centennial Exposition, attended by nearly ten million people. There the "colonial kitchens" of the Sanitary Fairs were expanded into whole colonial "homesteads."[18] The Connecticut and Massachusetts buildings were putatively "colonial," as was the popular "New England Log-House," at which visitors toured the parlor and bedrooms and were served food of "Ye Olden Time" in the kitchen.[19] Cultural historians have linked the Centennial Exposition with the American discovery of "tasteful" home decoration, as well as a heightened popular interest in the American Revolution.[20]

The Centennial Exposition in turn inspired the creation of two organizations to develop still more house museums devoted to Washington: his headquarters at Morristown and at Valley Forge, which were preserved by a group of women who patterned their group after the MVLA.[21] More important house museums were founded during the course of the 1880s. Though Andrew Jackson's Hermitage had been in the custody of the state since before the war, in 1888 it was preserved and displayed as a museum by the Ladies' Her-

mitage Association, another organization modeled after the MVLA.[22] Also in 1888, Mary Galt and other self-professed "daughters of Williamsburg" created the Association for the Preservation of Virginia Antiquities (APVA), spurred by rumors that "unholy negotiations" were under way to move the home of Washington's mother to a more accessible location for "money-getting purposes."[23] The membership of the APVA was female, although it was strongly influenced by a "Gentlemen's Advisory Board." Historian James Lindgren has interpreted the APVA as an elite "revitalization movement" that repudiated local popular political agitation and expressed the desire to "rebuild their war-torn society upon its antebellum foundations" by using buildings as metaphors for the old order. Mary Galt thought that newly politicized poor men, black and white, should be disenfranchised until "deference" to authority could be "cultivated" in them, and she believed that historic sites had the potential to establish that form of control. Another founder, Cynthia Coleman, blasted "the way in which the miserable negroes behave now about everything we hold sacred, or attach any sentiment to."[24] The association preserved Jamestown Island as a historic site but was especially proud of their restoration of the home of Mary Ball Washington in Fredericksburg, Virginia. The sign outside the house read simply, "Home of Mary, Mother of George, Shrine Open Daily."[25]

By the nineties, house museums were being established at the rate of about two per year.[26] New museums were accompanied by a wave of patriotic organizations, popular historical pageantry, historical societies, and antique collecting.[27] It is crucial to note that although they shared the earlier patriotic agenda of the MVLA—that house museums reinforced the inexorably linked love of home and love of country—late-nineteenth-century museums would increasingly focus on their ability to promulgate national loyalty in an increasingly polyglot citizenry. The invention of a shared vision of America, set in an immutable past, was a potent middle-class response to the conflicts and heterogeneity of the late nineteenth century. In the words of historian Michael Wallace, the more the American bourgeoisie felt threatened by social instability, "the more they grew convinced of their inherent, because inherited, legitimacy."[28]

The Daughters of the American Revolution, founded in 1890 by Mary Lockwood, would eventually control a significant share of the nation's house museums. The DAR was established because the Sons of the Revolution had flatly refused to admit female descendants of Revolutionary patriots into their association, despite the argument made by one SAR member that, since women had done so much to keep domestic life going during the Revolution,

they should be allowed "to help commemorate the names of the sires of the Revolution."[29] Lockwood responded, "Why is not the patriotism of the country broad and just enough to commemorate the names of women also?—were there no mothers in the Revolution; no dames as well as sires whose memories should be commemorated?"[30]

Within months the DAR was formed. Despite Lockwood's revisionist rhetoric, the Daughters would in fact commemorate chiefly the "sires" of the Revolution, their memorials celebrating the conventional mythology of the Revolutionary period.[31] At the 1890 inaugural meeting, the DAR declared its mission to "teach patriotism by erecting monuments and protecting historical spots, by observing historical anniversaries, by promoting the cause of education, especially the study of history, the enlightenment of the foreign population, and all that makes for good citizenship."[32]

The use of history to Americanize immigrants was a frequent justification for historic preservation at the turn of the century, but no organization did more to this end than the DAR.[33] It claimed that such historical education was a method of "safeguarding the land against the ravages of ignorance and sedition."[34] The DAR's plan to "carry the gospel of Americanism to every American home"[35] was designed to address the fear of "the addition to our country's population of subjects of despotic monarchies [who] were so imbued with hatred for government that they might endeavor to substitute anarchy for law and order."[36] From the first the DAR acted to acquire the historic places it identified as potentially useful in stabilizing America, since these buildings were "passing into the hands of improper people."[37]

Other patriotic organizations agreed. The Colonial Dames, a smaller and more exclusive association than the DAR, preserved the Van Cortlandt house in upstate New York. Mrs. J. V. R. Townscend, Colonial Dame and regent of the MVLA, declared that the "Americanizing of the children by enlisting their interest in historical sites and characters is of great significance to any thinking mind."[38] With such similar agendas it is not surprising that the two groups had occasion to clash. In 1904 a battle between the Dames and the Daughters erupted in New York City over the Morris-Jumel mansion. The New York Park commissioner was designated to be, in the words of the *Times*, "the Solomon of the situation," and the DAR was granted custody.[39] The Colonial Dames would march on, however, marshaling historic resources and proudly describing their evolution: "We acquired valuable real estate, a historic mansion and a large endowment fund; we formed a corporation to hold the property; we acquired a museum with the highest standard for comparison; we set up housekeeping; we maintained a social status in Washington; we invited the world and his wife to visit us; we are women of property."[40]

The larger and less exclusive DAR achieved a remarkable record of accomplishment in the field of historic preservation, with more than 250 houses in its custody by 1941.[41] The inclination of the DAR to memorialize houses associated with male political history, national and local, was pronounced, despite Lockwood's call to commemorate "the mothers in the Revolution."[42] This can be explained by the quintessentially political goal of the DAR, to use history to achieve a society uniformly supportive of the American government. The presentation of the conventional mythology of the Founding Fathers was consistent with the politics of women who construed themselves as Daughters.[43] On women's political issues the DAR was generally conservative, stating that "the influence of women in society and in the home, if rightly appreciated, is far greater than any power the right of suffrage could confer upon her."[44]

This is not to say that there were no historic house museums dedicated to women as the turn of the century approached—for example, the home of "Mary, Mother of George." The celebration of the wives and mothers of male political figures would continue to be a minor genre of historic preservation, as would the memorialization of mythological female figures.[45] The most famous museum commemorating a woman was almost entirely apocryphal: the Betsy Ross House in Philadelphia, established in the 1890s. The preservation of this house is related more directly to the period's cult of the flag than to interest in the history of women.[46] The Betsy Ross Memorial Association was created by a Ross descendant, who identified a house on Arch Street in which the first flag was supposedly sewn. Though the verity of either the tale of Betsy Ross or the exact location of the house was unconfirmed, the organization began fund-raising, achieving a million subscriptions for the preservation of the house by 1905. Following the MVLA's example the group sold commemorative prints, in this case a lithograph titled *The Birth of Our Nation's Flag,* depicting Ross presenting the completed standard to an admiring company of male patriots. A tract publicizing the cause was issued—Addie Guthrie Weaver's *The Story of Our Flag*—in which the author asserted that "all loyal American hearts will welcome the glad tidings that active steps have been taken to purchase the birthplace of the Star-Spangled banner." It would, she said, "be the mecca and shrine of the whole nation."[47]

Both the cult of the flag and the DAR would find a place in the monumental World's Columbian Exposition in Chicago, which observed the four-hundredth anniversary of the "discovery" of America by Columbus. The White City of 1893, birthplace of the pledge of allegiance to the flag, provided another opportunity for women to express their historical visions to a mass audience, in this case nearly thirty million people.[48] The Columbian Exposition, like

the Sanitary Fairs and the 1876 Centennial Exposition, was linked to the historic preservation movement and popular patriotism. But coinciding as it did with the intensification of the debate over woman suffrage, it proved to be far more controversial. A heated debate arose among women's groups over how women's history in particular should be presented at the exposition.[49] That this controversy was suffused with politics is indicated by the fact that when the DAR agreed to participate, the fear was voiced among the membership that "it would commit the society to the Suffrage movement." Lockwood, perhaps recalling her wish to commemorate the brave women who participated in the Revolution, described the Daughters' wariness as "Victorian."[50] Yet amid the discernibly feminist voices of the exposition, many women openly worried, "What will be the result if only the dull-witted ones are left to maintain the elevation of the home?"[51] Many exhibits at the exposition reflected this apprehension. From a replica of that "sacred spot," Mount Vernon, to the colonial interiors of the Massachusetts building, domestic iconography was as popular as ever.[52]

However, the "New England Kitchen" of the Columbian Exposition differed from similar exhibits at earlier fairs. Run by Ellen Richards, this was the famous Boston kitchen for the working class, self-consciously designed by reformers to teach workers how to prepare healthful, cheap, and, of course, "American" food.[53] In many ways this progressive rather than historical New England kitchen and the suffrage controversy reveal a new divisiveness in middle-class women's culture that would not soon be resolved. The exposition was not the last occasion at which women in power would attempt to use domesticity as the oil poured on waters troubled by women's demand for the vote, as we shall see. While social and political reformers marched on, the conservative members of the DAR would retreat into their traditional pursuits, not the least of which were house museums.[54]

In the years following the Columbian Exposition, women around the country undertook historic preservation projects. Adina De Zavala and the Daughters of the Republic of Texas remembered the Alamo in 1893; the Native Daughters of the Golden West set up the California Landmarks Commission; and Colorado clubwomen lobbied successfully for legislation protecting the archeological remains of ancient Cliff Dwellers from plunderers who hawked them in the "curio-shops of Denver."[55] In the South a committee of women known as the Uncle Remus Memorial Association preserved the home of Joel Chandler Harris in 1909 as a monument to "the domestic virtues, a guarantee of the world's respect for faithful married love and for the hearthstones of the world."[56] In the teens, the National Association of Col-

ored Women memorialized the Washington, D.C., home of Frederick Douglass, in the words of Mrs. Booker T. Washington, "with the same veneration as is true of Mount Vernon."[57] In the North, Caroline Emmerton opened the House of the Seven Gables in Salem to the public in 1908, using it as a source of funds to support settlement-house work, which she located in two other seventeenth-century houses. She maintained that the "historical and literary associations of the old houses must surely help in making citizens of our boys and girls."[58] Nearby in Harvard, Massachusetts, Clara Endicott Sears purchased the old farmhouse in which Bronson Alcott's Fruitlands experiment in communal living took place, at first intending to raze the "eyesore" adjacent to her estate. When she discovered its historical significance, she instead turned the house into a museum and in 1914 began hosting lavish, exclusive luncheons there for associations she deemed appropriate, including the Colonial Dames and the Society for the Preservation of New England Antiquities (SPNEA).[59] Elsewhere in the East, the newly formed New York History Club saw to it that immigrant children were exposed to sites of patriotic inspiration. The *New York Times* boasted that "many an eight-year-old foreigner . . . is beginning to know the historic spots near his squalid home."[60]

The historic preservation movement was gaining momentum in the cultural climate of the Progressive Era. Here was an influential and prestigious ideological agency that had clearly come to stay, and not surprisingly, it was at this time that men began to involve themselves in significant numbers. For example, in Massachusetts, an advisory commission known as the Trustees of Reservations was established in 1891, and in New York, the New York Scenic and Historic Preservation Society was formed in 1896.[61] Distinguishing their methods from those of women's voluntary associations, men drew directly on the power of government. Both the Trustees of Reservations and the New York Scenic and Historic Preservation Society worked to recommend sites for potential acquisition by the state, some to be administered by these organizations once in government custody. The New York organization (renamed the American Scenic and Historic Preservation Society in 1901 and modeled after the British National Trust) was chartered by the state of New York to purchase and hold property, which by the turn of the century included historic houses as well as monuments, graves, and parks.

As state participation in (and male domination of) historic preservation expanded, so did the influence of large metropolitan museums. By the end of the nineteenth century, such museums were important agencies of what one historian calls the "sacralization of culture." The public exhibits that heretofore had been eclectic collections of "curiosities" were now being reorganized by

large museums into highbrow, cultivated forms.[62] It was argued that museum collections would stimulate the public to systematically collect antiques and other tasteful objects, and such collecting would in turn induce "habits of neatness, order, and skill."[63] Large museums were beginning to take notice of the aesthetic value of collections in house museums. In 1906 the Boston Museum of Fine Arts held the first large exhibit of American decorative arts, a display of early American silver. In 1909 the Metropolitan Museum of Art held a major exhibit of American furnishings and artifacts, innovatively arranged by historical period rather than by object type.[64] Nonetheless, though their interest in historic objects grew, the metropolitan museums would remain essentially oriented toward connoisseurship, sharply distinguishing this genre of museum education from that of the small history museum. The slick, professional exhibitry of metropolitan museums would, however, reinforce a growing element of elitism and connoisseurship in house museums and create pressure for ever more elegant period rooms and staff well versed in high-style antiques.

The increasing role of state government, of metropolitan museums, and of "professional" organizations like the SPNEA in historic preservation mark a watershed in the history of house museums.[65] At the turn of the century, British preservationist C. R. Ashbee had noted the decentralized nature of American historic preservation compared to that of Britain and France, and he argued as a representative of the British National Trust that America should "federate the different interests" that were working "haphazardly."[66] Soon after Ashbee made this evaluation, the trend began to reverse itself, though not without a degree of resistance. Ashbee himself described one ambivalent reaction to his mission to create a National Trust in America, the response of a fellow ship passenger: "That's mighty interesting, but can't you suppress the title; Americans hate Trusts." In a letter to William Sumner Appleton, a woman preservationist registered concern that centralized bodies like the SPNEA would "swallow up all the local societies that are poor and struggling, like the big corporations."[67] This was a compelling charge in the political context of the Progressive Era.

As men became more and more involved in history museums, women's position of leadership was gradually eroded. According to one historian, the "new generation of museum men" at the turn of the century replaced "the unsorted clutter of the sanitary fair and Centennial colonial kitchens" with "carefully conceived rooms."[68] Among the new "museum men" was George Francis Dow of the Essex Institute of Salem, Massachusetts. The Essex Institute had held its first exhibit of colonial objects in 1875, organized by the Salem

Ladies Centennial Committee. But it was Dow, a museum professional, who has been credited with having created the first American museum period rooms in 1907. As had the period rooms of the Sanitary Fairs, the Centennial, and the Columbian Exposition, Dow's colonial rooms featured female "hostesses" in "homespun costumes." He received inquiries about the outfits and the "hostess" system from other history museums.[69]

Furthermore, the power of men was manifest in the growing interest of newly professionalized architects in historic buildings. The DAR, for example, experienced public humiliation over their administration of the restoration of Independence Hall in Philadelphia at the turn of the century. The Daughters had accepted the donated services of architect T. Mellon Rogers, but his work on the building was publicly attacked by the American Institute of Architects.[70] For the first time, the ability of the nonprofessional DAR to properly protect a historic resource was openly questioned. The Independence Hall fiasco occurred during the attempt to tighten professional architectural credentials at the turn of the century, in keeping with this Progressive Era trend in other professions, including museum work. Though the American Institute of Architects had existed since 1857, new requirements included elevated levels of education and practical experience.[71] Women once had a place in the nineteenth-century architectural field, especially as writers of architectural literature, but now rising educational standards limited the opportunity for women to earn professional standing.[72]

By the early twentieth century, the once predominantly voluntary activity of running house museums was slowly being professionalized. In general, women retained their roles as fund-raisers, as low-salaried workers, and above all as volunteer curators and tour guides, but men increasingly took over positions of leadership. Dow's system of using women as "hostesses" became the rule. An early-twentieth-century guidebook for museums explained, "Among all the houses that are interpreted to visitors there are only a few in which men act as guides; at Monticello, colored men servants give a series of short set talks. In general, a man does not fit well into the role, partly, no doubt, because most historic houses are domestic in character and one naturally expects to find women in them. Colored men fit in southern houses, to be sure, but with them there is little flexibility or real understanding. Above all, guides should be people of resource, and—save in certain kinds of houses where men might be said to belong—guides should be women. This is the fruit of experience in many places."[73] Boards of trustees, "composed of men of influence and means," managed the activities of the "ladies' auxiliary," which was said to be "better able to assume charge of social events in the museum. For example, a

ladies' committee may assume charge of an exhibition of textiles, public-health exhibits, children's fairs, bazaars, household-arts exhibits, and other numerous matters of great value."[74] The shift from women's direct control of history museums to their relegation to an "auxiliary" role was looming but as yet incomplete in the early decades of the twentieth century.

Before this pattern could become generic, large corporations and the federal government would have to enter the field to provide the funding necessary to salary the professional "museum men," and this would not occur until later in the twentieth century. However, some of the governmental structures that eventually sponsored federal control of historic house museums were beginning to emerge in these early decades. The concern that America's natural resources might disappear with the western frontier had generated new conservation efforts, which in turn had inspired the creation of protected national parks, such as Yosemite and Yellowstone in the 1890s. In 1906 the Roosevelt administration expanded the federal government's power to protect areas of natural and archeological interest with the passage of the Antiquities Act. Modeled after Britain's Ancient Monuments Act of 1882 and linked to the professionalization of anthropology, the Antiquities Act enabled the president to designate national monuments by executive order.[75] In part because the Antiquities Act itself did not provide for funding or for effective enforcement, the National Park Service was created in 1916.[76] The agency focused primarily on the nation's spectacular natural history resources; it hired no historians and controlled few historic structures until the 1930s.[77] Still, the move from federal direction of natural and prehistoric preservation to a program of acquisition of historic sites, especially house museums, would be only a small leap.

During the twentieth century, historic house museums would remain celebrants of male political history, patriotism, and the ideology of domesticity. The early domination of the movement by women's groups would be increasingly challenged by the new "museum men," by professional architects, and by the intensifying interest of state and federal government. Yet as the first decade of the twentieth century closed, when women's power over museums was declining and their public role was being reformulated, an unusual house museum was founded. Unwittingly documenting women's political culture in the pivotal years marked by increasing cultural heterogeneity and the debate over the suffrage amendment, the Concord (Massachusetts) Woman's Club created the Orchard House museum to commemorate Louisa May Alcott's popular domestic novel, *Little Women.*

▪ *Concord in the Early Twentieth Century: Metamorphosis and Reaction*

It was during Louisa May Alcott's lifetime that the Massachusetts village of Concord began its reluctant metamorphosis into a modern suburb of Boston. Immigrants, the railroad, and an industrial economy heralded the process. By 1846 the Boston–Fitchburg rail line had been built by Irish laborers, and in 1872 the Framingham–Lowell was added, contributing to the development of Concord Junction, the new industrial end of town where immigrants could find housing. In the first decade of the twentieth century, improvements in the commuter railway system made Concord a "streetcar suburb" requiring new waterworks, sanitation systems, and building codes.[78]

Of course the very innovations that would make the new Concord a standard-bearer of New England suburban life denoted a change in its cultural character. The Italian laborers who built the sewer system in 1898 moved to old farms on the hillside and modest dwellings near the depot. With electric lights came electric streetcars bringing the bustle of tourists, and inevitably the old Concord dynasties were challenged by diverse groups of newcomers hoping to participate in the political system. The Irish immigrants who had come to build railroads and serve as domestics in Concord's fine homes experienced a population boom in the sixties and achieved a significant foothold on the school board by the late eighties.[79]

The apprehensions of Anglo-American Concordians, many of whom considered themselves the only legitimate political leaders of the town made famous by the Revolutionary War, gradually but palpably intensified, and soon the more aggressive manifestations of Yankee antagonism toward the Irish were beginning to meet with still more aggressive resistance.[80] By the end of the century direct attacks on an immigrant minority were no longer possible: The 1910 federal census revealed that only 38 percent of Concord's population was of English extraction. The majority of citizens now came from Italy, Scandinavia, Ireland, and eastern Europe to work in Concord's mills, factories, and municipal projects.[81]

The *Boston Post* expressed relief that "the case of the Alcott house" suggested a method of retaining such places "as national possessions" in the face of "the wave of alien inundation . . . creeping in on old Concord." "The farms on the surrounding hillsides," the *Post* warned, "are passing yearly into the hands of foreigners unfamiliar with our history."[82] One of the founders of Orchard House museum had led the movement for its preservation "as a memorial to

Louisa May Alcott, not alone on account of the worth of Miss Alcott's life and writing, but also to bring to increasing public notice the value of the standards of living of her generation."[83]

The preservation of such "standards" also concerned the ever-articulate Henry Adams, who likened the sons and daughters of Puritan stock to "the Indians or the Buffalo who had been ejected from their heritage." Such displaced New Englanders had been "forced out of the track" by the new immigrants, by "coal, iron, steam," and by corrupt entrepreneurs. If it is true, as T. J. Jackson Lears argues, that fin de siècle modernization went hand-in-glove with an antimodernism that was "a complex blend of accommodation and protest," then Orchard House and its founders illustrate how this impulse could manifest itself in the aggrandizement of the "traditional" American past.[84]

In fact, Concord had an established history of brandishing its Anglo-American heritage in the face of sociocultural change. The 1875 national celebration of the centennial of the Lexington–Concord battle drew mass participation, thanks to the Fitchburg and Lowell railways, whose capacities were "soon tried to their utmost."[85] The committee for the commemoration was composed of Concord's most prominent citizens, two of whom were fathers of founders of the Orchard House museum.[86] But this earlier generation of historic celebration would differ in several key ways from the Alcott memorial. Formal and male-dominated, the Concord Centennial celebration made a sharp distinction between public and private space, in contrast to the blurring of spheres characteristic of the house museum. The gentlemen noted that the "resplendent" decoration of "private homes" during the gala, though extraordinary, "did not come properly within the province of the committee."[87] Also in sharp contrast to the Orchard House memorial were attitudes toward female participation. Not surprisingly, there were no female speakers. Women were mentioned twice, once by Ralph Waldo Emerson, who read a widow's pension deposition describing her husband's heroic sacrifice, and once as the metaphorical America, "for manly hearts to live and die for."[88]

Despite their eagerness to be a part of the festivities, the women of Concord were nearly left out, as an account by Louisa May Alcott illustrates.[89] As they stood in the twenty-degree cold waiting for the promised ceremonial escorts to lead them to seats designated for the "weaker vessels," it dawned on them that they had been forgotten. Alcott declared: "Patience has its limits, and there came a moment when the revolutionary spirit of '76 blazed up in the bosoms of these long-suffering women; for, when some impetuous soul cried out, 'Come on, let us take care of ourselves!' there was a general movement; the

flag fluttered to the front, veils were close reefed, skirts kilted up, arms locked, and with one accord of the light brigade charged over the red bridge, up the hill into the tented field, rosy and red nosed, disheveled but dauntless." By the time the women arrived, it was late and the seats were filled. They sat at the edge of the platform, "with the privilege of reposing among the sacred boots," and it was not until the ball that evening, when "woman was in her sphere," each attired in the garb of a colonial foremother, that men made efforts to placate the neglected females.[90] Alcott warned that the women, who "bravely bore their share of that day's burden without the honor" would someday "utter another protest that shall be 'heard round the world.'"[91]

Despite the struggle over women's claim to participation in the Centennial, the committee was sure that those with Revolutionary forbears "*felt* in their veins the blood of the Revolution."[92] The main oration of the day was directed toward this corps of Puritan descendants. George William Curtis, editor of *Harper's,* outlined the new "responsibilities" that had befallen them, unforeseen by the Revolutionary Fathers because America was then a "homogeneous people" well steeped in the "intelligent practice of self-government." Immigration had introduced into Massachusetts men whose lack of "traditional association with the story of Concord and Lexington" signaled "immense ignorance" and a susceptibility to "powerful and organized influences" incompatible with "freedom of thought and action." He feared that the addition of the "emancipated vote" to that of the immigrant would "overwhelm the intelligent vote." The remedy used thus far, he argued, was itself dangerous: "the constant appeal to the central hand of power."[93]

The years between the Civil War and the early twentieth century found those Concord residents who claimed colonial inheritance engaging in ritual activities signaling first slightly worried self-congratulation, and then the desperate rallying of their Anglo-American resources against "alien inundation" as the century closed. Concord's exclusive patriotic societies, established at the turn of the century, were major contributors to Americanization efforts, above all teaching "obedience to law, which is the groundwork of true citizenship."[94] The Concord chapter of the Daughters of the American Revolution, led by one future Orchard House founder, Harriett Lothrop, saved the venerable Bulkeley house on the square.[95] Perhaps the most noteworthy historic activity in turn-of-the-century Concord was the creation of a national patriotic organization, the Children of the American Revolution, also at Lothrop's initiative.[96] The connection between this activity and Concord's dramatic social transformation is clear: Lothrop touted the beneficial "influence" attendance to CAR meetings would have on immigrant children.[97]

Concordians engaged in considerable debate over public strategies to improve the character of children, reflecting their growing alarm over the presence of immigrant families. The Massachusetts Civic League sent a lecturer to Concord to suggest that the town construct a municipal playground, following an article in Concord's newspaper claiming that "nothing so encourages and helps the making of American citizens out of this heterogeneous joblot of immigrants in our midst."[98]

This concern about the proper molding of young Americans was an expression of a nagging anxiety over the relationship between "proper" homelife and national loyalty. The superintendent of Concord's public schools announced a new emphasis on "moral education," instilling those qualities "upon which a republican constitution is founded."[99] At the same time, the editors of the local newspaper ran a substantial, thirty-part syndicated series on "character development," addressing "the deplorable laxity of morals" among the populace and arguing that "the only remedy is to begin with the children and to mold their plastic minds into higher ideals of thinking and living." Significant for the dawning activism on behalf of the Louisa May Alcott memorial, it was posited that "one of the best textbooks for character teaching is biography."[100]

It was assumed that the ideal vehicle for such "character development" was the Anglo-American home. Specifically, it was the single-family suburban home that began to take on mythical dimensions as the potential savior of American morality. In Concord, distress over "the home" was in part expressed by the adoption of the Massachusetts Tenement House Act for Towns of 1912. After a lengthy period of debate (and research by one of the founders of Orchard House, selectman Murray Ballou), the town voted to accept the legislation in 1914.[101] Elmer T. Forbes, chairman of the Housing Commission of the omnipresent Massachusetts Civic League, had explained to Concordians why they should adopt this set of building regulations, arguing that it was possible for towns "to protect themselves from this objectionable type of dwelling." Though there were no tenements in Concord, he warned that "now is the time for Concord to decide whether it will continue to be a town of homes, to choose between homes and tenements."[102]

Anglo-American Concord's claim to political leadership was legitimated by the colonial history exemplified in its fine and proper homes. A gratified lecturer told the Concord Antiquarian Society in 1901 that the town had been established by "a Natural Selection of the best and bravest of the stock of Old England" who came expressly to "establish these homes."[103] Another writer a few years later boasted that Concord was characterized by "old-fashioned," "comfortable" homes, that "representatives of the old families are still influen-

tial in the town," and that its citizens exhibited "in their bearing proud consciousness of a glorious past."[104]

Part of this "proud consciousness" was the fashion of decorating Concord's homes in Colonial Revival style. Beginning with the Philadelphia Centennial Exposition in 1876, and increasing in intensity through the twentieth century, many Concordians abandoned their ornate Victorian furniture in favor of the "colonial." Bessie Hudson, one of the Orchard House founders, wrote that viewing exhibits of historic furniture in Philadelphia made chic "a flood of new decorations" such as "milking-stools and flat-irons tied up with bows of ribbons."[105] Colonial decoration would lend many of Concord's private parlors the ambience of museum period rooms, presaging a comforting retreat into the past as the twentieth century progressed.

Concord's profound identification with its past made tourism a local industry as the popularity of historic "pilgrimages" grew. Late in the nineteenth century, Concord was "another Stratford, another Mecca, to which come pilgrims from the Old World and the New to worship at its shrines."[106] Advertisements in the back of a pamphlet published by the Antiquarian Society in 1902 indicate the flourishing businesses oriented toward servicing the tourist trade. They included Richardson's Pharmacy (the unofficial "Protestant" pharmacy, versus Snow's "Catholic" drugstore), selling "genuine Thoreau pencils," guidebooks, and postal cards; Horace Tuttle's livery, which rented carriages that met trains at the rail station "and the Electrics at the Public Square"; Hollis Howe, the jeweler, offered "Concord Souvenir Spoons" and "Minutemen Stick Pins"; and Hosmer's Dry Goods hawked "Souvenir China" with "Concord Views."[107] Years before, Louisa May Alcott had tartly predicted that the town would become merely "a museum for revolutionary relics."[108]

▪ *The Concord Woman's Club and the Literary Foundation of the Orchard House Museum*

It was in early-twentieth-century Concord that Lothrop approached the Concord Woman's Club (CWC) with her plan to establish the Orchard House museum. Lothrop's decision to approach a women's club demonstrated an understanding of the cultural agenda of this important force in the postbellum women's movement. United under the General Federation of Women's Clubs in 1892 (which had more than one million members by World War I), women's social clubs had grown side by side with the temperance crusade. Clubwomen engaged in these activities as the "natural" extension of the traditional female role. Temperance advocate Frances Willard called it "the

home going forth into the world."[109] Certainly the conversion of the Alcott family home into a public memorial fell gracefully into this category.

In 1912 the General Federation of Women's Clubs declared conservation, broadly speaking, its "raison d'être," that among their many callings, club-women would be the preservers of "all that is good in the civilization of the past."[110] This was far from an antiquarian pursuit; the past was felt to have the power to influence the present, in particular to guard against the deterioration of the basis for public morality, "the home." The GFWC had long celebrated the "active, restricted, but altogether useful life" of colonial women.[111]

This historical perspective was part of an effort to revitalize the home through "the gospel of better living."[112] GFWC historian Mary Wood stated in 1912 that domestic science was "a way whereby housekeeping should be elevated from drudgery to dignity," by spreading the notion that "simplicity and usefulness were the ultimate test of home furnishings." She asserted that "until the women of this land have awakened to the value of a simple, well-ordered and dignified home life, the workers of the General Federation will continue their labors."[113] The single-family home was to be the seat of women's awakening to the power of domesticity as a public moral tool. A Philadelphia women's club argued that old houses should be repaired rather than new buildings constructed. The club claimed it had succeeded in convincing local housing authorities "not to build the large tenement, but to improve the separate home."[114] The GFWC zealously pursued "the question of proper housing," for as one state federation declared, "the millennium awaits only the perfect home."[115] The uniting of womanhood into an organized force that would educate itself and employ domestic values to rescue the tumultuous public realm was an alluring prospect to many women.

The interests of women's clubs generally were shared by the Concord Woman's Club. Founded in 1895 for the purposes of "educational and social culture," its membership policy was selective, acquired only by a vote of the executive board. Their motto, emblazoned on the frontispiece of every yearbook, was "Leave the Chaff and Take the Wheat."[116] The club consciously traced its roots directly to the Sanitary Commission via the New England Woman's Club. One Concord clubwoman explained, when the commission disbanded, "active women felt a desire to keep their forces united by some means."[117]

So rooted in nineteenth-century activism, the women's club that created the Orchard House museum was not merely antiquarian in its concerns. Rather, the establishment of this museum was based on the clubwomen's consciousness of pressing social problems and "conservationist" impulses toward

their solutions. Classes and lectures organized by individual committees were the main focus of the club at the turn of the century. Literature, science, art, and "child study" were early favorites, but classes in current events became more frequent during the first decade of the twentieth century.[118] In 1910, soon-to-be Orchard House museum founder Abby Rolfe's "Health Study Class" took an interest in pure food, and under her leadership the club began funding an Appalachian school.[119] Club events featuring seemingly nonpolitical domestic topics began to take on public implications. Rolfe hosted a well-attended talk by Grace Weston, "Exterior and Interior Furnishings of a Home," which strongly recommended that "all unnecessary bric-a-brac" be eliminated from the home environment in favor of morally superior "plain but substantial" furniture. The CWC had been exposed a decade earlier to the politically charged aesthetic doctrine of the Arts and Crafts movement by C. R. Ashbee, "the most significant member of the Anglo-American cultural exchange." Ashbee was on a lecture tour to garner support for the British National Trust, which he argued should be seen "in the light of the larger development of English-speaking people as a whole," and its promise to "safeguard the historic associations of the race and preserve the amenities of life."[120]

Eventually the club began to engage speakers who made even more straightforward political arguments. Mrs. May Alden Ward presented a paper, "History in the Making," which detailed the damage done to England by the "appalling" coal strike, making ominous reference to "complications" in American coal mines that signaled the unrest to come.[121] A large audience enjoyed the club's presentation of a dramatic reading of Israel Zangwill's "The Melting Pot," about the Russian Jew's "safe escape to America, the love and reverence he felt for this great, free nation, where all races were mingled in the melting pot."[122] Soon the need for action on behalf of the immigrants was placed before the clubwomen; one speaker outlined the "various agencies at work for the protection of the immigrants and showed the need of friendly help from all Americans."[123]

Concern over what to do about the influx of "new immigrants" was fundamental to the movement for the preservation of Orchard House. The process began before it was purchased by the Louisa May Alcott Memorial committee of the CWC, when Orchard House was owned by Harriett Lothrop. She had acquired Orchard House at the turn of the century and for a decade pursued buyers interested in preserving it as a memorial to *Little Women*. The property adjoined her own summer house, once Hawthorne's Wayside, which had also been one of the childhood homes of Louisa May Alcott.

Lothrop's original plan to raise funds for the purchase and preservation of

Orchard House was detailed in a 1901 letter. She proposed that the Little Women Clubs of America initiate a one-dollar fee for the first year of membership and twenty-five cents per year "every year afterward—as the fund for caring for the place." According to Lothrop's plan, management of the fundraising would be "conducted on the lines of Mt. Vernon as preserved to venerate Washington's memory," emphasizing "personal and womanly supervision."[124] Eventually articles documenting public support for the project appeared in local papers. The *Boston Herald* bemoaned the decay of the "lonesome brown house in the Concord pines," saying "the windows are black, and a glaring 'For Sale' sign bars the door once thrown open to every visitor."[125] A later issue published a letter from "An Englishwoman," asking, "Why in the name of almost everything that good Americans hold dear should that home of Louisa May Alcott not be bought by public subscription and be made a museum and show place like Washington's home?"[126] And in late 1910, a woman from Rhode Island approached the newly formed Society for the Preservation of New England Antiquities (SPNEA), asking the organization to purchase Orchard House and arguing its merits as "a shrine in the affections of the American people," to which thousands already flocked.[127]

Despite popular interest in the house, Lothrop was unsuccessful in her attempts to sell it for fully ten years. In 1911 she suggested that the CWC coordinate fund-raising efforts, the goal to be commensurate with her asking price.[128] Lothrop had once said that she did not "desire to make money out of this," although she had emphasized, "I have to work very hard at my literary work to care for myself and educate my daughter. And of course the house is the heart of the whole thing. Take that away and what would I have left? So it must not be less than $5,000."[129]

Tense haggling apparently ensued, as John Pratt Alcott complained that "we had tried many times to buy it but it was not until the club women of the town brought their united efforts to bear that the price was put within reasonable limits."[130] The problem was that Orchard House was in poor condition, making the projected restoration cost formidable. The Concord Woman's Club reported that Lothrop ultimately dropped the price to three thousand dollars, although the deed documents the token purchase price of one dollar.[131]

Facing this extensive and costly project, the club decided that the direct assistance of men would be useful, and in 1911 it voted a committee "and their husbands" to form a corporation.[132] The addition of men to the Louisa May Alcott Memorial Association gave the women access to expert counsel and political resources. The association retained the CWC's selective membership

policies. New members were admitted by invitation only, a kind of social sorting of wheat from chaff.[133]

The founders of the Orchard House museum belie the popular perception that house museum founders were quaint, rather apolitical, antiquarian ladies and gentlemen concerned chiefly with tea parties and Chippendale. The museum's founders actively participated in the political culture of the early twentieth century, albeit in varying degrees and each in her or his own way.[134] Each saw the Orchard House museum as a project congruent with certain political and social goals. That the founders' political causes were not always the same suggests that the new public institution had a number of potential meanings and that historic preservation was a source of consensus for an otherwise divided group.

Lothrop, although not one of the charter members of the museum, can be considered one of its founders because of her active pursuit of the purchase of the house by the CWC.[135] A successful writer of children's stories, including the *Five Little Peppers* series under the pseudonym Margaret Sidney, she and her husband, Daniel, moved to Concord shortly after their marriage; he commuted to Boston daily to his job as a publisher of children's books. After his death in 1892, Harriett Lothrop retained her Concord home as a summer residence, wintering in Boston. She purchased the adjacent Orchard House in 1901. Her interests included the DAR, of which she founded the Concord branch, her own Children of the American Revolution, the Concord Woman's Club, the Society of Descendants of the Mayflower, and the Women's Board of Missions. Lothrop steeped herself in the history of "Old Concord," sponsoring historical pageants, displaying her restored Wayside in tribute to Hawthorne, and working on behalf of the DAR's local projects.[136]

Lothrop harbored a distinct anxiety about the changes in Concord, some of which she herself represented. She was not a native Concordian, however much she wished to be immersed in its history. Notwithstanding the fact that her own husband had been one of Concord's modern commuters, she later deplored the trolley lines "as directly against the spirit of Old Concord."[137] And though she restored Hawthorne's house, even giving personal tours, she complained about the tourists who intruded on her home.[138]

Lothrop's writings document her sense that Concord was being threatened from without. She wrote a guidebook for tourists to "Old Concord" in 1893, which spiritualized Revolutionary historic sites and at the same time proffered some gratuitous critiques of and warnings against immigrants and the poor.[139] For example, in a description of a carriage ride taken by Lothrop and a companion to view the "tablet on the bluff" commemorating the 1775

battle, she described their wariness of "a tramp," with "sullen eyes" querying "the Fate that would give us a carriage and deny him one."[140] Her fear of the strangers who did not share in her reverence for colonial history, or in her material comfort, inspired a pivotal incident in her most famous novel, *The Five Little Peppers and How They Grew*.[141]

That Lothrop and Louisa May Alcott both wrote children's stories would seem to explain her enthusiasm for the Orchard House project. Yet there are indications that Lothrop was not a particular fan of Alcott. In the first place, there are a number of striking similarities between *The Five Little Peppers* and *Little Women*, such that Lothrop was called "simply a vulgar duplicate of Miss Alcott."[142] Lothrop defensively insisted that she "never copied any one," that the "little brown house" was her own fancy, and that she herself had imagined that the "help mother" theme was best achieved by the elimination of Mr. Pepper. She often "made derogatory remarks about certain authors who had, in their books, infringed upon the personalities of individuals to such an extent that these individuals could be recognized."[143] Because the sale of Alcott's novels increased after her death, the competition between the works of Lothrop and Alcott was unremitting.[144]

In her 1893 Concord guide, Lothrop only briefly mentioned Orchard House as the home of Amos Bronson Alcott and "the daughter who opened the golden way to Fame and Fortune by the realistic drama of 'Little Women,' that was immediately set up on the stage of every quiet home centre." The only other reference to Louisa May Alcott was cursory and associated with Wayside, where she said the "little women" had once lived.[145] Her testimonial to the writers of Concord emphasized "the immortal three who wrote, lived and are sheltered here in death." Her elevation of Emerson, Hawthorne, and Thoreau extended to her "tour" of the Sleepy Hollow cemetery, in which she gave directions to their graves, and to Daniel Lothrop's, but she did not direct tourists to the popular site of Louisa May Alcott's grave.[146] For Lothrop, writer of children's books and widow of a publisher of children's books, to make short shrift of Alcott is certainly noteworthy. Yet all of this changed in 1901, when Lothrop purchased Orchard House and began her decade-long attempt to sell it as a memorial to Louisa May Alcott. In fact Lothrop's real estate agent revealed that she had purchased the house explicitly "to protect Wayside, her home."[147]

In the spring of 1911, the Concord Woman's Club incorporated its Orchard House committee, establishing the Louisa May Alcott Memorial Association. The charter members of the association exhibited certain general characteristics: Most were members of Concord's Unitarian First Parish, and most

joined in husband-and-wife pairs. Most were not native to Concord, though they had lived there long enough to be considered Concordians. This credential was enhanced through their participation in key Concord activities such as the Antiquarian Society, the Unitarian First Parish, the Woman's Club, the library committee, and town government, and, for the men, the elite Concord Social Circle and the Middlesex Institution for Savings. Significantly, the professional activities of a majority of the male members were concentrated in enterprises that brought change to Concord: the railroads, utility companies, banking, and municipal projects.

The founders with the strongest Concord roots were Bessie and Woodward Hudson, whose respective fathers, George Keyes and Frederic Hudson, had been on the committee that ran the Centennial proceedings in 1875. As a young girl, Bessie Keyes volunteered for the Antiquarian Society; she later joined the social Ladies' Tuesday Club, and, as Mrs. Woodward Hudson, became active in the Concord Woman's Club, the Concord Female Charitable Society, and the Concord Home for the Aged. In 1922, many years after the 1895 passage of a bill permitting women to be on the library committee, Bessie Hudson would be elected the first female member. She was also a vocal and long-standing member of the school committee.[148] Mrs. Hudson was consistently elected to the board of the Louisa May Alcott Memorial Association, serving in various capacities including that of president. Unafraid of controversy, she established and led the Concord branch of the Massachusetts Association Opposed to the Further Extension of Suffrage to Women, along with another prominent Concordian, Mrs. Charles Francis Adams.[149]

Bessie Keyes's marriage linked her to the world of corporate law. While Woodward Hudson was a student at Harvard Law School, she "kept pace with her future husband . . . by following his courses herself without benefit of tutor."[150] Hudson specialized in railroad law, eventually becoming chief counsel for the Boston and Albany Railroad and later for the New York Central and Hudson River Railroad, which operated the Boston and Albany after 1904 when railroads consolidated.[151] His work as an attorney in a rapidly centralizing railroad industry placed Hudson in the center of political controversy. Boston street railways had combined; they were merged with interurban railways, and finally there were just three huge consolidated railroad companies in Massachusetts. The New York Central was one of the three.[152] His work on behalf of the railroad combination was exceptionally successful.[153]

Woodward Hudson was also active in Concord's civic affairs, as chairman of the school committee, treasurer of the Concord Free Public Library, member of the Board of Health, water commissioner, and trustee of the Middlesex

Institution for Savings. Hudson was on the sewer commission during construction of the original system, hiring the Italian immigrants who so efficiently completed the work, many of them subsequently settling in Concord Junction and outlying areas. He was in the New England Tariff Reform League and the Concord Social Circle, and he was an amateur genealogist in the New England Genealogical Society. In 1911, Woodward Hudson joined his wife in organizing the preservation of Orchard House.[154]

Though most were not Concord natives, other men now affiliated with the CWC through the Orchard House cause had much in common with Woodward Hudson. Another prominent railroad attorney for the Boston and Albany, George P. Furber, was "a recognized authority" on cases dealing with employers' liability.[155] Charles K. Darling had studied law at Boston University and worked for the Fitchburg railroad and the Old Colony and Cheshire railroads. He was a retired brigadier general of the "Spanish War," a Unitarian, a historian of the Boston chapter of the Sons of the American Revolution, and a member of the Massachusetts Historical Society.[156] Russell Robb, a midwesterner by birth, was the director of more than twenty-five of the new light and power combinations, as well as a member of the elite Concord Social Circle, the Unitarian First Parish, the American Academy of Political and Social Science, and the Mississippi Valley Historical Association.[157] Murray Ballou spent his entire career in the American Powder Mills office in Boston and was credited with "the dissolution of all the powder company trusts, which was of immense assistance to the industry." With Woodward Hudson, he was on the board of the Middlesex Institution for Savings and a member of the Concord Social Circle and the Unitarian Church, and he had distinguished himself by serving as an influential selectman for twelve years. In addition to supervising the construction of Concord's municipal services in the early twentieth century, Ballou was primarily responsible for Concord's enactment of the Tenement House Act for Towns.[158]

The wives of these businessmen were involved in various projects and social groups beyond the Concord Woman's Club, principally the Unitarian Church, the Charitable Society, and the Garden Club. Perhaps inspired by her husband's war record, Elizabeth Darling was best known for founding the Concord Red Cross Chapter in 1917 and for her service to veterans hospitals.[159] Edith Robb was a "prominent clubwoman," a member of the Garden Club, the Horticultural Society, the Concord Antiquarian Society, and the Ladies' Tuesday Club. The Tuesday Club was purely social, formed in 1888, when meetings of the men's Social Circle "left the wives alone." For nearly twenty years, Margaret Blanchard Smith "carried" the Concord Charitable

Society, along with participation in the Antiquarian Society and the Home Garden Association. Not all of the women who worked for the Alcott memorial were active in projects in the public realm. Mabel Wheeler Ballou, for example, was noted for her dedication to "her homelife."[160]

The undisputed leader of the original Alcott Memorial Association was CWC president Mrs. Abby Winchester Rolfe. Abby Winchester was born in 1834 in Lunenburg, Massachusetts, to parents of "Revolutionary stock." She attended Ipswich Academy, then became a schoolteacher in Dedham. There she met a fellow teacher, Henry C. Rolfe, and married him in 1856.[161] Sometime before the Civil War, the couple moved to their Middle Street home in Concord. By 1876, Henry Rolfe had given up teaching "on account of his health" and taken up the grain business. The Rolfes were members of the Trinitarian Congregational Church, where for many years Mrs. Rolfe taught Sunday school.[162]

As a young woman, Abby Rolfe worked in Concord's Anti-Slavery Society, but she was best known as the "beloved president" of the Women's Christian Temperance Union (WCTU), in which she participated from as early as 1874 until her death in 1921. The mission of the Concord WCTU signified its identification with child rearing and the moral power of women. Its goal of fostering "the right guidance of the young in their impressible years" was "so rooted in the hearts of mothers, wives and sisters that its influence must be great."[163] Because Alcott also figured prominently in Concord's temperance crusade, Rolfe's memorialization of her was most likely based on personal acquaintance.[164] Given this likelihood of Rolfe's personal acquaintance with Alcott and the fact of their shared interests, it is no wonder that she became the first president of the Louisa May Alcott Memorial Association, rallying the CWC to organize itself on behalf of the Orchard House museum. The WCTU's efforts to "make the world Homelike" could find no better expression than in the public mission of Orchard House, once the home of Concord's most celebrated temperance advocate.[165]

The founders of Orchard House were of two basic types: couples who came to the Alcott Memorial Association from activities like the Social Circle, the Unitarian Church, town government, and the Tuesday Club; and individual women like Abby Rolfe who, except for CWC membership, appear to have stood apart from the social set of Concord. Two other Orchard House founders were in the latter category—Carrie Hoyle and Anne Burrill. Like Abby Rolfe, Carrie Hoyle joined the Louisa May Alcott Memorial Association without her husband. The Hoyles did not have any of the hallmarks of the Concord elite and were primarily known for the way they "devoted themselves

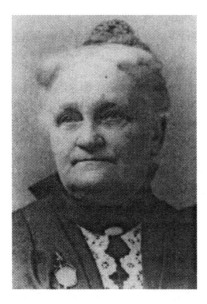

Abby Rolfe, founding president of
the Louisa May Alcott Memorial
Association. COURTESY OF THE
CONCORD FREE PUBLIC LIBRARY.

to the welfare of the First Church of Christ, Scientist, of Concord."[166] (Only
two Orchard House founders were not affiliated with the Unitarian Church:
Rolfe and Hoyle.) Anne Burrill, a Unitarian, joined the association apparently
as a widow.[167] Born in 1840 in Fairfield, Vermont, Burrill moved to Concord
in 1885 and became active in the Unitarian Bible Society and in the cause that
would absorb most of her energies, woman suffrage. It seems quite possible,
given these shared interests, that Burrill, like Rolfe, knew Alcott.[168] These
three women—Rolfe, Hoyle, and Burrill—were distinct from the other fe-
male founders in another key respect: They were born within a decade of Al-
cott.[169] Two of these women were associated with Alcott for the common
goals of suffrage and temperance, suggesting that they may well have wished
to memorialize the real Alcott, and not a "historical" abstraction based on
Little Women.

By contrast, all the other women in the Louisa May Alcott Memorial As-
sociation were of the next generation, and they joined with their Social Circle
husbands. These men were part of the new corporate elite, and through their
activities in railroad and utility combinations, banking, and municipal im-
provements, had helped implement the modernization of rustic, nineteenth-
century Concord for which their nostalgia was both genuine and ironic. Their
wives added the Woman's Club project of the preservation of Orchard House
to an assortment of other causes, formulating social and cultural goals with a

self-consciously female inflection. By identifying Concord's m
with a mythologized Anglo-American history, and by encoura;
grants and their families to do the same, they authenticated theii
tural leaders, using their new social power to create institutions like the Or-
chard House museum. For them, *Little Women* and Orchard House were
emblems of the virtuous and ostentatiously traditional domesticity that could
establish a reassuring stability as they entered the new world of the twentieth
century. The ambivalence, anxieties, and dreams of reform played out in *Little
Women* may account for its profound appeal to generations of women in the
throes of a dynamic transformation in their traditional "sphere." The club-
women of Concord were no exception; *Little Women* provided the literary
foundation upon which the public meaning of their Orchard House museum
was constructed.

The heartfelt appeal of *Little Women* derives from its powerful brew of fact
and fiction, autobiography and imagination, Alcott's own experience and the
experience of women generally.[170] Although thought of as a "true" story, it ac-
tually excluded much of the reality of her unusual childhood. Particularly fic-
tional is the central emotional and physical stability of the March family. The
Alcotts moved constantly and were impoverished more severely than were the
Marches, because of Bronson Alcott's ill-paying philosophical vocation,
which often took him away from home for extended periods.[171] Meanwhile,
Abigail Alcott supported the family by taking in boarders, sewing, and mak-
ing missionary visits to the poor in Boston, while the children worked as nan-
nies, servants, and teachers. Eventually, it was Louisa Alcott's lucrative writ-
ing career that pulled the family from poverty, enabling her parents to move to
Orchard House in 1858 and live there for many years.[172] In contrast with the
imperturbable March family of *Little Women*, the unity of the Alcott marriage
was threatened by such unique problems as transcendentalist Bronson Al-
cott's experiment in communal living at Fruitlands, which posited the superi-
ority of a communal "consociate family" over a society of nuclear families.[173]
The key to Louisa Alcott's portrayal of the rebellious Jo was her father's zealous
experiments in child rearing, whereby he struggled to tranquilize his bright
and willful second daughter into a paragon of the romantic personality.[174]

Moreover, Alcott's tale was not set in the actual period of her childhood, but
in the Civil War years when she was already an adult. Sarah Elbert points out
that this device enabled Alcott to link her argument for "an enlightened
family life as the best means for raising a new woman and saving the Union" to
the compelling causes of patriotism and abolition.[175] Alcott's brand of nine-
teenth-century feminism saw the home as the fountainhead of women's pub-

lic moral influence. This argument, rooting a political agenda for social better-
ment in the values of the middle-class domestic realm, would remain a re-
source for a later generation of women. Begun in her old room in Orchard
House, seat of transcendental romanticism, and finished in the Bellevue Ho-
tel, a "haven for reformist women," *Little Women* presents in concentrated
form some features of the emerging crisis soon to be realized in Progressive re-
form. While she was writing the novel, Alcott's connections to the newly
formed American Social Science Association were strong, placing her in the
avant-garde of the transition from evangelical to Progressive programs of so-
cial change.[176]

The underlying meanings of domestic imagery in Alcott's fictional
environments also presage the Colonial Revival generated by later Anglo-
Americans, including those who founded institutions such as the Orchard
House museum. The workings of the moral, modest, and functional March
cottage suggest a romanticization of the domestic usefulness of women in the
colonial Yankee homestead. *Little Women's* touting of a productive "golden
age" is in essence the author's critique of late-nineteenth-century ornamental
womanhood and radical feminism.[177] Alcott's celebration of the emblematic
colonial hearth was strictly symbolic; in actuality she used the profits of her
pen to install a furnace in Orchard House.[178] More autobiographical was her
emphasis on the traditional virtue of "making do." This identifies Alcott as a
representative of the "shabby genteel" variety of New Englander, displaced by
the new economic order but asserting the superiority of inherited status over
the nouveaux riches as well as recent immigrants.[179]

The tension between a latent Progressive vision and nostalgia makes *Little
Women* a complicated document, particularly in its treatment of nineteenth-
century feminism. The ambiguities of the novel reflect Alcott's inner debate
over women's evolving social role vis-à-vis the home. Beneath the narrative
surface lies a perplexing blend of discordant ideologies: liberal, arguing that
women should participate in reform through the application of their domes-
tic skills to society as well as the home; conservative, suggesting that women's
primary concern should be the home itself; and radical, criticizing women's
domestic role as detrimental to their full development.[180] From the promise
of a female "pilgrim's progress" within the home to the sympathetic portrayal
of Jo's need for freedom from domestic strictures, *Little Women* is packed with
internal contradictions that demonstrate Alcott's own dynamic struggle with
the historical transformation of woman's "sphere" in the late nineteenth cen-
tury. Such struggles would continue within women's culture in the early twen-
tieth century, and it was *Little Women's* very ambivalence that gave it lasting

appeal while these issues remained unresolved, in particular to the founders of the Orchard House museum. So Alcott was not the last New England woman who would propose an activist domesticity and a model home that could provide a basis for social reform. The early-twentieth-century founders of the Orchard House museum would build on Alcott's legacy, although their vision would be shaped by a very different historical moment.

With this foundation, the 1911 fund-raising efforts for the purchase and restoration of the house were carried out quickly and efficiently. Pamphlets were prepared and distributed to women's clubs, colleges, and magazine editors and were "otherwise sent to reach every woman in the state if possible." Donations poured in from WCTU chapters, women's clubs, individual donors, and schoolchildren, confirming CWC president Abby Rolfe's feeling that "if all who have in the last fifty years enjoyed the books written in that house, the characters built there, would contribute a small sum the object would be accomplished."[181]

The largest single fund-raising event held in Concord on behalf of the Orchard House restoration was one that "kindled anew" the "patriotism that burns in every man, woman's and child's heart who lives in Concord," a presentation of a play, *The Story of Our Flag*, in the early spring of 1911.[182] The play was initially presented for the Unitarians but was repeated a month later as an Orchard House benefit. The cast consisted of twenty "young ladies" in white Grecian costume, bearing banners representing events in American history, reading patriotic poems, and singing songs such as "Columbia the Gem of the Ocean," "America," and, presumably on behalf of national unity, "Swanee River."[183] It was noted that many children were in the audience, "and to them especially was the affair most instructive and it imparted a lesson that will never be forgotten." The *Concord Enterprise* urged every parent to "endeavor to have his or her children present at the repeat performance."[184]

The reconstruction of Orchard House occurred both literally and figuratively. Literally, because the house was in serious need of repair, and figuratively, because to raise funds the club had to construct a new, public meaning for the once-private dwelling. The language of the restoration campaign documents this construction, which was rooted firmly in Alcott's authorship of *Little Women*. The campaign also tellingly emphasized issues such as the sanctity of childhood and the influence of the home environment. The fact that "the most beloved house in America" was "falling to ruin" tapped into the fear that traditional home life itself was under siege: "The large yard is filled with weeds. The hospitable step has rotted away. Through the uncurtained windows the visitor sees bare rooms where tattered strips of wallpaper are hanging

dismally from the walls. The old house has long been the retreat for the imagination of countless boys and girls. . . . Its associations are little less than sacred to them."[185] Lovers of Orchard House lamented "the unhomelike aspect of the house that has been a second home to half the girls in the world" and pleaded the cause of rescuing the house "before it is too late, and we have nothing but ruins to show where Meg, Jo, Beth and Amy once lived in spirit."[186]

Potential donors were directed to look backward to their "sacred" past, one profoundly associated with the values of Alcott's famous novel. The house would be saved in tribute to the "happy memories" that children "now old in years" had of those "fascinating children" of *Little Women*. It was "an appropriate act for American girlhood and boyhood to preserve this house."[187] Because the beloved Jo, Meg, Beth, and Amy were "associated with childhood days," surely "any man, woman or child" who remembered them "will only be too glad to aid in perpetuating the house where the characters . . . originated."[188] Some went so far as to argue that Orchard House was tangible evidence that the fictional Marches had actually existed, "conclusive and definitive proof that, after all, the story was true, and not made up out of the author's head."[189] The highly effective fund-raising pamphlet recalled the "great and wholesome influence" of *Little Women* "on almost every girl who has lived in the last forty years," warning that the house was "now so desolate it is a pathetic sight."[190]

When the museum was officially opened in May 1912, a Boston reporter remarked that the plain house and its furnishings had "a significance akin to that of Lincoln's log cabin" in demonstrating the conditions under which "lives of such lofty spirit were achieved." Alcott was "both an exemplifier and recorder of the free, courageous, sturdy type of character which distinguished last-century Concord."[191] At the opening ceremonies, all were touched by the "remembrances" of Edward Emerson and John Pratt Alcott and especially by the singing of "Auld Lang Syne."[192] The theme of Orchard House as a memorial to a nostalgic version of the "traditional" American home persisted well into the twentieth century. A 1957 magazine article exclaimed, "If ever there was a 'typical, old-fashioned American home,' this is it."[193] That a museum dedicated to the iconoclastic Alcotts could be infused with this meaning is a testimony to the force of will of the original shapers of the institution's public role.

▪ Women's Political Culture and the "Invention of Tradition" in Concord, 1875–1910

The Orchard House museum was part of a larger phenomenon that Eric Hobsbawm has identified as "the invention of tradition," in this case one

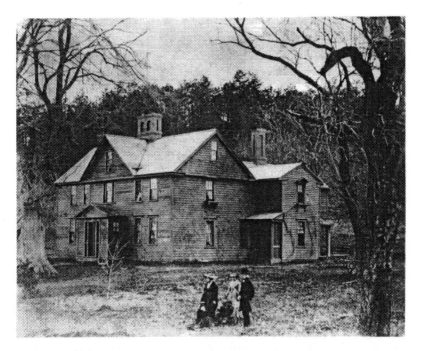

The historic Orchard House, c. 1865, which Louisa May Alcott referred to as "Apple Slump." *Standing, left to right:* Abigail Alcott, Louisa May Alcott, and Bronson Alcott. *Seated:* Anna Alcott Pratt and her son, Frederick. COURTESY OF THE LOUISA MAY ALCOTT MEMORIAL ASSOCIATION.

crafted primarily by and about women.[194] The history presented in the Orchard House museum was a telling blend of fantasy and reality. Many saw it as the sentimental March cottage of *Little Women*, yet others had actually known it as the part-time home of writer, reformer, and suffragist Louisa May Alcott. This range of interpretations of Orchard House facilitated its function as an agency of invented history that could unite an increasingly polarized female elite.

Concord had a record of popular political struggle over the meaning of history to women's public role. Louisa May Alcott's warning that the ill-treatment of women at the Centennial would provoke "another protest that shall be 'heard round the world'" was not rhetorical flourish. In a boldly confrontational move, suffragists organized a rally as a public retort to the administrators of the Centennial. Concord's characteristic reverence for "all inherited worth" led women to use their colonial heritage as the basis for their call for the vote.[195]

Suffragist Harriet Robinson recalled the events of the Centennial, outlining the indignities suffered by women who could claim ancestry from John Hancock, Ben Franklin, and Ezra Ripley.[196] At the same time, Robinson noted that material evidence of the historic activity of women was undeniably present in the form of "silent memorials," the "scissors that cut the immortal cartridges made by the women that eventful day, and the ancient flag that the fingers of the mothers of the Revolution had made."[197] These exhibited "relics" confirmed what the male oratory denied, a Revolutionary tradition for women, albeit an essentially domestic one.

At the suffrage rally the following month, Lucy Stone pointed out that although the town had voted that the enormous sum of ten thousand dollars be raised through taxes to fund the Centennial celebration, Concord's women, who paid one-fifth of the taxes, were not permitted to vote on the allotment. This, Stone said, was an especially egregious version of "taxation without representation."[198] Like Alcott and Stone, Robinson continued the use of Revolutionary political rhetoric in uncovering the hypocrisy of Concord's claim to be the seat of "personal liberty."[199]

Alcott agreed, characterizing Concord's legendary reformers as "black sheep" in "a conservative old town" and expressing her frustration in trying to get women to register to vote for the school committee when limited suffrage was granted in 1879.[200] (Robinson called the poll tax, which nontaxpaying women had to pay in order to vote, a "class suffrage law."[201]) Even with this right, Concord's women did not display a great deal of interest in voting.[202] The pace of women's school-board voting was accelerated in the late 1880s, however, when male and female Protestants banded together to keep Catholics off school committees across Massachusetts, but the state remained firm in its general antisuffrage stance.[203] The results of the 1895 "mock referendum" on woman suffrage confirmed this resistance.[204] The frustration of Concord's suffragists must have been great during the closing decades of the nineteenth century, especially for one of their leaders, Orchard House founder Anne Burrill.

Thwarted in their efforts to use the colonial inheritance of the male political realm, suffragists turned to an assertion of the potential value of women's domestic virtue to the polity. This argument drew upon the traditional parlance of "separate spheres" and "republican motherhood," adding a crucial dose of liberal individualism to refute the contention that a man's vote could represent a woman's individual and distinct point of view. Rooting women's political rights in a colonial past in which their role had been principally domestic further encouraged suffragists to make domesticity itself a weapon in

the prosuffrage arsenal. Robinson's view that women had used domestic skills for political purposes in the past would reappear again and again as symbolic justifications for women's emerging public power. The drawback of this strategy was that it reinforced domestic ideology even as it extended women's "sphere."[205]

Of course this was not mere strategy. Most suffragists were convinced of the power of women's moral influence within the home, which they had long seen as the building block of the republic. They argued that they wanted to bestow this healing maternal influence upon the body politic. A suffragist explained: "Woman's place is in the home. This is a platitude which no woman will ever dissent from. . . . But Home is not contained within the four walls of an individual home. Home is the community. The city full of people is the Family. The public school is the real Nursery. And badly does the Home and the Family and the Nursery need their mother."[206]

Antisuffragists agreed that women possessed particular moral skills derived from their domestic orientation. As the Massachusetts Women's Anti-Suffrage Association manual put it, "the fundamental difference is this—that the suffragist (like the socialist) persists in regarding the individual as the unit of society, while the anti-suffragist insists that it is the family." The anti-suffragists emphasized "the power of individual homes" to alleviate social problems.[207]

In short, suffragists and antisuffragists alike capitalized on and contributed to an escalating sense of crisis in regard to the home and the family, and women of both points of view dedicated themselves to the Orchard House memorial. Suffragists argued the social benefits of women's moral influence expressed through individual votes; antisuffragists thought granting votes to women would impinge on their traditional power over the home and rob the home of its status as the basic moral and political unit of society. It was this kind of "crisis of cultural authority" that historians from Richard Hofstadter to T. J. Jackson Lears have identified as fuel for the Progressive fire.[208] For women, this crisis was obviously of great import, since many critics placed the blame for changes both in the home and in politics on women's new public profile. A rising tide of antimodernism, most often in its putatively "colonial" incarnation, became a hallmark of bourgeois women's culture. Building on their experiences with museums, Sanitary Fairs, and the Columbian Exposition, middle-class women engaged in various public activities in the service of a seemingly inviolable cause—the celebration of American history—moving themselves from the exclusion characteristic of Centennial ceremonies to actual, highly visible participation.[209]

Public activities glorifying women's traditional domestic role proliferated, ranging from the attempts to revive the craft skills of colonial women promoted by the Blue and White Society of Deerfield, Massachusetts, to women's continuing participation in the more traditional male-focused house museum movement.[210] Alice Morse Earle's popular *Home Life in Colonial Days* claimed a place in history for colonial foremothers by presenting images of the "home-bred, home-living, and home-loving" women of the past as exemplars of hearty femininity for modern women to emulate.[211]

Concord's clubwomen were part of a wider trend in early-twentieth-century middle-class women's culture, in their enjoyment of a new public role, in their defensive celebration of their "colonial" domestic inheritance, and in their efforts to create a public institution communicating their concerns about the home. Just as antebellum women founded Mount Vernon as a shrine to unity, so the *Little Women* shrine would be dedicated to unity by these early-twentieth-century clubwomen as the threat of public conflict over suffrage drew nearer.

The popularity of Alcott's novel was extraordinary, and it was growing. *Little Women* was selling better in the first quarter of the twentieth century than it had in Alcott's lifetime. By 1927, the *New York Times* ran a headline announcing "Little Women Leads Poll: Novel Rated ahead of Bible for Influence on High School Pupils." Students polled rated the Bible second; *Pilgrim's Progress* came in third.[212] Women of various persuasions found something of personal meaning in the novel and its author. Jewish and Italian immigrant girls joined a "Louisa May Alcott Club," which met in the South-End House, where they learned "all the activities of a natural home."[213] At the same time, however, a young French Catholic found an alternative meaning, saying, "There was one book in which I believed I had caught a glimpse of my true self—*Little Women*." Simone de Beauvoir would grow into one of the most influential feminist thinkers of her century.[214]

These very different responses illustrate that *Little Women*, through its singular characterization of Jo's internal struggles, could be read to express the janus-faced predicament of the early-twentieth-century woman, poised between the "cult of domesticity" and the era of "the new woman." Alcott had remarked with some disapproval that women preferred novels over prosuffrage tracts like Harriet Robinson's, but Robinson herself celebrated the fact that "a thousand little streams have helped to swell the tide which has uplifted the sphere of woman's life. The modern novel has added its 'winning wave.' Its heroine is no longer an Amanda, a Malvina, or a Melissa, whose dove-like eyes are ever pleading for male protection."[215] The genius of *Little Women* was that

it preserved the deeply felt values of domesticity through the insular warmth of the March cottage, while simultaneously expressing Jo's rebellion against its restrictions. Thus the domestically located trials of the fictional Jo March provided a better basis for a universally appealing "shrine" than could those of the actual unmarried, prosuffrage working woman, Louisa May Alcott. Just as Alcott "invented" her own life story in *Little Women*, the Concord Woman's Club "invented" the history of Orchard House.

The foundation for the preservation of Orchard House had been securely fixed on Alcott's authorship of *Little Women*, when the National American Woman Suffrage Association office in Boston stepped in and threatened to steal the show. In the fall of 1911, six months before Orchard House was opened to the public, Concord's local paper published a letter from NAWSA prematurely asserting that the Alcott memorial was now "an accomplished fact" and that therefore Concordians might wish to "have occasional glimpses of Miss Alcott's views on Woman Suffrage." The letter went on to describe Alcott's support of the early suffrage movement, but no further "glimpses" appeared in Concord's newspaper.[216] The founders of Orchard House, suffragists and antisuffragists alike, continued to sidestep this aspect of Alcott's life, apparently keenly aware of the divisions in their uneasy coalition. It was not until after the museum was established in the spring of 1912 that Concord's women began to split over the suffrage issue, after years of denying that they would do so. From that perspective it seems that Orchard House was in part a document of their attempt to keep the peace.

The stresses within the Concord Woman's Club reflected some general shifts in the women's club movement; as the emphasis changed from "self-culture" to "municipal housekeeping" it became more difficult to avoid the suffrage question.[217] When Progressivism and social science gained a wider audience, suffrage as a reform effort virtually merged with the large liberal wing of the Progressive movement and thereby experienced major advances.[218] As a part of this shift, clubwomen were moving toward scientized historical explanations for women's place and also toward explicitly Progressive justifications for women's political participation. The GFWC leadership relied increasingly on evolutionary models, declaring in 1912 that the club movement was "a part of the evolution of the species" and that civilization was doomed if the "activities of men are not supplemented by those of woman."[219] This argument was vulnerable to counterattack by the antisuffragist ranks of the GFWC. If it could be claimed that women had evolved with special skills, then it could also be argued that they had evolved specifically for their domestic role.[220]

Given the push and pull of the suffrage controversy, the GFWC clung des-
perately to its motto, "Unity in Diversity." By 1910 support for suffrage was
clearly growing, and the issue became difficult to dodge.[221] In a 1912 address,
Mary Wood declared that "the organization as a whole does not indorse the
suffrage movement," being "composed of ardent suffragists and strong anti-
suffragists." But she had to admit the virtual inevitability of woman suffrage.
Therefore, "women must be ready for it when it comes, so that the country
shall not again suffer from the too sudden influx of a large body of citizens who
are still unprepared for citizenship."[222] Suffragists had shifted their focus
from confronting "all sides of the question" to nativist common ground.

Many clubwomen vehemently disagreed with Wood's analysis. Back in
Concord, the antisuffragists had only begun their public fight. The issue,
though bypassed by the CWC generally, had appeared early in 1912 when a
"study class" hosted a debate between a suffragist and a representative of the
Massachusetts Association Opposed to the Further Extension of Suffrage to
Women.[223] By this time antisuffrage forces in Concord had been vitalized by
their opposition to the straw ballot for the presidential vote in October, in
which 163 of Concord's women participated. Antisuffragists boycotted the
proceedings.[224] The president of the newly formed Concord branch of the
Massachusetts Association Opposed to the Further Extension of Suffrage to
Women was Orchard House founder Bessie Hudson, supported by Mrs.
Charles Francis Adams.[225] In the spring of 1913 Hudson organized several
public antisuffrage activities. At an "enthusiastic" meeting at the Hudson res-
idence, women analyzed and debated the Republican, Democratic, and Pro-
gressive platforms.[226] Later that spring, Mrs. Hudson presided over a rally at
which antisuffrage leaders Ernest Bernbaum and Alice George spoke before a
large crowd. Bernbaum recommended that women maintain their "special-
ization" in the home. Mrs. George, an American representative for the British
National Trust, shared Hudson's interest in both antisuffrage and historic
preservation.[227]

On the other side of the debate, Concord's suffragists had a longer history
of organized activity, beginning with Alcott and continuing through the
efforts of Orchard House founder Anne Burrill, who took over the movement
in the late 1880s and lived to see its success.[228] Though credited with leader-
ship of Concord's suffrage movement, Burrill kept a lower profile than did
antisuffrage leader Bessie Hudson. In fact the president of the Concord
Suffrage League in 1912–13 was the distinguished Mrs. Robertson James,
sister-in-law of William and Henry James. Mrs. James, like Hudson, held
meetings in her commodious Concord home.[229]

The larger suffrage effort had already introduced itself to Concord as early as November 1911, immediately before the NAWSA published its letter detailing Alcott's prosuffrage sentiments. Margaret Foley, a master of the prosuffrage publicity stunt, appeared "rather unexpectedly" in Concord "in an auto," the first in a series of prosuffrage speakers. Foley would reappear in Concord at the height of prosuffrage activity to lecture to a packed town hall on the necessity of the franchise to the fulfillment of women's homemaking responsibilities.[230] In fact the Concord Suffrage League repeatedly hosted lecturers who explained women's political aspirations in terms of their domestic role. Susan W. Fitzgerald maintained that "women are by nature and training housekeepers" and that therefore they should "have a hand in the city's housekeeping, even if they introduce an occasional house-cleaning."[231] Similarly, Kate Upson Clark, champion of the power of the proper single-family home to inspire desirable behavior in children of all classes, delivered a talk to a large audience in Mrs. James's home in which she compared the nation to a family that should be "mothered as well as fathered." As women kept their homes clean, so they should "keep the larger house clean."[232]

Once the antisuffragists began to organize formally, the Concord Suffrage League brought out the heavy artillery. Anna Howard Shaw, NAWSA president, WCTU leader, and Methodist pastor, spoke in Concord in March 1913.[233] Perhaps precisely because the antisuffrage effort was intensifying and because of Shaw's reputation for applying her brilliant oratorical skills to a critique of men, Concord's suffragists seem to have been especially concerned with retaining their respectability. Advertising Shaw's talk, they assured readers that "it is impossible to accuse her of either rant or tirade." With the same purpose, Concord's home-town suffragists now invoked Louisa May Alcott and Ralph Waldo Emerson in order to prove that suffrage advocates were "not 'long-haired men and short-haired women,' 'cranks,' 'faddists,' and 'emotionalists.' "[234] The invocation of the transcendentalists, heretofore Concord's iconoclasts, to support the conventionality of a point of view is testimony to the legitimizing bent of Concord's historical memory.

The CWC had long been wary of such sharply divisive charges and countercharges, fruitlessly hoping for "Unity in Diversity." Support for suffrage was growing in Massachusetts generally, and in 1914 the GFWC formally endorsed woman suffrage, creating a problem for the Massachusetts Federation and the CWC. It was in this year that Concord witnessed a dramatic increase in female voting.[235] And soon a referendum on woman suffrage would precipitate an irrevocable split in Concord's female population, the CWC in particular. Early in 1915, the campaign was under way. Anne Burrill hosted a lec-

ture at the James house by Mrs. Thomas Curtis, who "showed very forcibly why women need the ballot as a tool . . . to safeguard the health of the family."[236] Bake sales and band concerts were held, and the dynamic Margaret Foley made her return engagement. Lecturing to an overflowing crowd at the town hall, Foley contended that women's homemaking duties put them in a "predicament" because "the greater part of all the activities upon which the successful bringing up of a family depends are carried on outside of the home."[237]

The antisuffragists retaliated. Concord's own Edith Melvin spoke to an audience at an antisuffrage meeting, detailing "The Menace of Woman Suffrage," and Bessie Hudson reported that the Concord antisuffragists had enrolled "quite a few new names."[238] Perhaps sealing the issue in the minds of many voters was an article in the local paper, asserting "The National Woman Suffrage Association is distributing Socialist literature and employing Socialist speakers, and Socialism is rampant in every state and country where women have the ballot."[239]

The rift between Concord's women, once confined to a relatively narrow arena, threatened to become unbridgeable in all phases of women's activities, from the most mundane to those that made front-page headlines. When Kathryn Adams Morgan (daughter-in-law of John Pierpont) asked to borrow Anna Manion's silver coffee urn as she had on numerous occasions, her request was denied: Manion recalled, "When she told me it was for an antisuffrage party, I told her she couldn't have it for I was decidedly in the other camp."[240]

Far more serious was the final split in the Massachusetts Federation of Women's Clubs and the CWC, spurred by the impending suffrage referendum and by the GFWC's endorsement the previous year. Though the CWC knew that suffrage would be discussed at the Massachusetts Federation meeting in the town of Marion in the summer of 1915, they sent their seven delegates "uninstructed" on how to vote should a suffrage resolution be attempted. They voted four to three against, but the resolution passed with 203 yeas, 99 nays, and 95 abstentions.[241] Antisuffragists publicized their opinion that "the fact that delegates arrived at Marion on the friendliest of terms and departed enemies, hardly on speaking terms, is prophetic of the disruption of club life in clubs whose members desire neutrality and cooperative, non-partisan work."[242] Ida Chase Baker, successor to Orchard House founder Abby Rolfe as CWC president, publicly retorted that "the delegates who represented the Concord Woman's Club returned with their loyal friendships in no way diminished."[243] However, the evidence of member dissatisfaction became

irrefutable when in September, at the end of the 1915 club season, a larg
ber of CWC members resigned over the issue of neutrality. Interestir.,
traditional leaders of the pro- and antisuffrage movements, including Burrill
and Hudson, who had worked together to establish Orchard House, re-
mained in the club. The CWC stopped publishing lists of its members in its
annual bulletin after the 1915 crisis, called "the greatest dissension that ever
rent the club."[244]

This was not the last public controversy involving the founders of Orchard
House. In September 1915, the Concord Suffrage League opened an office
over Anderson's grocery. It was traditional that municipal employees installed
all political banners from light poles above the main street, so the league ap-
proached Murray Ballou, selectman and Orchard House founder, for permis-
sion to hang the canary-yellow prosuffrage standard. Permission was granted,
but the road commissioner and a judge, relatives of antisuffragist Bessie Hud-
son, had it conspicuously removed. After much adverse publicity, the banner
was reflown, although in a less eye-catching place. The "skirmish" was called
"one of the bitterest battles ever experienced by the town." "War" was declared,
and the incident resulted in the largest prosuffrage rally held in Concord to
that date.[245]

However, the suffragists lost the war over the Massachusetts suffrage refer-
endum, soundly beaten both in Concord and statewide, because of the
strength of organized antisuffrage.[246] Antisuffrage activist Ernest Bernbaum
explained that the Massachusetts referendum had failed because voters had
become "disgusted with the temperament, the notions, and the methods typi-
cal of the few women who clamored for the vote."[247] Yet Concord's suffragists
had hardly proven themselves radicals. In 1915, on the eve of the referendum,
they marched with Louisa May Alcott's blue and gold "votes for women" ban-
ner in Boston's suffrage parade. Their float featured a husband and wife in a
domestic scene, representing the theme "Together in the Home."[248] Perhaps
as a result of the propensity of suffragists as well as antisuffragists not to stray
too far from domestic justifications, in the heat of the 1915 CWC "war" it was
reported that interest in Orchard House had shown "no abatement."[249]

Bessie Hudson, ardent leader of the antisuffrage cause in Concord, re-
mained on the board of Orchard House, despite the old Alcott-associated
blue-and-gold flying above the heads of her parading opponents. Orchard
House retained its status as a mutually agreeable project for the clubwomen of
Concord despite their astonishingly bitter public confrontations. The expla-
nation lies in the sheer power of domestic ideology in the Progressive Era. For
though some of Concord's female population wanted to preserve the home

while expanding their public role (justified by their Anglo-American heritage), others could be called "material traditionalists," hoping to strengthen women's traditional role through publicly proselytizing their vision of the appropriate twentieth-century home.[250]

The struggle of suffragists and antisuffragists alike to define twentieth-century domesticity, literally to find a place for the cherished domestic values of their childhoods while confronting a swiftly changing world, was shared by an astounding range of Progressive thinkers. Their efforts were the foundation upon which the meaning of the Orchard House museum was ultimately built.

Orchard House as an Agency of Domestic Reform

The early-twentieth-century crisis of Anglo-American cultural authority was identified in part by perceived threats to the "American home" and the related effort to reconcile the new public role of women with their traditional domestic responsibilities. This transformative crisis found its expression in Progressive phenomena as diverse as settlement houses, the growth of suburbs, tenement house reform, and the Arts and Crafts movement. Cogent attacks on "the home" suggested alternative approaches, and women left the home to participate in reform movements, but nevertheless the metaphor of the "colonial" hearth and home pervaded much Progressive Era rhetoric. Reformers' attachment to this potent metaphor sponsored concrete attempts to impose a selective and symbol-laden domesticity on an intractably heterogeneous population. The psychic crisis beneath this effort suggests why the "invention of tradition" described by Hobsbawm was so pervasive in this period, often functioning to suppress radical possibilities as newly minted methods of celebrating the Anglo-American past were wielded in a hegemonic instrumentalism.[251] The house museum movement, following the ascendancy of Progressivism, can be placed in this larger context.

Housing reformers applied the legitimizing power of popularized "history" to a diffused but persistent commentary on American society through house form and decoration. This rhetorical and analytical tropism was central to the era. Herbert Croly, the "architect of progressivism," shared with many housing reformers a distaste for the Victorian aesthetic and also a desire to organize and involve the state in the achievement of an alternative. The characteristically romantic turrets and irregularities of Victorian architecture had become an anathema among reformers and arbiters of taste by the early twentieth century. The tasteful replacement was simpler, of "Anglo-Saxon" rather than Eu-

ropean derivation, and, importantly, easily replicated in middle-class as well as working-class communities.[252] This was not a superficial change in fashion, but the embodiment of the Progressive mentality and domestic reform agenda, which in many cases tended to reduce social problems to "the lack of a proper model for suburban housing."[253] To achieve this "model," many bureaucratic and activist associations were instituted by women's clubs, civic associations, and governments.[254] Housing reformers shared a vision of the ideal twentieth-century American dwelling: separate, suburban, and "Anglo-Saxon" in design. This ideal became even more vivid in the wake of the "new immigration." The evils of apartment living, from tenements to boarding houses, seemed to be undermining the very basis of American civilization.[255]

Reformers argued that the American home should be not only separate and private, it also should be individually owned. They praised home ownership as "the most conserving and conservative force acting to hold man to the retention of the best civilization" and offered documentation of the decrease in church memberships in neighborhoods where "multiple-type" buildings lured immoral, "foot-loose families."[256] It was worrisome, reformers suggested, that "recent immigrants from Southeastern Europe have not the home-owning instincts of the earlier races."[257] As one writer explained, "the suburban house is a type of progress."[258]

These fears were fed by the Darwinian social theory and environmental determinism of the early twentieth century. The "racial" superiority of the "Anglo-Saxon" was attributed to a characteristic style of homelife.[259] Two features of the home received the most blame for the vulnerability of the "stock"—Victorian house form and deteriorating womanhood. The new emphasis on "Anglo-Saxon" design was a reaction against the corrupting luxury of the "feminized" Victorian house and a stern warning to the "new woman" that a return to a more austere, "colonial" domesticity was the only way to avert the horrors of "race suicide."[260] The context was not only the rise of women but also the inexorable proliferation of consumer goods, reaching glut proportions by the 1890s. To ward off decadence, the new furnace-heated suburban houses were also supplied with hearths.[261] Visits to "historic shrines" were also prescribed, the influence of which would purportedly help to solve these problems in the native "stock" and those "constantly increasing with the flotsam and jetsam of foreign immigration."[262]

The Colonial Revival and the American Arts and Crafts movement (which celebrated "Anglo-Saxon" craftsmanship) had in common the elevation of emblems of a racially pure "golden age." Both forms were "antimodern" impulses, ultimately serving to "revitalize and transform modern bourgeois cul-

is important to note that "colonial" form was loosely interpreted, additional" features were often invented. The primary identifying "Anglo-Saxon" form was simplicity, deemed an extremely moral q......, Both the "colonial" and Arts and Crafts forms were preferred by the new "commuter pastoralists" of the suburbs, where "old-looking new houses" and colonial reproductions were the rage. One popular architect advised that Americans families pretend that the house they lived in was their ancestral home.[265]

What distinguished such tastes from mere fad was the serious and single-minded attempt to convince working-class and immigrant Americans to emulate the new domestic style of the middle class.[266] But middle-class efforts to reform the domestic styles of working-class families ran into the same kind of resistance that industrialists encountered when imposing their work ethic on immigrant employees.[267] An example of the conflict between middle-class standards and working-class preference is the remarkably fretful tone of the debate over room use in the early twentieth century. According to domestic reformers, the working class preferred to eat, socialize, and sometimes work in their kitchens, making a parlor in any extra space, which they reserved for display and rarely used. Reformers wanted to eliminate the parlor and use the space for a dining room, leaving the kitchen as a work space only.[268]

The extent to which domestic reformers were irked that working-class families liked parlors went beyond rational explanation, although at least two arguments were provided. Reformers battled to persuade the working class to dispose of their treasured parlor fittings, especially upholstery, carved furniture, curtains, and wallpaper, on the basis that such decorations, and therefore the workers themselves, were collecting dirt and germs. Reformers were shocked at the way in which working-class families reveled in their "dust-catching" luxuries, out-of-fashion ornamented furniture, "unhygienic" feather-beds, and "ugly" sideboards, purchased as soon as they had the cash or the credit.[269] Wasteful spending was the second argument against the working-class parlor. It was too extravagant, reformers agreed, for workers to purchase parlor furniture.[270] Theodore Roosevelt's 1909 Home Commission therefore pressed for the removal of anything "unnecessary" from working-class homes, in favor of the simple furnishings, small rugs, and polished floors typical of Colonial Revival and Arts and Crafts interiors. In a model exhibit of tenement house furnishings, "objects with meaningless line," the "brocade lounge," and the "turned-leg table," would be replaced by an "honest little sideboard" and a picture of George Washington, which would "consciously or unconsciously" uplift "the workingman."[271]

Pertinent to the form of the Orchard House museum were not the reforms aimed at the solution of the genuine practical and structural problems of tenement-dwellers, but rather the beleaguered self-consciousness of middle-class reformers, manifested in a range of responses to the domestic lives of the working class, from seemingly gratuitous critiques of furniture styles to analyses of the meaning of "the home" to the survival of the American Republic.[272] The "home" and "mother" were still seen as the generators of civic virtue and the insurance against rapacious commercial individualism, hostages as ever to republican values, yet paradoxically dependent upon the industrial production of abundant domestic consumer goods.

Well-known housing reformers Robert DeForest and Lawrence Veiller agreed with Jacob Riis that "homes are quite as much needed to make good citizens as to make good men."[273] The philanthropist DeForest demonstrated the link between housing reform and the new popularity of public exhibits. Under his leadership the New York Tenement House Committee was responsible for a 1900 exhibit on tenement reform attended by more than ten thousand people, as well as for the establishment of the state's Tenement House Commission.[274] Soon thereafter he became involved in the first national exhibit of colonial artifacts and was instrumental in establishing the first collection of American colonial furniture and decorative arts in a major museum, the American Wing of the Metropolitan Museum of Art.[275] These two activities were related in DeForest's mind because he was an explicit believer in the morally uplifting power of objects in the home environment. He called for the establishment of a formal working relationship between museums and department stores to take active roles in "moulding public taste" and restraining manufacturers from making shoddy goods, just as he had advocated teamwork between private charity and the state to restrain the landlords of tenements.[276]

Upon one point tenement house reformers and the domestic reformers agreed. Though distinctions may be drawn between tenement house reform and domestic reform, the scientized environmental determinism pervading middle-class thought united them.[277] The tenement reformer's purpose in removing "crude" pictures in "atrocious" ornate frames and replacing them with portraits of Washington could hardly be more obvious. Similarly, the plain lines of "colonial" objects harmonized their symbolic value with the new philosophy of an efficient domestic science, providing a rationalization for proselytizing "American" standards of cleanliness, display, and cultural uniformity. Sanitary reform explains the existence but not the desperate tone of the middle-class critique of elaborate decorative ornamentation.[278] Historic

house museums would prove to be indispensable agencies for inculcating the values of domestic reform.

The general goal of Progressive domestic reform was to inculcate new domestic standards. In the midst of cultural battle, settlement house workers concerned themselves with "the little amenities" such as "the need for a parlor or front room for respectability and status."[279] A description of a typical settlement house's "pretty green sitting room with its crackling fire and gay rugs and simple early American furniture" reveals the parlor and its decor as examples for imitation or at least attachment, linking them to the newly proliferating house museum.[280] Certainly the attempts of settlement house workers to redecorate neighborhood flats was only one small part of this remarkable movement. Yet the use of an actual house as an agency of reform reveals much about how individuals reared on the values of nineteenth-century domesticity could transmute those values into new Progressive institutions. Jane Addams recalled how the "brick walls of the house" kept her safe from childhood fears of death. Addams suggested this was a common experience: "Certainly we all vaguely remember, when death itself or stories of ghosts, had come into our intimate child's circle, that we went about saying to ourselves that we were 'not afraid,' that 'it could not come here,' that 'the door was locked, the windows shut' that 'this was a big house.' "[281] Certain that "the child surviving" in all her readers would recognize this fear, Addams captured the strategic meaning of "the home" to her generation. Though rejecting the traditional decorative role of nineteenth-century vintage womanhood, through the carefully chosen furnishings of Hull House, she hoped to suggest "the best life of the past."[282] Like the house museum, the settlement house parlor suggested that history and the home environment could join forces to give meaning to life, and, as Addams put it, the "blessings which we associate with a life of refinement and cultivation can be made universal."[283] In this way, she could safely jettison some dimensions of the past, such as the feminine role she had been expected to fulfill, and still feel safe enough to criticize the inequities of twentieth-century America by institutionalizing her own amazing version of the "large house" of her childhood.

Addams, like the house museum founders, coped with the disjunction between past and present by constructing a working dialectic, but Charlotte Perkins Gilman and other "material feminists" rejected "the home" and traditional motherhood altogether.[284] This was riskier, both personally and socially, and Gilman's provocative ideas provided a counterpoint against which the more common guardians of "the home" could formulate updated arguments. Gilman argued that "the home" was an ancient and repressive institu-

tion, ill suited to the needs of modern social progress in general and women specifically. She challenged the "unquestioning acceptance of the home as something perfect, holy, quite above discussion."[285] Like Addams, she linked "the home" to history and memory, asserting that "the main basis of this home-sanctity idea is simply the historic record of our ancient religion of ancestor-worship." This, she explained, gave rise to the worship of the "homes of our ancestors" as well as of old things, "the fiddle-back chair acquiring imputed sanctity by the simple flux of time." Obviously Gilman did not admire the house museum movement, and the details of her opposition to "the home" help to identify the houses' social function as "shrines." On one hand, she called such worship an atavistic "race habit."[286] Although she shared the suspicion of domestic reformers that upholstery had "softened" human muscle, she saw this as evidence of the "downward pull of inviolate home-tradition."[287] On the other hand, the taste for the "colonial" was more than mere atavism to Gilman; "The Yellow Wallpaper," her chilling story of a woman degenerating into madness, was set in "a colonial mansion, a hereditary estate, I would say a haunted house and reach the height of romantic felicity." S. Weir Mitchell, the fashionable doctor whose treatment of women, usually a prescription for passive and infantilizing "rest," was the basis for the story, was a writer of Colonial Revival novels. His patients included both Addams and Gilman.[288]

So there were "ghosts" in Gilman's "large house" as well, but unlike Addams, she found no safety there. Both women agreed that the meaning of the house and its furnishings, "the home," had been shaped by the past and had to be adjusted to meet the needs of the new century and, in particular, the "new woman." As individuals in the Progressive Era came to terms with the emblems of stability in a time of flux, so this preoccupation came to characterize the period as a whole. The past, personal and social, was a problem for the Progressives. What to keep, to abandon, to blame, or to revive of the past was perhaps the era's central issue, "the home" its cardinal metaphor, the rise of women its relentless flashpoint. It was in this context that the historic house museum movement blossomed.

The Orchard House museum was constructed by Concordians absorbed in the social and ideological challenges of the early twentieth century. To ascribe this conscious, concerted effort to a merely antiquarian impulse is inadequate. The museum was devised by a community that perceived itself to be under threat of deterioration, and it must be seen as part of a nationwide pattern of retreat into a comfortable and largely invented Anglo-American past. Woven into this same pattern were pervasive popular versions of both Darwinism and

psychology, intensifying a belief in the power of the childhood environment to mold character and the historical "environment" to mold "racial" character. The fact that the public meaning constructed for Orchard House designated it as the home of Alcott's "little women" highlights its invented quality and points to the methods these New Englanders had at their disposal to appropriate symbols of the past.

Women, as individuals and as members of clubs across New England and New York, responded to the pleas of the Concord Woman's Club for participation in the establishment of a "shrine" to the memory of their childhood reading of *Little Women*. The novel must have struck especially deep chords at the turn of the century, embodying the pathos of middle-class women's culture in its expression of not only the stultifying effects of the traditional domestic environment on women but also the inexorable "hunger for home" that many women felt would arise from attempts to depart from its security. Some women would recognize and admire Alcott's choice of the latter, but most would remain transfixed by her poignant portrayal of Jo, perhaps especially by the novel's strangely unsatisfying denouement. In effect, Alcott's novel had anticipated what would be a chronic and thorny issue for women, as their desire for experience outside traditional domesticity grew while their belief in the sanctity of "the home" remained inviolable.

This ambiguity helps to explain why the general focus of the Orchard House museum was on the "little women," and why Concord's most ardent suffragists and antisuffragists could agree on the appropriateness of such a shrine. The fact that the museum embodied both the nostalgic, propagandistic domesticity of the "material traditionalist" as well as the actual life of Louisa May Alcott made it an attractive project for a middle-class community of women whose differences were now hard to contain. The nonverbal nature of the memorial made such a reconciliation possible. In contrast to museums dedicated to political figures, many of the visitors to Orchard House had direct experience with *Little Women*, a novel that was "part of American household furniture."[289] In this way, a "resisting reading" of the museum's generally conservative message was always theoretically possible.[290]

The Concord Woman's Club's "reinvention" of Orchard House had paralleled Alcott's "reinvention" of her own childhood. Alcott's replacement of what she called her "pathetic family" with a more stable, less problem-ridden one arose from deep personal wishes. Likewise the CWC enshrined Orchard House as though it were the March family cottage. The CWC's suppression of the real history of the Alcotts—for example, that Bronson had directly attacked the single-family home in his Fruitlands experiment or that Louisa

May Alcott spent much of her time living in a boarding hotel in Boston—transformed Orchard House into a model single-family suburban home and the Alcotts-cum-Marches into the ideal Anglo-American nuclear family. Orchard House was made available as a reference work for anyone wishing to legitimize their domestic standards. Settlement house workers who had addressed issues of domestic reform by "visiting" the homes of their constituents were often asked if they felt that they were intruding on revered domestic privacy.[291] House museums solved this problem by setting up "model" homes to which curious visitors flocked. By 1913 John Pratt Alcott, nephew of Louisa May Alcott, could boast that "pilgrims come from far and near to visit this shrine." People "from every type of life from the simplest to the most cultivated" came to Orchard House via the rail station, from Boston and from around the world, to see the home of the beloved "little women."[292]

When they arrived, they found a house furnished in the style of "last century Concord," which was "not in advance of its time" but rather was of the "quaint and dignified fashion of a hundred years before." Because "the Alcotts were poor and their furniture was undoubtedly of a most nondescript kind," the house took on "a significance more akin to that of Lincoln's log cabin," offering insight into "the unfavorable conditions under which lives of such lofty spirit were achieved."[293] The decor conveyed a message as political as that of the renowned log cabin, the crude but honest homemade starting point for a climb upward. The decorative detail of Orchard House was replicable by the most humble Americans, as well as by the propertied middle class aspiring to a life of gentility.

Despite the fact that most of the furniture in the house was documentable through John Pratt Alcott, the house showed signs of an early-twentieth-century aesthetic in some key ways. At this time Concord's abundant "colonialisms" were being refurbished by the pervasive influence of the Arts and Crafts style, making the fact that the Alcotts did not have opulent Victorian furniture all the more advantageous for those wishing to make the rooms look vaguely tasteful.[294] The lack of "genteel" furniture in the nineteenth-century style, the "battered furniture and odd chairs" described by Abigail Alcott as having adorned the childhood home of the Alcott girls, were now preferable to Victorian excess.[295] The sparse, carpetless look of the dining room of the Orchard House museum was far from Victorian in decorative orientation. Given the reverence for simplicity and "makeshift ambiance" of early-twentieth-century taste, Orchard House would have been relatively pleasing.[296]

The house itself, literally of colonial vintage, also fit the public's impressionistic definition of "colonial," represented by a well-used hearth and a spin-

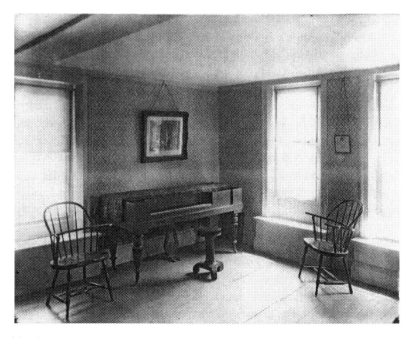

The Orchard House museum's period parlor early in the twentieth century. PHOTO-
GRAPH BY MARY NORTHEND, COURTESY OF THE SOCIETY FOR THE PRESERVATION OF
NEW ENGLAND ANTIQUITIES.

ning wheel. The anachronistic placement of this emblematic textile tool in the
corner of the dining room illustrates the display function of "colonial" refer-
ents in the early-twentieth-century aesthetic and served to remind visitors of
the colonial roots of the Alcott family. Though the house retained enough
Victorianisms to convey the passage of time, it also contained many features of
the domestic reformers' ideal home, in its spare furnishings, workshoplike
kitchen, and separate living and dining rooms, and above all as a "place of rest
and relaxation for the family, and most especially the man of the house."[297]

Bronson Alcott's commodious study suggested the ideal Progressive home,
but here the museum ran counter to a major theme in *Little Women*, the ab-
sence of Mr. March. If Louisa May Alcott was brought home, so too was the
authoritative male, providing the Orchard House museum with the funda-
mental social contours of the single-family suburban home. The CWC found
in Orchard House a new venue through which to convey a rich and detailed
message, revealing the house museum as a potential resource from which the

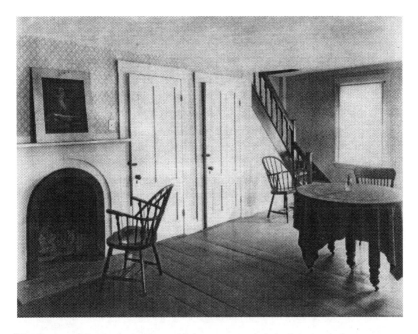

The Orchard House museum's period dining room early in the twentieth century.
Photograph by Mary Northend, COURTESY OF THE SOCIETY FOR THE PRESERVATION
OF NEW ENGLAND ANTIQUITIES.

historical legitimacy of "the home" could be respectably and authentically
acquired.

House museums were especially well suited as models for the correct dis-
play of meaning-heavy domestic "relics." Their mythological function was lo-
cated in their capacity to embody an apparent resolution of the period's con-
flict between nostalgia for a primitive "golden age" and the celebration of
progress. Such institutions were variants of the pervasive fin-de-siècle anti-
modernism that Lears describes as palliative in both its apparent repudiation
of modern society and its provision of an "agenda for bourgeois self-reforma-
tion." The acquisition of "antimodern" objects of "taste" shored up the very
feature of modern culture of which it purported to be critical, that is, consumer
culture.[298]

Like advertising, house museums supplied a means of "finessing the com-
plexities of scale" of modern consumer choice by loading select objects with

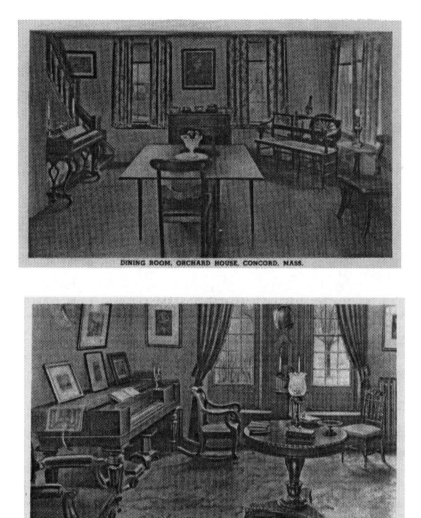

Postcards of the Orchard House museum period rooms, depicting the full development of the early-twentieth-century interpretation.

commemorative meaning.[299] In particular "the home," as an emblem of the revered values of the past and of rightful personal and "racial" development, had to be constructed of the correctly encoded artifacts. The content of this code shifted at the turn of the century from Victorian consumptive abundance to formal Anglo-American simplicity. This prescription was made all the more urgent by the lack of actual "ancestral homes."[300] As did the nonnative Concordians who created the Orchard House museum, communities could collectively reestablish an "ancestral home," and individuals could join "consumption communities" to identify themselves as well-rooted Americans. The Anglo-American middle class proselytized a less stratified pattern of domestic display, hoping thus to find evidence of their hegemonic power and, perhaps more poignantly, of the continued existence of their idealized home, America itself. House museums served this purpose well because their history-saturated "object constellations" communicated symbolically, making their hegemonic message less vulnerable to counterassertion.[301]

The worlds of meaning in the new and dazzling department stores competed with and supplemented the goals of the museum. Both exhibited objects for the education of "taste," both employed "hostesses" and treated partakers as "guests."[302] Yet if the house museum's tone was one of reverent awe, intended to foster self-controlled reflection, the department store used new exhibit techniques to create "a potentially uncontrollable circumstance of longing and desire" through a weakening of "sensual controls." This merchandising by the department stores appealed to the "new feminism" emerging in the early twentieth century, which rejected the restraint and temperance of earlier suffragists in favor of consumptive pleasures.[303] In contrast to the department stores' frenzy of display was the counterpoise of Orchard House, with its unified older suffragists and younger antisuffragists, and its sentimental, austere message about what objects a proper "home" would contain. Likewise, the agendas of museums and retailers overlapped within a materialized public debate over what "object constellations" signified a true "home" and the role of the home's evolving but ever-present centerpiece, the woman of the house.

Joining museums and stores in this agenda were mass-market women's magazines, the epitome of which was Edward Bok's *Ladies' Home Journal*. Bok credited a series titled "Inside a Hundred Homes," followed by a pictorial series on "good and bad taste," for bringing the magazine's circulation up to an unprecedented one million.[304] Such features, enabling women to study the interior of hundreds of houses, solved the problem of the intrusive "friendly visitor" while still intending to reform homes by democratizing taste. Bok

hoped readers felt that the magazine's refined editors "actually came in person" to their homes.[305] *Ladies' Home Journal* declared formal simplicity to be in "good taste," in the belief that styles tending toward "colonial" or Arts and Crafts form had the power to uplift character and contribute to civic virtue.[306] Because of their skill in the selection of the properly moral objects, women could maintain their traditional status as guardians of the Republic.

The twentieth-century "colonial" interior of Orchard House fused an agenda for reform of "the home" with a critique of Victorian consumerism and display. Advertisers and department stores found the "colonial" furniture manifesting this critique an eminently saleable commodity. The power of advertising would prove titanic. When manufacturers began to produce simple, historically referential furniture, the critical content of this aesthetic was diverted into ad campaigns to induce a widespread preference for "morally superior" things.[307] Early-twentieth-century advertisers, magazine editors, furniture manufacturers, and department stores tapped into this implicit critique of mass-produced furniture to offer a homeopathic cure by which the consumer could purchase a critique of consumerism. It was not strange, therefore, that in 1902 the glittering Marshall Field department store should exhibit a "Colonial Room."[308] In fact, "colonial" and Arts and Crafts style became so thoroughly associated with consumerism that it was subject to the formidable commentary of Thorstein Veblen, who argued that the elevation of more expensive, handcrafted, imperfect goods over inexpensive, nearly perfect machine-made goods amounted to "conspicuous consumption."[309]

For women, the repeated celebration of a historical period that generally limited them to domestic roles would make "colonial" furniture a kind of ideological bridle. Veblen had already revealed women's designation as the household's "ceremonial consumer."[310] Since "the home" retained its polemical definition as the seat of civic virtue, then designating women as conduits for a steady press of "American" objects into the new single-family suburban homes would be the consummate fusion of women's personal and public roles. The escalation of women's symbolic household labor, the unremitting quest for perfect cleanliness and order, constantly subverted by the other members of the family, was part and parcel of this role, as was the effort by advertisers to divert feminism into "freedom of choice" for the female consumer.[311] The twentieth-century mainstream's cultural prescription touting women's responsibility to create separately functioning moral homes in the suburbs was the direct descendant of the "domestic feminism" of Catharine Beecher, the by-product of women's domestic justifications for suffrage, the antithesis of "material feminism," and the heart of the "feminine mystique."[312]

Orchard House, symbolic single-family home of the March family, now in a suburb of Boston, filled with "colonial" and otherwise quaintly American commodities, and massively popular, is an eloquent testament to the Anglo-American crisis of the early twentieth century. The persistence of this cultural memory is astonishing. In the 1950s a popular magazine affirmed, "If ever there was a 'typical, old-fashioned American home,' this is it."[313] A 1983 feature on Orchard House in a decorating magazine devoted to putatively "colonial homes" spoke appreciatively of its acquirable charm and the "dining room where the sisters staged their plays for their friends."[314]

The actual historic residents of Orchard House—a wild old transcendentalist and a passionate suffragist—were there thanks to the financial support of their daughter, an unmarried working woman. In spite of the fantastic conservative undertow draining the history of Orchard House, at least its basis in *Little Women* means its imaginary and potentially subversive tour guide has often been Jo March, who dreamed of keeping her individuality as she grew into womanhood. This imaginative product of Louisa May Alcott's "hunger for home" continues to draw crowds of admiring women and girls who may recognize Jo March's dilemma as their own.[315]

Visitors to Monticello. COURTESY OF MONTICELLO, THOMAS JEFFERSON MEMORIAL
FOUNDATION, INC.

Chapter

Campaigning for Monticello

Monticello's establishment in the 1920s as a flagship American house museum documents a turning point in the history of the movement. Like Mount Vernon and Orchard House before it, Monticello was posited as a unifying influence for seemingly intractable political rifts. However, the story of its founding reflects the changing role of women as house museums increasingly drew the attention of men in the period after World War I.

It was the World War that had demonstrated how strikingly conventional the notion had become that house museums could induce allegiant behavior. For example, the Wilson administration's Committee on Public Information, "the most visible and official organ in the contest to mantle the war with transcendent ideological significance," sponsored through its Division for Work with the Foreign Born a much-publicized "pilgrimage" to Mount Vernon. On the Fourth of July, 1918, representatives of thirty-three ethnic groups absorbed the heady ambience of the "shrine" while an Irish tenor sang "The Battle Hymn of the Republic."[1] In the hypernationalistic postwar era, the utility of the house museum as patriotic medium and the desire to turn away from European aesthetics toward "Americana" fostered a boom in both the creation of historic "shrines" and the collection of American antiques. Along with the usefulness of the period room to the effort to regulate "taste" and promote that aspect of consumer culture linked to the Colonial Revival, this interest drew new, often male, patrons to the house museum.[2]

The Masculinization of the Historic House Museum Movement

The primary role of voluntary associations of women in founding house museums was shifting, but the male professionals who took their places would build on familiar nationalistic and reverential motifs. Despite Charles Hosmer's suggestion that "women were predominant in the preservation movement as long as it stressed history and patriotic inspiration" and that "men's groups tended to save old homes for their own sake, and often deemphasized the inspirational aspect of preservation," professional men in the museum field were frequently drawn to the dogmas associated with, for example, "colonial" American form.[3] Though in general they valued the opinions of "professionals" and were less flowery in their definitions of the social value of old houses, these new shapers of the historic house museum were no less motivated by the ideological expediency of charismatic "historic" settings than were their nineteenth-century predecessors.

It was true that the DAR had become even more dedicated to the peculiar romance of "Americanism," important expressions of which were its historic houses. Between 1910 and 1932 the organization's membership more than doubled to almost 170,000 women.[4] The notorious rightward bent of the DAR after World War I, which included an attack on Jane Addams for her antiwar activities, was not incompatible with their program of historic preservation.[5] For example, the Daughters celebrated the defensive agency of women by rebuilding and furnishing the Georgia cabin of the legendary Nancy Hart, whose claim to fame was that during the Revolution she had captured a band of British invaders and held them at gunpoint.[6]

Other women's groups also continued to pursue the establishment of house museums. Within two months of Theodore Roosevelt's death in 1919, the Woman's Roosevelt Memorial Association had purchased his New York birthplace, planning to rebuild and refurnish it as "a permanent citizenship foundation for the foreign born," where immigrants could learn "the priceless privileges and stern obligations of American citizenship." In 1922 the association divided itself into separate women's and men's committees.[7] In the twenties, a women's organization formed to transfigure Arlington House (the Lee mansion that became the first federally owned historic house when it was seized by the Union after the Civil War) into a proper historic house museum. And at this time it was still possible for a women's club to conduct tea parties and bake sales to raise funds to preserve a venerable old mansion, as did the Ladies' Tuesday Club of Jamaica Plain, Massachusetts, on behalf of the Loring-Greenough House.[8]

Women's interest in historic house museums continued, and the new "museum professionals" found innovative ways to use their collections to address contemporary problems. But because these were often subsumed under the traditional bogey of looming social instability, it was a matter of putting old wine in new bottles. In 1921 the director of the American Association of Museums wrote an article, "The Future of Museums in the Life of the People," in which he worried about "disquieting tendencies" that could not be "counteracted by suppression or force." It was therefore the task of American museums "to inspire and cultivate more wholesome and saner interests and truer ideals."[9]

Major museums seeking to inculcate "more wholesome" ideals turned to the inspirational power of the recreated domestic interior, linking highbrow museums to house museums in both motive and method through the period room exhibit.[10] As early as 1908, the "German method" of displaying artifacts in room settings was advocated to the Metropolitan Museum of Art, but it wasn't until the large private collections of "early American" antiques reached full bloom in the twenties that museums were able to acquire sufficient artifacts for substantial period rooms.[11]

No single museum exhibit was more carefully designed to inspire "truer ideals" than the American Wing of New York's Metropolitan Museum of Art, which opened in 1924, the year Congress passed the National Origins Act restricting immigration. The American Wing was a series of period room settings filled with high-style colonial American artifacts donated primarily by Margaret Olivia Sage and Robert DeForest. It was enormously popular, drawing more than three hundred thousand people in its first year alone.[12] According to R. T. H. Halsey, the influential curator of the American Wing, the period rooms helped acquaint a heterogeneous public with "our" lost American principles. "Many of our people are not cognizant of our traditions and the principles for which our fathers struggled and died. The tremendous influx of foreign ideas utterly at variance with those held by the men who gave us the Republic, threaten and, unless checked, may shake its foundations."[13] He oriented the exhibit politically when he told a group of New York Republican women that the period rooms illustrated the "homelife of those who protected this country from enemies within just as you women in this country in this last campaign did such convincing work to preserve us from the dominating influence of foreign ideas."[14]

The American Wing celebrated not only colonial men "by whose efforts and sacrifices the Republic was made possible," but also feminine domestic virtue. "Colonial women," Halsey asserted, "were never idle," for "when the

daily tasks were done they employed themselves in beautifying their homes." Taken together, the high-style domestic interiors of the American Wing revealed "our ancestors" (presumably in contrast to "theirs") to have been "people of good breeding with consequent good taste."[15] The value of the exhibits in justifying twenties consumerism did not go unappreciated. One reviewer said the display demonstrated that "our ancestors" acted upon their "innocent desire to surpass each his neighbor in the decoration of houses."[16]

Evidently the interests of the new museum professionals and traditional women's preservation societies were not irreconcilable. The "uses" of history in the elegant American Wing paralleled the general educational thrust of house museums, which constituted a thriving industry by mid-decade largely because of the proliferation of the automobile.[17] The 1920s marked the highest point of popular regard for "Americana" to date, and it was in that remarkable decade that the American ability to memorialize highly selective historical imagery found its most paradoxical expression when, in 1924, Calvin Coolidge signed both a bill establishing the ever-popular Statue of Liberty National Monument and also the National Origins Act.

Two milestones in the field of historic preservation were initiated in the 1920s by men whose fortunes rose with that of the automobile: Henry Ford constructed his eclectic museum village in Dearborn, Michigan, and John D. Rockefeller Jr. began the restoration of Virginia's Colonial Williamsburg. Each "village" of museum structures reflected its creator's particular conception of the relationship between America's past and the future of the expanding capitalist economy. Ford, whose discontent with the present had grown after World War I, created an idealization of the fountainhead of the twentieth-century industrial plant, an imaginary rural village filled with self-reliant inventors and artisans, a nostalgic vision of an America free of class conflict and war. Rockefeller recreated an Edenic microcosm in which a colonial elite governed an elegant and stable village.

Henry Ford's interest in preserving historic buildings began with his 1923 purchase of the Wayside Inn in Sudbury, Massachusetts, which he restored and converted into a museum and hostelry. The Wayside Inn was said to give "foreigners . . . a way of finding out what is the real spirit of this country"; the DAR sent immigrant children there for a dose of "Americanism."[18] Also in the midtwenties, Ford restored the house in which he was raised to look as it did in 1876, when he was thirteen. Ford pulled workers off the assembly line to search for bits of his mother's china and the rusty skates of his youth. He found a woman who looked like his mother, had her attired in nineteenth-century dress, and filmed her spinning at the fireside.[19] Here was a man for whom history's allure was rooted in highly personal issues.

Soon Ford began collecting buildings and having them moved near his home in Dearborn, Michigan. At this time he was profoundly disillusioned by the failure of his dream of a placid and prosperous industrial economy based on the five-dollar day.[20] What began as "an artifactual projection of Henry Ford's recollection of his nineteenth-century agrarian boyhood in the Middle West" soon turned into a fantastic assortment of seemingly unrelated buildings.[21] By the time the notional "village" was fully assembled, it included the cabin in which William McGuffey was born, Thomas Edison's laboratory complex, a five-hundred-ton stone medieval English cottage, slave quarters from a Georgia plantation, a New England village green, various mills and shops in which artisans engaged in their historic crafts, and the steamboat *Suwanee*. Nonetheless, Ford believed that through Greenfield Village he had "reproduced American life as lived; and that, I think, is the best way to preserve at least part of our history and tradition."[22]

A number of explanations have been posited for this extraordinary composition, to which Ford retreated more and more frequently as the years went on. John Wright suggests that Ford built Greenfield Village "out of guilt" over his role in changing the American landscape, and out of his desire to live down the infamous "history is more or less bunk" statement. Hosmer argues that Ford wished to celebrate material progress through Greenfield's incredible display of American inventions and technologies.[23] Most convincing, however, is Michael Wallace's view that Greenfield expressed Ford's disenchantment with the present through a backward projection of his vision of ideal social relations. Wallace explains the impression of past social worlds generated by Greenfield's assembled exhibits: "Ford's thrifty and reliant common folk (if only his assembly line workers were half so virtuous!) acted as individuals; square dancing was about as close as they got to collective action."[24] Ford objectified his notion of the time before the mass production and mass consumption of capitalism had taken a wrong turn, symbolized in his view by World War I and the fact that the somber Model-T was being taken out of production because of the challenges from Chrysler and General Motors. This spurred his retreat into Greenfield's didactic past, relished by himself and presumably the hundreds of thousands of motorists flocking to the idiosyncratic mirage of a historic village.

Before Ford embarked on his massive Greenfield enterprise, he had been approached by one Rev. W. A. R. Goodwin, pastor of the Bruton Parish Church in Williamsburg, Virginia. Goodwin told Ford he should consider restoring Williamsburg, as his automobiles were "the chief contributors" to the aesthetic debasement of the town, attracting filling stations, billboards, concrete roads, and traffic lights. Goodwin charged that "most of the cars

which stop at the garages and gas tanks are Ford cars."[25] Ford declined to respond, but the story was leaked to the press and widely reprinted. The *Detroit Sun* lampooned "the spectacle of the Old Dominion huckstering off her ancient capital to an outsider in order to get a flivver imitation of departed glory."[26]

Soon Goodwin's lobbying succeeded in gaining John D. Rockefeller Jr.'s avid attention. Rockefeller had already shown interest in such endeavors, for example by donating a considerable sum for the restoration of Marie-Antoinette's ill-famed peasant play-village, the *Hameau Rustique*, which Rockefeller called "a perfect dream of beauty and delight."[27] Whereas Ford had personally supervised every phase of the creation of Greenfield Village, Rockefeller delegated the recreation of Colonial Williamsburg to professional architects. While planning for the restored village, Rockefeller began to purchase buildings through Goodwin, anonymously so that prices would not become inflated. By 1928, however, word was out and Rockefeller's project was a public one.[28] By the time he was through demolishing, restoring, and even reconstructing, Rockefeller had spent seventy-nine million dollars for a pristine eighteenth-century "reproduction" village commemorating the colonial planter elite.[29]

Rockefeller's assessment of the meaning of Colonial Williamsburg touted "the lesson that it teaches of the patriotism, high purpose, and unselfish devotion of our forefathers to the common good."[30] The mythologized Williamsburg displayed the material benefits derived from the aristocracy's judicious exercise of unquestioned power. But the middle-class consumers of the restored Williamsburg took away a different and more tangible inspiration. As soon as the site opened in 1934, the public responded enthusiastically to its stylish effects by consulting Williamsburg for home decorating ideas.[31] Kenneth Chorley, president of Colonial Williamsburg, said its massive popularity was "a proof that *history can be sold*."[32]

Fortunately all of this enterprise did not go entirely uncriticized. Frank Lloyd Wright spoke at a conference in Williamsburg in 1938 and raised hackles by facetiously congratulating Rockefeller and his staff for revealing "how shallow and little life was then."[33] However, professional historians did not take the lead in reviewing the scholarship at Williamsburg. When J. Franklin Jameson placed notices in the *American Historical Review* and "a dozen historical journals published in the Northern states" asking for assistance in researching eighteenth-century Williamsburg, he received no response. In 1932, the Williamsburg staff called a conference of historians to help devise a way to interpret Williamsburg to the eager public, but the historians

emphasized the importance of publishing scholarly monographs rather than popular pamphlets. Samuel Eliot Morison argued that "in this country we are too much bothered about educating and improving the masses," and he claimed that information in scholarly publications would eventually "percolate to the public below."[34]

Meanwhile, Rockefeller's version of the colonial past grew more and more popular, frequently understood as a kind of model "colonial" suburb. As Wallace explains, Rockefeller's vision of Williamsburg, "the appropriate past for the desired future," was of "total social order." "Intelligent and genteel patricians preside over it; respectable craftsmen run production paternalistically and harmoniously; ladies run well-ordered households with well-ordered families in homes filled with tasteful precious objects. The rest of the population—the 90 percent who create the wealth—are nowhere to be seen."[35] This genre of appropriation of the American past by corporate sponsors would not end with Greenfield Village and Williamsburg, and critical attention to such powerful sources of popular historical perceptions would not be awakened for decades.

Meanwhile, the polemical power of the house museum had retained its original constituency of voluntarist women. The part they played, however, was significantly altered by a new political and cultural milieu and by the new role of men in the movement, evidenced by the fact that the drama of Monticello's establishment as a museum began in the U.S. Congress.

▪ Maud Littleton's "One Wish": The Campaign to "Rescue" Monticello, 1911–17

In July 1912, a few months after the Orchard House museum opened to the public, an anxious but determined woman sat before the House Committee on Rules of the U.S. Congress to argue that Monticello, once the Virginia home of Thomas Jefferson, be made into a museum.[36] Although she began tentatively, explaining "I am not an experienced public speaker and am a little bit nervous," her plan to convince the national government to displace the owner of the estate, Rep. Jefferson Levy, by right of eminent domain was far from timid. Maud Littleton, wife of Levy's Democratic colleague Martin Littleton, was attempting to apply the Progressive disposition to expand government power to what had been the traditionally female cultural task of creating commemorative homes.[37]

Her testimony began with a description of her own visit to Monticello, which had been occupied by the Levy family since the 1830s. The Texas-born

Littleton said she could recall having seen only the "big, oil portraits of the Levys," goads to her bitter disappointment at finding little of Jefferson's spirit there, making her feel as if "somebody was taking his place in Monticello—an outsider, a rank outsider." She tartly declared, "I believe that there is no widespread interest to have it known as a memorial to Commodore Uriah P. Levy."

Her arguments against the Levy family's ownership of Monticello were threefold: that it was a "sacred" place, which ought to be accessible to all Americans; that Jefferson Levy was an "outsider" who did not have the moral right to expose Monticello to "the desecration of being lived in"; and that the purchase of the "shrine" by Uriah Levy early in the nineteenth century had represented the triumph of mere money over the more transcendent value of patriotism. She asked the committee, "Is it possible that the commercialism of America is so deep-rooted that it will tolerate, much less indorse a sordid scramble between those who have the longest purse for our treasures which represent the highest point patriotism has ever reached in this Country?"[38] And, she continued in outrage, "Is it only through Levy's favor that we can take our children up to the top of that little mountain to teach them lessons in history?"

The house came into the Levy family when Uriah Phillips Levy, a figure of historical importance in his own right who admired Jefferson's principles of religious freedom, purchased Monticello in 1836.[39] Levy willed Monticello to "the People of the United States," to be used as an agricultural school for the orphans of naval officers. Shortly after he died in 1862, however, the estate was seized and sold as property of an "alien enemy" by the Confederacy. When the Confederacy fell, the Levy family contested the terms of the will, which eventually was declared invalid by the New York Court of Appeals. A single heir, Jefferson Levy, was able to consolidate his title to the estate by 1879. In 1912 Congressman Levy's attachment to what had been for so long his family's property made him unwilling to sell Monticello, even as a memorial.[40] In retort, Maud Littleton pointed out that Uriah Levy had originally willed Monticello to the United States.

Littleton had issued a letter of appeal late in 1911 titled "One Wish," outlining her vision of a public Monticello.[41] At her 1912 congressional testimony, she read a selection of the responses, including letters from Gov. Woodrow Wilson, a number of DAR chapters, Upton Sinclair, and Elbert Hubbard, who requested permission to reprint "One Wish." The letter of support for government acquisition of Monticello from New York State Sen. Franklin Roosevelt proved consequential because his presidency would mark the initiation and rapid expansion of federal sponsorship of historic house museums.[42]

The ideological application of these institutions was asserted again and

again in the responses to "One Wish." Malcolm Jennings of Marion, Ohio, declared, "In these days of unrest and senseless clamor and criticism of the work of the fathers who builded so wondrously the beginnings of this our Republic, we can not have too many memorials of the inspired patriots to win the attention and arouse the wandering intellects of our thoughtless citizenry."[43] Cora Davis, president of the National Women's Relief Corps, made clear that voluntarist women had established themselves as the traditional guardians of such "shrines": "It is a poor commentary on the patriotism of a mighty nation like ours that its 'master builders' are forgotten in the drift of commercialism, and if such shrines are to be rescued from oblivion it will be because of women's work."[44]

Many in the new field of historic preservation agreed with Cora Davis that women's networks were well suited for establishing house museums, among them the influential preservationist William Sumner Appleton of the Society for the Preservation of New England Antiquities (SPNEA). In a brief correspondence with Littleton, he asserted his faith in the timeworn methods of enshrining a historic house, advising:

> I feel that you are making a mistake in trying to act through Congress rather than through a society formed for the particular purpose of preserving this house, as was done in the case of Mount Vernon. To place the ownership and care of such a building in the hands of the national Congress can only result in making it to a certain extent the foot ball of politics. . . . I think that a much better plan would be to organize some such national society as the Mount Vernon Ladies' Association, perhaps copying their organization absolutely. . . . I can't help thinking that one or more ladies could be found in each state sufficiently interested to serve in such an organization, and at the same time contribute a sufficient sum.[45]

Appleton had obviously accepted at face value the MVLA's self-conception, the centerpiece of which was its putative lack of political entanglements. Littleton did not have to be reminded that her mission had its roots in the great MVLA movement to preserve Mount Vernon. Headlines reflected her hope that Monticello could become "another Mount Vernon"; she herself paraphrased Ann Pamela Cunningham to contrast Levy's reluctance to part with the estate with John Augustine Washington's desire to make Mount Vernon "a common heritage for the children of a common father."[46]

Historians, too, have compared the two movements. Hosmer's interpretation, which focuses primarily on the personalities of the two leaders, faults Littleton for her "expression of animosity" toward Levy, which he argues was

the "crucial" tactical distinction. Cunningham, on the contrary, was "sufficiently dedicated to the cause of Mount Vernon to swallow her pride." Interestingly, Hosmer is sympathetic toward Cunningham's tearful approach to John Washington but in describing similar circumstances charges Littleton with displaying "histrionics." Although Littleton used every "lobbyist device," as Hosmer says pejoratively, the distinction between the two movements appears linked to personal qualities only when important changes in historical milieu are overlooked.[47]

Between the antebellum period and the twentieth century, essential changes occurred in women's voluntarism as it was transformed by a new relationship with the expanding state, a change that is vividly documented by the differences in the modi operandi of Cunningham and Littleton. Cunningham did work with legislatures when necessary, but she viewed the antebellum government as weak, even "degenerate," and her faith in the ability of women's voluntarism to achieve remarkable things was well founded. By Littleton's day, however, women's networks had been drawn closer to the state as many of their formerly private goals and functions were co-opted by the expanding Progressive Era government.[48] Littleton was enthusiastic about the possibility of applying these expanded powers to the task of acquiring Monticello for "the people." Thus in her quest to "rescue" Monticello, Littleton had turned immediately to the state when Jefferson Levy would not acknowledge the original, though legally overturned, terms of Uriah Levy's will.

Littleton knew that the right to condemn and seize property for "public use" is allowed by the Fifth Amendment and that definitions of "public use" were being elaborated in this period.[49] Establishing an incontestably significant "public use" for Monticello was therefore crucial to Littleton's case, spurring congressional debate over this dimension of constitutional law. Former Assistant Attorney General James Beck advised Littleton that the right of the federal government to condemn and seize property of historical interest had been established by *United States v. Gettysburg Railway Company* at the turn of the century. In this decision, Justice Rufus Peckham wrote that the legislature could seize portions of the Gettysburg battlefield, as "any act of Congress which plainly and directly tends to enhance the respect and love of the citizen for the institutions of his country and to quicken and strengthen his motives to defend them, and which is germane to and immediately connected with and appropriate to the exercise of some or all of the powers granted by Congress, must be valid."[50]

Reactions to this argument were mixed: The initial effort to gain congressional approval for the proposal of Littleton and her newly formed

Jefferson–Monticello Memorial Association passed in the Senate, but it was defeated in the House in December 1912.[51] Opponents questioned various dimensions of the growth of government involvement with historic sites. *House Beautiful* published an editorial against Littleton's attempt to "oust" Monticello's "proprietor" but in favor of expanding government influence, suggesting it deploy "the same sort of censorship over historic houses that the Italian government exercises" by appointing a committee to see to it that historic buildings would not "be put to desecration."[52] Many objected strongly to the use of eminent domain for this purpose, including Appleton: "I am a tremendous believer in buying Jefferson's home for preservation, but as luck would have it I am also an ardent Jeffersonian in my principles, and can't help feeling that Jefferson would turn in his grave at the mere suggestion that the Federal government should buy his home by right of eminent domain, thereby turning out the occupant."[53]

Reference to particular visions of Jeffersonian principles was apt, because from its inception the Monticello campaign was bound up with a Democratic Party struggling to employ the image of Jefferson to hold together factions: northern and southern, urban and rural, nativist and immigrant. In 1905, the *New York Post* noted the attempt "to make Jefferson at once the great individualist and the great socialist," adding it was "pretty clear evidence of the hesitation in which the Democratic Party finds itself." This was true both nationally and within Littleton's and Levy's home state of New York, as the party's traditional upstate–downstate fracture was exacerbated by the outgrowth of the split between Tammany politicians and those associated with insurgents like the young FDR.[54] Although Littleton's organization claimed the qualified support of some prominent Republicans (Henry Cabot Lodge disputed Littleton's opinion that Jefferson was a great politician but admitted respect for "his love of art and architecture"), its composition was largely Democratic.[55] This was sniffed out by Senate Republicans who insisted that a lengthy preamble celebrating Jefferson be stricken from the text of Littleton's resolution before it would pass.[56] Some Littleton supporters linked her cause directly to the struggle against the Republican Party. Hon. Timothy Woodruff of New York said, "Prior to the organization of the National Progressive Party, I do not think it would have been appropriate for me, a life-long Republican, to have been identified with your cause, but now that the new party to which I belong has been created and adopted Jefferson and Lincoln as our patron saints the situation is materially altered."[57] Even Levy himself had advocated Jefferson's political utility. In an address at Monticello to the Jefferson Club of St. Louis in 1901 he said, "I am sure pilgrimages of this character cannot fail to inspire

and unite our party; for as attention is called to the platform of true Democracy, as laid down by Thomas Jefferson, the people will rally around our banners and restore the government to our administration."[58]

Perhaps this argument had been solidified in Levy's mind by his well-publicized correspondence with William Jennings Bryan, in which the prominent Democratic populist argued that Monticello should be purchased by the government, or barring that, by "the Democrats of the country," as "a memorial of the great Democratic President."[59] Littleton supporter Woodrow Wilson, the first southerner and Democrat to become president since the Civil War, had given Democrats hope that national party power could be consolidated, in part by the elimination of the last vestiges of white sympathy for Reconstruction as its history was rewritten by academic historians and in popular culture.[60] Littleton had placed herself in the rhetorical tradition of a southern preservationist attacking northern culture shared by the Mount Vernon Ladies' Association as well as the Association for the Preservation of Virginia Antiquities; the Monticello battle can be seen as another dimension of the post-Reconstruction effort to recover the Old South described by historian James Lindgren.[61]

Undaunted, Littleton went on to appeal to the state of Virginia, and she succeeded by February 1914 in convincing its legislature to pass a key resolution declaring that Levy's ownership of Monticello was inhibiting public access.[62] She returned to Washington in 1914 with petitions in hand, fresh sponsorship, and a broadened base of support.

By now the cause was reaching a wider audience. In 1914 a provocative article appeared in *Good Housekeeping* titled "Monticello—Shrine or Bachelor's Hall?" (Jefferson Levy was unmarried.) In it, southerner and journalist Dorothy Dix, a well-known syndicated columnist who wrote advice to the lovelorn, bemoaned the scarcity of "Meccas" to which an American could go for "a pious pilgrimage to the holy places where lived and died those who have made America great."[63] According to Dix, "The hand of the vandal has torn down their birthplaces, or an alien sits at the fireside where they planned their immortal deeds, and their belongings have been scattered."[64]

References to the Levys as "aliens" and "outsiders," despite the fact that they had been in the country for many generations, were expressions of a rising tide of antisemitism. In reaction to the wave of immigration from eastern Europe, Jews were increasingly excluded from jobs, clubs, colleges, and residential areas. John Higham notes that this period advanced the "Shylock tradition, the notion of the Jews as an immoral, unmannerly people, given to greed and vulgarity."[65]

Dix claimed that "the story of Monticello passing into alien hands is one of peculiar pathos." She presented as truth a seamy tale, popularized by an article in the *New York Sun* written by a former Democratic congressman, of the unprincipled method by which Uriah Levy had supposedly come to possess the "shrine."[66] According to Dix, since in Jefferson's day no appropriations were made for state "entertaining," the gracious president had spent all of his own money on ceremonial festivities and had fallen into debt. Upon his death his estate had to be sold to pay these debts, thus rendering his widowed daughter and her eleven children homeless. A subscription for three thousand dollars was raised from friends in Philadelphia to purchase Monticello for them and was sent by messenger to Virginia. The young emissary confided in his nefarious stage-coach companion, Uriah Levy, who seized his opportunity, when the messenger subsequently got drunk and dallied, to dash ahead and buy the estate for twenty-five hundred dollars from under the poor widow and her Jeffersonian offspring. Dix continued, "The next day the sober and repentant young man arrived and besought Captain Levy to take the three thousand dollars that the generous Philadelphians had given for the purpose, and let Monticello go back to the Jefferson family. Captain Levy refused to part with his bargain."[67] The *Sun* article had fifth-generation American "Judah" Levy responding, "Mein frien,' you are a glever feller, but you talk too much. I will take a huntret thousand dollars."[68] In short, Dix marshaled antisemitism to shift the blame back in time from those members of the Levy family who had contested the will to Uriah Levy himself. The public was therefore encouraged to support Littleton in her efforts to have Congress remove the "aliens" and acquire the "decaying" house by right of eminent domain. "Surely," Dix added, "the Democratic party, now in power, will do its duty to the great founder of the Democratic party by setting apart Monticello as a shrine to which all Americans may go and gather fresh inspiration and new faith in democracy."[69]

In February 1914, Littleton succeeded in convincing Congress to pass a joint resolution declaring Monticello "the Mecca of all lovers of liberty," citing a petition signed by "thousands of patriotic American citizens" worried about the lack of public access to the house. A presidentially appointed commission was proposed to oversee the possible acquisition of the site. It was as secretary of state that Bryan (keenly aware of the need to shore up the fragile Wilsonian coalition) strongly urged his fellow Democrat to sell "to commemorate the great Democratic administration of President Wilson."[70]

Jefferson Levy bowed to pressure and agreed to sell Monticello, provided he retain a life interest in the estate. Littleton's harsh assessment of Levy was abandoned; now she praised him as the custodian who had done his best to

care for the estate until the people could take over.[71] In her testimony on behalf of a 1914 joint resolution, Littleton informed Congress that more than five thousand people already visited the estate annually, and she read an impressive letter of support from none other than her longtime champion (now president) Woodrow Wilson. She asked if Monticello must "suffer the uncertainties of private ownership longer, to be auctioned or mortgaged, or maybe to be divided into building lots?" Appealing to the power and responsibility of Congress to make Monticello public property, she outlined in baroque terms the complementary relationship between men and women in creating monuments:

> Everyone knows that four years ago women consecrated themselves to the noble task of caring for Monticello's sacred dead. Without it being their particular duty or especially incumbent upon them, it was a work so much a labor of love, so womanlike, that it did not seem inappropriate for women to undertake it, for, since the days of old when Mary and the other women came to the tomb of Christ to anoint and bury his body, the care of the dead has seemed to become woman's sacred work. And ever since then when men have contended with the strifes and passions of life and fought its battles, when they were over and the great man was dead, then it is that noble women have come forward to bury his body or care for his neglected grave. And to-day women are on the battlefield, following the wake of the armies, risking their very lives to rescue the dead and given them Christian burial.[72]

This metaphor would increase in pertinence as the World War unfolded.

By 1916, Littleton had enlisted the influence of the Daughters of the American Revolution. The Daughters requested of Congress custody of Monticello "by right of descent from the patriots." In a comment demonstrating the power of house museums to unite otherwise divided women, Mrs. William Story, president of the DAR, explained to the legislators, "I said to my daughters at [the recent DAR convention that] there is no one thing that any one woman could do that would please 92,000 other women, but I believe this is the exception which proves the rule; and there is not one member of our society who is not ardently pleading for the preservation of this wonderful place."[73]

The debate continued through 1916, focusing primarily on issues of cost and the appropriateness of using tax revenues for the project. The DAR withdrew its request for custody by the end of the year to remove congressional suspicions of "selfish interest." Despite the fact that Story and Littleton reported

the continuing sanction of President Wilson, the exigencies of World War I overshadowed the Monticello debate, and Congress adjourned in 1917 without having passed a bill for its purchase.[74]

Clearly the historic house museum movement had entered a new phase, in which the traditional methods of women's organizations were being transformed by the political climate of the twentieth century. While celebrating the "womanliness" of the task of memorializing the houses of the patriots, Littleton also emphasized that it was not women's "particular duty or especially incumbent upon them," suggesting that the newly expanded state take some of the responsibility for historic "shrines." Like other turn-of-the-century women's voluntary organizations, Littleton's Jefferson–Monticello Memorial Association invoked the "domestication of politics" on behalf of a realm of cultural and social responsibilities that women no longer felt were exclusively their domain.[75]

Subsequent efforts by women's groups to acquire Monticello by using the MVLA prototype were unsuccessful, signaling the beginning of the end of a remarkable era in which voluntarist women had been the pioneers and preeminent champions of the American historic house museum movement. After the war, Levy was eager to sell Monticello. The Thomas Jefferson National Memorial Association, a Richmond-based women's group organized along MVLA lines and led by Miss Ruth R. Cunningham, rose and fell by 1922, when Levy gave them three weeks to raise fifty thousand dollars to bind a contract of sale underwritten by "wealthy men from New York City."[76] At roughly the same time the National Monticello Association was formed in Washington, announcing that "women would make [Monticello] second only to Mount Vernon." Records of its activities, though sparse, speak vividly of the enthusiasm of founder Marietta Minnigerode Andrews, an accomplished painter and writer who enjoyed her work on behalf of Monticello as part of a whirlwind social life, declaring a lack of interest in politics though she was a southern Democrat by birth and an avid Wilsonian. With Rose Gouverneur Hoes (a socially prominent suffragist, Democratic political activist, and lecturer on the First Ladies), Andrews hosted colorful receptions, theatricals, and historical tableaux to publicize the Monticello cause.[77]

In the wake of these undertakings, an alliance of male lawyers and businessmen headquartered in New York incorporated the Thomas Jefferson Memorial Foundation, which enlisted the support of Maud Littleton as well as the Richmond and Washington women's networks (Andrews solicited and won the support of numerous Washington notables, including Woodrow Wilson and Samuel Gompers). Success came through this organization and by 1923

Marietta Minnigerode
Andrews (1869–1931)
dressed in period costume
to promote the preserva-
tion of Monticello. COUR-
TESY OF MRS. ARMISTEAD
PETER III, WASHINGTON,
D.C.

the process of memorializing Thomas Jefferson through a public Monticello
had begun.[78]

The Thomas Jefferson Memorial Foundation
and Democratic Politics, 1923–28

Republican victory in the 1920 presidential election signaled the collapse of
the Wilsonian coalition. The vacuum left the Democratic Party as splintered
as before, groping for ways to bring about a desperately needed unity. The
rural, Ku Klux Klan-tinged wing was a strange bedfellow indeed for the im-
migrant, machine-associated urban faction; both obviously lacked broad ap-
peal to the voting public. Yet by the 1930s a revived Democratic Party had co-
alesced: the New Deal its policy, Franklin Roosevelt its leader, and Thomas
Jefferson its paterfamilias.[79] It was in this context that the Thomas Jefferson
Memorial Foundation was founded by Jefferson enthusiasts Democratic al-
most to a man, led by loyal Wilsonian and future FDR supporter Stuart Gib-

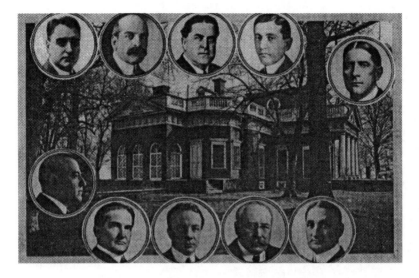

Monticello and early Thomas Jefferson Memorial Foundation activists. *Top row, left to right:* Sen. Royal S. Copeland, Felix Warburg, Gov. E. Lee Trinkle, Will H. Hays, and Stuart G. Gibboney. *Bottom row, left to right:* Manny Strauss, George Gordon Battle, Theodore Roosevelt, Alton Parker, and William G. McAdoo. COURTESY OF MONTICELLO, THOMAS JEFFERSON MEMORIAL FOUNDATION, INC.

boney. Its history demonstrates the transition of the house museum movement from an era led by unenfranchised though politically engaged women to one in which the viability of the house museum as a direct political agent was recognized by male leaders. For example, never one to forego an innovation, the young FDR was involved from the start with the allied ventures of unifying the Democratic Party using Jefferson as a rallying point and converting Monticello into a patriotic "shrine." He had supported Maud Littleton's seemingly failed venture, and at last in his presidency, he fulfilled her vision by establishing on a grand scale the power of the government to claim privately owned historic sites for "public use."

Virginia-born Wall Street attorney Stuart Gatewood Gibboney was well positioned to have heard of Littleton's lobbying crusade. A fellow New York Democrat, Gibboney had been deeply involved in the Wilson administration (afterward an activist on behalf of the presidential aspirations of Wilson's son-in-law, William Gibbs McAdoo) for whom the thwarted hopes for both Democratic concord and the enshrinement of Monticello must have been compelling causes.[80] As the chief organizer of the Thomas Jefferson Memorial

Democratic U.S. Sen. Royal S. Copeland of New York raises funds for the Thomas Jefferson Memorial Foundation in 1923. COURTESY OF MONTICELLO, THOMAS JEFFERSON MEMORIAL FOUNDATION, INC.

Foundation, he rallied a remarkable number of Democrats: mainly lawyers, New Yorkers, or associates from his Wilson days, such as Sen. Royal S. Copeland and former Secretary of State Bainbridge Colby. The new TJMF, incorporated in Albany in April 1923, consisted at heart of this genre of member, overshadowing the few Republicans and leaders of Monticello women's groups (thought of as "lovely, patriotic ladies") represented among the founders.[81]

After the initial planning meetings in New York early in 1923 that led to the charter, the foundation was left with the daunting task of raising $100,000 of the $500,000 purchase price by the end of the year to meet the terms of the contract with Jefferson Levy. This goal was secured when a group of wealthy New York businessmen, including Felix Warburg and Gibboney himself, agreed to serve as underwriters.[82] The TJMF raised some of the funds that year—for example, Senator Copeland hosted a publicity-garnering dinner envisioned as a "spiritual pilgrimage" to Monticello, held on a train parked in Grand Central Station, at which he served as "ticket collector" of donations— but in December the underwriters were called upon to support the bulk of the payment.[83] Plans were in high gear, nevertheless, for further fund-raising. A national "Jefferson Week" in April 1924 would be celebrated in schools and churches, and the public was assured of the continued interest of New York

businessmen.[84] For the festivities in New York City, the body of Jefferson's gig was brought to opening ceremonies "to stimulate national interest" in Monticello.[85] It would arrive there in time to be displayed at the Democratic national convention in June.

Enthusiasm was obviously running high in the TJMF for the elevation of Jeffersonian principles in tandem with the memorialization of Monticello, but problems soon emerged over exactly "which teachings were being revived," as Merrill Peterson puts it. He notes that despite the movement's hope to merge its patriotic considerations with its less explicit political ones, the potential for the use of Monticello and Jefferson as political instruments soon became the object of criticism from various quarters.[86] Early in 1924 TJMF officer Edward Albee released a statement, no doubt appealing to the generally reactionary political climate of the day, that the TJMF would make Monticello "an active agency of relentless war against the dangerous radicalisms of our time, when the teachings of Jefferson are needed as never before in the history of our country." Unfortunately the TJMF was now in a position to be advised to brush up on the writings of Jefferson. A *Nation* editorial pointed out that he was after all a revolutionary, jibing that the TJMF might as well make the birthplace of A. Mitchell Palmer "a Temple of Tolerance." "No," the editorial continued, "the fathers of this country were not the thin-spirited souls who make up the Sons of the Revolution, the memorial funds, and the patriotic societies of today. Thomas Jefferson liked nothing better than a rebellious spirit."[87]

From another camp it was sternly suggested that the TJMF should qualify its homage to Jefferson by taking careful note of his "serious error of judgment in doing what he could to undermine the Supreme Court." Longtime Monticello allies Samuel Gompers and William Jennings Bryan were cited as notorious contemporary threats, and a dire warning was issued that "they must not be allowed to utilize the proposed commemoration of Jefferson's services to strengthen their present attack on the Supreme Court."[88] Yet the TJMF, despite the link to the Democratic Party lurking beneath claims of total nonpartisanship, was hardly an ominous force. Gibboney said that the particular principles the foundation had chosen to celebrate were reverence for "civil liberty, religious freedom, and the progress of mankind through universal education." In fact, the effort to assuage differences among Democrats was of such profound concern for many involved in the TJMF that the foundation was precluded from engaging in crude political warfare of any kind, electoral preferences notwithstanding. The effort was a more ameliorative phenomenon than the critics suggested. Gibboney used poetic terms to characterize the

essence of Jefferson as the archetype of reconciliation of extremes revived in "an American Shrine," Monticello: "Who was Thomas Jefferson? He was a man in whose veins mingled the two streams of blood which united have in all ages given to humanity its prophets and its priests and its kings, the plebeian red of Peter and the aristocratic blue of Jane; the progeny of manly force and womanly sweetness, of virile energy and feminine refinement."[89]

Indeed, the TJMF was established in a political context that called simply for modes of accord between poles within the Democratic Party and for a dignified face without. The need was urgent in the months in which the TJMF was forming, as the Democrats found themselves facing their first national convention following the 1920 defeat, arguing bitterly from nearly irreconcilable rural and urban factions over such hot-button issues as Prohibition, farm relief, and taxation policies.[90] Whereas the Republicans attracted the "middling elements" of the electorate, the Democratic Party struggled to find a centripetal mechanism to draw together extremes represented by urban immigrant machines and "an increasingly jeremiad-oriented rural faction" tinged by the KKK. Into the breach came a full-blown Jefferson revival in which the Founding Father stood as a link between an agrarian bloc touting an all-American heritage identified with Jefferson's beloved countryside and a culturally diverse urban constituency responsive to the Jeffersonian principle of freedom of religion. A concerted revival was necessary because, as TJMF national director Theodore Kuper recognized, Jefferson was at this time at best "a forgotten man" (at worst, a scoundrel) in scholarship and in the public mind, such that the organization had to generate not only support for their particular project but basic veneration for Jefferson as well.[91]

In March 1924, Gibboney announced that arrangements for the TJMF to pay the remainder of its mortgage and to manage the conversion of Monticello into a museum were moving forward despite the death of Jefferson Levy earlier that month.[92] Later that spring the national "Jefferson Week," intended to fulfill the twin purposes of raising funds and reverence for Jefferson, was deemed a success. By June, however, many foundation officers found themselves immersed in the Democratic National Convention at Madison Square Garden, which would make history for the incredible 103 ballots the contentious Democrats took to choose their nominee, John W. Davis, a New York lawyer and charter member of the TJMF. The embattled initial choice had been between Gibboney's old friend and the favorite of many other TJMF activists, William Gibbs McAdoo, representing the rural faction, and Al Smith, governor of New York, an urban progressive of immigrant stock. McAdoo stood firmly for Prohibition and "traditional values"; he refused to

repudiate the support of the KKK. Smith, "wet" and vividly Catholic, was a prime target of Klan attack. The party "virtually committed suicide" by vicious internal squabbling, particularly over whether there should be a statement in the platform denouncing the Klan, and by publicly vilifying the two potential nominees, before finally choosing Davis as the compromise candidate for whom many were not completely enthusiastic.[93]

Although the TJMF had a strong contingent behind McAdoo, many Smith supporters could be counted among the Monticello backers as well.[94] For example, Martin Manton (a charter member of the TJMF) helped to finance Smith's nomination campaign, Bainbridge Colby gave a rousing speech in favor of the anti-Klan plank, and New Yorkers Royal Copeland and Franklin Roosevelt favored Smith.[95] On the McAdoo side was Gibboney, of course, but also George Fort Milton, Arthur Mullen, J. Bruce Kremer, and Breckinridge Long.[96] With the Smith adherents preaching religious tolerance and the Klan declaring "we want the country ruled by the kind of people that settled it," the situation was prime for the ambiguous, celebratory Jeffersonianism of the Monticello cause.[97] Sen. Pat Harrison of Mississippi called for unity by suggesting the Democrats heed "the soft voice of reasonableness coming to us from Monticello," but it was more frequently true that Jefferson and Monticello were invoked to support opposing arguments. For example, during the debate over whether the KKK should be named explicitly for condemnation in the platform, several speakers cited Jeffersonian freedom of religion, but opponents, essentially McAdoo supporters, made a Jeffersonian civil liberty argument in favor of freedom of speech and assembly.[98] In any case, the TJMF was a highly visible presence at the convention, from its attention-getting display of Jefferson's gig to its highly publicized campaign to bring two hundred boys to the convention "to learn the processes of government first hand," each "delegate" having been chosen by "ballot" and each ballot representing a donation to the restoration of Monticello.[99]

TJMF officer John W. Davis proved no threat to Coolidge in the general election, but the foundation did not immediately retreat from involvement with electoral politics. With the Democrats regrouping for the 1928 presidential contest, Gibboney found himself enmeshed in charges of partisanship when he invited Al Smith to speak at the Monticello dedication ceremony slated for July 4, 1926.[100] The press noted: "The Governor's journey into the South will not be without political significance. . . . He has rarely if ever spoken below the Mason and Dixon line, and it is believed that his speech at Monticello will be something in the nature of an invasion into new territory to make himself known so as to further his Presidential aspirations."[101]

In response, an anonymous circular letter was sent to Democrats nationally from "A Daughter of the American Revolution," accusing the TJMF of attempting to "sell" Smith to hostile southern Democrats with the ultimate purpose of "placing a Roman Catholic in the White House." Further, the TJMF was chided for abetting no less than a "hellish coup of Rome." Gibboney reported that about one million copies of this letter had been distributed and suggested that it may have been arranged by the KKK (the DAR publicly repudiated the letter). After rumors of threats to Smith by the Klan should he venture to the South, he finally retracted his acceptance of the TJMF's request that he speak on the subject of "Americanism." A distressed Gibboney made a rather peculiar public statement, presumably though unsuccessfully to refute charges of partisanship, stating that he and Breckinridge Long, who had extended the invitation, had been "McAdoo men" at the 1924 convention, although Gibboney added he had found himself in the "most unusual" position of having had Governor Smith as his second choice.[102]

The Monticello dedication on the 100th anniversary of Jefferson's death and the 150th of the signing of the Declaration of Independence went ahead without Smith, but it reflected recent events by focusing on the issue of religious tolerance. After a graveside wreath-laying ceremony, three clerics chosen to represent the Jewish, Catholic, and Protestant faiths marched to the tune of "Onward Christian Soldiers" toward Monticello just as a rainstorm darkened the skies.[103] The Episcopalian bishop of New York read from his notes by flickering candlelight, proclaiming that Jefferson's memory was "a beacon to warn us against all forms of bigotry, intolerance and discrimination against men because of their religious beliefs."[104] Although the high proportion of Jewish support for Monticello had always been meaningful on this principle, in part as a rejoinder to the hypernationalistic antisemitism lurking about the rural faction of the Democratic Party, the Al Smith crisis prompted the TJMF's amplification of the religious freedom theme.[105]

At the ceremony recognition was made of a figure important in the resuscitation of the scholarly image of Jefferson and a popularizer of Monticello's preservation as a house museum. Claude Bowers was presented with a medal from the TJMF for, in the words of University of Virginia President Edwin Alderman, having "destroyed the Jefferson of passion and prejudice, of myth and fable, and restored to the vision of his countrymen the myriad-minded statesman and philosopher who forgot the titular honors of the world."[106] In other words, the somewhat amorphous revitalization of "Jeffersonian principles" carried out by the circumspect TJMF had received an enormous shot in the arm with the 1925 publication of Bowers's *Jefferson and Hamilton*, which vindicated Jefferson and portrayed him as the originator of the party of "re-

form," versus Hamilton's party of "interests," and attempted to align the contemporary Democrats and Republicans with these two orientations. Bowers became an activist on behalf of Monticello and also in the sorely needed redefinition of the Democratic Party.[107]

Significantly, FDR took note, publishing an enthusiastic book review and melding Bowers's vision of a reform-oriented Democratic platform with his own. As Merrill Peterson so convincingly describes, it was a crucial step in FDR's incredible reformulation of Jeffersonianism to harmonize with the big-state liberalism of the yet inchoate New Deal.[108] An apostle of Jefferson as a vehicle for Democratic self-definition, Bowers became a frequent speaker at political gatherings and an appointee to the Thomas Jefferson Centennial Commission, a bipartisan congressional delegation chaired by Gibboney in close cooperation with the TJMF. The commission's purpose was to organize the commemoration of the sesquicentennial of the signing of the Declaration of Independence and the one-hundredth anniversary of Jefferson's death. Among many activities were an official "Monticello Day" and the keystone "Patriot's Pledge of Faith Day," celebrated by national bell tolling and flag saluting and consummated when "every man, woman, and child" was "afforded the opportunity" to pronounce the commission's official "pledge," which read:

> I do hereby pledge and declare my sincere belief and devout faith in the fundamental ideals of my country so bravely proclaimed to the world by the immortal signers of the Declaration of Independence; and in their words and noble spirit "we pledge to each other our lives, our fortunes, and our sacred honor" to the support of those ideals; and as a token of my sincerity and as evidence of my gratitude for the blessings which that noble document has afforded all Americans, I do hereby make this contribution for the preservation of Monticello, the home of Thomas Jefferson, as a national memorial to the author of the Declaration of Independence and as a patriotic shrine for the children of America.[109]

Admittance of Jefferson into the civic pantheon and the enshrinement of Monticello seemed assured, but the Democratic Party's organization around the Jeffersonian "reform" axis designated by Bowers was yet to be wholly achieved. Characterizing the Republican National Convention as a "tribute to Hamilton," Bowers focused the 1928 Democratic National Convention delegates' attention on Jefferson, arguing that to understand the conflicting views of government in his interpretation of the Jefferson–Hamilton polarity was "to grasp the deep significance of this campaign."[110]

The relatively placid convention nominated Monticello supporter Al

Smith, which would have seemed purely auspicious for the TJMF had not a vigilant press, quick to associate it with the Democratic campaign, uncovered a splashy story detailing Gibboney's dismissal of a Monticello "hostess" because she had declared to a touring party that she was voting for Hoover "because you can't trust a Catholic in politics." The article was careful to mention Gibboney's long association with the Democratic Party as a way of insinuating a partisan motive. In a measured response that would draw attention to the proper "Americanism" of disregarding religious affiliations in electoral decisions, Gibboney stated that the TJMF "would not countenance for a moment any person connected with the foundation expressing such an un-American sentiment, and particularly in the home of Thomas Jefferson, the father of religious freedom in America."[111] Nevertheless, the Democratic presidential candidate was defeated once again. This time, however, the Republican ascendancy would crash with the stock market.

▪ *"If Hamilton Were Alive": The Thomas Jefferson Memorial Foundation in the New Deal Era*

Despite its roots in Democratic electoral politics and its strong ties to the Roosevelt administration, the TJMF had shed its overtly political orientation by the end of the New Deal presidency. The germ of this gradual process was present as early as 1926, when the TJMF board of governors made the remarkable claim that "if Hamilton were alive today" he would have been a leader in the Monticello campaign.[112] In any case, the muting of the Democratic affiliation that marked the TJMF's earliest years is notable. Merrill Peterson wondered whether it was because "the public goals it sought were being realized beyond expectations, by a Democratic administration in Washington, or because the business side of this Virginia tourist attraction became uppermost, or because the American people were coming to feel that Jefferson, after all, was a museum piece."[113] It was true that by this time key fractures in the Democratic Party (over fundamentalism, the KKK, and the rural–urban conflict over Prohibition) were now on the wane, making the coalition-building function of Monticello obsolete. And, as Peterson suspected, the realization of the Roosevelt presidency made Monticello an icon of the realm.[114] Not insignificantly, moreover, the passing of faithful Democrat Stuart Gibboney in 1944 and the rise of new TJMF leadership with a different set of priorities ushered the conversion of its agenda to one centered primarily on establishing Monticello as a museum.

Before that occurred, however, the TJMF's political inflection was most ap-

parent in the connection between Gibboney and the president. FDR stayed in touch with the TJMF throughout his presidency, corresponding with Gibboney, remaining on the board of governors, and spending time at his "summer White House" at the estate of Edwin Watson, the president's secretary, on land adjacent to that of the TJMF's Monticello.[115] The omnipresent First Lady visited to study the reproduction furniture for sale in the Monticello gift shop, a subject of great interest to her in light of her own reproduction workshop at Hyde Park.[116] Gibboney thought of himself as "an enthusiastic New Dealer"; to FDR he was both a loyal supporter and "a devoted friend" who shared his desire to "perpetuate the memory of Jefferson."[117]

For example, FDR wrote to him seeking the Founding Father's sanction for what was arguably the most controversial dimension of the New Deal expansion of executive power: the "court packing" plan. In January 1936 the president asked Gibboney to hunt down references by Jefferson to the Supreme Court.[118] The TJMF archives hold a file, apparently assembled in this period, of transcribed Jefferson quotations on the subject of judicial review, including one in which he stated that making the Supreme Court justices "the ultimate arbiters in all constitutional questions" was "a very dangerous doctrine indeed."[119] For an administration besieged by judicial declarations that its key initiatives were unconstitutional, these were instrumental words. Beyond the court-packing controversy, the New Deal did succeed in advancing federal power, including the grand entrance of the National Park Service into the business of administering house museums, one of FDR's personal enthusiasms.

This particular interest made for some prickly moments between Gibboney and FDR when suggestions arose between 1932 and 1935 that perhaps the time was right for the government to step in to resolve the mortgage on Monticello and subsume it within the National Park Service. Though the TJMF welcomed specific kinds of federal help, in particular a Civilian Conservation Corps (CCC) contingent in the early New Deal years and the president's name on the letterhead, the idea of government takeover of Monticello was not well received, and Gibboney thought that intermittent murmurs about "relieving us of the care of Monticello" would not bear fruit. With "FDR on the Board," he asserted, "we don't have to worry."[120] Interest to acquire Monticello had proven keen on the part of the new historical operatives of the NPS, an interest that Gibboney successfully deflected. Early in 1934, however, an influential Jefferson descendant urged Gibboney that, with a Democratic administration in Washington, it was an "opportune time" to get Congress ("which we Republicans think may be already only too well disposed towards

Franklin Delano Roosevelt at Monticello for Independence Day festivities, 1936.
COURTESY OF MONTICELLO, THOMAS JEFFERSON MEMORIAL FOUNDATION, INC.

the President and all his works") to take over Monticello for use as a summer White House. Citing the partisanship simmering beneath the surface of the TJMF project, he said the "national shrine" concept had been too hard to "sell" for political reasons, and even the summer White House idea would have to be acted on while Gibboney's allies were in power, as he would "never get it through a Republican administration."[121] Gibboney apparently demurred. When in the following year a TJMF officer wrote to inquire whether the Federal Land Bank could loan money to Monticello and was informed that this measure was for agricultural relief only, the inquiry apparently contributed to the revival of the federal takeover question.[122] Correspondence between Gibboney and the president addressed a proposal "to purchase Monticello out of Relief Funds" originating from various quarters, notably FDR's own close associate, Secretary of the Interior Harold Ickes. Gibboney spoke firmly, saying "the Foundation is getting along very nicely" and "needed no help from the Government," though he was careful to include some of the cordial comments that pervaded their exchanges, adding "I am very proud of your remarkable accomplishments."[123]

Gibboney knew that his relationship with FDR was secure, based on a shared political philosophy both men felt was grounded in Jeffersonian principles. In an introduction to FDR's Independence Day address delivered at Monticello in 1936 (an election year), Gibboney thanked the president "for keeping green the memory of Thomas Jefferson," acclaiming in particular his devotion "to the cause of the common people whom Jefferson served and trusted." Jefferson, like Roosevelt, "his worthy successor," had "fought for equal opportunity and against all special privileges." Lest anyone should doubt the resemblance, FDR then said of Jefferson: "He was a great gentleman. He was a great commoner. The two are not incompatible."[124] But linking FDR to the commemoration of Jefferson was risky business where bipartisan congressional support was necessary. For example, in the late thirties when the TJMF became an active agent in the Jefferson Memorial project, Gibboney conducted a letter-writing campaign in which he was compelled to address the partisan issue directly. He wrote that President Coolidge had once warned him that a memorial to Jefferson "would never be erected because many narrow-minded Republicans believed that in erecting a memorial to Jefferson they would be glorifying the Democratic party, and he did not believe the Democratic party would be in power again. He stated, however, that he differed with the narrow-minded in his party and was in favor of such a memorial."[125] Philadelphia Museum Director Fiske Kimball, who was in charge of the restoration of Monticello, agreed, saying failure to approve funding for the embattled memorial would simply "play into the hands of those reactionaries who merely give lip service to democracy, who are determined there shall never be a memorial to Jefferson, and who will use any subterfuge to defeat it."[126]

The TJMF and its associates charged "narrow minded" partisanship on the part of Republican opponents to projects commemorating Jefferson, yet Gibboney served as an adviser to Roosevelt in vetting the political orientation of commission officials. Edwin Watson corresponded with Gibboney to ascertain that the appointees to the Thomas Jefferson Bicentennial Commission that Gibboney was recommending were "Democrats, all Democrats—I mean real Democrats," not, added Watson anxiously, defecting "Wilkie Democrats." Gibboney sent him a list of "good Democrats of the 1940 vintage," guaranteeing that one questionable appointee was indeed a reliable, "100% Roosevelt Democrat."[127] Yet at the same time, other members of the TJMF recognized, perhaps out of the same anxiety manifest in Edwin Watson's request for "real Democrats," that quavering approval for FDR signaled the need to diversify their base of support as the election approached. Early in

1940, for example, TJMF officer Henry Alan Johnston ferried through the nomination of Wendell Wilkie to the board of governors, telling Wilkie that "the growing wave of public opinion in your favor" represented "the good, sound common sense of the American people." One wonders how Gibboney would have reacted to Johnston's huzzah to Wilkie: "More power to you."[128]

While the TJMF continued to prosper, satisfying its mortgage in 1940, Gibboney's congressionally enmeshed Thomas Jefferson Bicentennial Commission struggled for appropriations, with opponents alleging political bias. Critics incorrectly charged that this group, rather than the Jefferson Memorial Commission (which, admittedly, shared participants), was responsible for the proposed inscriptions on the monument, ostensibly cobbled together to "make Thomas Jefferson look like a communist," or at least, one presumes, a progressive.[129] Correspondence between Kimball and Gibboney, both of whom were involved in the TJMF, the memorial commission, and the bicentennial commission, illustrates a continuing struggle to gain congressional support for the government-funded projects.[130] The lesson was clear: To associate the memorialization of Jefferson with a progressive Democratic agenda would be to make it a political football.

As the forties and World War II unfolded, Stuart Gibboney's Democratic reign was coming to a close. Advised for medical reasons to scale back on his activities, Gibboney proposed to the board in 1942 that he move the office of the TJMF from Manhattan to Monticello, where he could replace the retiring superintendent and run the foundation from tranquil Charlottesville. Besides, Gibboney explained, the wartime ban on "pleasure driving" had meant a drop in tourist-generated revenues for the TJMF, and the New York office was expensive to run. The move was opposed as grossly improper by Wilkie enthusiast Henry Alan Johnston, who lobbied behind the scenes to prevent the "books" of the organization from moving to Virginia with Gibboney. Despite the opposition, of which Gibboney may or may not have been aware, he transplanted the office and his residence to Monticello in the spring of 1943. The financial reins of the TJMF remained in New York, however, with Treasurer Frank Houston.[131]

After Gibboney's death in April 1944, FDR apparently asked Secretary of the Interior Harold Ickes (presiding over the now well-developed National Park Service) to reopen the question raised a decade earlier about the feasibility of government acquisition of Monticello. Ickes had suggested that it be designated a national historic "shrine" but not actually appropriated by the NPS because the wartime Congress did not support the authority of FDR's primary mechanism for such takeovers, the Historic Sites Act. FDR was un-

fazed, responding, "I think the property should be in the Federal Government for all time."[132] Most of the TJMF officers were undoubtedly less than pleased about the prospect of giving up governance of Monticello, since they had achieved the fulfillment of its mortgage in 1940 and were now turning a profit and enjoying the mass tourism and popular enthusiasm its founders dreamt of in 1923. And, although the site retained some of its timeworn Democratic polemical power (for example, Truman used it as the setting for touting the Marshall Plan, comparing the United Nations charter to the Declaration of Independence), by the mid-1940s Monticello entered a new phase given form by the charismatic Fiske Kimball.[133]

▪ *Professionalizing the Historic House Museum: Fiske Kimball's Monticello*

One of Stuart Gibboney's greatest accomplishments was the appointment of Fiske Kimball, a Harvard-trained architect and professor of art at the University of Virginia, to chair the TJMF's restoration committee in 1923. A recognized expert on Jefferson's aesthetic principles, Kimball would donate his services to the TJMF for thirty years, throughout his influential tenure as director of the Philadelphia Museum.[134] Although Kimball's sharply etched agenda for the development of the Monticello museum differed substantially from Gibboney's, the two men worked side by side until Gibboney's death in 1944, after which Kimball continued his work with the incoming president, New York banker Frank Houston.

It was in the early days of Houston's presidency that FDR and Fiske Kimball, from different vantage points, would attempt to pry open the door Gibboney had closed to government involvement with Monticello. When the president revived his vision of an NPS-operated Monticello after Gibboney's death, Secretary of the Interior Ickes reminded him that the full takeover he envisioned would require the acquiescence of the hitherto unwilling TJMF, "of which you are a member."[135] Kimball was approached, probably because he was well placed to negotiate from his dual positions with the TJMF and as a member of the advisory board for the National Park Service under the Historic Sites Act. In response, he offered Houston his informed opinion that FDR's idea, that the TJMF "might be persuaded" to deed Monticello to the nation, was "adverse" for several reasons:

(1) We are able to supply our whole surplus revenue to the development of this one property, whereas if it were federally owned, the receipts would go

Fiske Kimball and TJMF colleagues on the Monticello lawn. *Left to right:* Milton S. Grigg, Fiske Kimball, Frank K. Houston, Henry Johnston, and William S. Hildreth.

COURTESY OF MONTICELLO, THOMAS JEFFERSON MEMORIAL FOUNDATION, INC.

to the Treasury and have to be reappropriated by Congress to the Park Service, with every probability Monticello would fare less well financially. (2) We and our committees, who include the best experts on the architecture, grounds, and furnishings of Monticello, are able to devote our knowledge wholly to this property, whereas the staff of the National Park Service, none too numerous, has to divide its attention among many properties.[136]

However, Kimball suggested cautiously, "short of federal ownership, there are many forms of cooperation provided by the Historic Sites Act"; one might prove "advantageous." Over the course of the next year, Kimball attempted to use his influence to secure a cooperative agreement between the TJMF and the National Park Service under the terms of the Historic Sites Act. Kimball had made positive assessments of similar arrangements already in place at Independence Hall and Jamestown, and he stressed that the primary advantage would be the ability of the government to spend money on Monticello, leaving the TJMF in retention of its title and in ultimate authority. The draft contract offered funds and NPS "assistance" with interpretation, and in return the foundation would assent to consultations with the NPS director on all matters involving preservation. The agreement would be terminable by the founda-

tion after one year should it prove troublesome.[137] Even this con
worded contract unnerved TJMF officers, who apprehended that
the thin end of the wedge of government usurpation, or at the very l
an unhealthy drift toward state interference in private matters.[138] Kimball
urged that if even the Association for the Preservation of Virginia Antiquities
could enter into a government contract at Jamestown, "overcoming all their
fears of Yankee government," surely the TJMF could also do so.[139] The
board rejected the agreement, however. Although Kimball hoped that the
issue could be revived yet again, he admitted to the NPS director that, despite
his best efforts to "educate" them, the foundation officers remained reluctant,
as "men of large affairs" so often were, to permit the government to become
involved in "their concerns."[140]

Kimball's carefully reasoned arguments and his authoritativeness in dealing
with the dazzling powers of the national government reflected a formidable
personality that would shape the post-Gibboney era of Monticello's develop-
ment. When he began his work with the TJMF, Kimball was already a distin-
guished authority on early American architecture, whose scholarly writings
had rekindled respect for Jeffersonian design. Articulate, commanding, and
well-connected, Kimball embraced a position of national leadership in the
museum field. His values were clear: The period room should be more than a
romanticized, inspirational "shrine"; it should be based on sound historical re-
search to present as accurate a picture of the past as possible. Familiar as these
standards have since become, they were then part of a professionalizing trend
in the house museum movement, an innovation, and not always a welcome
one.

Two intellectual currents contributed to Kimball's orientation: a monu-
mental vision of the American Republic and a scientized historicism. These
ideas were squarely in the cultural milieu of the Progressive Era and were
manifest in his analyses of architecture and period rooms in general and
Monticello in particular. Critical of both modernism and the Colonial Revival,
Kimball celebrated Jefferson's classicism as the expression of America's native
architectural style, well suited to its place in the history of western civiliza-
tion.[141] However popular, Anglo-colonial buildings were, to Kimball,
provincial and derivative, inadequate to the "monumental requirements of a
powerful nation." The classical revival of which Monticello was a part "met a
real need in American architecture, which the naive and delicate colonial style
could never have satisfied."[142] Kimball argued that the nation must not forget
"the fundamental unity of our culture with that of Europe" but also must rec-
ognize the emergence of a classically inspired form that was "characteristically

American." Grounded in his view of the dignity and "monumentality" of the American experiment, Kimball's aesthetic vision was Progressive in its attempt to link architecture to politics via rationality rather than sentiment, classicism rather than romanticism.[143] He met with considerable criticism of his interpretations, in the context of early-twentieth-century "culture wars" between impassioned Colonial Revivalists and self-satisfied modernists. Yet it was Kimball's tone of complete scientific objectivity that lent credence to his arguments. Commentators noted the absence from his work on colonial architecture of the usual "emotional bias" and "patriotic prejudices."[144] Like Henry Adams and others of his ilk, Kimball gained enormous authority in his well-informed opinions through his adoption of the "German method" of "objective" historical research.[145]

Kimball's approach contributed to an attitude toward the house museum differing markedly from, for example, the voluntarist women of the nineteenth-century MVLA (and even from Stuart Gibboney's spirited boosterism). Kimball's influence over Monticello and the field as a whole reflected an uneven though palpable mid-twentieth-century trend in which voluntarists, mainly women, were replaced in positions of leadership by professionals, mainly college-educated men. The complex workings of this trend are illustrated in part by Kimball's battle with chronic criticisms by traditional museum constituencies of Monticello's period rooms as "too bare" or "unhomelike" in contrast with other house museums less wedded to the concept of historically accurate refurnishing.

Monticello became a museum in the wake of R. T. H. Halsey's 1924 Metropolitan Museum period rooms. Kimball had been invited to give a lecture series on colonial architecture at the Metropolitan in the early twenties, and when he assembled a committee to restore Monticello's interior in 1925, he enlisted Halsey. Halsey's influence, along with that of German period rooms and more populist forms such as those at the Philadelphia Sesquicentennial, sharpened Kimball's thoughts about the social function of the museum.[146] Though often idealistic, he was fascinated by popular taste and his observation that the public, which " 'knows what it likes,' actually likes what it knows."[147] Kimball playfully characterized the vagaries of uneducated taste, saying, "It is a commonplace of the history of culture that each generation detests the art of its fathers, hesitantly tolerates that of its grandfathers, and takes into its bosom that of its great-grandfathers, which henceforth becomes part of the accepted canon of artistic propriety."[148] If a period room was liked, the public deemed it "the bright harbinger of the better things of our own enlightened day." Of course Kimball was less detached about his own opinions, con-

sidering them based on refined, objective judgments. It was this studied reaction, rather than the grosser popular form he parodied, that Kimball hoped his period rooms would produce. The period room (rather than either purely artistic display or exhibits organized by materials preferred by collectors and students of design) was especially well suited to elevating the public's capacity for refined judgment, revealing associations between things in a setting "equivalent to the one they had in their own day" to supplement "the joy of seeing" with "the joy of knowing."[149] Museums, Kimball suggested, should cultivate a varied audience including the connoisseur, the historian, the student of industrial processes, and—importantly—the public at large, to "recognize the diversity of the public, of its aims, and of values. The museum building itself must not be merely an assemblage of neutral and echoing halls; it must become an organism receptive to manifold functions and having a living body to house the varied life of the spirit."[150] Kimball defined a social role for museums serving a republic the Founding Fathers asserted was dependent on an educated citizenry.

Kimball's restoration and furnishings policy for Monticello was derived from these ideals and from a deep veneration for Thomas Jefferson. His Harvard training in research and analysis was deployed scrupulously in furnishing period rooms only with pieces proven to be associated with Jefferson. This policy clashed with the received popular standards for house museums, which dictated that they should appear "homelike" and that Monticello as an evocative "shrine" would above all be "a human thing, no cold, impassive pile of marble."[151] Yet since Kimball was "unalterably opposed" to using reproductions or period pieces without a Jeffersonian provenance, the house appeared "unhomelike," "cold," "museumlike," or, as Gibboney described it, simply "bare."[152] Kimball nonetheless was prepared to encounter opposition to his professional standards. When Gibboney allowed Jefferson's bedroom to be decorated with non-Jefferson furniture, Kimball opined that it was, in fact, "wretched stuff." Knowing how to motivate Gibboney, self-selected guardian of Jefferson's historical image, Kimball foreboded that the "gilt bed and valances by no means [should] be allowed to remain. The comparison of these with certain charges from the right and left, to people who may innocently believe them part of the original furnishings may give color to the old charges of Jefferson's licentiousness. Do get them out at once."[153] And to descendants of Uriah Levy, who pleaded with Kimball to allow portraits of Uriah and Jefferson Levy to be displayed as "an act of justice to the men who restored and preserved Monticello for ninety-seven years," he did not equivocate.[154]

Gibboney approved of the way in which Kimball had approached furnish-

"with only Jefferson pieces," but he did wish Kimball would
[f]lexibility with the second, and soon the architect's rigidity
[c]ontention. For example, in 1925 Gibboney wanted to permit
[] Hoes, a Monroe descendent and one of the leaders in the
[] the Monticello crusade, to furnish a "Monroe Room" up-
stairs. Possibly, Gibboney had suggested with little sense of irony, there could
also be a John Quincy Adams room. Kimball complained to Halsey that al-
though Monroe had often visited, he could not, after all, find that "any room
was known by his name." An Adams room, he added wryly, "seems to me
rather out of place." Halsey certainly reinforced Kimball's will that nothing
should go into the house without his explicit approval, and that there was
"great danger" in allowing anyone else to furnish "even a bedroom," but he sug-
gested that Kimball loosen his policy of not using period pieces.[155] Halsey
proposed, "As the real Jefferson articles come to you they can replace those
previously installed for the purpose of furnishing. There is a good deal of com-
plaint in the neighborhood of Charlottesville that nothing is being done to
make the house look livable."[156] These complaints persisted throughout the
1940s, with Kimball generally holding firm, although by 1944, a "Monroe
Room" was being composed under the supervision of Kimball's wife, Marie,
who was appointed curator in that year.[157]

The appointment was not mere nepotism. Marie Kimball was an educated,
capable scholar of history in her own right, and her correspondence in general
and writings on the furnishings of Monticello in particular reveal a thoughtful
adherence throughout her tenure to the policies instituted by her husband
decades before, with only one conservative change early in 1946 allowing for
the purchase of pieces documented to be similar to those at Jefferson's Monti-
cello when the originals were not available.[158] In the absence of the profes-
sional Marie Kimball as curator and the enthusiast Gibboney (whom Fiske
Kimball probably saw as somewhat of a loose cannon), it might be tempting to
reduce his professionalizing authority to simple sexism or to interpret its rocky
induction as a gender-based conflict of cultures. But Fiske Kimball's chronic
clashes with women voluntarists and his disagreements with Gibboney un-
derscore the complexity of the professionalizing process in the house mu-
seum. Although he railed against the garden-club women for their less-than-
accurate plantings and floral decorations in "cheap china-store stuff,"
declaring in partial jest, "Ain't wimmin awful," he also worked closely with
Marie Kimball on projects requiring her expertise and research skills.[159] For
example, they jointly took on the "ladies'" criticism of their reproduction of
Jefferson's library curtains. Despite the fact that the Kimballs constructed an

exhibit detailing the historical evidence validating the design, a controversy over the purported unsightliness of the curtains ensued.[160] Comparisons between the Kimballs' exacting administration and the more familiar voluntarist style, clearly associated with women, were often made. One critic charged that the "comfortable" atmosphere lacking at Monticello could be produced by "any good committee of ladies" as "they have at Mount Vernon." Another urged that the "colored men" who gave tours of Monticello should be replaced by the more usual "cultured ladies," to which Fiske Kimball replied that he'd had rather bad luck with them, elaborating "witness thus recent unbridled attacks on the restoration of Jefferson's curtains." "Indeed," he added, "I think it is fair to say that everything the Foundation has done at Monticello has been the subject of constant local opposition from the good ladies . . . leading me in one famous instance . . . to forget politeness."[161]

The type of personal politics Kimball bemoaned was a hallmark of the professionalization of the historic house museum early in the twentieth century. His end of the argument represented a change in mode that was coterminous with the entrance of college-educated men into a field formerly defined by voluntarist women. Yet the case of Monticello demonstrates that the central feature of the process may not have been simply clashing values arising from gendered "separate spheres," as Lindgren has suggested, or, as Hosmer posited, that women were just not interested in the newly professionalized field without the patriotic enthusiasms characteristic of the early movement.[162] As male and female proponents of the house museum navigated the complicated manifestations of early-twentieth-century gender ideology, they found interests and values in conflict, and also in common. However, women's educational and professional qualifications lagged decades behind, making it difficult for them to compete with men for positions of leadership in the redefined movement. Indeed, the march toward male domination of the field was inexorably on, toward the fulfillment of Maud Littleton's Progressive Era vision of active government participation in the historic house museum movement.

Costumed rangers interpret the reconstructed kitchen cabin at Booker T. Washington National Monument. COURTESY OF THE NATIONAL PARK SERVICE, BOOKER T. WASHINGTON NATIONAL MONUMENT.

Chapter

"The Bricks of Compromise Settle into Place"

Booker T. Washington's Birthplace and the Civil Rights Movement

The practical and ideological success of the TJMF's Monticello set the stage for an extraordinary transformation in the historic house museum movement as the Democratic Party ascended to the presidency in the New Deal era. Booker T. Washington's birthplace became a National Park Service site in the wake of the government's widely expanded role in the creation and interpretation of historic house museums during the 1930s.[1] The influx of federally sponsored professionals alone was significant. As Charles Hosmer puts it, "Because the federal programs focused on hiring personnel from professions that had traditionally included few if any women, the new generation of preservationists was overwhelmingly male."[2] And, although the National Park Service history program was established in a spirit emphasizing popular access to conventionally "patriotic" historic sites, the idea of a government policy supporting a more democratically representative history gradually emerged in sharply political contexts.

A New Deal for Popular History

In 1931, NPS Director Horace Albright hired the agency's first historian, the aptly named Verne Chatelain, to develop the federal government's early policies for the acquisition of house museums and historic sites. Chatelain and a committee of Park Service staff proposed to Albright that the government agency begin to "actively advocate, investigate and promote a proper national

historical policy" to identify sites "pertinent to the development of the Nation." Chatelain is credited with the idea of basing the acquisition and interpretation of NPS sites on a system of "broad themes" of "national significance," an overarching model that shaped the current federal system of historic sites.[3] These standards were established with the intention of ensuring the professionalism and cohesion of the new national historical program by preventing the influx of "insignificant" sites. However, as we shall see, they were easily invoked or ignored in favor of the potential political utility of historic sites in the National Park Service, for better or worse an agent in the development an official historical canon.

The power of the National Park Service was eventually expanded by an act of Congress signed by outgoing President Hoover in 1933. Franklin Roosevelt's Executive Order 6166, streamlining federal bureaucracy, transferred all sixty federally controlled parks, monuments, cemeteries, and battlefields previously administered by the War and Agriculture Departments into the Department of the Interior's National Park Service.[4] Secretary of the Interior Harold Ickes worked to restore public confidence in the department still sullied by earlier controversies (including the Ballinger–Pinchot affair and the Teapot Dome scandal). Guided by an enthusiastic chief executive, Ickes's term saw the areas administered by the National Park Service more than double.[5]

The New Deal's response to the economic crisis of the 1930s was a boon to historic house museums and to historic preservation generally, concentrating the attentions of unemployed architects and historians on crumbling historic buildings. The Civilian Conservation Corps hired young professionals as "cultural foremen" or "history assistants" to work for the budding NPS history program.[6] In 1934, the Historic American Buildings Survey (HABS) cooperated with the American Institute of Architects to hire more than a thousand architects through the Civil Works Administration to document deteriorating American buildings. The HABS drawings and the Works Progress Administration (WPA) guidebooks of the Federal Writers' Project directed community attention to architectural and historical landmarks, often providing the basis for later preservation efforts.[7]

The federal government's history program was further expanded by the passage of the milestone 1935 Historic Sites Act, which strengthened the ability of the NPS to acquire buildings and sites determined to be of "national significance."[8] The Historic Sites Act had been inspired by the enormous success of Rockefeller's Colonial Williamsburg and was vigorously supported by Kenneth Chorley and his Williamsburg staff.[9] It was Rockefeller who funded

the influential *Report to the Secretary of the Interior on the Preservation of Historic Sites and Buildings*, requested by Ickes early in 1935. The report pointed to millions of yearly visitors to hundreds of house museums and bemoaned the small role that the national government was playing in the phenomenon. Comparing the history programs of governments such as those of as Great Britain, France, and Germany, the report argued that the United States had an inadequate national history policy and recommended the passage of new legislation expanding the power of the National Park Service to acquire historic sites and to initiate a federal program of historical education based on these resources.[10]

New Deal arguments for expanding federal interest in historic sites emphasized the need to protect historic buildings from destruction at the hands of business, a goal linked to the longstanding value placed on the utility of historic "inspiration" to the achievement of national goals. The Rev. W. A. R. Goodwin, founding activist of Colonial Williamsburg, captured the spirit of FDR's Second Hundred Days by testifying before Congress on behalf of the Historic Sites Act. Goodwin claimed that only the federal government had the power to stave off the ravages of commercialism: "Commercialism is like the car of the Juggernaut ... because it goes where it wants to go. It has no vision in the sense of an appreciation of these historic values, and no matter what is in its way, it must get out of the way. That destruction will occur unless there is some guard provided for these priceless things."[11] Goodwin further claimed that "the historic assets of this country are of more worth to this Nation financially and sentimentally than are the assets of any other one industry."[12]

The Historic Sites Act was an appropriate addition to the Second Hundred Days in several key respects. The argument for the need to protect historic "shrines" through the creation of organizations with enough power to counter the destructive potentials of laissez-faire commerce had been fully articulated in the Progressive Era. The Second New Deal's legislative response to many of "the social issues that had been the concern of Progressives since the beginning of the century" was a fitting context for the definition of a national public policy for historic preservation.[13] The careless disregard of business for anything but profit was identified as the primary enemy of historic sites of "national significance," and the Historic Sites Act was consistent with the Roosevelt administration's disenchantment with "economic royalists" in the Second New Deal. Further, the Historic Sites Act enabled FDR to cloak the leftward bent of the Second Hundred Days in American history, in efforts to set his policies apart from more radical political elements that were gaining

popularity.[14] Using language echoing that of Justice Rufus Peckham in *United States v. Gettysburg Railway,* Roosevelt urged passage of the act: "The preservation of historic sites for the public benefit, together with their proper interpretation, tends to enhance the respect and love of the citizen for the institutions of his country, as well as strengthen his resolution to defend unselfishly the hallowed traditions and high ideals of America."[15]

The original bill that became the 1935 Historic Sites Act called for a survey of potential national historic sites and for cooperative agreements between government and private organizations for the preservation of historic buildings. That these provisions produced little debate demonstrated the success of the historic house museum movement in establishing its social and political role. However, section 2(e)—granting the secretary of the interior the ability to deploy eminent domain—sparked considerable disagreement, harking back to the dispute over Monticello earlier in the century and reflecting concern over FDR's attempts to expand executive power. By 1935, Congress was more accustomed to using the right of eminent domain than it had been in Maud Littleton's day but resisted granting this power to an executive official. Ickes argued that the bill would enable the National Park Service "to work much more rapidly than has been the case in the past." Chatelain concurred. Such rapidity of action would be a useful part of a national planning program designed to "save the old while developing the new," in step, certainly, with the New Deal. "Modern industry," Chatelain warned, "is practically wiping out all traces of the old."[16] Such warnings advanced support for the bill but, after lengthy debate, Congress declined to give the secretary of the interior the power to assert eminent domain. House museums and other sites would continue to enter the national system by gift, purchase, or when Congress defined a "public use" for a property under the Fifth Amendment.

The path of the Historic Sites Act had been smoothed by the popularity of several pre–New Deal government historic properties, such as the Morristown and Yorktown sites of the early thirties. George Washington Birthplace National Monument was considered a particular success, despite the fact that the popular 1932 "replica" of Washington's boyhood home was entirely spurious.[17] The abundant enthusiasm of the National Park Service for acquiring eastern historic sites was in part a strategy for acquiring along with them the support of eastern members of Congress, as well as a desire to have the federal government "move as an equal partner with the Rockefellers in Williamsburg."[18]

Chatelain planned that New Deal NPS properties would "recreate for the average citizen something of the color, the pageantry, and the dignity of our

national past."[19] Later he reflected that at this crucial phase he "could not turn to agencies like the American Historical Association and get any good ideas," leaving him to rely on models developed by "Great Britain, France, and to some extent Germany."[20] To implement his goals, Chatelain hired young historians fresh from graduate school and made key acquisitions, such as Hopewell Village in Pennsylvania, an eighteenth-century iron-producing community, and Salem Maritime National Historic Site.[21] FDR himself regularly got into the act, for example pressuring Ickes and Congress into accepting a donation of the ostentatious Frederick Vanderbilt house adjoining his own Hyde Park estate, having dissuaded Vanderbilt's niece from accepting an offer to purchase the mansion from the Harlem-based church of Father Divine.[22]

While the federal government's holdings in historic house museums grew, private projects managed to struggle on through the hard times of the thirties as interest in historic house museums escalated. Many historical societies previously oriented toward collecting and publishing documents now opened their own house museums.[23] In the Depression years, May Lanier and the Connecticut chapter of the Daughters of the Confederacy launched the "last great national campaign modeled on the Mount Vernon crusade" to make a house museum of the Robert E. Lee birthplace, Stratford Hall, finally opening it to the public in 1935.[24] At the dedication ceremony, Lee biographer Douglass Southall Freeman praised the women of the Robert E. Lee Memorial Association: "Two hundred and fifty thousand dollars have been raised and paid during a period when the heat of adversity has dried up many of the fountains of beneficence. . . . There could have been no more positive evidence of your conviction that our age is not breaking with the past, but is making the past a part of our inspiration for the future."[25] The museum successfully contested a takeover attempt by the federal government, as had the Mount Vernon Ladies' Association, whose house museum now boasted an annual attendance of half a million people.[26]

The expansion of the house museum movement prompted the publication of the first monograph on the subject in 1933. Laurence Vail Coleman reported on the state of house museums in America, arguing for "greater uniformity" in their management. He explained that in New England, for example, they were administered primarily by historical societies, in New York by the state, and in Pennsylvania by cities. National ownership was at that time a "new development," but Coleman envisioned a standardized "country-wide system of national historic houses."[27] He stated unequivocally that "the influence of these museums is great," and asserted that "historic houses have brought out a

new duty of the state," voicing the growing acceptance by the public of the government's appropriation of previously voluntary activities.[28]

The benefits that historical exhibits could offer the state did not go unnoticed or unexploited. In 1935, Arthur Parker's *Manual for History Museums* praised the potency of one exhibit in Rochester, New York, called "The Shrine of the Citizen": "It outlined the obligations of the citizen and pointed out his duties and his highest rights. It depicted the scene of the signing of the Declaration of Independence, and, as allegory, displaying an altar of Liberty upon which rested the Constitution. . . . That this allegory had meaning that registered was proven by the fact that men wearing hats took them off when they approached it, and several women knelt in prayer before it."[29]

Other museum professionals of the thirties were critical of such uses of history, linking emotionally wrought exhibits with a "patriotic prejudice" arising "to the general detriment of society." Evidently commenting on transatlantic developments, T. R. Adam of the American Association for Adult Education shrewdly observed in 1937, "The totalitarian implications . . . are worthy of note; it is precisely these undisciplined emotional forces that lead to the mass hysteria of state worship."[30]

Military mobilization after the attack on Pearl Harbor drained the budgets and reduced the staff of federal history programs. The war-saturated ideological climate and the growing imperative for public and private historic house museums to justify their costs led many to spotlight the long-standing claim that they inspired patriotism. The American Association of Museums passed a resolution in December 1941 committing museums to "fortify the spirit on which Victory depends."[31] Colonial Williamsburg was used as a site for "wartime orientation." One soldier wrote, "Of all the sights I have seen and the books I have read, and the speeches I have heard, none ever made me see the greatness of this country with more force and clearness than when I saw Williamsburg slumbering peacefully on its old foundations."[32]

After the war, budgets slowly increased, but the defensive posture assumed by history museums left its mark. The marginalization of the NPS as a nonessential element of the federal bureaucracy prompted this justification: "The individual citizens faced by a troubled world turned in the moment of national danger to the national historical parks and shrines for a renewal of their faith in their country's traditions and their country's destiny, for encouragement, and patriotic inspiration. Many people seemed desirous of reconsecrating themselves to the ideals for which this country stands by direct emotional experience on soil made sacred by the heroism and unselfish patriotism of our forefathers."[33]

The prevailing wartime declaration of the political usefulness of museums inspired Theodore Low to remove the formal fig leaf behind which some museums had hidden their political agendas and suggest that these agendas be openly debated and refined. His 1942 *The Museum as a Social Instrument* criticized any museum attempting to distance itself from engagement in political and social issues. Low argued that the function of the museum was not to preserve rarefied aesthetic and historical artifacts and ideas, thereby offering "inspiration," but rather to assist in the direct resolution of pressing social problems. He suggested what the future role of museums might be if they became self-conscious "social instruments": "The museum's task lies in preparation for the peace to come. It is then, in a world which we hope will be more ready to understand the problems of others, from nations down to individuals, and which will be searching for ways to make "peace" a word having real and lasting meaning, that the museum can assume a leadership benefiting its position."[34]

These high hopes for the peacetime public role of museums ran headlong into the defensive mentality of the cold war. Kenneth Chorley of Colonial Williamsburg lobbied in 1948 for increased funding of the national Yorktown site by defining a "Truman Doctrine" for history museums: "There was never a time in the history of this country or in the history of the world when freedom and human liberty were as important as they are today. The citizens of the United States, and in fact the citizens of the world, need a rededication to the principles of freedom and human liberty. . . . The area embracing Jamestown, Williamsburg, and Yorktown provides a responsibility and challenge to carry this message forward which is without parallel anywhere in our country."[35]

Cold war prosperity also ushered in a building boom, activating preservationists to develop their own containment strategies designed to block the destruction of architectural resources. The weakening of the National Park Service during the war hampered the federal government's ability to respond, despite the Historic Sites Act. The gap was filled by a private organization able to move quickly in cooperation with federal and state preservation agencies. The National Trust for Historic Preservation was granted a congressional charter in October 1949. Underwritten by the nation's wealthiest families and conceived of by museum professionals, the National Trust advocated federal legislation to protect threatened buildings and initiated its own collection of historic house museums. The trust accepted only those properties that came with an endowment, so the buildings it acquired were almost exclusively mansions.[36]

The forties also saw the continuation of the trend initiated by Rockefeller

and Ford in the establishment of a number of corporately sponsored museum villages, which Michael Wallace describes as the "Corporate Roots Movement." For example Stephen Clark of the Singer Sewing Machine Company created the Farmer's Museum in Cooperstown, New York, memorializing early-nineteenth-century rural life. As Wallace explains, it "projected a sentimentalized portrait of the past and celebrated the transcendence of primitive living conditions."[37] Similarly, Albert Wells of the American Optical Company was developing his fictional early-nineteenth-century Massachusetts settlement of Old Quinebaug, later renamed Old Sturbridge Village, "to preserve the ever-good things of New England's past." At the same time, the recreated village was intended to demonstrate "how virtues and ideals expressed in them can be applied to life and work today." Wells hoped "the young man, training for an industrial job, will have the chance to work in the village under the guidance of craftsmen skilled in early New England crafts, and he will learn by actual experience the background of our industrial history. . . . When the young man is at last placed in an industrial job, he will realize that, as an individual, he is taking part in carrying on a fine inheritance. He will understand, too, how modern industry assures a life far more abundant than what existed under a handicraft system."[38]

Other such villages being developed in the forties included Mystic Seaport, Plimoth Plantation in Massachusetts, the Shelburne Museum in Vermont, and the restored Old Deerfield Village in western Massachusetts, where Henry Flynt claimed to have established "a monument to our ancestors who have inculcated good ideals and have been a source of strength to us."[39] Museum villages, supported by throngs of motorists, were so celebrated in the early cold war era that by the time the Eisenhower administration came to power, Colonial Williamsburg, purged of references to its enslaved population, was "a semiofficial auxiliary of the state," to which visiting international dignitaries were brought for insight into America.[40]

▪ *George Washington Carver National Monument and the Desegregation of National Memory*

It was also in this period, however, that an early milepost of a limited diversity in historic preservation appeared, closely linked to the growing need for parties in power to court the political loyalty of African-Americans and paving the way for the federal government's commemoration of Booker T. Washington's "birthplace cabin." Early in 1943, legislation to make a "national shrine" of the birthplace of George Washington Carver in Diamond, Missouri, was in-

troduced by Dewey Short and Harry Truman to a receptive Congress.[41] The overwhelming support for creating the memorial was notable, considering that nonessential domestic expenditures were being diverted to military projects.

The context for this support lay in wartime race relations and the increasingly organized political power of African-Americans. It was obviously crucial to engage black workers and soldiers in the war effort. Yet the depth of discontent with the government's Jim Crow employment policies was made clear to the Roosevelt administration by the threatened 1941 march on Washington organized by A. Philip Randolph, which resulted in speedy federal action to alleviate discrimination in defense jobs. The expanding National Association for the Advancement of Colored People (NAACP) and the Congress of Racial Equality, the latter established in 1942, were among the organizations now positioned to voice African-American soldiers' resentment of the abuse they endured in military service and at home. As Richard Dalfiume points out, "The hypocrisy involved in fighting with a segregated military force against aggression by an enemy preaching a master race ideology would become readily apparent to black Americans."[42] By late 1943, the War Department had begun to pursue good relations with the black press, although the effect on military policy was as yet negligible.[43]

The African-American "Double V" campaign for racial justice was a compelling cause. Harvard Sitkoff explains, "Never before in American history had Negroes been so united and militant."[44] Since African-Americans had migrated north for defense jobs, they began to constitute a recognized swing vote in a number of cities. The shift of black voters away from the party of Lincoln began in the early New Deal, which in turn sparked both a concern in Democratic leaders for retaining this constituency and the rise of leaders possessing a degree of genuinely raised consciousness. Ickes (head of the Department of the Interior and therefore of the National Park Service from 1933 to 1946) had been active in the NAACP. His public gestures included patronage appointments to African-Americans and efforts in behalf of Marian Anderson's performance at the Lincoln Memorial after she had been refused Constitution Hall by the DAR.[45] Yet some remained leery of Democratic and Republican measures to garner "Negro support." Ralph Bunche openly worried that "the black vote can be traded for improved facilities and services."[46]

Truman's argument for the establishment of the first national memorial to an African-American was based on a celebration of Carver's dream of reforming the oppressive system of one-crop tenant farming in the South. This may well have been a tacit defense of controversial New Deal agricultural poli-

cies (which limited cotton production with disastrous effects for black share-croppers); Truman offered detailed criticism of the oppressive system rather than acknowledging government responsibility for its victims.[47] The numerous letters of support sent to Truman from black leaders nationwide attested to the proposal's political expediency, particularly to a senator heavily dependent on the black vote.[48] Likewise, support from the press was wide-ranging. Calling it a "gracious gesture," the *Richmond Times-Dispatch* had said that the idea deserved "national support." The *New York Times* editorialized, "Amid so many disagreements and so many controversial measures, this bill stands out as one about which there can be no just difference of opinion. . . . In making the plantation where he was born a national home Congress honors not only the material advantages which his work has brought and will bring about. It honors a man of science who has brought honor on his nation. . . . Surely no other of all our wrestlers with iron fortune had a harder start."[49] On the heels of the Depression, Carver was recognized as exceptional for his rise from poverty despite colossal social and economic impediments. Paradoxically, he was also put forth as "a symbol and proof to minority groups everywhere that democracy works."[50]

It was this argument that formed the core of the most potent rationale for the establishment of the memorial as "a contribution to Negro morale in the war."[51] Its proponents considered it "a war measure designed to furnish a worldwide symbol of racial goodwill . . . and a partial refutation of the most damaging accusations the Axis has been able to level against us in this war—charges relating to our treatment of the Negro." A letter of support to Senator Truman read, "at this time of public tension between the races, it will help to assert the bonds of common citizenship and common humanity." Another said that the "Negro people the country over would construe the passage of the bill as simply being democracy in action; a democracy, after all, worth fighting for and even dying for that it may forever be preserved." W. O. Lewis of the Baptist World Alliance concurred that the monument would "promote better relations between Negroes and whites," and Mary McLeod Bethune pointedly stated, "This memorial commemorating the achievement of a Negro will serve as an additional link in bringing about the unity in America which we are fighting for abroad." A petition of support included the signatures of Franz Boas, Hugo Black, Albert Einstein, Theodore Dreiser, Walter Lippmann, Thomas Hart Benton, and, notable for his part in the plan to march on Washington, A. Philip Randolph.[52]

A key figure in the success of the lobbying effort was a white southerner and professor of social sciences at Washington University whose specialty was race

relations. Richard Pilant wrote more than seven hundred letters to legislators and other government officials on behalf of the Carver Memorial Association, the objective of which he identified as the promotion of "interracial understanding." He explained, "Having been born blind and refused by all the services, this has been one way in which I have sought to serve my country," arguing that a memorial to Carver would be the first in "world history consecrated to race peace." Such a commemoration would be a direct challenge to racists because "Negroes distinguished in music, athletics, and literature are all lumped as possessing 'natural' talent, whereas Carver as a scientist . . . threatens their notions of race inferiority." Pilant, perhaps aware of the usefulness of placating white southern Democrats in the Rooseveltian coalition, also testified that there was widespread southern support for the monument, claiming, "This is no New England abolitionist Society."[53]

By 1943, Congress had few qualms about using the power of eminent domain to acquire the Carver birthplace if Ickes was unable to obtain it "at a reasonable cost."[54] Apparently Ickes supported the inclusion of the memorial into the NPS, despite the fact that it did not meet agency standards mandating that the site possess substantial material remains of Carver's life, and despite arguments that Tuskegee or perhaps a scholarship fund would be a more appropriate monument than the site of a slave cabin. One reader responded to the *Times* editorial by contending Carver would not have wanted "curious tourists [to] visit his obscure birthplace, which meant so little to him in his life."[55] It was true that Carver had already created his own museum in 1939 at Tuskegee, featuring his scientific achievements as well as his paintings, and Henry Ford had reconstructed a Carver cabin at Greenfield in 1942.[56] The Democratic administration's determination to establish a national Carver memorial of its own suggests the desire to win the political endorsement of the black community. The bill passed in July 1943, in a summer marked by violent racial conflict.

Carver was by this time a mythological figure, and as such he meant different things to different people. African-Americans celebrated his scientific achievements, which, though important, were often exaggerated.[57] In fact, the interpretation of Carver's career caused problems for the National Park Service when research by University of Missouri scientists failed to substantiate many of the scientific discoveries popularly attributed to him. The research was kept under wraps by the NPS for fear of alienating the African-Americans the site was designed to please. Nonetheless, to many the fact of a national monument to an African-American seemed just and overdue.[58] Yet although some wished to memorialize Carver's achievements in the context of the in-

credible odds against him, the Carver myth also had a different, more menacing, dimension: "As each new group or cause adopted Carver as a symbol, the mythology was expanded. In the end he was credited with almost singlehandedly remaking the South and being the world's greatest chemist, while remaining a humble old black man who looked to God for inspiration, meekly accepted segregation, and proved that merit was rewarded in the American economic system."[59]

It was early in 1944 when Ickes wrote to Carver monument advocate Richard Pilant at Hull House that the National Park Service had been unable to purchase the birthplace "at a fair price" and that it would indeed be necessary to go forth with condemnation proceedings pending a congressional appropriation. A few months later, Pilant was informed that no provision of funds had been made because Congress had determined that the memorial had "no connection whatever with national defense and the war effort."[60] Finally in 1948 the government filed its petition of condemnation. Congress's apparent insistence on the necessity to establish a historic site's immediate ideological utility as a prerequisite for funding would carry over to the cold war era, instituting a motif for the site as it struggled for resources. Although Pilant continued to refer to it as a memorial "dedicated to interrace peace," he also argued that it was "part of the psychological defense of our nation and of the free nations."[61] Park Service historians claimed the site as a "dramatic example of the American Democratic Faith," adding, "Patriotism is nurtured by the vital growth of noble traditions."[62]

When the newly designated monument was in limbo because of the lack of appropriations for condemnation and operating funds, an alternative advocacy group to Pilant's Carver Memorial Association stepped in to bridge the gap. Late in 1949, the George Washington Carver Memorial Foundation, led by an African-American, Sidney J. Phillips, and chartered by the Missouri legislature, began operating the memorial as a "model farm" and undertook a highly successful publicity campaign on behalf of the underfunded site.[63] Phillips appointed a fellow Tuskegee Institute graduate and one of Carver's former students, B. B. Gaillard, to share his collection of Carver artifacts with the public and to run the farm in demonstration of some of the agricultural principles espoused by Carver. Gaillard's administration was praised initially by the NPS.[64] But the Phillips-led group would become the target of significant opposition from within and without the black community.

The most obvious source of resentment came from Pilant and his Carver Memorial Association, which had been largely responsible for the establishment of the memorial in the first place. Pilant's vision of the political niche he

A young Sidney J. Phillips consults with his mentor, George Washington Carver, at Tuskegee Institute. COURTESY OF VIRGINIA P. RONEY AND BETTYE P. DANIELS.

hoped the monument would fill was very particular. "We have international organizations to promote peace, and science, and religion, but as yet we have no international organization to promote interracial understanding."[65] Conceiving of the memorial as the hub of American leadership in "interrace peace (both races)," Pilant struggled unsuccessfully to orient the site's development. Tensions were clear in Pilant's correspondence with Secretary of the Interior Douglas McKay discussing his invitation, apparently by Phillips, to be the keynote speaker at the site's dedication ceremonies in 1953. In obvious competition with the Phillips group, Pilant described himself as the "originator of the idea" who had done an "unobtrusive job" without a "high-priced publicity machine." Pilant received a rather terse and certainly unsatisfying response, thanking him for his "interest" in the site, informing him that the ceremonies were being run by Sidney J. Phillips, and adding that Secretary McKay hoped that Mr. Pilant might "also be in attendance."[66] Undaunted, Pilant responded by thanking McKay for accepting "our invitation" and then coaching him that his dedicatory speech should "serve as a proper occasion to call the attention of the world to the fact that the United States is no longer justly the target of world criticism for its treatment by and large of the Negro." And in a "last

Secretary of the Interior Douglas McKay at the 1953 dedication ceremony for George Washington Carver National Monument. COURTESY OF THE NATIONAL PARK SERVICE, GEORGE WASHINGTON CARVER NATIONAL MONUMENT.

minute effort to clear up the situation" of the relationship between the Pilant and Phillips organizations, he added that "we do not want a Jim Crow National Monument or Negro colony in our midst."[67] Phillips had made clear in a news release the previous year that his organization hoped that blacks would eventually fill all of the positions at the new national park.[68]

Meanwhile, rivalry over the Carver legacy was brewing on another front. A powerful board member of the Carver Foundation at Tuskegee made note of the large congressional appropriation finally made to the site and suggested that "a bet has been missed if the Foundation doesn't see where it can figure in," worrying that the Phillips group would "despoil everything which Tuskegee has a right to."[69] Correspondence between Claude D. Barnett of the Associated Negro Press and F. D. Patterson, president of Tuskegee, reveals a rivalry between Tuskegee and the seemingly entrenched Phillips group over the right to the Carver heritage. This battle became so bitter that Barnett began to pursue means to expel Phillips. He suggested that if Tuskegee couldn't administer the site's funding directly, then "it really would be well to dig up the white man

[i.e., Pilant] who actually deserves the credit for starting the whole thing. . . . [I]f he worked in close harmony with or under the direction of Tuskegee, it would be fine."[70]

Pilant could hardly have hoped for a more effective ally. Access to the Carver archives at Tuskegee was blocked to anyone thought to be associated with Phillips. Soon Barnett congratulated Pilant on being named the site's curator, and within a couple of years, Phillips's staff had been removed despite their previously acknowledged competence and their wish to be retained when the Park Service took over.[71]

■ *Up from Slave Cabin: Sidney J. Phillips Reconstructs*
 the Booker T. Washington Birthplace "Shrine"

What explains the intensity of the attack on Phillips's George Washington Carver Memorial Foundation? The answer lies in the history of the Booker T. Washington National Monument, with which the George Washington Carver National Monument became intricately bound. Early in 1946, Phillips issued a formal announcement of the establishment of the Booker T. Washington Birthplace Memorial, acquired, he said, "by graduates, former students, former workers at Tuskegee and Hampton Institutes, and friends of Booker T. Washington."[72] In fact, late in 1945, Phillips had become temporary owner in deed of the property he purchased at auction, bidding successfully against the Negro Organization Society, an extension of Hampton Institute founded in 1909 "to wage an unceasing campaign for better homes and better morals" by convincing rural blacks to "apply themselves to the sanitation and embellishment of their homes." Barnett's Associated Negro Press (ANP) reported that Tuskegee, though not bidding directly, "looked with favor upon the effort of the Negro Organization Society to obtain the site" to be developed as "a shrine."[73] An article in a Virginia paper provides an eyewitness account of the confusion at the auction over who Phillips was and why he was able to resolve the bidding so rapidly: "Phillips . . . said he was a newspaperman . . . , an educator, a graduate of Tuskegee, and represented over four and a half million Negroes of religious organizations. Few of the churchmen at the sale knew Phillips."[74] The reporter maintained that Phillips had appeared earlier, claiming to be with the press in order to find out what the Negro Organization Society could afford to bid; at the auction Phillips ran the bidding quickly up beyond this point, arousing suspicious "talk among the crowd."[75]

Despite the reporter's apparent doubts, Phillips was indeed a distinguished graduate of Tuskegee, an educator, and a self-styled journalist involved with

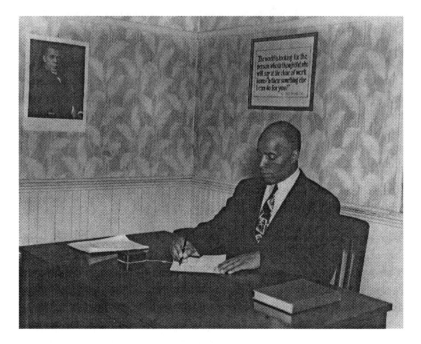

Sidney J. Phillips at his desk at Booker T. Washington's birthplace. COURTESY OF
VIRGINIA P. RONEY AND BETTYE P. DANIELS.

the National Baptist Convention, though none of these roles directly pro-
vided the support he needed to purchase the Booker T. Washington birth-
place.[76] It was in his capacity as an advertising specialist in "Negro markets"
for the Nehi Corporation that he convinced company officials that purchasing
the site would increase sales of their soft drinks among black consumers. This
was only the most dramatic in a series of enterprising marketing campaigns
run by Phillips, who had left his promising career in agricultural education to
head his own Booker T. Washington Sales Agency. In the Booker T. Wash-
ington Birthplace Memorial, Phillips found a medium through which to
bring these two parts of his career together, relying heavily on his promotional
skills to construct a combination "shrine," working demonstration farm, and
industrial school on the Tuskegee model.

Phillips's Booker T. Washington Sales Agency had been contracted early in
1940 by Nehi to design and carry out advertising programs to reach black con-
sumers. Creativity was essential; many manufacturers were reluctant to use
advertisements featuring blacks for fear of alienating their white clientele.[77]

Phillips rose to the challenge by promoting Nehi through what he called a "personalized advertisement," dispatching a Nehi-sponsored gospel quintet called "Sons of the South," bearing sodas, to black churches, clubs, and schools.[78]

Phillips was hired in 1943 to run Nehi's "special market program," part of which consisted of the donation of his services to collect salvage and sell war bonds to African-Americans during the war as a "patriotic gesture." Phillips built upon the credibility he had achieved through the success of his earlier promotions to carry out an extraordinary plan to use Nehi money for the purchase of the Booker T. Washington birthplace as Nehi's "appreciation of Booker T. Washington's services to his country."[79] Phillips argued that as the memorial became known, "in the same proportion the contribution made by Royal Crown Cola, through the Nehi Corporation, will be made known. Negro newspapers will make comment on the Memorial and those who have made it possible. Negro leaders from the public platform and in privacy and otherwise will speak in language that will be unforgettable relative to helpful assistance given by a great Southern concern."[80]

Shortly after the purchase of the site, Phillips similarly applied his powers of persuasion to the Virginia legislature, which appropriated fifteen thousand dollars for the memorial and trade school.[81] Phillips marched fearlessly into the tangle of postwar politics to gain support for his remarkable project, which began with the "reconstruction" of the slave cabin in which Washington was born. Phillips was deeply versed in Washington's autobiography, which provided a detailed description of his "miserable, desolate, and discouraging" early home. "The cabin was without glass windows; it had only openings in the side which let in the light, and also the cold, chilly air of winter. There was a door to the cabin—that is, something that was called a door—but the uncertain hinges by which it was hung, and the large cracks in it, to say nothing of the fact that it was too small, made the room a very uncomfortable one. . . . There was no wooden floor in the cabin, the naked earth being used as a floor."[82]

Yet the cabin Phillips had constructed, with its neat exterior and nicely hung front door, varied considerably from this description. In keeping with the early house museum movement's general emphasis on glorification rather than historical reproduction, the Phillips replica suggested a tidy, all-American "log cabin." Although to Washington himself the cabin demonstrated the circumstances from which he was able to rise "up from slavery," the replica sidestepped the negative comment on the antebellum South that would have been made had the cabin been refurnished accurately. The

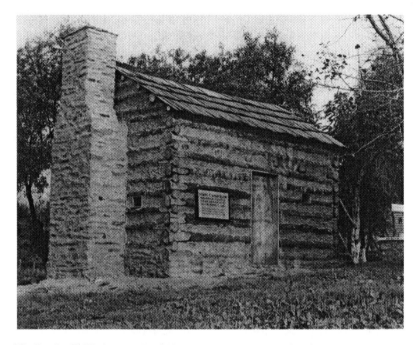

The Booker T. Washington birthplace cabin as reconstructed by Sidney J. Phillips's organization. COURTESY OF VIRGINIA P. RONEY AND BETTYE P. DANIELS.

packed-dirt floor was reproduced (as was the only feature of the cabin that Washington recalled happily, a "potato hole" in which cherished yams were stored) but the rest of the cabin was simply lined with framed inspirational quotations of Washington. Squarely in front of the cabin was placed a decorative wishing well with a sign that read, "Cast Down Your Buckets Where You Are," again quoting Washington.[83]

Phillips's unwillingness to reproduce the "miserable" cabin of Washington's description may well have arisen from his familiarity with the "Negro home improvement" programs of Tuskegee Institute, as a youth growing up on a farm in the shadow of the institution, a student, and a faculty member. A primary objective of the extension programs was the elimination of the one-room cabin, cited as the cause of moral and physical degeneracy among Alabama's black farming poor. Tuskegee's "movable school" gave advice not only on farming techniques but also on the sanitation and "beautification" of homes, the purchase of proper furnishings and "appropriate pictures," and the "removal of unnecessary bric-a-brac."[84] Linking "shacks" with "filth and

shiftlessness," one extension teacher rejected nostalgia for "the 'little old log cabin' and the 'old oaken bucket,'" saying, "It is all right to sing about the 'old oaken bucket,' but woe to him who dares to drink from it, because it is full of germs."[85] Because of the association of moral vice with "shacks," reproducing Washington's description of the material conditions of his childhood would have complicated Phillips's attempt to portray Washington's childhood in purely heroic terms.

The portentous dedicatory speeches for the cabin in June 1949 amplified one key subtext of the exhibits, revealing politicians' intentions to interpret the "shrine" in terms of the escalating debate over desegregation. A local circuit court judge celebrated Washington's acceptance of segregation, now coming under decisive attack. Washington's famous 1895 "Atlanta Compromise" stated, "In all things that are purely social we can be as separate as the fingers, yet one as the hand in all things essential to mutual progress."[86]

Washington was also well known for his public arguments that African-Americans should improve their position gradually, through individual effort, rather than by political action or other forms of "artificial forcing."[87] This was especially pertinent to the argument of Virginia Governor William M. Tuck, who used the dedication ceremony to respond to legal action initiated "to compel equalization of educational facilities"—in fact, the seeds of the Brown decision of 1954. He argued that such action was ill spirited and unnecessary, since "the government at Richmond was doing all it could for the race" by providing what he claimed were the best Negro schools in the nation.[88]

Phillips himself placed the "shrine" to Booker T. Washington in a clearly political context through his McCarthyesque fund-raising campaign. This was not unique to Phillips but followed in the wake of virulent postwar anti-communism adopted by many organizations, including the NAACP.[89] In 1951, when Phillips marketed a congressionally approved Booker T. Washington commemorative coin (which was to have been the principal fund-raising device for the site), he stated that a portion of the profits would be used to "fight communism." The public would be notified of "the public facts of Communistic teachings and activities as disclosed in the various hearings before the Committee on Un-American Activities.... Particularly will Negroes be warned against glib-tongued, mildmannered agents of Communism who seek to sell their un-American idea to underprivileged groups."[90]

In applying to the Ford Foundation for support, he likewise vowed "to fight the spread of Communism by showing that every American who desires can achieve ... and to prove the realness of our Democracy to doubting nations."[91] Others had also used this argument, in Phillips's words that "a chain

is no stronger than its weakest link," to advocate civil rights legislation, but Phillips co-opted it as Pilant had before him to argue the ideological and social utility of the birthplace "shrine."[92] Phillips apparently was not using this ideological stance as a mere fund-raising device. In a letter to the head of the National Baptist Convention, an organization in which he was actively involved, he suggested, "Inasmuch as the leading organizations throughout the country are denouncing Red China, it appears to me that it would be quite appropriate for the National Baptist Convention . . . to go on record as passing a resolution opposing the admission of Red China as a member of the United Nations." Phillips attached a so-worded resolution, which passed at the next meeting without opposition.[93]

■ *The Birthplace Legacy as Contested Terrain*

It was in his official capacity with the Booker T. Washington Birthplace Memorial that Phillips's anticommunism got the most reaction, positive and negative. Claude Barnett informed Tuskegee president F. D. Patterson that Phillips had written to the secretary of agriculture "on letterhead boasting some twenty southern congressmen as members of his board of governors" and added, "The diatribe which described the fight of the Booker T. Washington Memorial against communism among Negroes was quite fetching."[94]

While Phillips's linking of anticommunism to a black cause was capturing the fancy of politicians, Barnett was becoming increasingly critical of his tactics. Barnett, who was on the board of Tuskegee from 1932 to 1965, first took unappreciative notice of Phillips when he was running his ad campaign for Royal Crown. Barnett pointed out that Phillips's musical ensemble "Sons of the South" comprised "former members of a quartet which Tuskegee used to use in its fund solicitation work," perhaps misleading participants into "thinking they were helping Tuskegee." Barnett felt that Phillips "used his connection with the school merely for exploitative purposes and those purposes have been principally to aid the Phillips coffers."[95] Likewise, Patterson complained that publications coming from Phillips's agency, which quoted Washington and used the address "Tuskegee Institute, Alabama," capitalized "on the good will of the Institution."

By 1945, Patterson urged the Associated Negro Press not to support any project sponsored by Phillips. "We have long years of experience with him as a member of the staff, and then in his present relationship. I regret to say that I find him unscrupulous and that I believe any endorsement which comes from you would be used to the detriment of Tuskegee Institute and abused in accor-

dance with the possibilities of monetary gain."[96] Tuskegee advocates worried that Phillips was threatening certainly to divert funds that could go to the institute and possibly to sully the very prestige of Booker T. Washington and Tuskegee that was their stock in trade.

These were issues near and dear to Barnett's heart. He said, "No institution has exerted so profound an influence on my life as Tuskegee," and "Booker T. Washington touched our lives and left us a heritage that should be and is one of the most prized of our possessions."[97] This well-to-do, powerful businessman shared Phillips's enthusiasm for Washington but not his more expressive personal style; by contrast, Barnett was reserved and consistently characterized as "dignified."[98] With all of their differences, including political (Phillips was a Democrat and Barnett a dedicated Republican), they did share many of the values of their mutual mentor. For example, Barnett's Associated Negro Press, established in 1919, cultivated a tone described as one of "race calmness."[99] In 1932, the ANP boasted "on our staff is a Republican, a Socialist, a Democrat, and a Communist" but that "no partisanship obtruded."[100]

Phillips was well aware of the power and influence of both the Tuskegee network and the ANP, and he wrote Barnett regular appeals for support and submitted press releases. However, Barnett and other Tuskegee associates described Phillips's relationship to Tuskegee as profoundly antagonistic, the latter "a group which has too much conservatism and good taste to go to the mat with him."[101] Eventually, the ANP did release a statement from President Patterson disclaiming any connection between Tuskegee and Phillips, pointing out that one of his chief congressional supporters, southerner Compton White, "believes he is proving himself a friend to colored people" but "is opposed to fair employment practice legislation," which he held was "an instrument of Communists designed to cause trouble and discord, and contribute to the destruction of our country."[102]

Even late in his life, Phillips remained distressed by the attack from Tuskegee, which he described as having been a "major problem" because "thousands of dollars that might have helped to develop the memorial were withheld, and much cooperation that would have been given was not forthcoming." He believed that Tuskegee supporters worried that his projects "might detract from the importance or financial support of Tuskegee."[103] Barnett and Patterson explained their opposition in political terms, claiming that Phillips had made "the names of Booker Washington and perhaps Tuskegee stand for almost total reaction."[104]

The ouster of the staff of the Phillips-led George Washington Carver Memorial Foundation from that site late in 1952 marked the beginning of a se-

ries of setbacks for Phillips's Booker T. Washington Birthplace Memorial. The following year started with a highly public legal action against Phillips by Portia Washington Pittman, daughter of the object of Phillips's memorial. The suit for twenty thousand dollars charged that Phillips had reneged on an oral contract to pay her money earned from the sale of commemorative coins as recompense for her fund-raising efforts. Phillips countercharged that the agreement was invalid because he had been "blackmailed" into it when Pittman threatened to use her "influence" with legislators and with Truman to have funding for the minting of the coins withdrawn.[105] Though Phillips and Pittman would eventually resume cordial relations, the negative publicity was unhelpful. Phillips responded publicly, saying that Pittman's was only one of a number of claims to the unrealized profits of the commemorative coins. He argued the memorial was floundering because of "Negro reluctance" to purchase the coins, a theme to which he would return in explaining the project's ongoing fiscal hardships.[106]

The spring of 1953 brought yet another strenuous public struggle for Phillips as he made a bid for the presidency of Tuskegee following F. D. Patterson's resignation. Phillips's supporters did what they could. D. V. Jemison of the National Baptist Convention nominated him; George Schuyler of the *Pittsburgh Courier* endorsed Phillips's candidacy by arguing that Tuskegee should "go polytechnic." The editorial asserted that Tuskegee needed new leadership to update a curriculum oriented to the needs of blacks in the Reconstructionist South rather than the "Atomic Age." Phillips, Schuyler said, had at his industrial school at the Washington birthplace "turned out hundreds of skilled workers capable of holding their own in modern society."[107] The parallel between the educational missions of Tuskegee and Phillips's embryonic school at the Booker T. Washington Birthplace Memorial would not go unnoted. Barry Mackintosh of the National Park Service has suggested that Phillips's enterprise at the Washington birthplace should be understood as an effort to construct his own "second Tuskegee."[108]

In a circular letter addressed to Tuskegee trustees, Phillips said that he had "done more during the last ten years to keep alive the ideals and teachings of . . . Booker T. Washington than any other living American." He promised that under his leadership of Tuskegee "every effort would be made to sell solid, sound Americanism to all who came under the influence of the program."[109] Phillips followed up his initial letter with one asserting his ability to raise a remarkable annual congressional appropriation of two million dollars. "I am sure," he said, "that this can be made a reality if I am given the opportunity to serve as Tuskegee Institute's next president."[110] The importance to Phillips of

following directly in Booker T. Washington's footsteps is suggested by Allen Rankin's description of Phillips's stunned silence upon being told that he was eliminated from the running early on: "In that silence a man's lifetime dream crashed and shattered."[111]

■ Booker T. Washington National Monument and the Civil Rights Movement

Phillips's ideologically charged bid for the Tuskegee presidency occurred as the fiscal failure of the birthplace memorial was growing ever more apparent. Phillips had already written to NPS director Conrad Wirth asking him to initiate a study of the feasibility of the Booker T. Washington site being absorbed into the NPS.[112] Phillips was never one to shrink from establishing and deploying political connections. His experience with the Carver site told him that if the Booker T. Washington Birthplace Memorial's survival depended upon its acquisition by the federal government, he would continue to find himself immersed in southern politics. He actively courted the powerful Byrd machine in his work in behalf of the Democratic ticket in Virginia's 1953 state elections. Hence he wrote a series of articles designed to discourage black sentiment in favor of legislated school desegregation, praising black schools in Virginia and the "liberalism" demonstrated by the Democratic machine, proving that "the Negroes of Virginia can and will get friendship and cooperation."[113] Upon the election of Thomas B. Stanley to the governorship and J. Lindsay Almond as attorney general, Phillips reminded them of his ardent support in the form of enthusiastic letters of congratulation.[114] Both politicians would find their claim to fame in their leadership of "massive resistance" to desegregation the following year.

Despite the continuing support of the Nehi Corporation and the Virginia legislature, Phillips's Birthplace Memorial was bankrupt by 1955. Phillips explained the project's failure as the result of the opposition from Tuskegee and racial dissonance. He wrote, "Our experience indicates that the white people were more interested in seeing the ideals and teachings of Booker T. Washington perpetuated than Negroes."[115] Yet the very source of the project's failure as a black institution (which would have been Phillips's preference) was also the source of its ultimate success as a federal historic site: the burgeoning Civil Rights movement. When Phillips became a spokesman for the advantages to blacks of segregation, praising Virginia's Democratic leadership, he did not foresee that they were on the brink of one of the most remarkable episodes in the history of American race relations or that the enshrined cabin

from which Washington rose "up from slavery" would provide a means by which Virginia's leaders would claim that history was on their side.

Phillips's evaluation of the state of black education in Virginia had some limited validity. There was little to indicate that Virginia would become the leader in southern resistance to desegregation. Salaries of black teachers were roughly equivalent to those of whites, there were integrated universities and parochial schools, and blacks who could pay the poll tax did vote for school boards.[116] Yet Virginia's Democratic leadership, "an oligarchy composed of about a thousand persons" led by Sen. Harry Byrd, showed signs of becoming increasingly reactionary when in the 1952 presidential election Eisenhower carried the state, in part because prominent Democrats would not endorse the Stevenson ticket.[117] And it was in Virginia that some of the seeds of the momentous *Brown v. Board of Education* case were sown by NAACP litigation. As the defensive tone of William Tuck's dedication speech for the monument had tacitly revealed, Virginia was one of only two states whose educational policies would be immediately affected by the Supreme Court's ruling.[118]

As early as 1953, when Phillips was supporting the Byrd candidates and the Supreme Court was hearing arguments on Brown, a number of southern states were beginning to work out plans to evade a ruling to desegregate. When the decision was handed down in May 1954, Virginia's Governor Stanley invited some of the state's Negro leaders (Phillips not among them) to make a public statement accepting continued segregation.[119] They refused. Shortly thereafter Stanley convened a meeting of southern governors that resulted in a denunciation of Brown, and he appointed a bipartisan, thirty-two-member, all-white legislative committee chaired by Sen. Garland Gray, a body still devising an evasive legislative response when the implementation decree was handed down in May 1955.[120]

Though voters passed a version of the Gray committee's plan by referendum, it soon gave way to a rally of reaction in Virginia's legislature early in 1956; for a time Virginia closed its public schools rather than integrate them. Harking back to antebellum political justifications for protecting slavery, Byrd coined the phrase that would be the battle cry for southern government's rejoinder to the federal desegregation order. "Massive resistance" would be carried forth with a resolution in favor of "interposition" at its heart, asserting that a constitutional amendment was required when governmental powers were contested.[121] The social and political tension embodied in the "Southern Manifesto" asserting the rule of white supremacy, and in the "Warning of Grave Dangers" legislators penned against the Civil Rights bill being debated in Congress, was formidable.[122]

This was the moment at which the Booker T. Washington National Monument was born, led from the home of "massive resistance" to the floor of Congress by Sidney J. Phillips, who was preceded by widely reported statements headlined "Negro Leader Defends Segregation." Although he had indeed long reiterated Washington's advocacy of "gradualism" and self-help rather than organized political action, Phillips also had publicly interpreted the "Atlanta Compromise" to suggest that education might be in the arena of "mutual progress" in which the races should be of "one hand."[123] The Brown decision, he said, was "in keeping with the principles upon which our nation was founded—principles that we say we believe in, FREEDOM AND OPPORTUNITY FOR ALL." He said blacks justifiably resented legally imposed restrictions, but he was unequivocal in his endorsement of social segregation by choice, adding that changes in Jim Crow should be achieved slowly, through "friendly cooperation."[124] The rancor that arose in reaction to Brown in the months following this statement, however, destroyed any semblance of moderation, with the politically enmeshed Phillips shifting along with the vast bulk of southern politicians upon whom his enterprise had been dependent.[125] As in the case of his hero Booker T. Washington, it was Phillips's position on the subject of segregation with which many undoubtedly identified him and his proposed memorial. In the context of the backlash against the Brown decision, the national government's long overdue recognition of another distinguished black American was a double-edged sword.

On February 3, 1956, the very day that Autherine Lucy entered the University of Alabama, Congress held hearings on the establishment of Booker T. Washington National Monument. Though the Eisenhower administration had been advised to leave as much of the desegregation battle as possible to Congress in order to reinforce the resurgence of the North–South split of the Democratic Party, the Civil Rights movement was insistently knocking on the political door. In his state of the union address, Eisenhower had announced that a Civil Rights bill was forthcoming, seeking the support of the northern industrial cities and recognizing the significance of the black vote. Phillips's ally, Virginia Attorney General J. Lindsay Almond, denounced the bill as a direct attack on plans for resistance such as the one Virginia was devising.[126] As fraught politicians prepared to debate the bill and groped for emblems of compromise, the Booker T. Washington Memorial received massive congressional support.

The Department of the Interior had recently rejected the inclusion of the Frederick Douglass house in the National Park system, arguing that the radical abolitionist's contributions were "not of such outstanding national signifi-

cance as to warrant commemoration through a national historic site."[127] More palatable was Washington's historical image as a "race leader who told his people to accommodate themselves to the realities of white power, and whose own personal success illustrated that such a course could be personally rewarding."[128]

Many of the endorsements of the proposed monument reflected this interpretation. Booker T. Washington Jr. sent a telegram asserting that the monument would be "an inspiration to all people of goodwill and faith in the miraculous blessings and possibilities of America." Rep. Harrison A. Williams from New Jersey offered, "Over the troubled and storm-tossed waters of race relations, the spirit of Booker T. Washington shines as a beacon of clarity and calm."[129] The *New York Times* commented, "His message to Southern Negro farmers was the same as the one he delivered to learned audiences in great universities and in the capitals of Europe: keep close to nature, keep mind and body clean, learn everything that you can put to practical use in the circumstances with which you have to deal, and respect your neighbor."[130] Reference to the "capitals of Europe" was apt, because much legislation in this period designed to create some semblance of racial equity was again based on the international politics of the cold war. The oppression of blacks gave the Soviet Union the opportunity to undercut American appeals to Asian and African countries, as well as America's claim to be a land of justice and plenty. Rarely in these years did "a plea for civil rights before the Supreme Court, on the floor of Congress, and emanating from the White House, fail to emphasize that point."[131]

The Booker T. Washington Monument Foundation was no exception. Phillips urged, "Anything that our Nation does that focuses the attention of the world upon the ideals of democracy strengthens our position as a world leader. It is my belief that [this] will make us an invincible Nation. . . . The erection of such a monument will draw the attention of the world press, as well as serve as an inspiration to humble Americans of every race and creed."[132]

Reporting that people had been visiting the reconstructed birthplace cabin for nearly a decade, he assessed the impact of the monument on domestic politics. "Because of conflicting ideologies which are trying to be sold to our citizens . . . the American people need constant, and where possible, permanent reminders of the principles for which this land of ours stands. . . . Booker T. Washington's teachings are sane and fundamental. . . . They indicated a manner in which the impoverished section could work through all its people to get upon its feet. They sought to build goodwill among people of all races and creeds."[133]

However, unlike the Carver memorial, the Booker T. Washington mc... ment proposal was opposed by the National Park Service because the site failed to meet the NPS standard assessing "integrity of site," meaning the plantation lacked sufficient physical remains of Washington's life. This was not surprising, as slave cabins and artifacts were not usually objects of careful preservation, and the same had been true of the Carver memorial when it entered the system so expediently in the context of World War II. The Park Service recommended that Congress reject the bill, and that if it passed, Eisenhower should veto it. Although the stated preference of the NPS was to memorialize Washington at Tuskegee, "where he made his greatest contributions to American life," the agency was forced to concede that it "had no plans to actually do so."[134] Phillips thus had to defend the idea of memorializing in particular the birthplace of Washington, and he did so by citing the cultural significance of the historic house museum movement, saying, "It is in keeping with American traditions to establish monuments or memorials at the birthplace of men and women who have contributed in some form to our national well-being."[135] Invoking the traditional language of house museum founders, Phillips reported that the people who already visited the site demonstrated "a kind of sacred feeling for the birthplace," which served "as a constant reminder of the progress made by American Negroes under our democratic form of government." The conservative George Schuyler of the *Pittsburgh Courier* also placed the birthplace memorial in the context of American house museums generally by testifying that it "would best illustrate the humble origin of Washington in contrast with his ultimate position of greatness." T. J. Jemison of the National Baptist Convention made even grander claims. "We feel that the site of the national monument should be at his birthplace because . . . it is significant to know where a man has come from so as to better appreciate what he has done and the contributions that he has made. We take that position because . . . where Christ was born in Bethlehem the site is more or less a restoration, . . . not where he performed his miracles in Cana and other places."[136]

Phillips cited Washington's autobiography, *Up from Slavery*, as "the greatest success story ever written by a self-made American." This compelling mix of earnest wish, myth, and metaphor—the desire to have black history represented in a traditional house museum, the identification of Washington as an American self-made man, and the comparison of Washington to Christ, along with the pressing political concerns generated by the movement for civil rights—gleaned the votes of three-fourths of Congress and a presidential signature despite NPS disapproval, creating Booker T. Washington National

Monument in April 1956. Phillips had harnessed irony once again to desegregate the official history propagated by the National Park Service.

Yet this achievement did not secure his prestige as the NPS assumed control of the Booker T. Washington birthplace late in 1957. In events echoing his ouster from the George Washington Carver Monument, internal memorandums of the Park Service made clear the intention to remove Phillips and his staff from the monument, though hopes were that it could be done so as to spare the NPS "serious controversy." With the seemingly entrenched Phillips staking his claim to a place at the site and emphasizing his long-standing relationship to Governor Stanley, newly seated superintendent Chester Brooks supplied information for a series of articles that made a blistering attack on Phillips, published in the October *Roanoke Tribune*. The articles were headline stories by a local reporter seeking to analyze the dispatch of government grants to Phillips over the years as "pork barrel expenditures." The series portrayed Phillips as flagrantly self-promoting, wishing to be perceived as nothing less than "the second Booker T. Washington." The articles claimed that Phillips had paid himself and his friends large salaries and made extravagant purchases, such as a car with "gold lettering" (which may have been the sound truck Phillips purchased with funding from DuPont's "Cavalcade of America" to bring the Booker T. Washington story to southern schoolchildren).[137] Brooks then sent copies of the articles to Phillips's allies, reporting to his superiors that he was "cooperating" with the Internal Revenue Service in a review of Phillips's finances. Phillips left shortly thereafter.[138] He tried without success to have a history of his activities leading to the establishment of the monument included in the new NPS interpretive brochure, and he visited the site several times before he died early in 1965.[139]

When the Park Service took over the site, a long and painful debate arose over the accuracy of the location and construction of Phillips's "replica" birthplace cabin. By 1959, the NPS razed its neglected remnants and a new one was constructed, based on archeological and documentary research.[140] But by the midsixties, the NPS was so vexed over the issue of accuracy and so deeply engaged in interpreting the site through its "visitor center" exhibits that the "replica" cabin, once the major attraction of the site, was seldom viewed.[141] Disagreement ensued over whether the audio-taped description of the interior of the cabin from *Up from Slavery* should in fact be read by a "colored voice."[142] And equally thorny was the interpretation of Washington's social philosophy, with the NPS taking a conservative approach in the first brochure in 1957: "His belief that the Negro should adjust to his social and economic en-

vironment led him to advocate a doctrine of race relations which has survived in the South for three generations."[143]

Meanwhile, elsewhere in the world of the historic house museum, standard modes celebrating decorative elegance and nationalism continued to flourish in the context of cold war prosperity. In 1951, Henry Francis du Pont converted part of his Delaware home, Winterthur, into period rooms representing the most opulent historical styles.[144] At the same time, women's clubs were expanding their "Americanism departments" for the "Preservation of Our American Heritage," and the DAR endorsed the McCarran-Walter Act restricting immigration. One hundred years after the birth of the American house museum movement, the Daughters avidly carried on, else, they feared, "America as we know it will be gone."[145]

Conclusion

When Ann Pamela Cunningham said that Mount Vernon's establishment as a museum would initiate a "new era" in the nation's political life, she expressed what would become a hallmark of the early house museum movement: faith in the role of American popular history to shape the future. As in the case of our own congressional representatives stalking the Smithsonian's exhibit halls, early house museum founders knew the power of historical imagination to inform perceptions of current problems, energize social action, and legitimate authority and principles. It was the lively enthusiasm of house museum founders for the great issues of their times that gave the early movement form, dynamism, purpose, and, of course, a history of its own.

Therefore house museums are documents of political history, particularly of women's relationship to the public sphere. The American house museum began as public commentary controlled by disenfranchised though politically engaged women, but by the end of the movement's first century, it was reoriented to reflect the interests of male politicians, museum professionals, and businessmen, giving the house museum its modern cast, shaped by political circumstances and historical contexts.

The house museum movement was, initially, a product of "woman's sphere." The MVLA drew upon the nineteenth-century reverence for the home and conventional forms of womanly persuasion, from sentimental scenes to elegant soirees, to, as Cunningham put it, "make friends" with male politicians. Though they asserted that their museum would have a salutary

effect on the "degenerate" world of antebellum politics, the MVLA hoped to apply Washington's own counsel and avoid "entangling alliances" with the foreign realm of politics. Yet the exigencies of establishing a state-chartered, national organization and ferrying it through civil war transformed the MVLA's methods as well as its vision. When it became identified with the Wise wing of Virginia Democratic Party, the futility of arguing that women's public benevolence could remain utterly above politics became clear. The effort to enlist the support of the legislature made the "ladies" vulnerable to charges that they had violated their "sphere," forfeiting the right to chivalrous treatment. Forced to recognize that her tools could not be delicate ones, Cunningham did not shrink from public counterattack, and she prevailed. Any remaining political innocence on the part of the MVLA was certainly lost after the attempt to honor Everett and Yancy at the same dyspepsia-inducing ceremonial dinner. The perfect emblem for the metamorphosis of the MVLA may be Sarah Tracy, hired to provide the "presence of a lady" at wartime Mount Vernon, marching into Winfield Scott's office to demand respect for the fledgling museum in her charge. The MVLA then forged its creation myth, that it had founded Mount Vernon as a kind of domestic missionary transcending antebellum political conflict. In reality, it was a public institution led by women enmeshed in politics. Its subsequent retreat from that fact credited their achievement to a putatively nonpartisan MVLA and set the tone for the house museum movement for decades to follow.

The process of establishing a house museum brought women out of the private sphere, but it also could be a vehicle for negotiating the changing relationship between women's traditional power base, the home, to the public realm in general and the state in particular. The house museum could be meaningful to women who were, in terms of the revolution in women's roles, either conservative or liberal. Just as Mount Vernon had appealed to women split along sectional lines because both sides could claim George Washington, Orchard House served to unite women polarized by the issue of woman suffrage because both sides could derive legitimacy from the ambiguous domestic subtexts of *Little Women*. The fact that Orchard House could be construed as a monument to *Little Women* facilitated its existence as one of the few American house museums explicitly memorializing a woman. The portrayal of women's history would continue to hold only a minor place in the American house museum, which built instead on the tradition of Mount Vernon, emphasizing the political and social benefits of public exposure to the lives of American forefathers, famous and otherwise.

Yet, in contrast to Ann Pamela Cunningham, who entered the legislative

arena warily, Maud Littleton went directly to Congress, not for support but for power. The difference was not a matter of personality but one of a new relationship of women to government in the context of "the domestication of politics" and state expansion. Although Littleton's effort foundered, it drew mass attention and the notice of the Democratic politicians who would create the Monticello museum, not the least of whom was Franklin Roosevelt. Littleton contributed to the authority of the house museum movement and correctly divined that the Progressive Era was ripe for increasing state participation. She could not have foreseen the effects on the status of voluntarist women like herself or of the concomitant "professionalization" of the museum field when government and business provided salaried positions.

Changes in the house museum movement in the early twentieth century reflected other large cultural patterns, most notably the brandishing of the Anglo-American version of history in reaction to the "new immigration" and increasing heterogeneity. The MVLA had instituted a prototype during the sectional crisis, that the domestic life of George Washington could be a reservoir from which the nation could renew its republican vision as well as its private virtues. House museum founders used their institutions to bolster the image of the "home" and of elite forefathers as metaphors for particular interpretations of the American political and cultural tradition. In this way Orchard House, though memorializing a woman, was a traditional house museum, defined as an agent of mythologized Anglo-American domesticity protecting the values of Old Concord from "alien inundation." House museums in general, forefathers at the helm, filled with "colonial" associations and purged of references to slaves, servants, and other such complicating features, looked for all practical purposes like progenitors of the single-family suburban home so often posited as the linchpin of social stability.

Given this context it is easy to see why the Mount Vernon and Monticello museums were not construed as opportunities to interpret plantation slavery. The house museum genre was a paradox for African-Americans, whose cultural memory of slave cabins was vividly painful. Booker T. Washington's birthplace served a complex assortment of purposes, few having much to do with accurately depicting his life as an enslaved child. From the Nehi Corporation to politicians besieged by conflict over civil rights, the legacy of Tuskegee's Washington, like that of the MVLA's Washington, proved worthy of a house museum for reasons of political expediency rather than historical inquiry.

Likewise, when Monticello devotees invited Al Smith to make a controversial southern campaign speech on the portico and declared that Hamilton

himself would have waxed enthusiastic over the public preservation of Jefferson's mansion, the heart of the museum's mission was its currency for the living. This feature of the house museum movement allowed the rift-weary Democratic Party to rally around a constructed image of Jefferson, finally fulfilling Maud Littleton's vision by making Monticello an icon of the realm (if not a government property) in the New Deal.

As inheritors of the material legacy of the house museum founders, we now see the proper function of a museum as the presentation of historically accurate interpretations of the American past. Heirs also to the intellectual tradition upheld by Fiske Kimball earlier in the century, we may strive against the grain of the past to make our museums well documented, inclusive, and as free of bias as possible. Our frustrations at achieving this are derived in part from the fact that the interpretive effects of the house museum's political orientation are so often obscured by its rhetorical neutrality.

Although this is not a book about house museum interpretation, there are implications in the history of historic house museums for interpretive and curatorial planning. A reformed vision of the function of the "administrative history" would include an account of what obstacles the museum's history presents to full interpretation, explain why certain interpretive avenues were pursued with gusto while others languished or even had their material remains destroyed by the museumization process. It would clarify what intentions and wishes former constituencies brought to bear on the museum's development and would align these historical influences with those of the communities we wish to reach today. Above all, the history of American historic house museums demonstrates that their missions, far from being neutral and far from meriting the status of inviolability, were manufactured out of human needs bound by time and place. We have not only the right but the responsibility to revise them to accommodate new scholarship, new communities, and new agendas, openly inviting future generations to evaluate our actions in historical perspective.

Notes

■ *Introduction*

1. The place to begin to delve into house museum history has long been Charles Hosmer's monumental history of the preservation movement, from its inception in the 1850s through the 1920s. However, although Hosmer's work is comprehensive, it is not highly analytical. For example, though he noted women's primary role in originating the movement and their subsequent marginalization in the early decades of the twentieth century, Hosmer figured that women "apparently were not so enthusiastic" about historic preservation as the field was "professionalized." Subsequent scholars have focused on individual preservation organizations and history museums, initiating a more meaningful discussion of this significant aspect of the history of historic preservation. Charles B. Hosmer, *Presence of the Past: A History of the Preservation Movement in the United States before Williamsburg* (New York: G. P. Putnam, 1965), 300 and passim. See also Hosmer's *Preservation Comes of Age: From Williamsburg to the National Trust, 1926–1949* (Charlottesville: University Press of Virginia, 1981). Recent scholars explicitly considering the historical role of women in the preservation movement include Gail Lee Dubrow, *Planning for the Preservation of American Women's History* (New York: Oxford University Press, forthcoming); Barbara Howe, "Women in Historic Preservation: The Legacy of Ann Pamela Cunningham," *Public Historian* 12 (winter 1990): 31–61; Patricia West, "The Historic House Museum Movement in America: Louisa May Alcott's Orchard House as a Case Study" (Ph.D. diss., State University of New York at Binghamton, 1992); Fath Davis Ruffins, "'Lifting as We Climb': Black Women and the Preservation of African American History and Culture," *Gender and History* 6 (November 1994):

376–96; James M. Lindgren, "A New Departure in Historic Patriotic Work: Personalism, Professionalism, and Conflicting Concepts of Material Culture in the Late Nineteenth and Early Twentieth Centuries," *Public Historian* 18 (spring 1996): 41–60.

1 ▪ *Inventing a House Undivided*

1. On ancient museum prototypes and elite "cabinets of curiosities," see Kenneth Hudson, *A Social History of Museums* (New York: Macmillan, 1975), 6–9; Edward P. Alexander, *Museums in Motion: An Introduction to the History and Functions of Museums* (Nashville: American Association for State and Local History, 1979), 6–7; Alexander, "Charles Willson Peale and His Philadelphia Museum: The Concept of a Popular Museum," in his *Museum Masters: Their Museums and Their Influence* (Nashville: American Association for State and Local History, 1983), 44–77; David Brigham, *Public Culture in the Early Republic: Peale's Museum and Its Audience* (Washington, D.C.: Smithsonian Institution Press, 1995); Joel J. Orosz, *Curators and Culture: An Interpretive History of the Museum Movement in America, 1773–1870* (Ann Arbor, Mich.: University Microfilms, 1987), 16–42. On the early history of collecting, see Germain Bazin, *The Museum Age*, trans. Jan van Nuis Cahill (New York: Universe Books, 1967). The influence of the Great Expositions and the development of popular exhibits is discussed in Toshio Kusamitzu, "Great Exhibitions before 1851," *History Workshop* 9 (spring 1980): 70–89; Hudson, *A Social History of Museums*, 41–43; Alexander, *Museum Masters*, 146–49; Kenneth Hudson, *Museums of Influence* (Cambridge: Cambridge University Press, 1987), 11–13; Daniel Fox, *Engines of Culture: Philanthropy and Art Museums* (Madison: State Historical Society of Wisconsin, 1963), 13; Robert Hewison, *The Heritage Industry: Britain in a Climate of Decline* (London: Methuen, 1987), 86. The establishment of European monuments and museums in the nineteenth century fostered nationalism through the celebration of material symbols of cultural unity. Edward P. Alexander, "Artistic and Historical Period Rooms," *Curator* 7 (1964): 263; Charles R. Richards, *Industrial Art and the Museum* (New York: Macmillan, 1927), 5–16; Daniel Sherman, *Worthy Monuments: Art Museums and the Politics of Culture in Nineteenth-Century France* (Cambridge: Harvard University Press, 1989). For a history of American historical societies, see Leslie W. Dunlap, *American Historical Societies, 1790–1860* (1944; reprint, Philadelphia: Porcupine Press, 1974); David D. Van Tassel, *Recording America's Past: An Interpretation of the Development of Historical Studies in America, 1607–1884* (Chicago: University of Chicago Press, 1960); Walter Muir Whitehill, *Independent Historical Societies* (Boston: Boston Athenaeum, 1962); George H. Callcott, *History in the United States, 1800–1860* (Baltimore: Johns Hopkins, 1970); Norman Williams, Edmund H. Kellogg, and Frank P. Gilbert, *Readings in Historic Preservation* (New Brunswick, N.J.: Rutgers University

Press, 1983); Michael Kammen, *A Season of Youth: The American Revolution and the Historical Imagination* (New York: Alfred A. Knopf, 1978), 72; Henry D. Shapiro, "Putting the Past under Glass: Preservation and the Idea of History in the Mid-Nineteenth Century," *Prospects* 10 (1975):250.

2. Barbara Welter, "The Cult of True Womanhood: 1820–1860," reprinted in her *Dimity Convictions: The American Woman in the Nineteenth Century* (Athens: Ohio University Press, 1976), 21–41. For a discussion of the historiography of "woman's sphere," see Linda Kerber, "Separate Spheres, Female Worlds, Woman's Place: The Rhetoric of Women's History," *Journal of American History* 75 (June 1988): 9–39.

3. Mary P. Ryan, *Cradle of the Middle Class: The Family in Oneida County, New York, 1790–1865* (Cambridge: Cambridge University Press, 1981); David P. Handlin, *The American Home: Architecture and Society, 1815–1915* (Boston: Little, Brown, 1979), 4–6, 61. See also Clifford Edward Clark, *The American Family Home, 1800–1960* (Chapel Hill: University of North Carolina Press, 1986), 15–16.

4. Dorothy Ross, "Historical Consciousness in Nineteenth-Century America," *American Historical Review* 89 (October 1984): 909–28; Paul Johnson, *A Shopkeeper's Millennium* (New York: Hill and Wang, 1978); Welter, "Cult of True Womanhood," in *Dimity Convictions*, 21–41; Ann Douglas, *The Feminization of American Culture* (New York: Alfred A. Knopf, 1977), 45–117.

5. The term "domestic religion" is Colleen McDannell's. She says that it directly parallels the period's public "civil religion." The house museum represents the melding of these two powerful cultural conventions. See Colleen McDannell, *The Christian Home in Victorian America, 1840–1900* (Bloomington: Indiana University Press, 1986), 151, and Robert N. Bellah, "Civil Religion in America," *Daedalus* 96 (winter 1967): 1–21.

6. Clark, *American Family Home*, 19–28; Handlin, *American Home*, 38; Russell Lynes, *The Tastemakers* (New York: Grosset and Dunlap, 1954), 21–29; Gwendolyn Wright, *Moralism and the Model Home* (Chicago: University of Chicago Press, 1980), 10–11; John Kasson, *Rudeness and Civility: Manners in Nineteenth-Century Urban America* (New York: Hill and Wang, 1990).

7. Wright, *Moralism*, 10–11.

8. Handlin discusses another genre of midcentury popular literature celebrating a moral home environment, books describing the homes of famous authors and statesmen, which emphasized the relationship between birthplace and character; *American Home, 21*.

9. Catharine Beecher and Harriet Beecher Stowe, *The American Woman's Home* (New York: J. B. Ford, 1869), 455–58.

10. Kathryn Kish Sklar, *Catharine Beecher: A Study in Victorian Domesticity* (New York: W. W. Norton, 1976), 158, 137.

11. Welter, "Cult of True Womanhood," in *Dimity Convictions*, 211, n. 116. The term "home protection" was used in the later Women's Christian Temperance Union.

See Ruth Bordin, *Woman and Temperance* (Philadelphia: Temple University Press, 1981).

12. Quoted is Ann Pamela Cunningham, the founder of the Mount Vernon Ladies' Association of the Union, *Mount Vernon Record* 1 (May 1859), 140. "Republican motherhood" was the ideology defining the appropriate female civic contribution as the raising of republican sons (in republican homes) forged after the American Revolution. This tradition of female responsibility for civic virtue through the home was the basis for nineteenth-century "true womanhood" as well as an argument for female leadership in the creation of house museums. On "republican motherhood," see Linda Kerber, *Women of the Republic: Intellect and Ideology in Revolutionary America* (Chapel Hill: University of North Carolina Press, 1980) and Mary Beth Norton, *Liberty's Daughters: The Revolutionary Experience of American Women, 1750–1800* (Boston: Little, Brown, 1980).

13. Lori D. Ginzberg, *Women and the Work of Benevolence: Morality, Politics, and Class in the Nineteenth-Century United States* (New Haven: Yale University Press, 1990), 8–9; Elizabeth Willard Barry, "Woman's Mission," *Mount Vernon Record* 2 (July 1859), 3. On electoral expansion, see Glyndon G. Van Deusen, *The Jacksonian Era, 1828–1848* (New York: Harper and Row, 1963), 10–11; Rush Welter, *The Mind of America, 1820–1860* (New York: Columbia University Press, 1975), 179–85.

14. Robert Bellah defines this political, nonsectarian "religion" as "a collection of beliefs, symbols, and rituals with respect to sacred things and institutionalized in a collectivity." Shaped by "the words of the founding fathers," the American civil religion is marked by characteristic rhetoric, patriotic civic rituals such as Memorial Day parades, and holidays like Washington's Birthday. Bellah, "Civil Religion in America," 1–21. See also Russell E. Richey and David C. Jones, eds., *American Civil Religion* (New York: Harper and Row, 1974).

15. Parson Weems penned the quintessential document of the nineteenth-century Washington myth. See Mason L. Weems, *The Life of Washington*, ed. Marcus Cunliffe (1800; reprint, Cambridge: Harvard University Press, 1962). On the history of Washington worship, see Marcus Cunliffe, *George Washington: Man and Monument* (Boston: Little, Brown, 1958); Lawrence Friedman, *Inventors of the Promised Land* (New York: Alfred A. Knopf, 1975); Kammen, *Season of Youth*, and his *Mystic Chords of Memory: The Transformation of Tradition in American Culture* (New York: Vintage Books, 1991), 154–55, 649–50; David Lowenthal, *The Past Is a Foreign Country* (Cambridge: Cambridge University Press, 1985), 117–21; Barry Schwartz, *George Washington: The Making of an American Symbol* (New York: Free Press, 1987); and Karal Ann Marling, *George Washington Slept Here: Colonial Revivals in American Culture, 1876–1986* (Cambridge: Harvard University Press, 1988). For a discussion of another Washington memorialization, see Kirk Savage, "The Self-made Monument: George Washington and the Fight to Erect a National Memorial," *Winterthur Portfolio* 22 (winter 1987): 225–42.

16. John F. Sears, *Sacred Places: American Tourist Attractions in the Nineteenth Century*

(New York: Oxford University Press, 1989); Dona Brown, *Inventing New England: Regional Tourism in the Nineteenth Century* (Washington, D.C.: Smithsonian Institution Press, 1995). On the rural cemetery movement, see also Douglas, *Feminization of American Culture*, 211–12, and Stanley French, "The Cemetery as Cultural Institution: The Establishment of Mount Auburn and the 'Rural Cemetery' Movement," in *Death in America*, ed. David E. Stannard (Philadelphia: University of Pennsylvania Press, 1975), 69–91.

17. One observer described "a rabble, a mob of boys, negroes, women, children, scrambling, fighting, romping," which left behind a trail of broken china and muddied upholstery. See Kasson, *Rudeness and Civility*, 58–59.

18. Though it was the first such historic "shrine," the fact that the state of New York purchased the site when local citizens were unable to generate enough private support makes its establishment more typical of the twentieth century than the nineteenth.

19. New York State Legislature, *Assembly Select Committee on the Petition of Washington Irving and Others to Preserve Washington's Headquarters at Newburgh*, no. 356, March 27, 1839, quoted in Alexander, *Museum Masters*, 195, and Walter Muir Whitehill, "'Promoted to Glory': The Origin of Preservation in the United States," in *With Heritage So Rich: A Report to the Special Committee on Historic Preservation under the Auspices of the United States Conference of Mayors*, ed. Albert Rains and Laurance G. Henderson (New York: Random House, 1966), 37.

20. Hamilton Fish, quoted in Whitehill, "Promoted to Glory," 37. Michael Wallace says the approach of civil war mobilized the movement to memorialize Washington as an "antidote" for a republic "that seemed to be coming apart." Michael Wallace, "Visiting the Past: History Museums in the United States," in *Presenting the Past: Essays on History and the Public*, ed. Susan Porter Benson, Stephen Brier, and Roy Rosenzweig (Philadelphia: Temple University Press, 1986), 138.

21. Richard Caldwell, *A True History of the Acquisition of Washington's Headquarters at Newburgh by the State of New York* (Salisbury Mills, N.Y., 1887), 21, quoted in Wallace, "Visiting the Past," 138.

22. E. Jane Townscend, *Washington's Headquarters: Master Plan* (Waterford, N.Y.: New York State Department of Parks, Recreation and Historic Preservation, 1985); Alexander, *Museum Masters*, 194–95.

23. For example, Elswyth Thane, *Mount Vernon Is Ours: The Story of Its Preservation* (New York: Duell, Sloan and Pearce, 1966).

24. Jan Cohn describes Harrison and Sally Otis's 1801 visit and James Fenimore Cooper's in 1828. Henry Adams visited in the summer of 1850. Jan Cohn, *The Palace or the Poorhouse: The American House as Cultural Symbol* (East Lansing: Michigan State University Press, 1979), 196–97; Henry Adams, "The Education of Henry Adams," in *Democracy, Esther, Mont St. Michel and Chartres, The Education of Henry Adams*, ed. Ernest Samuels and Jayne N. Samuels (New York: Library of America, 1983), 759–64.

25. Edward Everett, *The Mount Vernon Papers* (New York: D. Appleton, 1860), 6–7.

26. S. P. Lee, Washington, D.C., to John Augustine Washington, Mount Vernon, March 15, 1846, MVLA Archives, Mount Vernon, Va.; U.S. Senate, Committee for the District of Columbia, 30th Congress, 1st Session, "Memorial of the Citizens of the United States Praying the Purchase of Mount Vernon by the Government," Washington, D.C., March 10, 1848; Everett, *Mount Vernon Papers*, 8; Benson Lossing, *Mount Vernon and Its Associations* (n.p., 1859), 355; Robert E. Stipe and Antoinette J. Lee, eds., *The American Mosaic: Preserving a Nation's Heritage* (Washington, D.C.: U.S. Committee, International Council on Monuments and Sites, 1987), 151; *Congressional Globe*, 33d Congress, 1st session, December 15, 1853, 52–54.

27. Everett, *Mount Vernon Papers*, 7–8; Hosmer, *Presence of the Past*, 42.

28. Louisa Cunningham, Rosemont, to Jane Washington, Blakeley, December 30, 1853, and Ann Pamela Cunningham, Philadelphia, to Mrs. John Augustine Washington, December 19, 1853, Mount Vernon, MVLA Archives.

29. Judith Anne Mitchell, "Ann Pamela Cunningham: A Southern Matron's Legacy" (master's thesis, Middle Tennessee State University, 1993), 14.

30. Grace King, *Mount Vernon on the Potomac: History of the Mount Vernon Ladies' Association of the Union* (New York: Macmillan, 1929), 13–19; Alexander, *Museum Masters*, 179–80; Thane, *Mount Vernon Is Ours*, 14; Mitchell, "Ann Pamela Cunningham," 13–18, 25–26. Judith Mitchell has done a remarkable job of constructing the life of Cunningham, despite the lack of documentation caused by a tragic fire in 1930 that destroyed Rosemont and Cunningham's papers within it.

31. Mitchell, "Ann Pamela Cunningham," 188–89.

32. Mitchell, "Ann Pamela Cunningham," 26; King, *Mount Vernon on the Potomac*, 12.

33. Mitchell, "Ann Pamela Cunningham," 30–34. On brothers dueling to defend sisters, see Catherine Clinton, *The Plantation Mistress: Woman's World in the Old South* (New York: Pantheon, 1982), 56–57.

34. Mitchell, "Ann Pamela Cunningham," 35–36.

35. Dated December 2, 1853, cited in King, *Mount Vernon on the Potomac*, 19–22.

36. This conflict would be personified by the longstanding feud between Virginia politicians Henry A. Wise and R. M. T. Hunter, which would in turn have a direct bearing on the fate of the MVLA, as we shall see. Clement Eaton, "Henry A. Wise: A Study in Virginia Leadership, 1850–1861," *West Virginia History* 3 (April 1942): 188.

37. Ginzberg, *Women and the Work of Benevolence*, 14–16.

38. Rable says that "much of the force of both the intellectual and the more popular Southern critique of northern capitalism rested on the notion that unbridled competition and a breakdown of traditional sex roles would ultimately destroy the home, thereby claiming many female victims. George C. Rable, *Civil Wars: Women and the Crisis of Southern Nationalism* (Urbana and Chicago: University of Illinois Press, 1989), 2–3. On the "cult of Southern womanhood" or "gyneolatry," see also W. F. Cash, *The Mind of the South* (New York: Knopf, 1941), 86.

39. Ann Pamela Cunningham, Philadelphia, to Mrs. [John A.] Washington, Mount Vernon, December 19, 1853, MVLA Archives.
40. Eleanor Washington, Mount Vernon, to Ann Pamela Cunningham, June 10, 1854, MVLA Archives.
41. Quoted in King, *Mount Vernon on the Potomac*, 22.
42. "A Southern Matron," *Washington Union*, April 20, 1854, quoted in King, *Mount Vernon on the Potomac*, 26.
43. King, *Mount Vernon on the Potomac*, 28-29.
44. King, *Mount Vernon on the Potomac*, 31.
45. Philoclea Edgeworth Eve, a cousin of Cunningham's from South Carolina, May 1854, quoted in King, 33.
46. Ann Pamela Cunningham, "An Appeal for Mount Vernon by the Mount Vernon Association of the Union," *Washington Circular*, November 24, 1854, MVLA Archives.
47. Louisa Cunningham, Rosemont, to Mary Amarintha Yates, January 3, 1854, quoted in Mitchell, "Ann Pamela Cunningham," 80; Mary Boykin Chesnut, *The Private Mary Chesnut: The Unpublished Civil War Diaries*, ed. C. Vann Woodward and Elizabeth Muhlenfeld (New York: Oxford University Press, 1984), 81.
48. Ann Pamela Cunningham, "To the Daughters of Washington," March 27, 1855, MVLA Archives. Ginzberg has shown that the antebellum ideology of benevolent femininity "sought to mute real differences among women, especially the class privileges of its middle-class proponents." Ginzberg, *Women and the Work of Benevolence*, 24-25. In the case of the MVLA, this ideology functioned to position the organization to argue that it was above divisive political issues, even as it was mired in them.
49. Ann Pamela Cunningham, "A Letter from the Founder and First Regent of the Mount Vernon Association," May 28, 1866, MVLA Archives.
50. See, for example, Ann Pamela Cunningham to John Gilmer, January 29, 1855, and other angry correspondence between Cunningham and the first Virginia committee. It was later reconstituted. The phrase referring to Virginia as "the native State of Washington" is taken from a contested circular published by the Mount Vernon State Committee of Virginia, July 4, 1855, MVLA Archives.
51. John H. Gilmer, Richmond, to Ann Pamela Cunningham, June 21, 1854; see also Cunningham to Gilmer, January 29, 1855, MVLA Archives.
52. Ann Pamela Cunningham, "A Letter from the Founder," May 28, 1866, 4-5, MVLA Archives.
53. See Ginzberg, *Women and the Work of Benevolence*, 36-66, 53, 67-97.
54. Cunningham, "A Letter from the Founder," May 28, 1866, 4, MVLA Archives.
55. Gerald W. Johnson, *Mount Vernon: The Story of a Shrine* (1853; reprint, Mount Vernon, Va.: MVLA, 1991), 23-24; William H. Pease and Jane H. Pease, *James Louis Petigru: Southern Conservative, Southern Dissenter* (Athens and London: University of Georgia Press, 1995).

56. King, *Mount Vernon on the Potomac,* 52.
57. Eric Wollencott Barnes, *The Lady of Fashion: The Life and the Theatre of Anna Cora Mowatt* (New York: Charles Scribner's Sons, 1954), 266–73, 267–69, 277–78; Thane, *Mount Vernon Is Ours,* 24–27. On Mowatt's spiritualism, see Anna Cora Mowatt, *Autobiography of an Actress* (Boston: Ticknor, Reed, and Fields, 1854).
58. Anna Ritchie to Ann Pamela Cunningham, Philadelphia, February 29, 1856, quoted in Thane, 38. John Buchanan Floyd was governor 1849–52; the current governor was Joseph Johnson, whose term was 1852–56.
59. Barnes, *Lady of Fashion,* 270–72; Thane, *Mount Vernon Is Ours,* 38–39; King, *Mount Vernon on the Potomac,* 52–35.
60. Barnes, *Lady of Fashion,* 271.
61. Thane, *Mount Vernon Is Ours,* 40–41; Cunningham, "Letter from the Founder," May 28, 1866, 4, MVLA Archives.
62. G. J. Barker-Benfield, *The Culture of Sensibility: Sex and Society in Eighteenth-Century Britain* (Chicago: University of Chicago Press, 1992), 250–51.
63. Cunningham, "A Letter from the Founder," May 28, 1866, 4–7, MVLA Archives.
64. Ann Pamela Cunningham, Philadelphia, to John Augustine Washington, Mount Vernon, May 10, 1856, MVLA Archives.
65. Thane, *Mount Vernon Is Ours,* 45, 60.
66. King, *Mount Vernon on the Potomac,* 52–53; Anna Ritchie to Ann Pamela Cunningham, June 18, 1855, MVLA Archives.
67. Ann Pamela Cunningham, "On the Vice Regents," n.d., MVLA Archives.
68. Thane, *Mount Vernon Is Ours,* 24, 27. On Octavia Walton LeVert, see *Catalogue of the Centennial Exhibition Commemorating the Founding of the Mount Vernon Ladies' Association of the Union* (Mount Vernon, Va.: MVLA, 1953), 9.
69. King, *Mount Vernon on the Potomac,* 113; Paul Johnson, *Shopkeeper's Millennium,* 47; Hosmer, *Presence of the Past,* 49. Thane, *Mount Vernon Is Ours,* may be consulted for information about the vice-regents generally, as may be the MVLA, *Catalogue of the Centennial,* 5–19.
70. Everett (1794–1865) had been congressman (1825–35), governor of Massachusetts (1836–39), president of Harvard (1836–49), secretary of state (1852–53), and U.S. senator (1853–54). Ronald F. Reid, *Edward Everett: Unionist Orator* (New York: Greenwood Press, 1990), 1–3; Ronald F. Reid, "Edward Everett's 'The Character of Washington,'" *Southern Speech Journal* 22 (1957): 144.
71. Reid, *Edward Everett,* 80–85; Reid, "Edward Everett's 'The Character of Washington,'" 150–52; Alexander, *Museum Masters,* 182; Hosmer, *Presence of the Past,* 47–48; King, *Mount Vernon on the Potomac,* 38–40. In this oration, Everett also argued that there should be a "national festival" celebrating Washington's birthday. Everett, "The Character of Washington," in Reid, *Edward Everett,* 173.
72. Reid, *Edward Everett,* 81–82; Hosmer, *Presence of the Past,* 47–48.

73. Everett, "The Character of Washington," in Reid, *Edward Everett,* 165, 152.
74. Everett, "The Character of Washington," in Reid, *Edward Everett,* 172–73.
75. Everett, "The Character of Washington," in Reid, *Edward Everett,* 168–68. On the image of George Washington as "transcendent Yankee," see William R. Taylor, *Cavalier and Yankee: The Old South and the American National Character* (New York: Harper and Row, 1961), 137. On George Washington as national father, see George Forgie, *Patricide in the House Divided* (New York: W. W. Norton, 1979), 13–58, 22–28.
76. Everett, *Mount Vernon Papers,* 489, iiv–v.
77. Everett, *Mount Vernon Papers,* 4–8.
78. Alexander, *Museum Masters,* 183.
79. Rable, *Civil Wars,* 43–44.
80. On Yancy, see William Garrot Brown, *The Lower South in American History* (1902; reprint, New York: Greenwood Press, 1969), 115–52; William Barney, *The Road to Secession* (New York: Praeger, 1972); John Witherspoon DuBose, *The Life and Times of William Loundes Yancy* (New York: Peter Smith, 1942).
81. William Brown, *Lower South in American History,* 133–34; Barney, *Road to Secession,* 89.
82. DuBose, *William Loundes Yancy,* 351.
83. Forgie, *Patricide in the House Divided,* 162–64; William Brown, *Lower South in American History,* 138–39.
84. Kenneth M. Stampp, *America in 1857: A Nation on the Brink* (New York: Oxford University Press, 1990), 266–94.
85. Craig M. Simpson, *A Good Southerner: The Life and Times of Henry A. Wise of Virginia* (Chapel Hill: University of North Carolina Press, 1985), 91, 94.
86. Simpson, *Good Southerner,* 92–94; Avery O. Craven, *The Growth of Southern Nationalism, 1848–1861* (Baton Rouge: Louisiana State University Press, 1953), 124; Henry T. Shanks, *The Secession Movement in Virginia* (New York: Da Capo, 1970), 46; John E. Fisher, "Statesman of the Lost Cause: R. M. T. Hunter and the Sectional Controversy, 1847–1887" (Ph.D. diss., University of Virginia, 1968), 41–42; Stampp, *America in 1857,* 51.
87. Simpson, *Good Southerner,* 99, 157–63; Fisher, "Statesman of the Lost Cause," 147–77; Michael F. Holt, *The Political Crisis of the 1850s* (New York: John Wiley, 1978), 252.
88. Craven, *Growth of Southern Nationalism,* 290; Stampp, *America in 1857,* 280.
89. Simpson, *Good Southerner,* 158–59, 170–71.
90. Simpson, *Good Southerner,* 138, 158, 160.
91. Simpson, *Good Southerner,* 137–39.
92. Ginzberg, *Women and the Work of Benevolence,* 48–53. On Petigru in the nullification crisis, his redefinition of the status of corporations, and his work to help aggrieved women gain custody of their children, property and safety, see Pease and

Pease, *James Louis Petigru,* 35–67, 107, 129–34; on his personal relationship with the Cunninghams, see Mitchell, "Ann Pamela Cunningham," 17; on Southern jurists as "protectors of women," see Rable, *Civil Wars,* 11.

93. *Journal of the House of Delegates of the State of Virginia, for the Session of 1857–58* (Richmond: William F. Ritchie, 1857), 152.

94. Robert S. Holzman, *Adapt or Perish: The Life of General Roger A. Pryor, C.S.A.* (Hamden, Conn.: Anchor Books, 1976), 7–8, 101–3.

95. Holzman, *Adapt or Perish,* 21.

96. Cunningham, "Letter from the Founder," May 28, 1866, 10, MVLA Archives.

97. *Richmond South,* January 26, 1858.

98. *Richmond South,* February 2, 1858.

99. Thane, *Mount Vernon Is Ours,* 71.

100. *Richmond Enquirer,* January 30, 1858.

101. Cunningham, "Letter from the Founder," May 28, 1866, 10, MVLA Archives.

102. *Richmond South,* February 12, 1858.

103. *Richmond South,* February 19, 1858.

104. *Richmond South,* February 24, 1858.

105. Ibid.

106. The quotes to follow describing this event are drawn from accounts in the *Richmond Enquirer,* February 25, 1858, and the *Richmond South,* February 26, 1858.

107. DuBose, *William Loundes Yancy,* 353.

108. *Richmond Enquirer,* February 25, 1858; *Richmond South,* February 26, 1858.

109. *Journal of the House of Delegates, 1857–1858,* 437.

110. Cunningham, "Letter from the Founder," May 28, 1866, 10, MVLA Archives.

111. Thane, *Mount Vernon Is Ours,* 73; King, *Mount Vernon on the Potomac,* 54; Mitchell, "Ann Pamela Cunningham," 62.

112. *Journal of the House of Delegates, 1857–1858,* 463, 479.

113. Ann Pamela Cunningham in *Mount Vernon Record,* July 1858, 1.

114. Alexander, *Museum Masters,* 196, 184–86.

115. Dorothy Troth Muir, *Mount Vernon: The Civil War Years* (1946; reprint, Mount Vernon, Va.: MVLA, 1993), 8.

116. "The Home of Washington," *The Ladies' Repository,* March 14, 1859, quoted in Mark Edward Thistlethwaite, *The Image of George Washington: Studies in Mid-Nineteenth-Century American History Painting* (New York: Garland, 1979), 120.

117. *Home Journal,* 1859, quoted in Marling, *Washington Slept Here,* 79.

118. Susan Fenimore Cooper, *Mount Vernon: A Letter to the Children of America* (New York: D. Appleton, 1859), 68, 1. The daughter of James Fenimore Cooper was well known for her critically successful nature diary, *Rural Hours* (1850). See Nina Baym, *Woman's Fiction: A Guide to Novels by and about Women in America, 1820–1870* (Ithaca, N.Y.: Cornell University Press, 1978), 81–82.

119. Cooper, *Mount Vernon,* 16–18.

120. In fact, a fellow planter found fault with Washington for going out into the field with his "beautiful English hunting watch" to time "Cuffy" at work, a practice supposedly out of line with Southern ways. Louis Wigfall, a Carolinian, quoted in Bertram Wyatt-Brown, *Southern Honor: Ethics and Behavior in the Old South* (New York: Oxford University Press, 1982), 178. On Washington and agriculture, see Cunliffe, *Washington: Man and Monument*, 130–33.

121. Adams, "Education," 763.

122. Cooper, *Mount Vernon*, 68–70.

123. Forgie, *Patricide in the House Divided*, 160. See his chapter, "Sentimental Regression from Politics to Domesticity," 159–99. On "Washington Domesticated," see Thistlethwaite, *Image of George Washington*, 116–51.

124. Elizabeth Willard Barry, vice-regent from Illinois, in *Mount Vernon Record*, July 1859, p. 3.

125. Ann Pamela Cunningham in *Mount Vernon Record*, May 1859.

126. Ibid.

127. Mary Rutledge Fogg, vice-regent for Tennessee, to Ann Pamela Cunningham, October 20, 1858, MVLA Archives; Alice Nisbet (writing for Cunningham) to Margaret Comegys, vice-regent for Delaware, December 28, 1858, MVLA Archives.

128. Ann Pamela Cunningham, quoted in King, *Mount Vernon on the Potomac*, 79; Samuel Ruggles to Ann Pamela Cunningham, quoted in King, 63.

129. Mrs. C. A. Hopkinson to Ann Pamela Cunningham, February 15, 1859, MVLA Archives. The political content of this letter sheds light on the nature of similar documents that may have been selectively destroyed by both Cunningham and the vice-regents. See Thane, *Mount Vernon Is Ours*, 147.

130. Mary Goodrich, vice-regent for Connecticut, to Ann Pamela Cunningham, March 20, 1860, MVLA Archives.

131. King, *Mount Vernon on the Potomac*, 100.

132. *Mount Vernon Record*, March 1860, p. 168.

133. *Mount Vernon Record*, April 1860, p. 189.

134. Daniel W. Crofts, *Reluctant Confederates: Upper South Unionists in the Secession Crisis* (Chapel Hill: University of North Carolina Press, 1989), 269.

135. Mrs. Roger A. [Sarah] Pryor, *Reminiscences of Peace and War* (New York: Macmillan, 1905), 98.

136. Mary Rutledge Fogg, vice-regent for Tennessee, to Ann Pamela Cunningham, October 20, 1858, MVLA Archives.

137. Schwartz, *George Washington*, 195.

138. Richard N. Current, *Lincoln and the First Shot* (Philadelphia: J. B. Lippincott, 1963), 30–35; Ralph A. Wooster, *The Secession Conventions of the South* (Princeton: Princeton University Press, 1962), 139.

139. Current, *Lincoln and the First Shot*, 138–39.

140. Holzman, *Adapt or Perish*, 53–60.

141. Ann Pamela Cunningham to M. A. Comegys, January 25, 1861, MVLA Archives.

142. King, *Mount Vernon on the Potomac*, 125–26; Thane, *Mount Vernon Is Ours*, 272. On women running plantations during the war, see Rable, *Civil Wars*, 50–72; Drew Gilpin Faust, *Southern Stories: Slaveholders in Peace and War* (Columbia: University of Missouri Press, 1992), 127–28.

143. Ann Pamela Cunningham to Sarah Tracy, December 3, 1865, MVLA Archives; Thane, *Mount Vernon Is Ours*, 163–64; King, *Mount Vernon on the Potomac*, 121; Alexander, *Museum Masters*, 188.

144. King, *Mount Vernon on the Potomac*, 120–21.

145. Ibid. For her refusal to contribute to the war effort, see Ann Pamela Cunningham to Sarah Tracy, December 3, 1865, MVLA Archives.

146. Thane, *Mount Vernon Is Ours*, 203; Muir, *Mount Vernon*, 123.

147. Ann Pamela Cunningham to Sarah Tracy, December 3, 1865, MVLA Archives.

148. King, *Mount Vernon on the Potomac*, 207.

149. King, *Mount Vernon on the Potomac*, 121, quoting a letter of February 9, 1861.

150. King, *Mount Vernon on the Potomac*, 123–24.

151. King, *Mount Vernon on the Potomac*, 106–7; Muir, *Mount Vernon*, 60.

152. Paul Johnson, *Shopkeeper's Millennium*, 28–29.

153. Muir, *Mount Vernon*, 48.

154. David Paul Brown (a Philadelphia lawyer and Cunningham's friend) to Sarah Tracy, February 24, 1861, quoted in King, *Mount Vernon on the Potomac*, 132.

155. King, *Mount Vernon on the Potomac*, 138; Mary Hamilton to Sarah Tracy, June 11, 1861, MVLA Archives.

156. Muir, *Mount Vernon*, 49–50.

157. Muir, *Mount Vernon*, 27.

158. Late in the spring of 1861, Mount Vernon stood at the demarcation line between the two armies. Ernest B. Furgurson points out, "If Abraham Lincoln had ordered any of his many commanding generals to lead the Army of the Potomac in a straight line from the District of Columbia to the Confederate Capital of Richmond, his troops would have had to march directly across George Washington's plantation at Mount Vernon. Between April 1861 and April 1865, the Union army did everything but that." Furgurson, introduction to Muir, *Mount Vernon*, 28.

159. Muir, *Mount Vernon*, 49, quoting Sarah Tracy to Ann Pamela Cunningham, April 13, 1861; on Emma Willard, see Ann Firor Scott, *Natural Allies: Women's Associations in American History* (Urbana and Chicago: University of Chicago Press, 1991), 62–63.

160. Sarah Tracy to Ann Pamela Cunningham, May 11, 1861, quoted in Muir, *Mount Vernon*, 56.

161. Muir, *Mount Vernon*, 25–27, 31.

162. Muir, *Mount Vernon*, 63, 77–78.
163. On women's organizations and the war, see Scott, *Natural Allies*, 58–77. On the war's "masculinizing of the ideology of benevolence," see Ginzberg, *Women and the Work of Benevolence*, 133–73.
164. Thane, *Mount Vernon Is Ours*, 182–83.
165. Edward Everett to Mary Morris Hamilton, February 13, 1864, MVLA Archives.
166. Thane, *Mount Vernon Is Ours*, 251–58, 264–69, 271. Edward Everett to Mary Morris Hamilton, February 13, 1864; minutes of meeting of February 22, 1864; George Schuyler to Sarah Tracy, February 13, 1864; Mary Morris Hamilton to Sarah Tracy, February 15, 1864; Mary Morris Hamilton to M. A. Comegys, February 9, 1864, MVLA Archives.
167. Thane, *Mount Vernon Is Ours*, 331–46.
168. King, *Mount Vernon on the Potomac*, 174–79, 181–82; Mount Vernon Ladies' Association of the Union, *Historical Sketch of Ann Pamela Cunningham: "The Southern Matron"* (New York: Marion Press, 1911), 39–46.
169. King, *Mount Vernon on the Potomac*, 177.
170. Thane, *Mount Vernon Is Ours*, 366.
171. Thane, *Mount Vernon Is Ours*, 404, 410–44, 390–394.
172. Thane, *Mount Vernon Is Ours*, 410–444. The MVLA Archives contain a "Remonstrance to Ann Pamela Cunningham, Regent, by the Vice Regents," 1872, in which Cunningham is requested "to refrain from all interference with the administration" of MVLA finances, and it is stated that she "is never to reside at Mount Vernon or to publish anything in regard to the Association without the examination and consent of the Grand Council."
173. Ann Pamela Cunningham, "Farewell Address," quoted in MVLA, *Catalogue of the Centennial*, 5.
174. Alexander, *Museum Masters*, 194; Hosmer, *Presence of the Past*, 59, 57; Darlene Roth, *Matronage: Patterns in Women's Organizations, Atlanta, Georgia, 1890–1940* (Ann Arbor, Mich.: University Microfilms, 1978), 373.

2 ▪ *Gender Politics and the Orchard House Museum*

1. Paula Baker, "The Domestication of Politics: Women and American Political Society, 1780–1920," *American Historical Review* 89 (June 1984): 620–47.
2. For a more detailed discussion, see Patricia West, "The Historic House Museum Movement in America: Louisa May Alcott's Orchard House as a Case Study" (Ph.D. diss., State University of New York at Binghamton, 1992), 30–41.
3. U.S. Sanitary Commission, *A Record of the Metropolitan Fair* (New York: Hurd and Houghton, 1867), ix.
4. Northwestern Fair Committee, *History of the Northwestern Soldier's Fair* (Chicago: Dunlop, Sewell and Spalding, 1864), 14; *Metropolitan Fair*, 2.

5. *Metropolitan Fair,* 121–23; *Northwestern Soldier's Fair* (Chicago: Dunlop, Sewell, and Spalding 1864), 438–41. The term "curiosity shop" is drawn from the 1840–41 Dickens novel of the same name.

6. *Metropolitan Fair,* 72–86.

7. U.S. Sanitary Commission, *Memorial of the Great Central Fair* (Philadelphia: U.S. Sanitary Commission, 1864), 78.

8. See Rodris Roth, "The New England or 'Old Tyme' Kitchen at Nineteenth-Century Fairs," in *The Colonial Revival in America,* ed. Alan Axelrod (New York: W. W. Norton, 1985), 159–83.

9. *Metropolitan Fair,* 182–83.

10. Ibid.

11. *Metropolitan Fair,* 39.

12. Joel Orosz says the popularity of the history exhibits at the Sanitary Fairs reinforced in particular the American art museum's ideal of democratic access. See Joel Orosz, *Curators and Culture: An Interpretive History of the Museum Movement in America, 1773–1870* (Ann Arbor, Mich.: University Microfilms, 1987), 318. For an example of the relationship between the Sanitary Fair "colonial kitchens" and permanent period rooms, see Elizabeth Stillinger, *The Antiquers* (New York: Alfred A. Knopf, 1980), 125.

13. *Northwestern Soldier's Fair,* 46.

14. David Van Tassel, *Recording America's Past* (Chicago: University of Chicago Press, 1960), 181–90.

15. James M. Lindgren, *Preserving the Old Dominion: Historic Preservation and Virginia Traditionalism* (Charlottesville: University Press of Virginia, 1993), 4 and passim. On women's activities in particular, see Darlene Roth, *Matronage: Patterns in Women's Organizations, Atlanta, Georgia, 1890–1940* (Ann Arbor: University Microfilms, 1978), 46–47; Marli Weiner, "Filling in the Picture of Women in the Nineteenth-Century South," paper presented at the Seventh Berkshire Conference on the History of Women, Wellesley College, Wellesley, Massachusetts, June 20, 1987; Charles B. Hosmer, *Presence of the Past: A History of the Preservation Movement in America before Williamsburg* (New York: G. P. Putnam, 1965), 68–69.

16. On new ways of learning about fashionable parlor decorations, see Katherine C. Grier, *Culture and Comfort: People, Parlors, and Upholstery, 1850–1930* (Rochester, N.Y.: Strong Museum, 1988), 21–28. For an example of a popular publication describing historic houses, see Jan Cohn's discussion of William Cullen Bryant's 1872 *Picturesque America* in Jan Cohn, *The Palace or the Poorhouse: The American House as Cultural Symbol* (East Lansing: Michigan State University Press, 1979), 203–4.

17. See Karen Halttunen, *Confidence Men and Painted Women: A Study of Middle-Class Culture, 1830–1870* (New Haven: Yale University Press, 1982). One historian says that collectors in the 1870s understood their activities as a way of celebrating "the courage and vision of the Puritan forefathers." Stillinger, *Antiquers,* 50.

18. Robert W. Rydell, *All the World's a Fair: Visions of Empire at American International Expositions, 1876–1916* (Chicago: University of Chicago Press, 1984), 9–37; John G. Cawelti, "America on Display: The World's Fairs of 1876, 1893, 1933," in *The Age of Industrialism in America*, ed. Frederic Cople Jaher (New York: Free Press, 1968), 324–34; Neil Harris, *Cultural Excursions: Marketing Appetites and Cultural Tastes in Modern America* (Chicago: University of Chicago Press, 1990), 111–31; Karal Ann Marling, *George Washington Slept Here: Colonial Revivals in American Culture, 1876–1986* (Cambridge: Harvard University Press, 1988), 25–52.

19. William Rhoads, *The Colonial Revival* (New York: Garland Publishing, 1977), 56–63; Rodris Roth, "New England Kitchens," 177; Jeanne Weimann, *The Fair Women* (Chicago: Academy Press, 1981), 396–97.

20. Russell Lynes, *The Tastemakers* (New York: Grosset and Dunlap, 1954), 112–17; Charles Hosmer, *Presence of the Past*, 81.

21. Laurence Vail Coleman, *Historic House Museums* (Washington, D.C.: American Association of Museums, 1933), 18; Charles Hosmer, *Presence of the Past*, 57; Lewis Barrington, *Historic Restorations of the Daughters of the American Revolution* (New York: Richard R. Smith, 1941), i.

22. Charles Hosmer, *Presence of the Past*, 59, 69–70; Coleman, *Historic House Museums*, 18.

23. Mary Mann Page Newton, "The Association for the Preservation of New England Antiquities," *American National Register* (September 1894): 9, 12, quoted in Marling, *Washington Slept Here*, 92–93.

24. James M. Lindgren, "'Virginia Needs Living Heroes': Historic Preservation in the Progressive Era," *Public Historian* 13 (winter 1991): 9–24. Mary Galt is quoted on p. 16, and Cynthia Coleman is quoted on p. 12. For an incisive, full-length treatment of this subject, see Lindgren, *Preserving the Old Dominion*.

25. Charles Hosmer, *Presence of the Past*, 65–68. The word "shrine" was removed in the mid-1980s. See Barbara J. Howe, "Women in Historic Preservation: The Legacy of Ann Pamela Cunningham," *Public Historian* 12 (winter 1990): 35.

26. Coleman, *Historic House Museums*, 18.

27. For example, see David Glassberg, *American Historical Pageantry: The Uses of Tradition in the Early Twentieth Century* (Chapel Hill: University of North Carolina Press, 1990); Stillinger, *Antiquers*, 49–51 and passim.

28. Michael Wallace, "Visiting the Past: History Museums in the United States," in *Presenting the Past: Essays on History and the Public*, ed. Susan Porter Benson, Stephen Brier, and Roy Rosenzweig (Philadelphia: Temple University Press, 1986), 141. The "revolution in identity" of the era's "new middle class" is discussed in Robert Weibe, *The Search for Order, 1877–1920* (New York: Hill and Wang, 1967), 111–32.

29. Senator Sherman, quoted in Mary S. Lockwood and Emily Lee Sherwood, *Story of the Records, D.A.R.* (Washington, D.C.: George E. Howard, 1906), 13–14.

30. Mary Lockwood, *Washington Post*, July 13, 1890, quoted in Lockwood and Sherwood, *Story of the Records*, 13–14.

31. See Barrington, *Historic Restorations*, passim.

32. Lockwood and Sherwood, *Story of the Records*, 24.

33. See Charles Hosmer, *Presence of the Past*, 299. By the early twentieth century, the Sons of the Revolution was directing half of its funds toward Americanization. John Higham, *Strangers in the Land: Patterns of American Nativism, 1860–1925* (New York: Atheneum, 1968), 237.

34. Lockwood and Sherwood, *Story of the Records*, 116.

35. Elizabeth Bryant Johnson, *American Monthly Magazine* (June 1898), quoted in Lockwood and Sherwood, *Story of the Records*, 45. The DAR's most infamous forays in the realm of "Americanism" would come in the early twentieth century, with its role in the post–World War I red scare, its attack on Jane Addams, and its vigorous pursuit of immigration restriction. See Martha Strayer, *The D.A.R.: An Informal History* (Washington, D.C.: Public Affairs Press, 1958), 68–69, 34, 57–66.

36. Mrs. Cornelia Fairbanks, quoted in Lockwood and Sherwood, *Story of the Records*, 86.

37. Mary Desha, *American Monthly Magazine* 12 (May 1898), 843, quoted in Charles Hosmer, *Presence of the Past*, 133.

38. Charles Hosmer, *Presence of the Past*, 138–39.

39. See Michael Kammen, "The Rediscovery of New York State History, Phase One," *New York History* 60 (October 1979): 381.

40. The National Society of Colonial Dames in America, *A Summary of the Histories of the National Society of the Colonial Dames and of the Corporate Societies, 1891–1962* (NSCDA, 1962), quoted in Darlene Roth, *Matronage*, 117.

41. Barrington, *Historic Restorations*, i–ii.

42. See Barrington, *Historic Restorations*, passim.

43. For another interpretation of why women's preservation efforts served to support "the male system," see Darlene Roth, *Matronage*. Roth argues that beneath this "public face" of Atlanta women's organizations was a "private face" of female self-congratulation and pride. The women in Roth's study used male memorialization and other club-oriented efforts as a vehicle for participation in the public realm.

44. "Chapters," *American Monthly Magazine* 5 (August 1894): 193–94, quoted in Wallace Evan Davies, *Patriotism on Parade: The Story of Veterans' and Hereditary Organizations in America, 1783–1900* (Cambridge: Harvard University Press, 1955), 284.

45. Marion Tinling and Linda Ruffner-Russell, "Famous and Forgotten Women," *Historic Preservation* 28 (July–September 1976): 14–19.

46. See Davies, *Patriotism on Parade*, 218–21. In the late nineteenth century, Flag Day was established (1893), public schools began to require a daily "salute" to the flag,

and in 1898 patriotic organizations lobbied for federal legislation banning dese-
cration of the flag. The effort failed on the national level but was successful in
some states. For an interesting discussion of the meaning of the Betsy Ross myth,
see Michael Frisch, "American History and the Structure of Collective Memory:
A Modest Exercise in Empirical Iconography," *Journal of American History* 75
(March 1989): 1146–1150.

47. See Charles Hosmer, *Presence of the Past*, 88–91; Marling, *Washington Slept Here*,
17–20; and Addie Guthrie Weaver, *The Story of Our Flag, Colonial and National,
with Historical Sketch of the Quakeress Betsy Ross* (Chicago: The Author, 1890), 75.
On the museum's current interpretation, see James Mayo, *War Memorials as
Political Landscape* (New York: Praeger, 1988), 69.

48. See Reid Badger, *The Great American Fair: The World's Columbian Exposition and
American Culture* (Chicago: Nelson Hall, 1979); Rydell, *All the World's a Fair*,
38–71; Neil Harris, *Cultural Excursions*, 111–31; Cawelti, "America on Display,"
334–46; and Marling, *Washington Slept Here*, 151–56. For a lengthier discussion of
the Columbian Exposition, see West, "Historic House Museum Movement,"
53–56.

49. This was, of course, white women's history; the subject of African-American
women's history was excluded from the exposition altogether. The reformer Ida
Wells-Barnett was one of the coauthors of a booklet distributed at the fair de-
nouncing this exclusion, in which Frederick Douglass called the exposition's
White City a "whited sepulcher." See Paula Giddings, "Ida Wells-Barnett," in
Portraits of American Women, ed. G. J. Barker-Benfield and Catherine Clinton
(New York: St. Martin's Press, 1991), 379; Badger, *Great American Fair*, 105–6;
Weimann, *Fair Women*, 121–24.

50. Lockwood and Sherwood, *Story of the Records*, 35–36; Lockwood quoted in
Weimann, *Fair Women*, 504. The Centennial had not been entirely free of con-
troversy. Male organizers refused to allow the Seneca Falls Declaration of Senti-
ments to be read at the opening ceremony, but Susan B. Anthony, Matilda J.
Gage, Sara Spencer, Lily Blake, and Phoebe Couzins marched to the podium and
presented it to the master of ceremonies as a protest, distributing copies as they
retreated. Badger, *Great American Fair*, 79. On women and the Columbian Expo-
sition, see Badger, 79–80, 101–2, 120–22.

51. Juliet Corson, "The Evolution of the Home," in *The Congress of Women Held at the
Woman's Building, World's Columbian Exposition*, ed. Mary K. O. Eagle (Chicago:
Monarch, 1894), 718.

52. Rhoads, *Colonial Revival*, 125–34; Mary Stewart Smith, "The Virginia Woman
of Today," in Eagle, *Congress of Women*, 411.

53. See Polly Wynn Allen, *Building Domestic Liberty: Charlotte Perkins Gilman's
Architectural Feminism* (Amherst: University of Massachusetts Press, 1988), 23.

54. The DAR did have its short-lived Progressive moment. It supported the Chil-
dren's Bureau, child labor legislation, tenement reform, and the betterment of

working conditions, until the red scare mobilized its reactionary tendencies. See Strayer, *D.A.R.: Informal History*, 90–92.

55. Robert L. Ables, "Adina De Zavala," in *Keepers of the Past*, ed. Clifford Lord (Chapel Hill: University of North Carolina Press, 1965); Charles Hosmer, *Presence of the Past*, 127; Rheta Childe Dorr, *What Eight Million Women Want* (1910; reprint, New York: Kraus Reprint, 1971), 39.

56. Julia Collier Harris, "The Winning of the Wren's Nest," in *The Life and Letters of Joel Chandler Harris* (Boston, 1918), 601, quoted in Darlene Roth, "Feminine Marks on the Landscape: An Atlanta Inventory," in *American Material Culture: The Shape of Things around Us*, ed. Edith Mayo (Bowling Green, Ohio: Bowling Green State University Popular Press, 1984), 83.

57. Mrs. Booker T. Washington, "Club Work among Negro Women," in *Progress of the Race*, ed. J. W. Gibson, J. L. Nichols, and W. H. Crogman (Napierville, Ill.: n.p., 1920), 181, quoted in Darlene Roth, *Matronage*, 373.

58. Caroline O. Emmerton, *The Chronicles of Three Old Houses* (Boston: Thomas Todd, 1935), 39.

59. Cynthia Barton, *History's Daughter: The Life of Clara Endicott Sears, Founder of the Fruitlands Museums* (Harvard, Mass.: Fruitlands Museums, 1988), 63–67, 75–76.

60. *New York Times*, March 23, 1902, p. 24, quoted in Kammen, "Rediscovery," 383.

61. Charles Hosmer, *Presence of the Past*, 91–101; Robert E. Stipe and Antoinette J. Lee, eds., *The American Mosaic: Preserving a Nation's Heritage* (Washington, D.C.: U.S. Committee, International Council on Monuments and Sites, 1987), 156. American Scenic and Historic Preservation Society, *Twenty-Fourth Annual Report to the Legislature of the State of New York* (Albany, N.Y.: J. B. Lyon, 1919), 41–43, 358.

62. Lawrence W. Levine, *Highbrow/Lowbrow: The Emergence of Cultural Hierarchy in America* (Cambridge: Harvard University Press, 1988), 146–58.

63. Edward S. Morse, "If Public Libraries, Why Not Public Museums?" *Atlantic Monthly* (July 1893): 774, quoted in Daniel M. Fox, *Engines of Culture: Philanthropy and Art Museums* (Madison: State Historical Society of Wisconsin, 1963), 16–17.

64. Stillinger, *Antiquers*, 126–28, Kammen, "Rediscovery," 393–94. The artifacts in the 1909 Metropolitan Fair exhibit, held as part of the Hudson–Fulton celebration, were eventually donated to the museum by Mrs. Russell Sage. This collection formed the core of the American Wing.

65. The definitive work on the SPNEA is James M. Lindgren, *Preserving Historic New England: Preservation, Progressivism, and the Remaking of Memory* (New York: Oxford University Press, 1995).

66. C. R. Ashbee, *A Report by Mr. C. R. Ashbee to the Council of the National Trust for Places of Historic Interest and Natural Beauty on His Visit to the United States* (London: Essex House Press, 1901), cited in Charles Hosmer, *Presence of the Past*, 302; C. R. Ashbee, *American Sheaves and English Seed Corn: Being a Series of Addresses*

Delivered in the United States, 1900–1901 (New York: Samuel Buckley, 1901), 9. Ashbee commented on a range of different preservation organizations, including the Massachusetts Trustees of Public Reservations, the Society of Colonial Dames, the DAR, and the MVLA.

67. Ashbee, *American Sheaves*, 1; Fanny C. Stone to William Sumner Appleton, April 26, 1910, quoted in Charles Hosmer, *Presence of the Past*, 240.

68. Stillinger, *Antiquers*, 125; Charles Hosmer, *Presence of the Past*, 193. Michael Wallace calls this new generation "nouveaux preservationists" from "the professional and managerial strata," who were "summoned into being by corporations and government bureaucracies." His interpretation of subsequent developments differs from mine in that he sees these men as working "alongside the corps of ladies" who had been responsible for historic preservation until this time. I see them as generally having taken primary control from the "ladies." See Michael Wallace, "Reflections on the History of Historic Preservation," in Benson, Brier, and Rosenzweig, *Presenting the Past*, 170–71.

69. Anne Farnam, "A Great Nineteenth Century Museum Survives: The Essex Institute of Salem," *Nineteenth Century* 5 (1979): 76–81; Charles Hosmer, *Presence of the Past*, 216. Christopher Monkhouse has pointed out that the "colonial" period rooms at the Pocumtuck Valley Memorial Association's Memorial Hall at Deerfield, Mass., predated those of the Essex Institute. Established in 1880, the exhibit featured a "colonial kitchen," bedroom, and parlor, as well as a "domestic room" displaying spinning and weaving equipment. Christopher Monkhouse, "The Spinning Wheel as Artifact, Symbol, and Source of Design," in *Victorian Furniture*, ed. Kenneth L. Ames (Philadelphia: Victorian Society, 1982), 157.

70. Constance Greiff, *Independence: The Creation of a National Park* (Philadelphia: University of Pennsylvania Press, 1987), 36–37, 221; Charles Hosmer, *Presence of the Past*, 87–88. The site was taken over by the National Park Service in 1951, after which the DAR simply donated funds for the NPS to administer the building.

71. Elizabeth G. Grossman and Lisa B. Reitzes, "Caught in the Crossfire: Women and Architectural Education, 1880–1910," in *Architecture: A Place for Women*, ed. Ellen Perry Berkeley and Matilda McQuaid (Washington, D.C.: Smithsonian Institution Press, 1988), 27–39.

72. See Gail Lee Dubrow, "Restoring a Female Presence: New Goals in Historic Preservation," in Berkeley and McQuaid, *Architecture*, 159–70. This decrease accelerated into the early twentieth century. On women in nineteenth-century architecture, see Lamia Doumato, "Louisa Tuthill's Unique Achievement: First History of Architecture in the U.S.," and Lisa Koenigsberg, "Mariana Van Rensselaer: An Architectural Critic in Context," in Berkeley and McQuaid, *Architecture*, 5–13, 41–54.

73. Coleman, *Historic House Museums*, 88.

74. Arthur C. Parker, *A Manual For History Museums* (New York: Columbia University Press, 1935), 37.

75. On the British Ancient Monuments Act and subsequent amendments to it, see Norman Williams, Edmund Kellogg, and Frank Gilbert, *Readings in Historic Preservation* (New Brunswick, N.J.: Rutgers University Press, 1983), 26–27, 100; and Robert Hewison, *The Heritage Industry: Britain in a Climate of Decline* (London: Methuen, 1987), 25. On the Antiquities Act, see Hal Rothman, *Preserving Different Pasts: The American National Monuments* (Chicago: University of Illinois Press, 1989).

76. Rothman, *Preserving Different Pasts*, xiii–xv, 85–87.

77. See Edwin C. Bearss, "The National Park Service and Its History Program, 1866–1986," *Public Historian* 9 (spring 1987): 10–18; and Harlan D. Unrau and G. Frank Williss, "To Preserve the Nation's Past: The Growth of Historic Preservation in the National Park Service during the 1930s," *Public Historian* 9 (spring 1987): 19–49.

78. Renee Garrelick and William Bailey, *Concord in the Days of Strawberries and Streetcars* (Concord, Mass.: Concord Historical Commission, 1985), 149, 25–27. Until later in the twentieth century, the cost of commuting from work in Boston to an outlying community such as Concord was prohibitive to the average worker, and day travel was a mark of privilege. The workers who serviced the towns lived near the station. The term "streetcar suburb" was coined by Sam Bass Warner in *Streetcar Suburbs: The Process of Growth in Boston, 1870–1900*, 2d ed. (Cambridge: Harvard University Press, 1978). See also Kenneth T. Jackson, *Crabgrass Frontier: The Suburbanization of the United States* (New York: Oxford University Press, 1985), 101.

79. Concord's first Catholic parish was established during the Civil War in a deserted Universalist church on Bedford Street. Previously, the immigrants either walked eleven miles to church in Waltham, or the Waltham priest came to serve Mass in the town hall. When the selectmen withdrew permission to use the hall, Catholics had to hold their services at a private home beside the green. Efforts were made to block their purchase of the old church, and only "the patriotism and sacrifices of Concord's Irish soldiers helped to reconcile the town to this innovation of a church with a crucifix." Alcott herself reflected the common Yankee prejudice in *Little Women*, designating Irish children in particular as the "sworn foes" of Amy March and her friends. Garrelick and Bailey, *Concord*, 25–26, 147–90; Townsend Scudder, *Concord: American Town* (Boston: Little, Brown, 1947), 289; Louisa May Alcott, *Little Women* (1868, 1869; reprint, New York: New American Library, 1982), 65. All subsequent references are to this edition.

80. The American Protective Association, a nativist organization whose recruits vowed never to vote for a Catholic, attempted to hold its 1894 meeting in the town hall with the support of some of Concord's citizens. Since the APA's train had to enter Concord Junction, the delegates were met with epithets and brickbats. Garrelick and Bailey, *Concord*, 152–54; John Higham, *Strangers in the Land: Patterns of American Nativism, 1860–1925* (New York: Atheneum, 1968), 62. Accord-

ing to Higham, the 1893 depression pushed the APA to its apogee in 1894, when its membership reached about half a million people.

81. Garrelick and Bailey, *Concord,* 149. Of the 99 births in Concord in 1909, 38 were of native parentage, 39 of foreign, and 22 of mixed parentage. By the following year, the town had ceased reporting these particular statistics altogether. *Concord Town Report,* 1909–10, 270. Concord owes its long tradition of collecting vital statistics to Lemuel Shattuck's nineteenth-century efforts (he eventually founded the American Statistical Association). See Daniel Boorstin, *The Americans: The Democratic Experience* (New York: Vintage, 1974), 169–70.

82. "Louisa May Alcott Home Now Restored," *Boston Post,* May 29, 1912.

83. Concord Woman's Club minutes, vol. 1, 1922, Concord Free Public Library, Concord, Mass.

84. Henry Adams, "The Education of Henry Adams" (1907), in *Democracy, Esther, Mont St. Michel and Chartres, The Education of Henry Adams,* ed. Ernest Samuels and Jayne N. Samuels (New York: Library of America, 1983), 938; T. J. Jackson Lears, *No Place of Grace: Antimodernism and the Transformation of American Culture, 1880–1920* (New York: Pantheon, 1981), xv.

85. One of the highlights of the day was the dedication of Daniel Chester French's "Minuteman" statue. In an attempt to link past with future, the celebrants had installed in the pedestal of the statue a "hermetically sealed copper box," containing items such as a town report for 1874, coins, stamps, a history of Concord, and some "newspapers of the day." *Proceedings at the Centennial Celebration of Concord Fight, April 19, 1875* (Concord, Mass.: Published by the Town, 1876), 63, 16. See also Scudder, *Concord: American Town,* 265–76. On Centennial celebrations, see Glassberg, *American Historical Pageantry,* 9–40.

86. George Keyes and Frederic Hudson, fathers of Bessie Keyes Hudson and Woodward Hudson, discussed below.

87. *Proceedings,* 31.

88. This was a line from a James Russell Lowell poem, written expressly for the occasion; it continued: "Our fathers found her in the woods/Where Nature meditates, and broods/The seed of unexamined things/Which Time to consummation brings." *Proceedings,* 133–34, 82–88.

89. All quotations from Louisa May Alcott, "The Concord Centennial: Unofficial Incidents Overlooked by the Reporters," unpaginated reprint from *Woman's Journal,* May 1, 1875, published in pamphlet form by the Orchard House museum, Concord, Mass.

90. On the colonial costumes of the "splendid" ball, see Scudder, *Concord: American Town,* 276.

91. In fact, Lucy Stone addressed a suffrage rally held in response to the incident. See Harriet Robinson, *Massachusetts in the Woman Suffrage Movement* (Boston: Roberts Brothers, 1881), 225–27. This incident was not the only revelation of a less than perfect consensus over the meaning of participation in the Centennial. The

published proceedings of the ceremony included contending interpretations in the form of replies to invitations that had been issued by the town to national dignitaries. Frederick Douglass declined to attend, but wrote of the significance of commemorating "a liberty in presence of which no privileged classes of wealth or religion, race or color, can long endure." William L. Garrison also declined because "as an advocate of peace, in a very radical sense, it would not be consistent for me to glory in the shedding of human blood," but he added that it was important to reflect upon "lessons of justice not yet enforced, equal rights still denied, of national unity not yet attained." Alternatively, Historian George Bancroft thought the celebration would recommend "the true art of colonization to the world." *Proceedings*, 147, 153, 152.

92. *Proceedings*, 64.

93. *Proceedings*, 112–16. Curtis, formerly of Brook Farm and friend of architectural reformer Andrew Jackson Downing, had for many years published a column in *Harper's* called "The Easy Chair," which sought to refine the aesthetic and decorative tastes of the readership. He apparently appreciated Concord's domestic heritage, as he wrote sections celebrating the Hawthorne and Emerson houses in various writers, *Homes of American Authors* (New York: G. P. Putnam, 1853). Russell Lynes, *The Tastemakers* (New York: Grosset and Dunlap, 1954), 109–10, 344; Scudder, *Concord: American Town*, 275; Rhoads, *Colonial Revival*, 40. On Centennial orations generally, see Glassberg, *American Historical Pageantry*, 9–14.

94. DAR, *Report*, 1906, p. 23, quoted in Higham, *Strangers in the Land*, 237.

95. Barrington, *Historic Restorations*, 20; Mary Fenn, *Old Houses of Concord* (Concord, Mass.: Old Concord Chapter of the Daughters of the American Revolution, 1974), 6. A memorial to Ephraim Bull, who had developed the Concord grape, was dedicated in 1900.

96. Lockwood and Sherwood, *Story of the Records*, 309–14. By 1900 there were more than ten thousand CAR members; its membership peaked in 1924 at about twenty-four thousand. The organization's most notorious phase was marked by its 1930s battle against "subversive" history textbooks. See Strayer, *D.A.R.: Informal History*, 71, 74–76, 189–205.

97. Davies, *Patriotism on Parade*, 298–99, citing the DAR, *Report, 1890–1897* (Washington, D.C., 1899), 43, and *Third Report, 1898–1900* (Washington, D.C., 1901), 49.

98. This urgency reflected the playground's movement's roots in G. Stanley Hall's theory that child development paralleled the development of "races," and that play was necessary to release lower "animal energies." The issue of a municipal playground continued to be debated in Concord town meetings, along with the controversial addition of "the much-discussed commercial course in the high school" which became "an ever-present question." *Concord Enterprise*, March 5, 1913, July 20, 1910, June 7, 1911, April 5, 1911; Dorr, *What Eight Million Women Want*, 36; Allen F. Davis, *Spearheads for Reform: The Social Settlements and the Pro-*

gressive Movement, 1890–1914 (1967; reprint, New Brunswick, N.J.: Rutgers University Press, 1984), 60–65. On the relationship between the playground movement and popular history, see Glassberg, *American Historical Pageantry*, 52–64. On the role of women in the establishment of playgrounds, see Mary Ritter Beard, *Woman's Work in Municipalities* (New York: D. Appleton, 1916), 133–39.

99. The instructors were to instill "the principles of piety and justice and a sacred regard for truth, love of their country, humanity and universal benevolence, sobriety, industry and frugality, chastity, moderation and temperance, and those other virtues which are the ornament of human society and the basis upon which a republican constitution is founded." Wells A. Hall in *Concord Town Reports 1910–1911*, 37, citing Section 18, Chapter 42, of the Public School Statutes of Massachusetts.

100. "It is believed that the child should be trained in practical morality. . . . Obedience should be willing, cheerful, and immediate," "Character Development," *Concord Enterprise*, January 18, 1911.

101. For a contemporary discussion of the Tenement House Act, see Prescott Hall, "The Menace of the Three-Decker," in *Housing Problems in America* (New York: National Housing Association, 1916), 133–52. Concord's vote on adoption of the act is documented in the *Concord Town Report 1914–15*, 18. The new regulations, specifying codes for building strength, form, and fire resistance, were published in the *Concord Enterprise*, May 15, 1915.

102. *Concord Enterprise*, March 5, 1913. Earlier successes in the regulation of home building were achieved in part through deed restrictions; for example, the sale of properties on Elm Street in 1897 stipulated that "no dwelling-house shall be erected or placed upon either of said lots which costs less than $4500 above the foundation." "At Old Concord," Concord Free Public Library Pamphlet 57, Item 31. This regulatory method was apparently not applied to industrial West Concord. There immigrant families were often crowded into apartments. Garrelick and Bailey, *Concord*, 167.

103. Albert E. Wood, *The Plantation at Musketequid* (Concord, Mass.: Concord Antiquarian Society, 1902), 25.

104. Josephine Latham Swayne, ed., *The Story of Concord Told by Concord Writers* (Boston: E. F. Worcester Press, 1906), 290–91.

105. This tendency was also no doubt supported by exposure to the impressive collection of colonial artifacts gathered by Cummings Elsthan Davis, which later in the century formed the core of the Concord Antiquarian Society museum. See Nancy Dodge Hartford, "The Concord Antiquarian Society and its Museum," *Magazine Antiques* (December 1974). Bessie Hudson, "A Century of Concord Homes," 1936, Pamphlet 57, Concord Free Public Library, Concord, Mass.

106. Theodore Wolfe, *Literary Shrines: The Haunts of Some Famous American Authors* (Philadelphia: J. B. Lippincott, 1895), 18.

107. Albert Wood, *Plantation at Musketequid*; Garrelick and Bailey, *Concord*, 154.

108. Louisa May Alcott to *Woman's Journal,* February 4, 1882, in *The Selected Letters of Louisa May Alcott,* ed. Joel Myerson, Daniel Shealy, and Madeleine B. Stern (Boston: Little, Brown, 1987), 257.

109. See Karen J. Blair, *The Clubwoman as Feminist: True Womanhood Redefined, 1868–1914* (New York: Holmes and Meier, 1980); Nancy Woloch, *Women and the American Experience* (New York: Alfred A. Knopf, 1984), 290; Frances Willard, quoted in Woloch, 287. For a discussion of the educational and sororal focus of nineteenth-century women's clubs, see Theodora Penny Martin, *The Sound of Their Own Voices: Women's Study Clubs, 1860–1910* (Boston: Beacon Press, 1987).

110. Mary I. Wood, *The History of the General Federation of Women's Clubs* (New York: Norwood Press, 1912), 312. See a similar statement in an editorial in *Federation Bulletin* 4 (June 1907): 326, quoted in William O'Neill, *Everyone Was Brave: The Rise and Fall of Feminism in America* (New York: Quadrangle Books, 1969), 89. As early as 1897, the Massachusetts State Federation had articulated women's role in the conservation of the natural world as well. This was a GFWC-wide phenomenon by the early twentieth century. See Jane Cunningham Croly, *The History of the Woman's Club Movement in America* (New York: Henry G. Allen, 1898), 594, 596; Mary Wood, *History of the GFWC,* 209; Mildred White Wells, *Unity in Diversity: The History of the General Federation of Women's Clubs* (Washington, D.C.: GFWC, 1953), 195.

111. Mary Wood, *History of the GFWC,* 23–26.

112. Wells, *Unity in Diversity,* 183.

113. Mary Wood, *GFWC,* 308.

114. Croly, *Woman's Club Movement in America,* 79–80.

115. Mary Wood, *History of the GFWC,* 309–10; New Hampshire Federation of Woman's Clubs, *Yearbook, 1907–8,* 29, cited in Blair, *Clubwoman as Feminist,* 106.

116. Croly, *Woman's Club Movement in America,* 614; Concord Massachusetts Woman's Club Yearbooks, 1899–1912, Concord Free Public Library, Concord, Mass.

117. Gladys Hosmer, "Looking Backward: 1895–1955," Concord Woman's Club Records, Concord Free Public Library, Concord, Mass., 1. Hosmer said the club had 184 members by 1895.

118. Concord Woman's Club Yearbooks, 1899–1912.

119. *Concord Enterprise,* January 29, 1910; Gladys Hosmer, "Looking Backward," 4.

120. *Concord Enterprise,* March 22, 1911; Concord Woman's Club Yearbooks, 1899–1912; Wendy Kaplan, "The Lamp of British Precedent: An Introduction to the Arts and Crafts Movement," in *"The Art That Is Life": The Arts and Crafts Movement in America,* ed. Wendy Kaplan (Boston: Little, Brown, 1987), 56–57; C. R. Ashbee, *American Sheaves,* 5. See also Rhoads, *Colonial Revival,* 411–12.

121. Asked about the "suffragettes," she responded that they were "considered a menace to safety and most unpatriotic." *Concord Enterprise,* March 27, 1912.

122. *Concord Enterprise,* February 26, 1913. According to Henry Feingold, this Zang-

will play became enormously popular among "uptowners" because it argued that "the sooner the new immigrants would give up their cultural characteristics and melt into the undifferentiated mass, the sooner anti-semitism would disappear." Henry L. Feingold, *Zion in America: The Jewish Experience from Colonial Times to the Present* (New York: Hippocrene Books, 1974), 147. In contrast to some of the other influences on the CWC, Zangwill was prosuffrage. See National American Woman Suffrage Association, *Woman Suffrage Arguments and Results, 1910–1911* (1912; reprint, New York: Kraus Reprint, 1971), 41–42. The play was also performed at Hull House. See Rivka Shpak Lissak, *Pluralism and the Progressives: Hull House and the New Immigrants, 1890–1919* (Chicago: University of Chicago Press, 1989), 46.

123. This was presented by Mrs. George Mellen. *Concord Enterprise*, January 27, 1915.

124. Harriett Lothrop to Miss Young, March 13, 1901; Lothrop Papers, National Park Service, Minuteman National Historical Park, Concord, Mass.

125. *Boston Herald*, December 8, 1907.

126. She went on to outline the types of women who should lend support for the project, from housewives ("for who can read her life and not see what a gift she had for making home and life comfortable for those about her?") to "all sisters and mothers, for a more devoted daughter and sister never lived." *Boston Herald*, June 28, 1910.

127. William Sumner Appleton and the SPNEA trustees declined to act "not because they doubted the merits of the case, but because they were convinced ample help would be forthcoming." Appleton only preserved those houses for which no immediate local support was pending, and by early 1911, the CWC's interest in the project was confirmed. Mrs. Stella Morse Livsey to Alice Longfellow and Appleton, SPNEA, August 16, 1910, SPNEA Archives, Boston, Mass.; SPNEA *Bulletin* 5 (April 1914): 18. For an important interpretation of the SPNEA, see James M. Lindgren, *Preserving Historic New England: Preservation, Progressivism and the Remaking of Memory* (New York: Oxford University Press, 1995).

128. The club recorded discussion of the idea as early as January 1911. Harriett Lothrop addressed the October meeting. Concord Woman's Club Minutes, 1911–12, vol. 1, p. 30, Concord Free Public Library, Concord, Mass.

129. Lothrop to Miss Young, March 13, 1901, Lothrop Papers.

130. John S. Pratt Alcott, "The 'Little Women' of Long Ago," *Good Housekeeping*, February 1913, 187. Lothrop's price was not unreasonable, however, based on a 1910 appraisal by the Concord Board of Assessors that gave the house a value of $700 dollars and the land a value of $3,600. Erastus H. Smith, chairman, Concord Board of Assessors, to William Sumner Appleton, SPNEA, November 15, 1910, SPNEA Archives, Boston, Mass.

131. The *Christian Science Monitor* of May 28, 1912, reported that the cost of repairs was $2,500 and the purchase price $3,000; this is affirmed by Gladys Hosmer, "Looking Backward," 5. An unpublished in-house chronology of the life of Har-

riett Lothrop documents Wayside historian Robert Derry's finding that the Orchard House deed says the price was $1. See Robert Derry, "Harriett Mulford Stone Lothrop," Wayside, Minuteman National Historical Park, National Park Service, Concord, Mass.

132. *Concord Journal,* April 14, 1955.

133. Personal interview with Jayne Gordon, then–executive director of Orchard House, February 3, 1989.

134. The charter members of the Louisa May Alcott Memorial Association were Abby Rolfe (president), Edith M. Robb, Mabel W. Ballou, Russell Robb, Bessie K. Hudson, Woodward Hudson, Elizabeth M. Darling, Laura P. Furber, Henry F. Smith Jr., Margaret Blanchard Smith, George P. Furber, Charles R. Darling, Anne H. Burrill, and Carrie M. Hoyle. The incorporation agreement was signed in April 1911.

135. She was the daughter of a wealthy Connecticut architect, Sidney Stone. Lothrop's popular stories of "the five little Peppers" were published under the pen name of Margaret Sidney because her father disapproved of women as professional writers. Undaunted, she serialized her stories in the children's periodical *Wide Awake* in the 1880s, and in 1881, she married its publisher, Daniel Lothrop. Along with his work as a publisher of children's books, Daniel Lothrop became known in the following decade as the founder of the American Institute of Civics, an organization dedicated to strengthening popular knowledge of civic obligations. Doris Fanelli, *Historic Furnishings Plan: The Wayside* (Harpers Ferry, W.Va.: National Park Service, 1983), 43. On the American Institute of Civics, see Barbara Miller Solomon, *Ancestors and Immigrants: A Changing New England Tradition* (Cambridge: Harvard University Press, 1956), 84.

136. Margaret Lothrop, *The Wayside: Home of Authors* (New York: American Book, 1968), 3. Margaret Lothrop was the only child of Harriett and Daniel Lothrop.

137. Lothrop to Young, March 13, 1901, Lothrop Papers. Sam Bass Warner notes that by this time, the country towns around Boston were "inundated by commuters." Warner, *Streetcar Suburbs,* 3.

138. Wolfe, *Literary Shrines,* 60.

139. Lothrop (Margaret Sidney, pseudonym), *Old Concord: Her Highways and Byways* (Boston: D. Lothrop, 1893), 56, 107.

140. Lothrop, *Old Concord,* 41–43.

141. In this, the book's most dramatic and frightening scene, the youngest Pepper girl is stolen by a malevolent organ grinder, whose only contact with the Peppers has been to cast aside in disgust an offer of a share in their too-humble meal of brown bread and cold potatoes. The child is eventually rescued by a wealthy boy named King and his dog, Prince. The poor but proud Peppers turn out to be distant relatives of Jasper "Jappy" King and are upper-class by the end of the book. Nonetheless, the message is clear: The virtuous American family, however displaced by "temporary" status loss, was being aggressively and deliberately threatened by

outsiders. Harriett Lothrop [Margaret Sidney, pseudonym], *Five Little Peppers and How They Grew* (1880; reprint, New York: Scholastic, 1989), 91–99.

142. For example, Lothrop's novel opens in a "little brown house," the mother out working while the children grumble about their poverty, cheering themselves by planning to make a cake for "mamsie's" birthday. The father is absent. Prominent incidents include the children's bout with the measles and a gift from a rich Dr. Fisher of a longed-for new stove for Polly Pepper. *Little Women* opens in a little brown house, the mother away at work, the children complaining about poverty and planning to give "Marmee" Christmas gifts. Key incidents are a bout with smallpox and the gift by a wealthy Mr. Laurence of a longed-for piano for Beth. Lothrop's novel includes many other similarities to *Little Women*, including Polly Pepper's forgetting to feed her pet bird, the charming of motherless "Jappy" King's curmudgeonly father by little Phronsie, and so on. Quoted is Thomas Beers, *The Mauve Decade* (1926; reprint, New York: Random House, 1961), 11.

143. Margaret Lothrop, *Wayside*, 170–76.

144. Dorothea Lawrance Mann, "When the Alcott Books Were New," *Publishers' Weekly* 116 (September 28, 1929), quoted in *Critical Essays on Louisa May Alcott*, ed. Madeleine B. Stern (Boston: G. K. Hall, 1984), 85. However, Lothrop's *Five Little Peppers* may have been the best-selling book of 1880. Randy F. Nelson, *The Almanac of American Letters* (Los Altos, Calif.: William Kaufman, 1981), 94.

145. Harriet Lothrop, *Old Concord*, 71–72, 60.

146. Lothrop, *Old Concord*, 14, 121–29.

147. Edward T. Harrington of Harrington Real Estate, Boston, to Appleton, SP-NEA, November 21, 1910, SPNEA Archives.

148. Photo caption, n.d., of Bessie Keyes as a "sweet young girl," Ladies' Tuesday Club records, Concord Free Public Library; *Concord Enterprise*, April 21, 1942; *Boston Herald*, March 27, 1942; Gladys Hosmer, "Looking Backward," 3, Concord Woman's Club Records, Concord Free Public Library.

149. *Concord Enterprise*, March 25, 1913; May 12, 1915.

150. *Memoirs of Members of the Social Circle in Concord, 1909–39* (Cambridge, Mass.: University Press, 1940), 381.

151. Hudson was president of the Boston and Albany while it was under federal control in World War I. *Boston Herald*, August 18, 1938; *Concord Herald*, August 18, 1938.

152. This trend met with considerable resistance of the Brandeisian variety, but it had its supporters. A 1908 report of the special Commission on Commerce and Industry written by Charles Francis Adams (Concord resident and husband of the coleader with Bessie Hudson of the local antisuffrage league) set forth what many business leaders thought were the advantages of combinations: simplifying the system, efficient operation, and the end of rate differentials. Republican Gov. Eben Draper supported railroad consolidation during his 1901–11 tenure. The state's Democratic leadership (1911–16) did not agree, passing antimonopoly leg-

islation and railroad regulations. Like Hudson, Adams was interested in Massachusetts history; he would be director of the Massachusetts Historical Society in 1912. Richard M. Abrams, *Conservation in the Progressive Era: Massachusetts Politics, 1900–1912* (Cambridge: Harvard University Press, 1964), 211, 232, 257; Michael E. Hennessy, *Four Decades of Massachusetts Politics, 1890–1935* (Norwood, Mass.: Norwood Press, 1935), 204–24; Worthington C. Ford, "The Massachusetts Historical Society," in *Annual Report of the American Historical Association for the Year 1912* (Washington, D.C.: American Historical Association, 1914), 220. On the history of Boston street railways, see Warner, *Streetcar Suburbs*, 21–29. For a discussion of combinations and street railways, see Jackson, *Crabgrass Frontier*, 109–11. On railroad consolidation in Massachusetts, see Abrams, *Conservatism in the Progressive Era*, 190–216.

153. His most consequential cases included one in which "the Massachusetts statute of 1892 providing for interchangeable tickets was declared unconstitutional" and *Doyle v. The Boston & Albany Railroad*, in which he enabled the railroad to win an attempted suit "to recover for the death of a milkman who was struck by a train on a grade crossing, the defense being that the milkman was asleep in his wagon when he crossed the track." *Memoirs of the Concord Social Circle*, 384.

154. *Boston Herald*, August 18, 1938; *Memoirs of the Concord Social Circle*, 385. The sewer system was built by Italian workers in 1898. Garrelick and Bailey, *Concord*, 164, 169.

155. *Boston Transcript*, March 4, 1919.

156. *Boston Transcript*, December 29, 1926.

157. *Boston Transcript*, February 15, 1927; *Boston Herald*, February 16, 1927; *Memoirs of the Concord Social Circle*, 268–69.

158. *Memoirs of the Concord Social Circle*, 190–91, 194; *Concord Enterprise*, July 12, 1922. In the Social Circle memoirs of Murray Ballou, an incident was described in which a local politician had abandoned a petition campaign because "if Murray Ballou opposes it, there is no use presenting it." *Memoirs of the Concord Social Circle*, 194. Murray Ballou's role in the passage of the Tenement House Act is documented in the *Concord Town Reports* of 1913–15. Henry F. Smith was a deacon in the Unitarian Church, as well as a prominent banker at the Middlesex Institution for Savings. Mr. Smith was active in the elite Social Circle and volunteered his skills to the Concord Free Public Library. *Concord Enterprise*, April 5, 1945.

159. *Concord Enterprise*, August 15, 1954; *Concord Journal*, September 5, 1954.

160. *Concord Enterprise*, February 22, 1962; *Memoirs of the Concord Social Circle*, 1; *Concord Journal*, March 1, 1962; *Concord Enterprise*, November 6, 1929; *Boston Herald*, June 18, 1942; photo caption, n.d., Ladies' Tuesday Club Records, Concord Free Public Library. The Concord Home Garden Association provided about one hundred local children with materials, space, and instruction on growing their own gardens, to "assist in the production of the food supply, and, above all, learn the value and joy of work." Home Garden Association Appeal for Funds, 1911,

Pamphlet 76, Concord Free Public Library; *Concord Enterprise*, April 24, 1912. On Progressive Era public garden projects, see David Handlin, *The American Home: Architecture and Society, 1815–1915* (Boston: Little, Brown, 1979), 192–95.

161. *Concord Enterprise*, July 13, 1921.

162. *Concord Enterprise*, June 7, 1916; *Concord Enterprise*, September 14, 1921; *Boston Transcript*, July 12, 1921. Perhaps because of Mr. Rolfe's advanced age (he was in his late eighties), he was the only husband who did not join his wife in activism on behalf of the Louisa May Alcott Memorial.

163. *Concord Enterprise*, January 12, 1910; *Concord Enterprise*, September 14, 1921. This passage argued that the WCTU was not attempting to regulate the behavior of those adults "whose tastes were confirmed" as they were "beyond being saved."

164. Gladys Hosmer "Looking Backward," 3; *Concord Enterprise*, September 14, 1921. Rolfe founded the WCTU branch at nearby Ayer, Massachusetts. It was not until 1882 that a Concord WCTU was formed with the help of Louisa May Alcott, who said it was "much needed in C[oncord]. A great deal of drinking, not among the Irish but young Americans, gentlemen as well as farmers and mill hands. Women anxious to do something but find no interest beyond a few." Alcott's activism on behalf of Concord's WCTU was brief because shortly after her initial involvement, her health began to decline. Alcott, March 1882, in *The Journals of Louisa May Alcott*, ed. Joel Myerson, Daniel Shealy, and Madeleine B. Stern (Boston: Little, Brown, 1989), 233. It is interesting to note that not all of the female founders of the Orchard House museum were dedicated temperance advocates. For example, the Ladies' Tuesday Club had been known on occasion to enjoy "spiked cider" and "lager beer." Mrs. M. M. Cochran, "History of the Ladies' Tuesday Club," vol. 4, Ladies' Tuesday Club Records, Concord Free Public Library.

165. *Concord Enterprise*, December 7, 1910; January 31, 1912. Abby Rolfe's biggest single WCTU project, one Alcott would no doubt have supported had she been alive, was the Ingleside Home for orphaned girls in nearby Revere. The home cared for about twenty adolescent girls, each chosen because her "surroundings are such that she is not receiving the control and good influences she should have." The home did not accept "those who have passed over the line." Mrs. Rolfe organized donations of food, linens, and clothing to the Ingleside Home.

166. *Concord Enterprise*, December 12, 1928. The Hoyles moved to Concord from Norwood in 1890. Mr. Hoyle worked for the Boston Harness Company in West Concord.

167. *Concord Enterprise*, February 9, 1921.

168. Alcott sold Orchard House to William T. Harris in June 1884 and leased rooms in Boston, later purchasing a house in Maine. She did continue to spend time in Concord with her sister and father until 1887, when the family moved to Melrose, Mass. Alcott, in Myerson, Shealy, and Stern, *Journals*, xxv–xxvi.

169. Alcott was born in 1832, Rolfe in 1834, Hoyle in 1835, Burrill in 1840. The next closest is Lothrop, born in 1844.

170. Louisa May Alcott, *Little Women*. The most satisfying analysis of Alcott's life and work is Sarah Elbert's *A Hunger for Home: Louisa May Alcott's Place in American Culture* (New Brunswick, N.J.: Rutgers University Press, 1987). For an annotated bibliography of other biographical and critical works on Louisa May Alcott, see Alma J. Payne, "Louisa May Alcott: A Bibliographical Essay on Secondary Sources," in Stern, *Critical Essays*, 279–86. For a summary of recent critical interpretations of *Little Women*, see Ann B. Murphy, "The Borders of Ethical, Erotic, and Artistic Possibilities in *Little Women*," *Signs* 15 (spring 1990): 562–67. For a more detailed analysis of *Little Women* as the "literary foundation" for the Orchard House museum, see West, "Historic House Museum Movement," 71–121.

171. For a listing of the continual moves made by the Alcotts when Louisa was a child, see the chronology in Myerson, Shealy, and Stern, *Journals*, xvii–xxvii. On Bronson Alcott's work, see Odell Shepard, *Pedlar's Progress: The Life of Bronson Alcott* (Boston: Little, Brown, 1937) and Frederick C. Dahlstrand, *Amos Bronson Alcott* (Rutherford, N.J.: Fairleigh Dickinson University Press, 1982). On the Alcott family, see Elbert, *Hunger for Home*, 1–117, and Madelon Bedell, *The Alcotts: Biography of a Family* (New York: Clarkson N. Potter, 1980).

172. Then-twenty-five-year-old Alcott remarked that "the wandering family is anchored at last," adding, "We won't move again for twenty years if I can help it." Alcott, August 1858, in Myerson, Shealy, and Stern, *Journals*, 90.

173. Emerson wrote that Alcott and his partner in the founding of Fruitlands, Charles Lane, had concluded "the maternal instinct, and the Family . . . oppose the establishment of the community," when Abigail Alcott announced that she and her girls were leaving Fruitlands. Quoted in Taylor Stoehr, *Nay-Saying in Concord* (Hamden, Conn.: Archon Books, 1979), 83. See also Elbert, *Hunger for Home*, 56–77; Dahlstrand, *Amos Bronson Alcott*, 195–96.

174. See "Model Children," in Elbert, *Hunger for Home*, 21–39; Charles Strickland, "A Transcendentalist Father: The Child Rearing Practices of Bronson Alcott," *Perspectives in American History* 3 (1969): 5–71. Ann Douglas says that Bronson felt Louisa "experienced the world largely as intractable materialia," that she "would not discover the unchanging Platonic unity behind appearances in which he believed." Ann Douglas, "Mysteries of Louisa May Alcott," in Stern, *Critical Essays*, 233. Karen Halttunen points out that when Louisa was born, Bronson had recently been converted from the idea of tabula rasa to a romantic theory of personality development. Karen Halttunen, "The Domestic Drama of Louisa May Alcott," *Feminist Studies* 10 (summer 1984): 235.

175. Elbert, *Hunger for Home*, 184.

176. Elbert, *Hunger for Home*, 191–93.

177. For analysis of Alcott's critique of radical feminism, see discussions of her 1871 story "Cupid and Chow-Chow" in Elbert, *Hunger for Home*, 237–39, and Joy A. Marsella, *The Promise of Destiny: Children and Women in the Short Stories of Louisa*

May Alcott (Westport, Conn.: Greenwood Press, 1983), 93–99. For darker interpretations that give limited consideration to the historical complexity of nineteenth-century feminism, see Martha Saxton, *Louisa May* (Boston: Houghton Mifflin, 1977), and Eugenia Kaledin, "Louisa May Alcott: Success and the Sorrow of Self-Denial," *Women's Studies* 5 (1978): 256–57.

178. Alcott remarked in her journals, "No more rheumatic fevers and colds, with picturesque open fires." Alcott, December 1871, in Myerson, Shealy, and Stern, *Journals,* 179.

179. Celia Betsky, "Inside the Past: The Interior and the Colonial Revival in American Art and Literature, 1860–1914," in Axelrod, *Colonial Revival in America,* 241–77.

180. Scholars who have grappled with this issue include Judith Fetterley, *"Little Women:* Alcott's Civil War," *Feminist Studies* 5 (summer 1979): 369–83; Elbert, *Hunger for Home,* 169–85; Madelon Bedell, "Beneath the Surface: Power and Passion in *Little Women,"* in Stern, *Critical Essays,* 145–50, and Jane Van Buren, "Louisa May Alcott: A Study in Persona and Idealization," *Psychohistory Review* 9 (summer 1981): 282–99. A 1985 dissertation by Angela Estes posits that the "submerged texts" in Alcott's fiction result from her attempts to apply the values of transcendental "self-reliance" to women's lives. See Angela M. Estes, "An Aptitude for Bird: Louisa May Alcott's Women and Emerson's Self-Reliant Men" (Ph.D. diss., University of Oregon, 1985).

181. *Concord Enterprise,* February 1, 1911; February 21, 1912. The predominantly female donors were recorded in the *Concord Enterprise,* March 1 and 29, April 12, May 3 and 10, and July 27, 1911; Abby Rolfe to Appleton, SPNEA, January 28, 1911, SPNEA Archives.

182. This performance may have been loosely based on Addie Guthrie Weaver's patriotic handbook of the same title, published with a call for funds to save the Betsy Ross house. Weaver, *Story of Our Flag.*

183. One of the Orchard House founders, Margaret Blanchard Smith, was in the quartet that performed patriotic songs. *Concord Enterprise,* March 22, 1911.

184. Ibid.; *Concord Enterprise,* March 29, 1911. The record of the Concord Woman's Club's annual meeting of April 10, 1911, documents a vote of thanks to the play's participants.

185. Undated newspaper clipping, SPNEA Archives; *Concord Enterprise,* August 10, 1910. This report of the decay of Orchard House recalls Alcott's description of the "poor, bare miserable room" of the Hummels. Alcott, "A Merry Christmas," *Little Women,* 15.

186. Undated newspaper clipping, SPNEA Archives; *Concord Enterprise,* June 29, 1910.

187. *Concord Enterprise,* August 10, 1910.

188. *Concord Enterprise,* February 1, 1911.

189. Undated newspaper clipping, SPNEA Archives.
190. The Concord Woman's Club fund-raising pamphlet quoted in the *Concord Enterprise,* February 11, 1911.
191. *Boston Post,* May 29, 1912. See also the *Boston Herald,* June 5, 1912, which declared "Grown-Ups Open Restored Home of 'Little Women.'"
192. *Concord Enterprise,* May 29, 1912.
193. Francis Steegmuller, "House of Little Women," *Holiday,* March 1957, 158.
194. Eric Hobsbawm, "Inventing Traditions," in *The Invention of Tradition,* ed. Eric Hobsbawm and Terence Ranger (Cambridge: Cambridge University Press, 1983), 1–14. Hobsbawm identifies the functions of "invented traditions" as the establishment of the social cohesion, the legitimation of institutions or status, and the inculcation of beliefs or conventional behavior.
195. On 1870s Concord, see Margaret French Cress, *The Life of Daniel Chester French* (Cambridge: Harvard University Press, 1947), 9.
196. Geoffrey Blodgett, "Harriet Jane Hanson Robinson (1825–1911)," in *Notable American Women,* vol. 3, ed. Janet Wilson James, Edward Wilson James, and Paul S. Boyer (Cambridge, Mass.: Belknap Press, 1971), 181–82. Robinson, who had been a labor activist at Lowell, lived in Concord for a time in the 1850s and is buried in its Sleepy Hollow Cemetery. Alcott helped Robinson get her suffrage tract published and then offered it to a "suffrage club" in Concord in 1881. See Alcott to Thomas Niles, February 12, 1881, in Myerson, Shealy, and Stern, *Selected Letters,* 252; Myerson, Shealy, and Stern, *Journals,* 231.
197. Harriet Robinson, *Massachusetts in the Woman Suffrage Movement,* 225.
198. Ibid.
199. Robinson, who had been a member of Concord's famed antislavery set, charged that "Concord was never an anti-slavery town, though some of its best citizens took an active part in the abolition movements. When the time came that women were allowed to vote for school committees, the same intolerant spirit which ignored and shut them out of the Centennial celebration was again manifested toward them." She conferred upon the town "the unenviable distinction" of being "the banner town for snubbing women voters." Harriet Robinson, *Massachusetts in the Woman Suffrage Movement,* 227. Robinson had personal reasons to be critical of Concord. She and her husband lived there briefly in the 1850s to assist his elderly mother, leaving in part because William Robinson was spurned by the Social Circle his grandfather had helped found. See Margaret Marsh, *Suburban Lives* (New Brunswick, N.J.: Rutgers University Press, 1990), 42–49.
200. Alcott to Mrs. Bowles, Concord, May 5 [no year], in Myerson, Shealy, and Stern, *Selected Letters,* 338. For Alcott's letters to the *Woman's Journal,* see *Selected Letters,* 237–38, 245–47, 256–57, 281–82.
201. The poll tax was reduced by an 1881 amendment to limit it to a still consequential fifty cents. Harriet Robinson, *Massachusetts in the Woman Suffrage Movement,* 107, 240.

202. Alcott remarked: "It is always humiliating to have to confess to outsiders, who look upon Concord as a representative town, and are amazed to learn that it takes no active part in any of the great reforms of the day, but seems to be content with the reflected glory of dead forefathers and imported geniuses, and falls far behind smaller but more wide awake towns with no pretensions to unusual intelligence, culture or renown." Alcott to the *Woman's Journal*, Concord, February 4, 1882, in Myerson, Shealy, and Stern, *Selected Letters*, 256.

203. Susan B. Anthony and Ida Husted Harper, eds., *History of Woman Suffrage*, vol. 4, 1883–1900 (1902; reprint, New York: Arno Press, 1969), 706.

204. Anthony and Harper, *History of Woman Suffrage*, 738. Of the nays, 186,115 were men and 861 were women. Of the yeas, 86,970 were men and 22,204 were women.

205. Historian Aileen Kraditor has described the shift in suffrage strategy of this period as a move from arguments based on "justice" to one of "expediency," most often taking the form of justifications that native-born white women's votes would "balance" ballots cast by black and immigrant men. I would argue that this shift reinforced the tendency of suffragists to employ Anglo-American colonial and domestic imagery in support of their political credentials. Aileen Kraditor, *The Ideas of the Woman Suffrage Movement, 1890–1920* (New York: Anchor Books, 1971), 38–39. See also Ellen Carol DuBois, *Feminism and Suffrage: The Emergence of an Independent Women's Movement in America, 1848–1869* (Ithaca, N.Y.: Cornell University Press, 1978), 174–78. On suffragists' efforts to temper their more radical arguments to gain wider support, see DuBois, 183–84, and O'Neill, *Everyone Was Brave*, 21–48. O'Neill argued that because of this emphasis, the vote, once achieved, failed to make a change in women's status because they had not made a broadly based critique of the most impeding structural phenomenon, the traditional family. On domesticity as the basis for women's emergent public power, see Baker, "Domestication of Politics," 620–47.

206. Dorr, *What Eight Million Women Want*, 327.

207. Mrs. Herbert Lyman, "The Anti-Suffrage Ideal," in Massachusetts Women's Anti-Suffrage Association, *Anti-Suffrage Essays by Massachusetts Women* (Boston: Forum Publications, 1916), 119–20. The Massachusetts Women's Anti-Suffrage Association was founded in 1894. Anthony and Harper, *History of Woman Suffrage*, 704.

208. Histories focusing on the Progressive crisis of cultural authority include Richard Hofstader, *The Age of Reform* (New York: Vintage Books, 1955); Weibe, *Search for Order;* Barton Bledstein, *The Culture of Professionalism* (New York: W. W. Norton, 1976); Robert Crunden, *Ministers of Reform: The Progressives' Achievement in American Civilization* (Urbana: University of Illinois Press, 1984), and Lears, *No Place of Grace.*

209. For example, Mary Livermore, temperance advocate, suffragist, and Sanitary Fair organizer, produced a historical pageant for Boston in 1889, which included a "Gettysburg Diorama" and tableaux of scenes from the history of Massachu-

setts. Mary Ritter Beard praised the pageants, saying the spirit of "democratic co-operation" left a "permanent impression." David Glassberg's fascinating study of pageantry confirms that Concord's Centennial was not unique in this respect. He argues that these celebrations used women to symbolize a "stable equilibrium of classes and interests." By the turn of the century, women were not only present but were also incorporating their own issues such as suffrage and domesticity into the pageants. See Glassberg, *American Historical Pageantry*, 301–2, 18, 135–37. On Livermore's Boston pageants, see Beard, *Women's Work in Municipalities*, 153–54, and Bettina Friedl, *On to Victory: Propaganda Plays of the Woman Suffrage Movement* (Boston: Northeastern University Press, 1987), 195–96.

210. Frances Davey and Thomas A. Chambers, "Common Parlors: Women, Anti-modernism, and Community Identity in Deerfield, Massachusetts, 1870–1920," *Gender and History* 6 (November 1994): 435–55; Rhoads, *Colonial Revival*, 366–67; Eileen Boris, *Art and Labor: Ruskin, Morris, and the Craftsman Ideal in America* (Philadelphia: Temple University Press, 1986), 116–18; Darlene Roth, *Matronage*.

211. Alice Morse Earle, *Home Life in Colonial Days* (1898; reprint, New York: Macmillan, 1946), 247. For a discussion of women writers as celebrants of the colonial period, see Marling, *Washington Slept Here*, 164–70.

212. Mann, "When the Alcott Books Were New," 85; *New York Times*, March 22, 1927, quoted in Stern, *Critical Essays*, 22.

213. Isabel F. Hyams, "The Louisa May Alcott Club," *Proceedings of the Second Annual Conference on Home Economics, Lake Placid, N.Y., 1902*, 18, quoted in Gwendolyn Wright, *Building the Dream: A Social History of Housing in America* (Cambridge: Massachusetts Institute of Technology Press, 1983), 128–29.

214. Simone de Beauvoir, *Memoirs of a Dutiful Daughter*, trans. James Kirkup (1958; reprint, New York: Penguin, 1987), 89.

215. Alcott, in Myerson, Shealy, and Stern, *Journals*, 231; Harriet Robinson, *Massachusetts in the Woman Suffrage Movement*, 170.

216. "Woman Suffrage Notes," *Concord Enterprise*, November 1, 1911.

217. Blair, *Clubwoman as Feminist*, 93, 98–105.

218. On the relationship between Progressivism and suffrage, see O'Neill, *Everyone Was Brave*, 146–68. On social science and suffrage, see William Leach, *True Love and Perfect Union: The Feminist Reform of Sex and Society* (New York: Basic Books, 1980), passim, and Donald Meyer, *Sex and Power* (Middletown, Conn.: Wesleyan University Press, 1987), 333–348. The major successes of this period included the passage of suffrage in the western states, the endorsement of suffrage by the Progressive Party in 1912, and by the GFWC in 1914.

219. Mary Wood, *History of the GFWC*, 4.

220. Kraditor, *Ideas of the Woman Suffrage Movement*, 14–16.

221. Blair, *Clubwoman as Feminist*, 111–13.

222. Mary Wood, *History of the GFWC*, 310.

223. *Concord Enterprise*, March 20, 1912. Massachusetts was the seat of organized antisuffrage, from early efforts in 1872 to the establishment of the Massachusetts Association Opposed to the Extension of Suffrage to Women in 1895. The National Association Opposed to Woman Suffrage was formed in 1911. See Eleanor Flexner, *A Century of Struggle: The Woman's Rights Movement in the United States* (Cambridge: Harvard University Press, 1959), 294–305; Anne Firor Scott and Andrew MacKay Scott, *One Half the People: The Fight for Woman Suffrage* (Chicago: University of Chicago Press, 1982), 25–27; and Kraditor, *Ideas of the Woman Suffrage Movement*, 12–37.

224. Scudder, *Concord: American Town*, 315–17.

225. *Concord Enterprise*, April 12, 1911.

226. *Concord Enterprise*, March 26, 1913.

227. She assured the assembled women that "40 percent of the working class, whose cause it is claimed by the suffragists will be uplifted by the vote of women, are in domestic or personal service, so that if a woman wants to help this class, all she needs to do is to go to her own home and make conditions better there." George also believed that women would give up privileges and protection if they represented themselves, saying "such equality would be a brutal and retrogressive view of woman's rights." Women, she said, should remain nonpartisan and work "for the common good outside the realms of political strife." *Concord Enterprise*, May 21, 1913. Alice N. George, "Suffrage Fallacies," in Massachusetts Women's Anti-Suffrage Association, *Anti-Suffrage Essays*, 27, 29. British housing reformer Octavia Hill also found antisuffrage and activism on behalf of the National Trust compatible pursuits. See Gillian Darley, *Octavia Hill* (London: Constable, 1990).

228. Burrill's activity as leader of Concord's nineteenth-century suffrage organization is documented in Concord Pamphlet 76, Concord Free Public Library. Burrill's obituary appeared in the *Concord Enterprise*, February 9, 1921.

229. Scudder, *Concord: American Town*, 316; *Concord Enterprise*, March 12, 1913.

230. *Concord Enterprise*, November 1, 1911; Sharon Hartman Strom, "Leadership and Tactics in the American Woman Suffrage Movement: The Perspective from Massachusetts," *Journal of American History* 62 (September 1975): 310–13. For discussions of the national movement in the 1890–1915 period, see Flexner, *Century of Struggle*, 248–75, and Scott and Scott, *One Half the People*, 24–37. Foley was of working-class Irish-American extraction, a brilliant speaker, and known for her fabulous popular gimmicks, such as going up in a hot-air balloon and convincing the manager of a circus to drape an elephant with a "votes for women" banner. Foley would reappear in Concord at the height of prosuffrage activity to lecture to a packed town hall on the necessity of the franchise to the fulfillment of women's homemaking responsibilities. *Concord Enterprise*, March 17, 1915.

231. *Concord Enterprise*, March 21, 1912; Kraditor, *Ideas of the Woman Suffrage Movement*, 230. Susan W. Fitzgerald, recording secretary of NAWSA, a Bryn Mawr graduate and wife of a Boston lawyer, wrote "Women in the Home," in *Woman*

Suffrage Arguments and Results, 1910–1911 (National American Woman Suffrage Association: 1912; reprint, New York: Kraus Reprint, 1971), unpaginated.

232. *Concord Enterprise*, March 12, 1913. Clark claimed that "a refined environment helps to produce refinement," and that "the revolting creatures of the slums in a vague way want to be decent, but they don't want to enough." Kate Upson Clark, *Bringing Up Boys* (New York: Thomas Y. Crowell, 1899), 136, 193. See Margaret Marsh's analysis of the context for Clark's work in "From Separation to Togetherness: The Social Construction of Domestic Space in American Suburbs, 1840–1915," *Journal of American History* 76 (September 1989): 511.

233. *Concord Enterprise*, February 26, March 5 and 12, 1913; Kraditor, *Ideas of the Woman Suffrage Movement*, 225, 8–9. On Shaw's reputation as a "sharp-tongued, man-hating feminist" as well as a brilliant orator, see O'Neill, *Everyone Was Brave*, 120–23.

234. *Concord Enterprise*, February 26, 1913.

235. Up from a relatively stable number of about 1,000 men and 100 women in the preceding three years, to 1,143 men and 878 women in 1914. By 1920, male/female participation was about even. *Concord Town Reports*, 1910–20, Concord Free Public Library. On the GFWC's endorsement of suffrage, see Blair, *Clubwoman as Feminist*, 1123–13.

236. *Concord Enterprise*, March 3, 1915.

237. *Concord Enterprise*, March 17, 1915.

238. *Concord Enterprise*, May 5 and 12, 1915. Edith Melvin, though an accomplished law clerk in Concord, had never applied for admission to the bar because she did not believe that women should become lawyers. She said she had begun to work outside the home only because her father, incapacitated by his Civil War service, had needed her support. After work hours, Melvin was active in the Unitarian Church and the Concord DAR, for example, addressing the Daughters on the history of women's legal rights in the colonial period. Her antisuffrage arguments were evolutionary, asserting that the "female of the species" was not well suited to the "business of government." She reasoned that women lacked the the power of "consecutive thought upon any intricate problem" and warned that the vote would therefore be a strain on and "detriment" to the nature of women. Edith Melvin, "A Business Woman's View of Suffrage," in Massachusetts Women's Anti-Suffrage Association, *Anti-Suffrage Essays*, 42. The strain that intellectual exertion was supposed to place on women had been a concern for some time. See Rosalind Rosenberg, *Beyond Separate Spheres: Intellectual Roots of Modern Feminism* (New Haven: Yale University Press, 1982), 1–27.

239. *Concord Enterprise*, August 4, 1915.

240. Garrelick and Bailey, *Concord*, 50.

241. Gladys Hosmer, "Looking Backward"; *Concord Enterprise*, July 14, 1915.

242. *Concord Enterprise*, July 7, 1915.

243. *Concord Enterprise*, July 14, 1915.

244. Gladys Hosmer, "Looking Backward," 6.
245. *Concord Enterprise*, September 29 and October 4, 1915; Scudder, *Concord: American Town*, 320–21.
246. *Concord Enterprise*, November 3, 1915; Strom, "Leadership and Tactics," 296; Flexner, *Century of Struggle*, 270–71.
247. Ernest Bernbaum, "The Anti-Suffrage Victory in Massachusetts," introduction to Massachusetts Women's Anti-Suffrage Association, *Anti-Suffrage Essays*, x.
248. *Concord Enterprise*, October 20, 1915. Glassberg indicates that the carrying of banners with historic referents was a conventional part of Progressive pageantry; *American Historical Pageantry*, 16.
249. *Concord Enterprise*, July 7, 1915.
250. This term is derived from the ideas of Dolores Hayden, who coined the term "material feminists" to describe those who wanted to advance women's social power and freedom by eliminating the oppressive features of the home, and Temma Kaplan, who has analyzed nonfeminist "female consciousness" among women who have taken collective public action in order to protect their traditional domestic role. Temma Kaplan described female collective action among the popular classes as being conservative, but with revolutionary results. The antisuffragist founders of Orchard House were middle-class, and their intended results were politically conservative. Temma Kaplan, "Female Consciousness and Collective Action: The Case of Barcelona, 1910–1918," *Signs* 7 (spring 1982): 545–66; Dolores Hayden, *The Grand Domestic Revolution: A History of Feminist Designs for American Homes, Neighborhoods, and Cities* (Cambridge: Massachusetts Institute of Technology Press, 1981). On the complexities and pitfalls of the historian's struggles to describe women's collective public action, see Nancy Cott, "What's in a Name? The Limits of 'Social Feminism': Or Expanding the Vocabulary of Women's History," *Journal of American History* 76 (December 1989): 809–29.
251. For discussions of the vast material on Progressivism, see Daniel T. Rodgers, "In Search of Progressivism," *Reviews in American History* 10 (December 1982): 113–32; David M. Kennedy, "Overview: The Progressive Era," *Historian* 37 (May 1975): 453–68; Peter Filene, "An Obituary for the Progressive Movement," *American Quarterly* 22 (spring 1970): 20–34; and Arthur S. Link and Richard L. McCormick, *Progressivism* (Arlington Heights, Ill.: Harlan Davidson, 1983). On the "status revolution" in the Progressive Era, see Richard Hofstadter, *The Age of Reform* (New York: Vintage Books, 1955). See also Robert Weibe's portrayal of the Progressive "search for order," arising from the disintegration of nineteenth-century "island communities," in Weibe, *Search for Order*, and compare to Bender's redefinition of "community" in Thomas Bender, *Community and Social Change in America* (New Brunswick, N.J.: Rutgers University Press, 1978). On the new Progressive Era professional association as a reoriented community, see Burton J. Bledstein, *The Culture of Professionalism: The Middle Class and the Development of*

Higher Education in America (New York: W. W. Norton, 1976). On the tendency of Progressive reform to suppress radical politics, see Gabriel Kolko, *The Triumph of Conservatism* (New York: Free Press, 1963), and James Weinstein, *The Corporate Ideal and the Liberal State* (Boston: Beacon Press, 1963). Crunden, *Ministers of Reform;* Lears, *No Place of Grace;* Hobsbawm, "Inventing Traditions." Lawrence Goodwyn has analyzed the role of "inherited culture" in undermining radical agendas, in Goodwyn, *The Populist Moment* (New York: Oxford University Press, 1978). The amazing popularity of historical pageants outlined by Glassberg, the attempt to inculcate a uniform "civic ideal" through public sculpture described by Bogart, and the rise of cultural philanthropy on behalf of the museums studied by Horowitz were all newly minted modes of "invented tradition." See Glassberg, *American Historical Pageantry;* Michele Bogart, *Public Sculpture and the Civic Ideal in New York City, 1890–1930* (Chicago: University of Chicago Press, 1989); Helen Lefkowitz Horowitz, *Culture and the City: Cultural Philanthropy in Chicago from the 1880s to 1917* (Lexington: University Press of Kentucky, 1976).

252. It is illustrative of the era's architectural tropism that Croly wrote forty-six articles and two books on house form and decoration and edited an architectural journal from 1900 to 1906. Harry Desmond and Herbert Croly, *Stately Homes in America from Colonial Times to the Present Day* (New York: D. Appleton, 1903); Herbert Croly (William Herbert, pseudonym), *Houses for Town or Country* (New York: Duffield, 1907). On Croly and architecture, see David W. Levy, *Herbert Croly of the New Republic: The Life and Thought of an American Progressive* (Princeton: Princeton University Press, 1985), 84–95; Handlin, *American Home,* 360–63. For a broad historical analysis of Croly, see Charles Forcey, *The Crossroads of Liberalism* (New York: Oxford University Press, 1961). For a detailed account of Croly's career as social-architectural critic, see West, "Historic House Museum Movement," 218–22. For examinations of the transition from Victorian to Colonial Revival in popular taste, see Gwendolyn Wright, *Moralism and the Modern Home* (Chicago: University of Chicago Press, 1980), and also her *Building the Dream;* Handlin, *American Home;* Clifford Clark, *The American Family Home, 1800–1960* (Chapel Hill: University of North Carolina Press, 1986); and Jonquil Seager, *"Father's Chair": Domestic Reform and Housing Change in the Progressive Era* (Ann Arbor, Mich.: University Microfilms, 1988).

253. Wright, *Moralism,* 234. Wright explains the tendency of American architectural reformers to propose a new "model home" whenever "a given set of problems grew too unwieldy." See *Moralism,* 292–93.

254. In 1910 the National Housing Association was established, funded by the Russell Sage Foundation, and by 1916 it could boast 135 local organizations and the participation of 209 cities. By 1913, Massachusetts had required all large towns to create planning boards to regulate housing. See the National Housing Associa-

tion report, *Housing Problems in America* (New York: National Housing Association, 1916), 527–29; Robert B. Fairbanks, *Making Better Citizens: Housing Reform and the Community Development Strategy in Cincinnatti, 1890–1960* (Chicago: University of Illinois Press, 1988), 29; Handlin, *American Home*, 152.

255. For sources describing how apartment life was contributing to moral laxity, see, for example, essays by C. H. Williams, James Ford, and Bernard Newman, in the National Housing Association's *Housing Problems in America*. The lack of the defensive and insulating features of the single-family home led one contemporary historian of the family to refer to the "boarding house problem" as "homelessness." Even the space surrounding the home had to be correctly designed to ensure separation, as Vernon Parrington explained in an article employing the "usable past." Arthur W. Calhoun, *A Social History of the Family*, vol. 3 (Cleveland: Arthur A. Clark, 1919), 181; Vernon Parrington, "On the Lack of Privacy in American Village Homes," *Home Beautiful* 13, 1903, 109–12.

256. Newman, in National Housing Association, *Housing Problems in America*, 160–61.

257. Prescott Hall, "Menace of the Three-Decker," 135.

258. C. Stanley Taylor, "The Financial Aspect of Industrial Housing," *Architectural Forum* 28 (April 1918): 137. See also Jackson, *Crabgrass Frontier*, 51, and Handlin's discussion of the creation of corporate and governmental institutions to enhance home ownership, as well as technical innovations making houses more affordable, in *American Home*, 236–52; "The Suburban House and Suburban Life," *House Beautiful* 14, July 1903, 113, quoted in Wright, *Moralism*, 235.

259. For example, see Edmond Demolins, *Anglo-Saxon Superiority: To What Is It Due?* (New York: R. F. Fenne, 1898), 135–59.

260. On "Anglo-Saxon" design and xenophobia, see Harvey Green, "Popular Science and Political Thought Converge: Colonial Survival Becomes Colonial Revival, 1830–1910," *Journal of American Culture* 6 (winter 1983): 3–24; Rhoads, *Colonial Revival*, 477–527, 535–44; Lizabeth Cohen, "Embellishing a Life of Labor: An Interpretation of the Material Culture of American Working-Class Homes, 1885–1915," in *Material Culture Studies in America*, ed. Thomas Schlereth (Nashville, Tenn.: American Association for State and Local History, 1982), 289–305; and Lears, *No Place of Grace*, 74–75. Lears addresses the "Anglo-Saxon" form of antimodernism but not the related and more persistent phenomenon of Colonial Revival. Rhoads offers a detailed chronicle of the Colonial Revival but misjudges its relationship to gender. Because Colonial Revival texts frequently praised hearty colonial grandmothers, Rhoads calls the "colonial" style "feminine." Actually, this type of reference was a sharp critique of twentieth-century women, and a call for a return to a more traditional domesticity in an environment that was in fact more "masculine," when men were men and women were women, so to speak.

261. Wright says this drove out "any spurious evolutionary schemes which might suggest that there had been other kinds of human living patterns." Wright, *Moralism*, 32.

262. George Cleaveland and Robert Campbell, *American Landmarks: A Collection of Pictures of Our Country's Historic Shrines* (Boston, 1893), vi, vii, quoted in Rhoads, *Colonial Revival*, 537. This was a vision shared by Harriett Lothrop.

263. Lears, *No Place of Grace*, 73. Lears applies this only to the Arts and Crafts movement. For links between Arts and Crafts and Colonial Revival values, see Rhoads, *Colonial Revival*, 303–13.

264. For example, the ubiquitous "bungalow" house, though hardly American colonial, was touted as such. Rhoads, *Colonial Revival*, 122–23. On the moral value associated with simplicity of form, see David Shi, *The Simple Life: Plain Living and High Thinking in American Culture* (New York: Oxford University Press, 1985), 100–124, 175–214; Clifford Clark, *American Family Home*, 146–51; Wright, *Moralism*, 230–35.

265. On "commuter pastoralism," see Shi, *Simple Life*, 194. For a discussion of "old-looking new houses," see John Stilgoe, *Borderland: Origins of the American Suburb, 1820–1939* (New Haven: Yale University Press, 1988), 290–95. The architect referred to was Joy Wheeler Dow. See Rhoads, *Colonial Revival*, 441.

266. See Cohen, "Embellishing a Life of Labor"; Seager, *"Father's Chair,"* 20–24, and Clifford Clark, *American Family Home,* 162. In general, fashion had historically served the middle class as a method of distinguishing them from the lower class; the distinction itself had been actively pursued by the bourgeoisie. See Neil McKendrick, John Brewer, and J. H. Plumb, *The Birth of a Consumer Society* (Bloomington: Indiana University Press, 1982), and Colin Campbell, *The Romantic Ethic and the Spirit of Modern Consumerism* (Oxford: Basil Blackwell, 1987), for contrasting views of the history of this phenomenon. The Colonial Revival attempt to create an American decorative norm was a new tack based on an apparent need to deny class differences through the creation of uniform bourgeois domesticity attainable by the working class. This phenomenon had its roots in the "aesthetic moralism" of Downing and Ruskin and was enhanced in the form of "domestic environmentalism," the association of the physical features of the home with moral development, amplified by social Darwinism and psychology. On "aesthetic moralism" see Lynes, *Tastemakers*, 21–29; Boris, *Art and Labor,* 53–81. On the early development of "domestic environmentalism," see Grier, *Culture and Comfort,* 5.

267. Herbert Gutman, *Work, Culture and Society in Industrializing America* (New York: Vintage Books, 1977).

268. See Charles C. May, "Housing Types for Workmen in America," *Architectural Forum* 28 (April 1918): 117, and William Roger Greeley, "Housing the Low Paid Workman," *Architectural Forum* 28 (April 1918): 154, for reformers' judgments about this pattern of room use. For a history of the Victorian bourgeois parlor, by

1900 out of fashion with many middle-class suburban and urban families, see Sally McMurry, "City Parlor, Country Sitting Room: Rural Vernacular Design and the American Parlor," *Wintherthur Portfolio* 20 (winter 1985): 261–80; Grier, *Culture and Comfort,* passim. On the separation of space in late-nineteenth-century middle-class homes, see Wright, *Moralism,* 34. The peculiar consternation over where workers ate is the best evidence both for reformers' moral vigilance over the emblems of respectable domesticity, as well as for working-class resistance to the prescriptions of domestic reform. For evidence of working-class preferences for both the parlor and eating and working in the kitchen, see Cohen, "Embellishing a Life of Labor," which demonstrates that workers rejected the domestic advice of reformers. Cohen also shows that some reformers did prefer that workers kept the parlor, so that at least socializing was removed from the kitchen. Grier documents antiparlor sentiment, 287. Seager explains that the reformers were defending the new morality of "functional purity" in the laboratory-like Progressive kitchen in *"Father's Chair,"* 175.

269. Cohen argues that a separate working-class material culture existed to the annoyance of reformers attempting to inculcate "American" style. Of course, the carved and upholstered furniture, deemed unsanitary and inappropriate by the reformers, was once standard decoration in the middle-class parlor in which the reformers themselves were raised. Cohen, "Embellishing a Life of Labor"; Grier, *Culture and Comfort,* 26–27.

270. See, for example, Sophonisba Breckinridge, *New Homes for Old* (New York: Harper and Brothers, 1921), 134–35, in which Breckinridge explained that immigrants bought parlor furniture because they thought it an American thing to do, though she said of the parlor suite, "It is not beautiful, and there is no reason to think of it as distinctly American, but the immigrant is not in a position to know that." See also Louisa Bolard More, *Wage Earners' Budgets* (New York: Henry Holt, 1907), 145–46, for an analysis of the tendency for workers to buy "elaborate parlor sets 'on time.'" On the "downward mobility" of parlor suites, see Grier, *Culture and Comfort,* 205–6.

271. On the Home Commission, see Wright, *Building the Dream,* 132–33. On the tenement house exhibit, see Bertha Lynde Holden, "Tenement Furnishings," *House Beautiful,* April 1900, 307–13.

272. For an account of tenement reform, see Roy Lubove, *The Progressives and the Slums: Tenement House Reform in New York City, 1890–1917* (Westport, Conn.: Greenwood Press, 1974).

273. Veiller had recruited DeForest (head of the Charity Organization of New York and an accomplished lawyer who had served as counsel for banks, railroads, and insurance companies) to join him in establishing the New York Tenement House Committee. Veiller praised "colonial" suburban houses, and DeForest was president of the Russell Sage Foundation when it funded the creation of the Forest Hills suburban housing development in 1909. Robert W. DeForest and

Lawrence Veiller, eds., *The Tenement House Problem* (1903; reprint, New York: Arno Press, 1970), 3, 5; Rhoads, *Colonial Revival*, 491; Lubove, *Progressives and the Slums*, 118–19, 144, 154–55, 227.

274. DeForest and Veiller's exhibit, attended by "all classes," had five models, more than one thousand photographs, more than one hundred maps, numerous charts and graphs, and supporting materials from around the world. Conferences were held in conjunction; parts of the exhibit were borrowed by other cities, and it was widely imitated. DeForest and Veiller, *Tenement House Problems*, III–15; Lubove, *Progressives and the Slums*, 122–25; Davis, *Spearheads for Reform*, 68.

275. DeForest administered the donation by Mrs. Russell Sage of the Eugene Bolles collection to the American Wing after its display at the Hudson–Fulton Celebration of 1909. Mrs. Emily DeForest gave the Woodbury Room (the furnishings of the home of an eighteenth-century New York aristocrat), and Robert DeForest gave the wing its facade, the old U.S. Bank from Wall Street, deconstructed stone by stone and brought to the museum. R. T. H. Halsey, *A Handbook of the American Wing* (New York: Metropolitan Museum of Art, 1924), viii, 352–53; Gary Kulik, "Designing the Past: History-Museum Exhibitions from Peale to the Present," in *History Museums in the United States*, ed. Warren Leon and Roy Rosenzweig (Urbana: University of Illinois Press, 1989), 13–14. On the American Progressive tendency toward a belief in pastoral romanticism as a potential cure-all, see Davis, *Spearheads for Reform*, 60.

276. DeForest explained, "The normal person is keenly sensitive to his surroundings," but this sensitivity was often "dormant," however, and people actually purchased ugly things. These ugly places and things, for example the "atrocity of the dining-room or of the living room," devitalized American life. Robert DeForest, "Getting in Step with Beauty," *American Review* 77 (January 1928): 63–68.

277. Seager, a geographer, defines them separately for the purposes of her work, saying that tenement house reform grew out of settlement houses and was directed toward the very poor to establish minumum standards of decency, whereas domestic reform grew out of the nineteenth-century debate over woman's place. I have argued that these debates overlapped on several grounds. See Seager, *"Father's Chair,"* 122. Fairbanks explains that his study of housing reform in Cincinnati reveals that the increased focus on tenements cannot be fully explained by their increased existence only, but also by the new and aggressive environmental determinism of the Progresssive Era; *Making Better Citizens*, 9.

278. See Holden, "Tenement Furnishings," 307–13. Mary Pattison's *Principles of Domestic Engineering* (New York, 1915) was dedicated to the "conservation of the individual home," and Rolla Tryon's 1917 Ph.D. thesis on domestic manufacture in the colonial period argued that domestic science courses replaced the educational dimension of colonial domesticity, the loss of which was causing a deterioration in the quality of American domestic life. Colonial domesticity had produced a "home-loving people." Rolla Martin Tryon, *Household Manufacturing in the*

United States, 1640–1860 (1917; reprint, New York: Greenwood Press, 1966), 6. See also Adrian Forty, *Objects of Desire: Design and Society from Wedgwood to IBM* (New York: Pantheon, 1986), 158–70, 170–73.

279. Davis, *Spearheads for Reform*, 65. He says housing reformers "often overlooked" such amenities, but many, of course, did not.

280. Description of a small settlement house in Boston, a "sister" settlement to the South-End House. Esther G. Barrows, *Neighbors All: A Settlement Notebook* (Boston: Houghton Mifflin, 1929), 37. See Wright, *Moralism,* 114–16. On colonial furnishings in settlement house interiors, see William Rhoads, "The Colonial Revival and the Americanization of Immigrants," in Axelrod, *Colonial Revival in America,* 343–49; Lizabeth Cohen, "Respectability at $50.00 Down, 25 Months to Pay! Furnishing a Working-Class Victorian Home," in Ames, *Victorian Furniture,* 238–39. Some of the working-class residents in the neighborhood of Boston's South-End House were surprised by its "lack of plush and stuffed furniture." Some rejected this prototype in favor of decorating with the "inevitable 'parlor set'" and "plush curtains." One young woman asked a settlement house worker to remember, "You have had your plush days." Another neighbor, a young man, brought his fiancée to see the "colonial" room, warning her that if she didn't care to decorate their future home in a similar fashion they would not be married. The settlement house worker later proudly reported that "their little room was uncannily like ours." Barrows, *Neighbors All,* 40.

281. Jane Addams, *The Long Road of Woman's Memory* (New York: Macmillan, 1916), 146–47. See also Jane Addams, *Twenty Years at Hull House* (1910; reprint, New York: New American Library, 1960), 21. Works on Jane Addams include Allen F. Davis, *American Heroine: The Life and Legend of Jane Addams* (New York: Oxford University Press, 1973); G. J. Barker-Benfield, "'Mother Emancipator': The Meaning of Jane Addams' Sickness and Cure," *Family History* 4 (winter 1979): 395–420; and Crunden, *Ministers of Reform,* 16–25, 66–68. On Hull House and immigrants, see Lissak, *Pluralism and the Progressives.* See also Kathryn Kish Sklar, "Hull House in the 1890s: A Community of Women Reformers," *Signs* 10 (summer 1985): 658–77.

282. Addams, *Twenty Years,* 78. She said, "No young matron has ever placed her own things in her own house with more pleasure than that which we first furnished Hull-House. We believed that the settlement may logically bring to its aid all those adjuncts which the cultivated man regards as good and suggestive of the best life of the past."

283. Addams, *Twenty Years,* 92

284. See Hayden, *Grand Domestic Revolution,* 182–227; Dolores Hayden "Charlotte Perkins Gilman and the Kitchenless House," *Radical History Review* 21 (spring 1980): 225–47; Mary A. Hill, *Charlotte Perkins Gilman: The Making of a Radical Feminist, 1860–1896* (Philadelphia: Temple University Press, 1980); Carol Ruth Berkin, "Private Woman, Public Woman: The Contradictions of Charlotte

Perkins Gilman," in *Women of America,* ed. Carol Ruth Berkin and Mary Beth Norton (Boston: Houghton Mifflin, 1979), 150–73; Allen, *Building Domestic Liberty;* O'Neill, *Everyone Was Brave,* 38–44, 130–33.

285. Charlotte Perkins Gilman, *The Home: Its Work and Influence* (1903; reprint, Urbana: University of Illinois Press, 1972), 49–52, 3.

286. Gilman, *Home,* 49–50.

287. Gilman, *Home,* 27–28.

288. Charlotte Perkins Gilman, "The Yellow Wallpaper" (1892), in *Fictions,* ed. Joseph F. Trimmer and C. Wade Jennings (New York: Harcourt Brace Jovanovich, 1989), 443. For a discussion of "The Yellow Wallpaper" and Mitchell's "colonial" novels, see Celia Betsky, "Inside the Past: The Interior and the Colonial Revival in Literature, 1860–1914," in Axelrod, *Colonial Revival in America,* 272–74; Michael Kammen, *A Season of Youth: The American Revolution and the Historical Imagination* (New York: Oxford University Press, 1978), 187–88. Mitchell wrote thirty-two historical novels between 1896 and 1902; his *Hugh Wynne* was a best-seller in 1896. Ernest Earnest, *S. Weir Mitchell: Novelist and Physician* (Philadelphia: University of Pennsylvania Press, 1950), 139–45, 32, 232–245.

289. Julian Hawthorne, "The Woman Who Wrote *Little Women,*" *Ladies' Home Journal* 39, October 1922, 125.

290. The extent to which this occurred is not documentable because records of visitors' reactions were not kept. The concept of a "resisting reading" is derived from Judith Fetterley, *The Resisting Reader: A Feminist Approach to American Fiction* (Bloomington: Indiana University Press, 1978).

291. A Boston settlement house worker reported on the frequency with which this question was asked. She explained that settlement house workers replied somewhat defensively that they "never went into a home without a legitimate errand or invitation." Barrows, *Neighbors All,* 13. Another interesting relationship between house museums and settlement houses existed in nearby Salem at about the same time Orchard House was founded. Caroline Emmerton purchased the House of the Seven Gables in 1908 for use as a settlement house, but she found it more practical to open it as a lucrative tourist attraction in order to fund social work in two other seventeenth-century houses she had moved to the site. The idea originated in "a committee of ladies," and the settlement house workers instructed immigrant children in domestic skills and history. Emmerton, *Chronicles of Three Old Houses.*

292. John Alcott, "The 'Little Women' of Long Ago," 187; Louisa May Alcott Memorial Association Records, Concord Free Public Library, Concord, Massachusetts; "New England Pilgrimage," *Boston Herald,* November 28, 1912. Even before the museum opened in 1912, more than forty thousand people each year toured the historic sites of Concord. *Concord Enterprise,* June 29, 1910.

293. "Louisa May Alcott Home Now Restored," *Boston Post,* May 29, 1912. Orchard House was also compared to Mount Vernon, making it the feminine analog to two powerful material emblems of male political culture.

294. Concord had numerous Arts and Crafts influences, including the temporary residence of Roycrofter Elbert Hubbard and Arts and Crafts illustrator Will Bradley, who had been hired by Edward Bok to do a series of drawings of tasteful homes in *Ladies' Home Journal* as part of Bok's domestic reform campaign of the early twentieth century. For more on Bradley, see Robert Judson Clark and Wendy Kaplan, "Arts and Crafts: Matters of Style," in *"The Art That Is Life": The Arts and Crafts Movement in America, 1875–1920*, ed. Wendy Kaplan (Boston: Little, Brown, 1987), 78, 94. Another Arts and Crafts influence on the CWC was C. R. Ashbee, "the most significant member of the Anglo-American cultural exchange" on behalf of the Arts and Crafts movement as well as historic preservation. Ashbee, a member of the Society for the Protection of Old Buildings, had given a lecture to the CWC in 1900 to gain support for Britain's newly founded National Trust. In his journals, Ashbee remarked on the affluence of his American audience, and on the fact that American owners of historic buildings frequently allowed them to deteriorate. Kaplan, "Lamp of British Precedent," 56–57; Rhoads, *Colonial Revival*, 251; Darley, *Octavia Hill*, 307; Concord Woman's Club Records, 1899–1900, Concord Free Public Library. For a record of the talks Ashbee gave on his American tour, see Ashbee, *American Sheaves*.

295. Abigail Alcott to Samuel May, September 19, 1853, quoted in Charles Strickland, *Victorian Domesticity: Families in the Life and Art of Louisa May Alcott* (University, Ala.: University of Alabama Press, 1985), 46.

296. For a discussion of how this aesthetic revived the old republican idea of civic virtue as derived from the freehold, thereby reinforcing traditional domesticity, see Cheryl Robinson, "House and Home in the Arts and Crafts Era: Reforms for Simpler Living," in Kaplan, *"Art That Is Life,"* 336–57.

297. On the meaning of the spinning wheel, see Monkhouse, "Spinning Wheel," 153–72. The above description of the ideal Progressive home is based on Seager's well-researched definition. See Seager, *"Father's Chair,"* 180.

298. The historic house museum phenomenon therefore supports Lears's thesis that antimodernism has paved the way for adjustment to rather than dissent from modernity.

299. Roland Marchand, *Advertising the American Dream: Making Way for Modernity* (Berkeley and Los Angeles: University of California Press, 1985), 359–63.

300. Cohn describes the change in the significance of "home" into the twentieth century, focusing on the transference of meaning from the actual to the symbolic ancestral home. Cohn, *Palace or Poorhouse.*

301. On "consumption communities," see Boorstin, *Americans: The Democratic Experience*, 89–90. See Grant McCracken's analysis of consumer culture, *Culture and Consumption: New Approaches to the Symbolic Character of Consumer Goods and Activities* (Bloomington: Indiana University Press, 1988), 57–70, 104–17, 133.

302. Leach, "Transformations," 330. Neil Harris, "Museums, Merchandising, and Popular Taste: The Struggle for Influence," in *Material Culture and the Study of American Life*, ed. Ian M. G. Quimby (New York: W. W. Norton, 1978), 140–174.

According to Harris, late-nineteenth-century museum founders were motivated by a sense of crisis over the debasement of public taste, which favored gaudy ornamentation and sentimental, romantic form. He explains that American high museums and department stores were established at the same time, but soon museums were less popular than the more dynamic store. Yet the relationship remained interactive, as DeForest's work demonstrates, as does the relationship between period rooms and subsequent factory production of "colonial" furniture. See Lynes, *Tastemakers*, 186.

303. Leach, "Transformations," 329, 337–39. Susan Porter Benson calls department stores "the Adamless Eden," simultaneously fun, empowering, wearing, and infantilizing. For a different view, see Boorstin, who outlines the carry-over from department stores to mail-order catalogs, especially after 1913 when parcel post made it inexpensive to send packages to rural route customers. Susan Porter Benson, *Counter Cultures: Saleswomen, Managers, and Customers in American Department Stores, 1890–1914* (Urbana: University of Illinois Press, 1986); Boorstin, *Americans: The Democratic Experience*, 101–9, 121–35.

304. See Jennifer Scanlon, *Inarticulate Longings: The Ladies' Home Journal, Gender, and the Promises of Consumer Culture* (New York: Routledge, 1995); Lynes, *Tastemakers*, 175–79; Christopher P. Wilson, "The Rhetoric of Consumption: Mass-Market Magazines and the Demise of the Gentle Reader, 1880–1920," in *Culture and Consumption: Critical Essays in American History, 1880–1920*, ed. Richard Wightman Fox and T. J. Jackson Lears (New York: Pantheon, 1983), 39–64.

305. Edward Bok, "A Bond of Common Sympathy," *Ladies' Home Journal* 8, April 1890, 8, quoted in Wilson, "Rhetoric of Consumption," 59.

306. See Shi, *Simple Life*, 181–89.

307. Roland Barthes identified a technique whereby an advertisement "innoculates the public" with a superficial critique of itself to soothe away any lurking "progressive prejudice." Barthes named this technique "operation margarine" after a familiar French commercial. Roland Barthes, *Mythologies*, trans. Jonathan Cape (1957; reprint, New York: Noonday Press, 1972), 41–42.

308. Neil Harris, "Museums, Merchandising, and Popular Taste," 152.

309. Thorstein Veblen, *The Theory of the Leisure Class* (1899; reprint, New York: New American Library, 1953), 114–18.

310. Veblen, *Theory of the Leisure Class*, 70; see also 52–60.

311. Ruth Schwartz Cowan, *More Work for Mother* (New York: Basic Books, 1983); Susan Strasser, *Never Done: A History of American Housework* (New York: Pantheon, 1982); Nancy Cott, *The Grounding of Modern Feminism* (New Haven: Yale University Press, 1987), 171–74.

312. Kathryn Kish Sklar, *Catharine Beecher: A Study in Victorian Domesticity* (New York: W. W. Norton, 1976); Hayden, *Grand Domestic Revolution*, 3, 22; Betty Friedan, *The Feminine Mystique* (New York, 1963).

313. Francis Steegmuller, "House of Little Women," 158.

314. "The Orchard House," *Colonial Homes* 9, July–August 1983, 78.
315. Elbert, *Hunger for Home*, xix.

3 █ Campaigning for Monticello

1. David Kennedy, *Over Here: The First World War and American Society* (New York: Oxford University Press, 1980), 65.
2. Charles B. Hosmer, *Presence of the Past: A History of the Preservation Movement in the United States before Williamsburg* (New York: G. P. Putnam, 1965), 299; Elizabeth Stillinger, *The Antiquers* (New York: Alfred A. Knopf, 1980), 189, 202–3. On the effects of this trend on house museums, see Geoffrey L. Rossano, ed., *Creating a Dignified Past: Museums and the Colonial Revival* (Savage, Md.: Rowman and Littlefield, 1991).
3. Hosmer, *Presence of the Past*, 300. For an interpretation of "professionalization" that differs from mine, see James M. Lindgren, "A New Departure in Historic Patriotic Work: Personalism, Professionalism, and Conflicting Concepts of Material Culture in the Late Nineteenth and Early Twentieth Centuries," *Public Historian* 18 (spring 1996): 41–60.
4. Nancy F. Cott, *The Grounding of Modern Feminism* (New Haven: Yale University Press, 1987), 94.
5. See Cott, *Grounding of Modern Feminism*, 255–56, 261; Martha Strayer, *The D.A.R.: An Informal History* (Washington, D.C.: Public Affairs Press, 1958), 68–69, 134.
6. The cabin was completed in 1931. See Lewis Barrington, *Historic Restorations of the Daughters of the American Revolution* (New York: Richard R. Smith, 1941), no. 142; Darlene Roth, *Matronage: Patterns in Women's Organizations, Atlanta, Georgia, 1890–1940* (Ann Arbor, Mich.: University Microfilms, 1978), 369–70.
7. American Scenic and Historic Preservation Society, *Twenty-Fourth Report to the Legislature of the State of New York* (Albany, N.Y.: J. B. Lyon, 1919), 40–41; Hosmer, *Presence of the Past*, 148–50.
8. Hosmer, *Presence of the Past*, 63–65, 289–90. The twenties also marked the rise of the "great Triumvirate of Collecting Ladies." Louisa DuPont Crowninshield, Katherine Prentice Murphy, and Electra Webb had great authority in the field of collecting antiques. In 1947, Webb founded a museum village of "early American" houses in Shelburne, Vt. See Stillinger, *Antiquers*, 240–48.
9. Paul M. Rea, "The Future of Museums in the Life of the People," *Museum Work* 3 (March 1921): 48, quoted in Daniel M. Fox, *Engines of Culture: Philanthropy and Art Museums* (Madison: State Historical Society of Wisconsin, 1963), 18.
10. In 1929, Fiske Kimball's survey of visitors to the Pennsylvania Museum found the period rooms to be the most popular exhibits. See Dianne Pilgrim, "Inherited from the Past: The American Period Room," *American Art Journal* 10 (May 1978): 5 and passim.

11. Stillinger, *Antiquers*, 164.

12. Margaret Olivia Sage purchased the massive collection of Boston lawyer Eugene Bolles after its display in the Hudson–Fulton celebration of 1909, donating it to the Metropolitan. Calvin Tomkins has suggested that Mrs. Russell Sage engaged in such remarkable philanthropic projects after the death of her husband to counter his "unsavory reputation as a financial manipulator" and associate of Jay Gould. Calvin Tomkins, *Merchants and Masterpieces: The Story of the Metropolitan Museum of Art* (New York: E. P. Dutton, 1970), 196–98. The success of the American Wing is recounted in R. T. H. Halsey and Elizabeth Tower, *The Homes of Our Ancestors as Shown in the American Wing of the Metropolitan Museum of Art* (Garden City, N.Y.: Doubleday, Page, 1925), xxi.

13. Halsey, *Homes*, xxii.

14. Quoted in Stillinger, *Antiquers*, 205.

15. Halsey, *Homes*, xxi, 114, viii.

16. "A Household of Continuance," *New York Times*, November 10, 1924, p. 16, quoted in Karal Ann Marling, *George Washington Slept Here: Colonial Revivals in American Culture, 1878–1896* (Cambridge: Harvard University Press, 1988), 220.

17. Laurence Vail Coleman, *The Museum in America*, vol. 1 (Washington, D.C.: American Association of Museums, 1939), 35. In 1914, the National Park Service registered 240,000 visitors, but twelve years later it hosted more than 2 million people. Hosmer, *Presence of the Past*, 1.

18. William B. Rhoads, "The Colonial Revival and the Americanization of Immigrants," in *The Colonial Revival in America*, ed. Alan Axelrod (New York: W. W. Norton, 1985), 359; Marling, *Washington Slept Here*, 163, 269–70.

19. Marling, *Washington Slept Here*, 283–88. The "Educational Department" of Ford's automobile factory was likewise interested in enforcing a "comfortable and cozy domesticity" in single-family homes among immigrant workers as part of its program of "welfare capitalism." See Stephen Meyer, "Adapting the Immigrant to the Line: Americanization in the Ford Factory, 1914–1921," in *American Immigration and Ethnicity*, ed. George E. Pozzetta (New York: Garland Publishing, 1991), 70.

20. See Michael Wallace's cogent analysis of Greenfield Village, in "Visiting the Past," in *Presenting the Past: Essays on History and the Public*, ed. Susan Porter Benson, Stephen Brier, and Roy Rosenzweig (Philadelphia: Temple University Press, 1986), 142–46.

21. Thomas Schlereth, "The Historic Museum Village as a Cross-Disciplinary Learning Laboratory," in *Artifacts and the American Past* (Nashville, Tenn.: American Association for State and Local History, 1980), 121.

22. Ford quoted in Charles Phillips, "Greenfield's Changing Past," *History News* 37 (November 1982): 10.

23. John Wright, quoted in Phillips, "Greenfield's Changing Past," 11; Charles B. Hosmer, *Preservation Comes of Age: From Williamsburg to the National Trust, 1926–1949* (Charlottesville: University Press of Virginia, 1981), 79.

24. Wallace, "Visiting the Past," 145.
25. In reality the coequal culprit was the nearby location of a World War I DuPont munitions plant. W. A. R. Goodwin quoted in Raymond Fosdick, *John D. Rockefeller Jr.: A Portrait* (New York: Harper and Brothers, 1956), 277, 274; Hosmer, *Preservation Comes of Age*, 14–15; Kenneth Hudson, *Museums of Influence* (Cambridge: Cambridge University Press, 1987), 147.
26. *Detroit Sun*, November 4, 1924, quoted in Fosdick, *John D. Rockefeller Jr.*, 277–78.
27. Fosdick, *John D. Rockefeller Jr.*, 356–57; Wallace, "Visiting the Past," 147. On other Rockefeller restoration projects around the world, see Fosdick, 349–68.
28. Fosdick, *John D. Rockefeller Jr.*, 280–94; Hosmer, *Preservation of the Past*, 18–19.
29. Wallace, "Visiting the Past," 147–48.
30. Quoted in *Colonial Williamsburg Official Guidebook and Map* (Williamsburg, Va.: Colonial Williamsburg, 1981), xv.
31. Hosmer, *Preservation Comes of Age*, 48.
32. Freeman Tilden, *The State Parks* (New York: Alfred A. Knopf, 1962), 25.
33. Hosmer, *Preservation Comes of Age*, 61.
34. Hosmer, *Preservation Comes of Age*, 884, 45–46; J. Franklin Jameson to Perry, Shaw, and Hepburn, October 2, 1928, Colonial Williamsburg Foundation Archives, Williamsburg, Va.; Proceedings of Meeting, Advisory Committee of Historians, October 21, 1932, 57–58, Colonial Willamsburg Foundation Archives, Williamsburg, Va.
35. Wallace, "Visiting the Past," 149.
36. For a groundbreaking overview of the preservation of Monticello, see Hosmer, *Presence of the Past*, 153–92. See also the brief but cogent interpretation, to which I will refer frequently, by Merrill D. Peterson, *The Jefferson Image in the American Mind* (New York: Oxford University Press, 1960), 380–94. In Monticello's archives is the unpublished "History of Monticello since 1926," written in 1978 by James A. Bear, which includes information on the Littleton effort.
37. Martin Littleton was a Democratic representative from New York who had defeated Theodore Roosevelt's candidate in the state's 1910 Democratic sweep. Shortly before Maud Littleton began her campaign to wrest Monticello from Levy, her husband was embroiled in a controversy over his actions on the Stanley Committee, which investigated U.S. Steel for possible violations of the Sherman Antitrust Act. Littleton had refused to sign either the majority or minority report, both of which were critical of U.S. Steel, favoring instead the repeal of the Sherman Act and its replacement by legislation more specific in its definitions of unfair practices. To many of his fellow Democratic members of Congress, this amounted to an outright defense of the trust. Littleton was not a candidate for reelection after his term ended in 1913. He resumed his practice of criminal law, gaining celebrity for his successful defense of Harry Thaw in his second trial for the murder of Stanford White. Littleton became "one of the most famous afterdinner speakers of his time." See *Congressional Record* 48, December 4, 1911–January 17, 1912 (Washington, D.C.: Government Printing Office, 1912); Arundel

Cotter, *United States Steel* (Garden City, N.Y.: Doubleday, Page, 1921), 203–5; Paolo Coletta, *The Presidency of William Howard Taft* (Lawrence: University Press of Kansas, 1973), 158–68; Harris E. Starr, ed., *Dictionary of American Biography*, vol. 2 (New York: Charles Scribner's Sons, 1944), 501–2. Jefferson Levy was a member of the fifty-sixth, sixty-second, and sixty-third congresses and was the leader of the "Gold Democrats" in the fifty-sixth. *New York Times*, March 7, 1924.

38. U.S. House Committee on Rules, *Hearings on Public Ownership of Monticello*, "Statement of Mrs. Martin Littleton, of New York, N.Y.," 62d Congress, 2d session, on S. Con. Res. 24, July 24, 1912 (Washington, D.C.: Government Printing Office, 1912); Maud Littleton, *Monticello*, (New York: n.p., 1912), no page.

39. Uriah Phillips Levy (1792–1862) was a naval officer who was court-martialed six times and dismissed from the navy twice in the ten-year period following the War of 1812 on various charges from dueling to insulting a fellow officer. Nevertheless, he was promoted to captain in 1844 and to commodore in 1860. He is most remembered for his efforts to have naval corporal punishment outlawed. *Who Was Who in America, 1607–1896* (Chicago: Marquis, 1967), 383; Alberta Eiseman, *Rebels and Reformers: Biographies of Four Jewish Americans* (Garden City, N.Y.: Doubleday, 1976), 1–33.

40. Hosmer, *Presence of the Past*, 152–57; William Howard Adams, *Jefferson's Monticello* (New York: Abbeville Press, 1983), 256; Merrill D. Peterson, *Visitors to Monticello* (Charlottesville: University Press of Virginia, 1989), 4–6; J. G. Randall, "When Jefferson's Home Was Bequeathed to the United States," *South Atlantic Quarterly* 22 (January 1924): 35–39. For Jefferson Levy's own account, see George Alfred Townscend, *Monticello and Its Preservation since Jefferson's Death, 1826–1902* (Washington, D.C.: Gibson Brothers, 1902).

41. "One Wish" is reprinted in the *Congressional Record* 48, April 3–23, 1912 (Washington, D.C.: Government Printing Office, 1912).

42. FDR's interest in memorializing Monticello was rooted in his admiration for Thomas Jefferson, at a time when this sentiment was not widespread. Page Smith, *Redeeming the Time: A People's History of the 1920s and the New Deal* (New York: McGraw-Hill, 1987), 362–65; Peterson, *Jeffersonian Image*, 264, 332, 355, 357–58, 448.

43. Reprinted in House Committee on Rules, *Public Ownership of Monticello*, "Statement of Mrs. Martin Littleton."

44. Ibid.

45. William Sumner Appleton to Mrs. Martin Littleton, October 28, 1912, Society for the Preservation of New England Antiquities (SPNEA), Boston, Mass.

46. *New York Times*, March 19, 1913; Littleton, *Monticello*, no page.

47. Hosmer, *Presence of the Past*, 166, 170–71.

48. In this context the house museum movement can be seen as part of the history of women's voluntarism generally. See, for example, Robyn Muncy, *Creating a Female Dominion in American Reform, 1890–1938* (New York: Oxford University

Press, 1991), and Ellen Fitzpatrick, *Endless Crusade: Women Social Scientists and Progressive Reform* (New York: Oxford University Press, 1990).

49. Congress can declare a site needed for "public use," and the owner of the property has the right to a judicial hearing to challenge the property's potential "public use." See Robert K. Greenawalt, "United States of America," in *Expropriation in the Americas*, ed. Andreas F. Lowenfeld (New York: Dunellen, 1971), 241–305, and Richard A. Epstein, *Takings: Private Property and the Power of Eminent Domain* (Cambridge: Harvard University Press, 1985).

50. "No Bar to Buying Jefferson's Home: James M. Beck Says Monticello Can Be Taken from Mr. Levy under Eminent Domain," unidentified newspaper clipping, Monticello Archives, Charlottesville, Va.; Littleton, *Monticello*, no page.

51. The vote was 101 yea, 141 nay, 138 abstentions, and 10 "present." Levy voted nay; Martin Littleton abstained. Arguments against the passage of the resolution went generally along the lines suggested by Appleton. Congressman Saunders argued that "the name and authority of this great man should not be invoked to sustain a movement to call into exercise the power of the Federal government to take over property for a use which in the contemplation of the Constitution has not been clearly ascertained to be a public one." U.S. House, *Debate on Monticello*, H. Res. 740, December 9, 1912, *Congressional Record*, 62d Congress, 3d session (Washington, D.C.: Government Printing Office, 1913).

52. Herbert S. Stone, "Buying Monticello," *House Beautiful* 33, January 1913, 50.

53. Appleton to Littleton, November 4, 1912, SPNEA Archives.

54. Robert F. Wesser, *A Response to Progressivism: The Democratic Party and New York Politics, 1902–1918* (New York: New York University Press, 1986).

55. Peterson, *Jefferson Image*, 264–65, 382–83.

56. Peterson, *Jefferson Image*, 383.

57. Quoted in Littleton, *Monticello*, no page.

58. Peterson, *Visitors to Monticello*, 173.

59. *Richmond Dispatch*, April 9 and 15, 1897. On Bryan, see Lawrence Levine, *Defender of the Faith: William Jennings Bryan: The Last Decade, 1915–1925* (New York: Oxford University Press, 1965).

60. It was Wilson himself who segregated Washington and arranged for the racist film *Birth of a Nation* to be screened in the White House and before members of Congress and the Supreme Court. Lawrence J. Friedman, *The White Savage: Racial Fantasies in the Postbellum South* (Englewood Cliffs, N.J.: Prentice-Hall, 1970), 168–72.

61. See James M. Lindgren, *Preserving the Old Dominion: Historic Preservation and Virginia Traditionalism* (Charlottesville, Va.: University Press of Virginia, 1993).

62. Hosmer, *Presence of the Past*, 173; Peterson, *Jefferson Image*, 384.

63. Dorothy Dix was the pseudonym of Elizabeth Meriwether Gilmer (1870–1951). See Maxine Block, ed., *Current Biography, 1940* (New York: W. W. Wilson, 1940), 249.

64. Dorothy Dix, "Monticello—Shrine or Bachelor's Hall?" *Good Housekeeping* 58, April 1914, 538–39.

65. John Higham, *Strangers in the Land: Patterns of American Nativism, 1860–1925* (New York: Atheneum, 1968), 160–61; Jonathan Sarna, *The American Jewish Experience* (New York: Holmes and Meier, 1986), 173.

66. Dix's story, based on an 1897 *New York Sun* article, "A National Humiliation" by Amos J. Cummings, was entirely false and was furthered by Littleton herself in her publication *Monticello* (n.p., 1912), 10. The property was auctioned after Jefferson's death and purchased by a Charlottesville merchant. Levy in turn bought Monticello, according to his biographer, in honor of Thomas Jefferson, whom Levy admired for upholding freedom of religion. Adams, *Jefferson's Monticello*, 237–63; Peterson, *Visitors to Monticello*, 4–6, 174–82; Eiseman, *Rebels and Reformers*, 25, 28. For a contemporary refutation copyrighted by Jefferson Levy, see Townscend, *Monticello and Its Preservation*, passim.

67. Dix, "Monticello—Shrine or Bachelor's Hall?" 540.

68. Adams, *Jefferson's Monticello*, 251, 260; Peterson, *Visitors to Monticello*, 176.

69. Dix, "Monticello—Shrine or Bachelor's Hall?" 541.

70. U.S. House Committee on Rules, *Hearings on Purchase of Monticello*, 63d Congress, 2d session, on H. J. Res. 390 and 418, February 23, 1914 (Washington, D.C.: Government Printing Office, 1915).

71. Hosmer, *Presence of the Past*, 174; U.S. House Committee on Rules, *Hearings on Purchase of Monticello*, "Statement of Mrs. Littleton," 63d Cong., 2d session, on H. J. Res. 390 and 418, February 23, 1914 (Washington, D.C.: Government Printing Office, 1915).

72. House Committee on Rules, *Purchase of Monticello*, "Statement of Mrs. Littleton."

73. U.S. House Committee on Public Buildings and Grounds, *Hearings on Purchase of Monticello*, 64th Cong., 1st session, on H. J. Res. 269, August 8, 1916 (Washington, D.C.: Government Printing Office, 1916).

74. U.S. House Committee on Public Buildings and Grounds, *Hearings on Purchase of Monticello*, 64th Cong., 1st session, on H. J. Res. 269, December 17, 1916 (Washington, D.C.: Government Printing Office, 1916); U.S. Subcommittee of the Committee on Public Buildings and Grounds, *Hearings on Purchase of Monticello*, 64th Cong., 2d session, on S. J. Res. 153, January 9, 1917 (Washington, D.C.: Government Printing Office, 1917); Hosmer, *Preservation Comes of Age*, 175–77.

75. See Paula Baker, "The Domestication of Politics: Women and American Political Society, 1780–1920," *American Historical Review* 89 (June 1984): 644–45.

76. Bear, "History of Monticello"; *New York Times*, April 13 and November 3, 1922.

77. *New York Times*, March 2, 1923; Bear, "History of Monticello," unpag.; Mabel Ward Cameron, comp., *The Biographical Cyclopaedia of American Women* (New York: Halvord Publishing, 1924), 167–68; John William Leonard, ed., *Woman's*

Who's Who of America, 1914–1915 (New York: American Commonwealth, 1916), 395; *New York Times*, August 8, 1931; Barbara J. Griffin, "The Life of a Poor Relation: The Art and Artistry of Marietta Minnigerode Andrews," *Virginia Cavalcade* 40, 41 (spring/summer 1991): 148–59, 20–23; Marietta Minnigerode Andrews, *My Studio Window: Sketches of Washington Life* (New York: E. P. Dutton, 1928), 352, 362–62, 374–78, and passim.

78. Hosmer, *Presence of the Past*, 178–192. Michael Wallace correctly points out that the effort to preserve Monticello was thus achieved by "wall streeters" rather than by the traditional "patrician women." Michael Wallace, "Visiting the Past: History Museums in the United States," in Benson, Brier, and Rosenzweig, *Presenting the Past*, 142.

79. See David Burner, *The Politics of Provincialism: The Democratic Party in Transition, 1918–1932* (New York: Alfred A. Knopf, 1970), 28–73. On the use of Jefferson as a means of uniting the Democratic Party in this era, see Peterson, *Jefferson Image*, 330–76. On the history of the TJMF see Peterson, *Jefferson Image*, 384–88; Hosmer, *Presence of the Past*, 185–88. Hosmer's interpretation rests heavily on personal correspondence he had in 1970 with Theodore Fred Kuper, whose tenure as "national director" during Gibboney's early years as foundation president is murky because he apparently severed contact with the TJMF after 1935, leaving little evidence of his activities in the TJMF Archives.

80. Gibboney (1877–1944) was the head of the highly successful TJMF until his death at Monticello in 1944. *New York Times*, April 25 and 26, 1944; *Who's Who in America*, vol. 16 (Chicago: Marquis, 1928), 903–4; *Who Was Who in America*, vol. 2 (Chicago: Marquis, 1956), 209.

81. A transcription of the certificate of incorporation of the TJMF at the Monticello Archives includes, for example, former Democratic presidential candidate Alton Brooks Parker, soon-to-be Democratic presidential candidate John W. Davis, Virginia's Democratic Governor E. Lee Trinkle, and Gibboney's Democratic attorney colleagues from New York, Moses Grossman and George Gordon Battle. Mrs. Martin Littleton was also a charter member. For a contemporary description of the founding of the TJMF, see John S. Patton and Sallie Doswell, *Monticello and Its Master* (Charlottesville, Va.: Michie Company, 1925), 70–78. The quotation characterizing the Richmond and Washington women's groups is from Theodore Kuper. Kuper to Walter Muir Whitehill, February 18, 1971, typescript at the Monticello Archives. The TJMF was aware of its most illustrious predecessor, the MVLA, praising the "patriotism and devotion of these ladies," whose Mount Vernon was a "true inspiration." From a promotional pamphlet titled "Shall We the American People as One Great Family Club Together?" published by the TJMF and the Thomas Jefferson Centennial Commission commemorating the 150th anniversary of American independence and the 100th anniversary of Jefferson's birth on July 4, 1926, TJMF Archives, Charlottesville, Va.

82. This process, from the point of view of TJMF national director Theodore Fred Kuper, is detailed in Hosmer, *Presence of the Past*, 180–83.

83. Documentation of the "pilgrimage" fund-raiser is in the TJMF Archives, Monticello. See also Hosmer, *Presence of the Past*, 182.

84. TJMF pamphlet in the Virginia State Archives, Richmond, Va.; *New York Times*, March 17, 1924.

85. *New York Times*, April 6 and 7, 1924. Gibboney was careful to verify the authenticity of the gig, consulting the great-great-grandson of Thomas Jefferson in March 1924. T. J. Randolph to Gibboney, March 4, 1924, TJMF Archives.

86. Peterson, *Jefferson Image*, 385–87; quoted is Gibboney's foreword to the Thomas Jefferson Memorial Foundation's *Thomas Jefferson: The Sage of Monticello, and His Beloved Home* (New York: Thomas Jefferson Memorial Foundation, 1926).

87. *Nation*, vol. 118, no. 3059, February 1924, 195–6.

88. Letter to the editor from H. H. Hegeman of the American Rights League, *New York Times*, April 1, 1924.

89. Gibboney, foreword to Patton and Doswell, *Monticello and Its Master*, 12–13.

90. Two works characterizing Democratic strife in the era are Burner, *Politics of Provincialism*, and Robert K. Murray, *The 103d Ballot: Democrats and the Disaster in Madison Square Garden* (New York: Harper and Row, 1976).

91. Burner, *Politics of Provincialism*, 5–6, 11; Peterson, *Jefferson Image*, 347–55; Kuper to Whitehill, February 18, 1971, typescript copy at the Monticello Archives; Hosmer, *Presence of the Past*, 184–85.

92. *World*, March 12, 1924.

93. Murray, *103d Ballot*, xiii, 41–42, 88–89, and passim; Burner, *Politics of Provincialism*, xii, 86–90, 110–18; David M. Chalmers, *Hooded Americanism: The First Century of the Ku Klux Klan* (Garden City, N.Y.: Doubleday, 1965), 202–24. On Al Smith, see Donn C. Neal, *The World beyond the Hudson: Alfred E. Smith and National Politics, 1918–1928* (New York: Garland Publishing, 1983), and Paula Eldot, *Governor Al Smith: The Politician as Reformer* (New York: Garland Publishing, 1983).

94. Peterson notes that the TJMF was "oriented in the main to the McAdoo element of the Democratic party." Peterson, *Jefferson Image*, 387.

95. Murray, *103d Ballot*, 69, 155, 135; Chalmers, *Hooded Americanism*, 204. Tensions between Smith and Copeland were brewing, however. See Neal, *World beyond the Hudson*, 158–39.

96. Murray, *103d Ballot*, 197, 42, 286, 112, 42.

97. Klan leader quoted in Murray, *103d Ballot*, 15.

98. Charles A. Greathouse, comp., *Official Proceedings of the Democratic National Convention Held in Madison Square Garden, New York City, June 24, 25, 26, 27, 28, 30, July 1, 2, 3, 4, 5, 6, 7, 8, and 9, 1924* (Indianapolis: Bookwater-Ball-Greathouse, 1924), 25, 295, 288, 289–91, 302, 112.

99. *New York Times*, July 1, 1924; Hosmer, *Presence of the Past*, 187–88; *New York Times*,

April 8, 1924. The following year, perhaps in response to the fact that the "delegate" fund-raiser was for boys, the TJMF conducted a similar one for "young ladies," who earned free trips to Paris rather than to a political convention. *New York Times,* June 14, 1925.

100. Peterson, *Jefferson Image,* 387; Hosmer, *Presence of the Past,* 188.

101. *New York Times,* April 29, 1926.

102. *New York Times,* June 15 and 16, 1926.

103. Claude Bowers, *My Life* (New York: Simon and Schuster, 1962), 133–34.

104. *New York Times,* July 5, 1926.

105. Kuper said that Felix Warburg, Jonah Goldstein, and Julius Rosenwald had tried to convince Levy to donate Monticello to the U.S. government as a way of celebrating "religious freedom" in response to the KKK. Kuper to Whitehill, February 18, 1971, typescript in Monticello Archives. Gibboney himself wrote in 1940 that in the early years of fund-raising for Monticello he had been "greatly heartened" by "the splendid support" of the "Jewish leaders of America." Gibboney, TJMF, to Herschel Lymon, Hebrew Union College, Cleveland, July 3, 1940, TJMF Archives. On antisemitism in this period in the rural bloc, see Don S. Kirschner, *City and Country: Rural Responses to Urbanization in the 1920s* (Westport, Conn.: Greenwood Publishing, 1970), 29–33.

106. Bowers, *My Life,* 134. Of the revisionism of his *Jefferson and Hamilton: The Struggle for Democracy in America* (Boston: Houghton Mifflin, 1925), Bowers said, "For at least two generations, youth had been fed on the theory that Jefferson was primarily responsible for the Civil War because of the Virginia and Kentucky Resolutions framed by Jefferson and Madison, that he was a liar and a hypocrite, that he was a mere dreamer and an atheist without any sound claim to statesmanship." Bowers, *My Life,* 126.

107. Peterson, *Jefferson Image,* 347–55, 360–63.

108. Frank Freidel, *Franklin D. Roosevelt: The Ordeal* (Boston: Little, Brown, 1954), 204; Arthur M. Schlesinger Jr., *The Crisis of the Old Order, 1919–1933* (Boston: Houghton-Mifflin, 1957), 104; Peterson, *Jefferson Image,* 351–53, 355–76.

109. U.S. Sesquicentennial of American Independence and the Thomas Jefferson Centennial Commission, *Official Plan for the Nation-Wide Celebration of the One Hundred and Fiftieth Anniversary of the Adoption of the Declaration of Independence* (Washington, D.C.: Government Printing Office, 1926), 8.

110. Bowers, *My Life,* 195–96.

111. *New York Herald,* September 23, 1928.

112. Pamphlet, "Shall We the American People as One Great Family Band Together?" 1926, TJMF Archives.

113. Peterson, *Jefferson Image,* 387.

114. Burner, *Politics of Provincialism,* 101.

115. FDR Papers, President's Personal Files 5319, "Thomas Jefferson Memorial Foundation," FDR Library, Hyde Park, N.Y.

116. She had copies constructed of Jefferson's chaise longue, swivel chair, and "lazy su-
san" table made for sale at Monticello (and also as a birthday present for FDR).
Kuper to Fiske Kimball, January 15, 1930; Kuper to Kimball, October 18, 1929,
TJMF Archives. The *New York Times* said of the Monticello reproductions, "One
can imagine little Johnny and Mary coming home from their little history class
and gaining a more personal understanding of the great statesman about whom
they had just been studying through the possession by the family of such a piece
of furniture." Frank Shuffleton cites a 1928 catalog of craftsman-made reproduc-
tions of Monticello furniture for sale at the gift shop. Shuffleton, *Thomas Jeffer-
son: A Comprehensive Annotated Bibliography of Writings about Him (1826–1980)*
(New York: Garland Publishing, 1983), 430.
117. FDR to Gibboney, April 18, 1938; FDR to Constance Gibboney, April 24, 1944,
FDR Papers; Stuart Gibboney to FDR, September 6, 1935, TJMF Archives.
118. Memorandum, FDR to Stuart Gibboney, January 20, 1936, FDR Papers. On
FDR's utilitarian Jeffersonianism, see Peterson, *Jefferson Image*, 355–76, and Frei-
del, 199–213.
119. Thomas Jefferson to William Charles Jarvis, September 28, 1820, transcribed and
on file in the Fiske Kimball series, TJMF Archives. Also in this file are copies of a
letter to the editor of the New York *World Telegram* dated June 11, 1935, arguing
that "the issue raised by the Supreme Court's NRA decision" was not a matter of
jettisoning the Constitution but rather of allowing it (as a quotation from Jeffer-
son showed he thought it should) to "keep pace with the times." "Certain reac-
tionaries," the writer warned, were making "a prison of the Constitution." Stuart
Gibboney passed the Jefferson quotation cited in the letter on to FDR later in
1935. It proved, in Gibboney's words, that "Jefferson was as much of a radical pro-
gressive" in later life as he'd been when he wrote the Declaration of Independen-
dence. Gibboney to FDR, September 6, 1935, TJMF Archives.
120. On the CCC at Monticello, see Gibboney, topical file "CCC Service at Monti-
cello," TJMF Archives, and FDR Papers. Gibboney to Kimball, September 20,
1933, TJMF Archives.
121. Harold Jefferson Coolidge to Gibboney, April 17, 1934, TJMF Archives.
122. Paul F. Tate to Henry Alan Johnston, February 13, 1935, TJMF Archives.
123. Gibboney to FDR, September 6, 1935, TJMF Archives. In 1944, Ickes wrote to
FDR on this subject, saying Gibboney had dropped the matter when he was ap-
proached in 1935. Harold L. Ickes to FDR, July 24, 1944, FDR Papers, Official,
NPS 1939–1945, FDR Library; Hosmer, *Presence of the Past*, 187–88.
124. Booklet, "Independence Day Exercises Held by the Thomas Jefferson Memorial
Foundation at Monticello, July 4, 1936," TJMF Archives.
125. Gibboney to Hon. William B. Bankhead, Speaker of the House, April 29, 1938,
TJMF Archives. There are numerous copies of this letter, with minor changes, to
various members of Congress.

126. Fiske Kimball to Leicester Holland, Library of Congress, April 7, 1938. Kimball's 1938 correspondence is replete with evidence of the political and aesthetic battles surrounding the monument project.
127. Gibboney to FDR, July 12, 1940; Edwin Watson, secretary to the president, to Gibboney, November 25, 1940; Gibboney to Watson, November 28, 1940, TJMF Archives.
128. Henry Alan Johnston to Wendell Wilkie, May 18, 1940, TJMF Archives.
129. Edward Boykin to Gibboney, October 7, 1943, and enclosures, including a copy of John Rankin's statement in the *Congressional Record* attacking the Bicentennial Commission, TJMF Archives.
130. See, for example, Kimball to Gibboney, November 7, 1942, TJMF Archives.
131. The TJMF's office was then relocated at Chemical Bank (where Houston worked) on Broadway from its original Pine Street office, from which it had operated until the midthirties. Gibboney to Breckinridge Long, October 2, 1942; Johnston to George J. Ryan, September 24, 1942; Gibboney to Johnston, May 20, 1943; TJMF Minutes, as transcribed by Cinder Stanton, Research Department, Monticello, TJMF Archives.
132. Ickes to FDR, July 24, 1944; Paul Appleby (acting director of the Budget Bureau) to FDR, September 4, 1944; FDR to Ickes, September 23, 1944, FDR Papers, Official, Container 16, Folder 6P, "National Park Service, 1939–1945," FDR Library; Hosmer, *Presence of the Past*, 188.
133. The TJMF Archives contain a scrapbook documenting Truman's Monticello Independence Day speech of 1947, including a transcription of his address. Gibboney's successor, Frank Houston, referred to Truman as a Jefferson "disciple" but, unlike Gibboney, he turned his comments almost immediately away from politics to Monticello itself. For an interpretation of the speech and its significance to foreign policy, see *New York Times*, July 7, 1947.
134. For a biography of Kimball, see George Roberts and Mary Roberts, *Triumph on Fairmount: Fiske Kimball and the Philadelphia Museum of Art* (Philadelphia and New York: J. B. Lippincott, 1959).
135. Ickes to FDR, July 24, 1944, FDR Papers.
136. Kimball to Frank Houston, March 14, 1945, TJMF Archives.
137. "Preliminary Draft of a Proposed Cooperative Agreement between the United States and the Thomas Jefferson Memorial Foundation, 1946"; Hillory A. Tolson, acting director, NPS, to Kimball, August 20, 1946, TJMF Archives.
138. See, for example, Johnston to Kimball, December 6, 1946; William Hildreth to Kimball, July 23, 1946, TJMF Archives.
139. Kimball to Johnston, December 4, 1946, TJMF Archives.
140. Kimball to Newton B. Drury, NPS director, January 27, 1947, TJMF Archives.
141. Joseph Lahendro, "Fiske Kimball: American Renaissance Historian" (M.A. thesis, University of Virginia, 1982), v–vi, 12–25, 34–40, and passim.

142. Statement by Kimball on Jefferson as an architect, 1944, TJMF Archives.

143. See Fiske Kimball, *Domestic Architecture of the American Colonies and of the Early Republic* (1922; reprint, New York: Dover, 1966), 260–61, and Lahendro, 10, v–vi.

144. Quoted in Lahendro, "Fiske Kimball," 31.

145. Lahendro, "Fiske Kimball," v–vi, 34–37, 581–83.

146. Roberts and Roberts, *Triumph on Fairmount*, 41, 66, 71–72.

147. Fiske Kimball, "They Like What They Know: Exhibition of Popular Favorites in the Philadelphia Museum," *Art News* 45 (August 1946): 51.

148. Fiske Kimball, "Victorian Art and Victorian Taste," *Antiques* 23 (March 1933): 103.

149. Fiske Kimball, "Museum Values," *American Magazine of Art* 19 (September 1928): 482.

150. Ibid.

151. "Jefferson's Home Should Be a Shrine," *Washington Herald*, March 16, 1925.

152. Kimball to Gibboney, June 15, 1937; Herbert D. Miles to Gibboney, December 14, 1940; Miles to Gibboney, November 8, 1940; Edna Webel to Frank Houston, July 2, 1945; Gibboney to Kimball, June 12, 1937, TJMF Archives.

153. Kimball to Gibboney, June 18, 1926, TJMF Archives.

154. Amelia Mayhoff to Kimball, November 9, 1928, TJMF Archives.

155. Gibboney to Kimball, December 1, 1925; Kimball to R. T. H. Halsey, January 2, 1926; Halsey to Kimball, January 12, 1926, TJMF Archives.

156. Halsey to Kimball, January 12, 1926, TJMF Archives.

157. See, for example, a memorandum to Houston by his secretary, Edna Webel, of July 1944 noting a pervasive negative reaction to Kimball's furnishings policy. The house needed, she said, "pieces correct for that period." The early stages of furnishing of the "Monroe Room" by Laurence Gouverneur Hoes is mentioned in Gibboney to Marie Kimball, January 24, 1944, TJMF Archives.

158. See, for example, Marie Kimball, *The Furnishings of Monticello* (1929; reprint, n.p., 1940); Marie Kimball, "Jefferson's Furniture Comes Home to Monticello," *House Beautiful*, August 1929, 164–65, 186. See also Roberts and Roberts, *Triumph at Fairmount*, passim, for an interpretation of the relationship between Fiske Kimball and Marie Kimball. The 1946 changes in furnishings policy are recorded in the TJMF board minutes as transcribed by Cinder Stanton of the Monticello Research Department.

159. Fiske Kimball to Gibboney, October 13, 1939; Kimball to W. A. Lambeth, April 20, 1927, TJMF Archives.

160. Roberts and Roberts, *Triumph at Fairmount*, 167; Kimball to Hazel Perkins, November 15, 1949, TJMF Archives.

161. Kimball to Perkins, November 15, 1949, TJMF Archives. Laurence Vail Coleman, in the first monographic treatment of the historic house museum, had noted the exceptional nature of Monticello's "colored men servants" acting as tour guides, adding that in general it was preferable that guides be women "of resource." See

Laurence Vail Coleman, *Historic House Museums* (Washington, D.C.: American Association of Museums, 1933), 88. The TJMF board approved the "reassignment" of African-American guides in favor of the traditional women guides in 1951. TJMF Board Minutes, transcribed by Cinder Stanton, Monticello Research Department, TJMF Archives.

162. James M. Lindgren, "'A New Departure in Historic Patriotic Work': Personalism, Professionalism, and Conflicting Concepts of Material Culture in the Late Nineteenth and Early Twentieth Centuries," *Public Historian* 18 (spring 1996): 41–60; Hosmer, *Presence of the Past*, 300. Also noting the professionalizing trend and its impact on the status of women in the museum field are Barbara Howe, "Women in Historic Preservation: The Legacy of Ann Pamela Cunningham," *Public Historian* 12 (winter 1990): 31–36, and essays in Jane R. Glaser and Artemis A. Zenetou, *Gender Perspectives: Essays on Women in Museums* (Washington, D.C.: Smithsonian Institution Press, 1994).

4 ▪ *"The Bricks of Compromise Settle into Place"*

1. Langston Hughes used the phrase "the bricks of compromise settle into place" to describe sorrowfully how the black students at his alma mater, Lincoln University, had come to terms with its all-white faculty. Langston Hughes, *The Big Sea* (1940; New York: Hill and Wang, 1993), 310. On Washington's birthplace as a National Park Service site, see Edwin C. Bearss, "The National Park Service and Its History Program, 1866–1986," *Public Historian* 9 (spring 1987): 10; William C. Everhart, *The National Park Service* (New York: Praeger Publishers, 1972), 31–34; Charles B. Hosmer, "The Broadening View of the Historical Preservation Movement," in *Material Culture and the Study of American Life*, ed. Ian M. Quimby (New York: W. W. Norton, 1978), 124.

2. Charles B. Hosmer, *Preservation Comes of Age: From Williamsburg to the National Trust, 1926–1949* (Charlottesville: University Press of Virginia, 1981), 267–68.

3. Chatelain quoted in Harlan D. Unrau and G. Frank Williss, "To Preserve the Nation's Past: The Growth of Historic Preservation in the National Park Service During the 1930s," *Public Historian* 9 (spring 1987): 21; Hal Rothman, *Preserving Different Pasts: The American National Monuments* (Chicago: University of Illinois Press, 1989), 200–202; Hosmer, *Preservation Comes of Age*, 565. Recently, the Park Service has been at work revising its "thematic framework." See "Revision of the National Park Service's Thematic Framework," a pamphlet produced by the National Park Service's "Working Group on the Revision of the National Park Service Thematic Framework" in 1996.

4. Bearss, "National Park Service," 11; Rothman, *Preserving Different Pasts*, 187; T. H. Watkins, *Righteous Pilgrim: The Life and Times of Harold L. Ickes, 1874–1952* (New York: Henry Holt, 1990), 552.

5. Rothman, *Preserving Different Pasts*, 162–65. On Ickes and the National Park

Service, see Watkins, *Righteous Pilgrim*, 549–55.

6. Unrau and Williss, "To Preserve the Nation's Past," 25–26; Hosmer, *Preservation Comes of Age*, 1250.

7. Unrau and Williss, "To Preserve the Nation's Past," 28–30; Hosmer, *Preservation Comes of Age*, 548–62; Michael Wallace, "Visiting the Past: History Museums in the United States," in *Presenting the Past: Essays on History and the Public*, ed. Susan Porter Benson, Stephen Brier, and Roy Rosenzweig (Philadelphia: Temple University Press, 1986), 149.

8. On the Historic Sites Act, see Hosmer, *Preservation Comes of Age*, 626–49; Bearss, "National Park Service," 11, 13–14; Unrau and Williss, "To Preserve the Nation's Past," 33–36; Barry Mackintosh, "The National Park Service Moves into Historic Preservation," *Public Historian* 9 (spring 1987): 54; Robert E. Stipe and Antoinette J. Lee, eds., *The American Mosaic: Preserving a Nation's Heritage* (Washington, D.C.: U.S. Committee, International Council on Monuments and Sites, 1987), 38–39.

9. Hosmer, *Preservation Comes of Age*, 67.

10. Elizabeth D. Mulloy, *The History of the National Trust for Historic Preservation, 1963–1973* (Washington, D.C.: Preservation Press, 1976), 8.

11. U.S. House Committee on Public Lands, *Hearings on Preservation of Historic American Sites, Buildings, Objects, and Antiquities of National Significance*, "Statement of Dr. G. W. A. R. Goodwin, Williamsburg, Va.," 74th Cong., 1st session, on H. R. 6670 and H. R. 6734, April 1, 2, and 5, 1935 (Washington, D.C.: Government Printing Office, 1935).

12. Ibid.

13. Page Smith, *Redeeming the Time: A People's History of the 1920s and the New Deal* (New York: McGraw-Hill, 1987), 641–42. On the relationship between Progressive Era assaults on laissez-faire and New Deal policy, see Sidney Fine, *Laissez-Faire and the General-Welfare State: A Study of Conflict in American Thought, 1865–1901* (Ann Arbor: University of Michigan Press, 1956).

14. For explanation of FDR's disillusionment with business in the Second New Deal, see Ellis W. Hawley, *The New Deal and the Problem of Monopoly* (Princeton, N.J.: Princeton University Press, 1966), 153–58. On pressures from the left and the Second Hundred Days, see William E. Leuchtenburg, *Franklin D. Roosevelt and the New Deal* (New York: Harper and Row, 1963), 95–117, 143–66. Scholars have debated whether the New Deal modified or simply protected American capitalism. Barton Bernstein argues that FDR "conserved and protected American capitalism," and William Leuchtenburg responds that FDR's goal and popular mandate was to conserve rather than dissolve the American state. See Barton J. Bernstein, "The New Deal: The Conservative Achievements of Liberal Reform," in *Towards a New Past: Dissenting Essays in American History*, ed. Barton Bernstein (New York: Random House, 1969), 263–88, and William E. Leuchtenberg, "The Achievements of the New Deal," in *Fifty Years Later: The New Deal Reevaluated*, ed. Harvard Sitkoff (New York: Alfred A. Knopf, 1985), 211–31.

15. FDR to Rep. Rene DeRouen, chairman of the Committee on Public Lands, April 10, 1935, in U.S. House Committee on Public Lands, *Preservation of Historic American Sites, Buildings, Objects, and Antiquities of National Significance.*

16. Later, Chatelain said that the eminent domain section was placed in the bill with the intention to "surrender it if the pressure got too great." Verne Chatelain, interview by Charles Hosmer, September 9, 1961, typescript, National Park Service, Harpers Ferry Center, Harpers Ferry, W.Va.

17. Hosmer, *Preservation Comes of Age*, 478–93, 607–10; Rothman, *Preserving Different Pasts*, 198–99; Mackintosh, "Park Service Moves into Preservation," 57; Karal Ann Marling, *George Washington Slept Here: Colonial Revivals in American Culture, 1876–1986* (Cambridge: Harvard University Press, 1988), 263–65.

18. Chatelain–Hosmer interview, 1–2, 17.

19. Chatelain quoted in Unrau and Williss, "To Preserve the Nation's Past," 22. On a similar celebration of American history in thirties literature, see Alfred Haworth Jones, "The Search for a Usable American Past in the New Deal Era," *American Quarterly* 23 (December 1971): 710–24.

20. Chatelain–Hosmer interview, 6.

21. Hosmer, *Preservation Comes of Age*, 658–64, 649–58.

22. Hosmer, *Preservation Comes of Age*, 675–80.

23. Hosmer, *Preservation Comes of Age*, 226–27; T. R. Adam, *The Museum and Popular Culture* (New York: American Association for Adult Education, 1939), 141; Laurence Vail Coleman, *Historic House Museums* (Washington, D.C.: American Association of Museums, 1933), 26–27.

24. Hosmer, *Preservation Comes of Age*, 190–201. FDR commended the museum as "a shrine dedicated to a great American family." See his introduction to Ethel Armes, *Stratford Hall: The Great House of the Lees* (Richmond: Garrett and Massie, 1936).

25. Douglass Southall Freeman quoted in Armes, *Stratford Hall*, 517. A 1929 article titled "Marse Robert's Home" in the *Louisville Courier Journal* had pronounced: "Here is but another proof of the binding together of our colonial ancestry into a homogeneous whole and evidence that we, their descendants, are all of one blood." Quoted in Armes, 449.

26. Coleman, *Historic House Museums*, 81; Hosmer, *Preservation Comes of Age*, 525–26.

27. Coleman, *Historic House Museums*, 26–33.

28. Coleman, *Historic House Museums*, iii, 19.

29. Arthur C. Parker, *A Manual for History Museums* (New York: Columbia University Press, 1935), 65.

30. T. R. Adam, *The Civic Value of Museums* (New York: American Association for Adult Education, 1937), 79.

31. Hosmer, *Preservation Comes of Age*, 717, 721–22; Bearss, "National Park Service, 14; quoted in Theodore Low, *The Museum as a Social Instrument* (New York: American Association of Museums, 1942), 16.

32. Raymond Fosdick, *John D. Rockefeller Jr.: A Portrait* (New York: Harper and Brothers, 1956), 296; Private R. Freedburg to John D. Rockefeller Jr., August 1942, quoted in Fosdick, 301.

33. Charles Porter, ed., "National Park Service War Work," Department of Interior, Branch of History Files, 1946, quoted in Hosmer, *Preservation Comes of Age*, 721.

34. Low, *Museum as a Social Instrument*, 16.

35. Kenneth Chorley to Rep. Schulyer Bland, June 3, 1948, quoted in Hosmer, *Preservation Comes of Age*, 723.

36. David E. Finley, *History of the National Trust for Historic Preservation, 1947–1963* (Washington, D.C.: National Trust for Historic Preservation, 1965), 1–6; Mulloy, *National Trust*, xi, 4–16; Hosmer, *Preservation Comes of Age*, 809–65; Michael Wallace, "Reflections on the History of Historic Preservation," in Benson, Brier, and Rosenzweig, *Presenting the Past*, 174.

37. Wallace, "Visiting the Past," 151. On the early years of Clark's venture, see Hosmer, *Preservation Comes of Age*, 97–109.

38. A. B. Wells, *Old Quinebaug Village* (1941), quoted in Hosmer, *Preservation Comes of Age*, 114. On Sturbridge, see Hosmer, 109–21.

39. Hosmer, *Preservation Comes of Age*, 129; Henry Flynt, quoted in Hosmer, 126.

40. Wallace, "Visiting the Past," 153.

41. This was actually a reintroduction of 1942 legislation, which was tabled until after Carver's death because National Park Service policy prohibited memorialization of living persons.

42. Richard M. Dalfiume, *Desegregation of the U.S. Armed Forces: Fighting on Two Fronts, 1939–1953* (Columbia: University of Missouri Press, 1969), 42. On black frustrations in this period, see Dalfiume, 64–81.

43. Ibid., 88–89. On politics and the nascent Civil Rights movement of the early forties, see also Jack Bloom, *Class, Race, and the Civil Rights Movement* (Bloomington: Indiana University Press, 1987), 76–77; Ronald Walters, *Black Presidential Politics* (Albany: State University of New York Press, 1988), 23–24.

44. Harvard Sitkoff, "The Detroit Race Riot of 1943," in *Blacks in White America since 1865*, ed. Robert C. Twombley (New York: David McKay, 1971), 315.

45. Katie Louchheim, ed., *The Making of the New Deal* (Cambridge: Harvard University Press, 1983), 260–61; Watkins, *Righteous Pilgrim*, 643–49, 257–58.

46. Ralph Bunche, *The Political Status of the Negro in the Age of FDR*, ed. Dewey W. Grantham (1940; reprint, Chicago: University of Chicago Press, 1973), 88–89.

47. Praising "private sector" efforts, Truman said, "the scientific discoveries and experiments of Dr. George Washington Carver have done more to alleviate the one-crop agricultural situation in the South than any one thing that has been done in the history of the United States." U.S. House Committee on Public Lands, Senate Committee on Public Lands and Surveys, *Joint Hearings on George Washington Carver National Monument*, "Statement of Hon. Harry S. Truman, United States Senator from the State of Missouri," 78th Cong., 1st session, on S. 37, S. 312, and H. R. 647, February 5, 1943 (Washington, D.C.: Government Print-

ing Office, 1943), 3–20. For brief explanations of the effects of the Agricultural Adjustment Acts on sharecroppers, see Hawley, *New Deal and the Problem of Monopoly* (Princeton, N.J.: Princeton University Press, 1966), 191–94; Leuchtenberg, *Roosevelt and the New Deal* (New York: Harper and Row, 1963), 137–38; Theodore Saloutos, "New Deal Agricultural Policy: An Evaluation," in *The New Deal: Conflicting Interpretations and Shifting Perspectives*, ed. Melvyn Dubofsky (New York: Garland, 1992), 221–46. On Truman's support of New Deal agricultural policies, see David McCullough, *Truman* (New York: Simon and Schuster, 1992), 246.

48. House Committee on Public Lands, Senate Committee on Public Lands and Surveys, *George Washington Carver National Monument.* For varying interpretations of Truman's Senate career vis-à-vis race, see Barton Bernstein, "The Ambiguous Legacy: The Truman Administration and Civil Rights," in *Politics and Policies of the Truman Administration*, ed. Barton Bernstein (Chicago: Quadrangle Books, 1970), 270–72, and Ronald R. McCoy and Richard T. Ruetten, *Quest and Response: Minority Rights and the Truman Administration* (Lawrence, Kans.: University Press of Kansas, 1973), 14–18.

49. *New York Times*, July 10, 1943; *Richmond Times-Dispatch*, September 12, 1942. See also the *Chicago Daily News*, October 20, 1942.

50. "Proposed Memorial to Dr. Carver," *New York Times*, February 6, 1943.

51. U.S. House Committee on Public Lands, Senate Committee on Public Lands and Surveys, *George Washington Carver National Monument.*

52. Dr. Richard Pilant, quoted in Anna Coxe Toogood, *Historic Resource Study and Administrative History: George Washington Carver National Monument* (Denver, Colo.: National Park Service, U.S. Department of the Interior, 1973), 56–57; House Committee on Public Lands, Senate Committee on Public Lands and Surveys, *George Washington Carver National Monument.*

53. House Committee on Public Lands, Senate Committee on Public Lands and Surveys, *George Washington Carver National Monument;* Pilant, quoted in an Associated Negro Press (ANP) news release, January 19, 1949, "Huge Crowd to Honor Carver on His Memorial Day," Claude Barnett Papers, Chicago Historical Society Archives.

54. The price of $25,000 was determined to be "just compensation." House Committee on Public Lands, Senate Committee on Public Lands and Surveys, *George Washington Carver National Monument; New York Times*, "Carver Memorial Authorized," July 9, 1943.

55. *New York Times*, July 23, 1943.

56. Linda O. McMurry, *George Washington Carver: Scientist and Symbol* (New York: Oxford University Press, 1981), 258, 261.

57. McMurry, *George Washington Carver*, 263.

58. Barry Mackintosh, "George Washington Carver: The Making of a Myth," *Journal of Southern History* 62 (November 1976): 527–28.

59. McMurry, *George Washington Carver*, 272.

60. Harold L. Ickes to Richard Pilant, February 19, 1944; Oscar Chapman to Pilant, April 3, 1944, Central Files, Department of the Interior, National Archives, Washington, D.C.

61. Pilant to Secretary of the Interior Douglas McKay, June 30, 1953; Pilant to McKay, March 20, 1953, Central Files, Department of the Interior, National Archives, Washington, D.C.

62. Paul L. Beaubien and Merrill J. Mattes, "George Washington Carver National Monument: The Archeological Search for George Washington Carver's Birthplace," *Negro History Bulletin* 18 (October 1954): 33–34.

63. Toogood, *Historic Resource Study*, 58–59; Beaubien and Mattes, "Carver National Monument," 33–34; ANP news release, February 22, 1950, Claude D. Barnett Papers.

64. Toogood, *Historic Resource Study*, 58–59.

65. "Huge Crowd to Do Homage to Carver on His Memorial Day," ANP news release, January 19, 1949, Claude D. Barnett Papers.

66. Pilant, at Joplin, to McKay, March 20, 1953; McKay to Pilant, George Washington Carver Birthplace Memorial Association, April 8, 1953, Department of the Interior Records, National Archives, Washington, D.C.

67. Pilant, in Granby, Mo., to McKay, May 29 and June 30, 1953; Pilant, Granby, Mo., to McKay, June 30, 1953, Department of the Interior Records, National Archives, Washington, D.C.

68. Barry Mackintosh, *Booker T. Washington National Monument: An Administrative History* (Washington, D.C.: U.S. Department of the Interior, National Park Service, 1969), 35.

69. Claude D. Barnett to F. D. Patterson, September 1, 1950, Claude D. Barnett Papers.

70. Barnett to Patterson, September 26, 1950, Claude Barnett Papers.

71. Mackintosh, *Booker T. Washington*, 35, 134–35; Toogood, *Historic Resource Study*, 58–59, 65; Barnett to Patterson, April 18, September 26, and October 24, 1950, Claude D. Barnett Papers; Barnett to Pilant, July 14, 1950, Claude D. Barnett Papers.

72. Sidney J. Phillips, Booker T. Washington Birthplace Memorial, to Barnett, ANP, February 6, 1946, Claude D. Barnett Papers.

73. Francis Greenwood Peabody, *Education for Life: The Story of Hampton Institute* (Garden City, N.Y.: Doubleday, Page, 1918), 264; Cynthia Neverdon-Morton, *Afro-American Women of the South and the Advancement of the Race, 1895–1925* (Knoxville, Tenn.: University of Tennessee Press, 1989), 119–21; ANP news release, October 17, 1945, Claude D. Barnett Papers.

74. Undated newspaper clipping by S. R. Johnson Jr. for the *Guide*, Claude D. Barnett Papers.

75. Ibid.

76. Phillips was born in 1901 in Pike Road, Ala., near Tuskegee, to an equally enterprising father. Rev. Joseph P. Phillips was an admirer of Washington and was one

of Wilson's "four minute men," working in Red Cross drives and selling liberty bonds among "the colored people." The elder Phillips began his career as a sharecropper and was influenced by Tuskegee to become a "progressive" farmer, diversifying his crops and amassing three hundred acres. Sidney Phillips followed in his father's footsteps, graduating from Tuskegee and then accepting a fellowship to study soils at the University of Wisconsin, where he received his M.S. Phillips then accepted a faculty appointment at Tuskegee. In his journalistic career, he published inspirational newsletters such as the *Negro Worker*, which emphasized Washington's philosophy. For example, in the December 1945 issue, it was recommended that "your employer appreciates more cooperation and less complaining." See *The History of the Four Minute Men*, no author (Birmingham, Ala.: Alabama Historical Publishing, 1921), 24; obituary of Joseph P. Phillips, obituary from memorial service for Sidney J. Phillips, collection of Virginia Roney and Bettye Daniels.

77. Coca Cola, for example, did not feature African-Americans in their advertisements until 1965. But by the 1950s the major soft drink concerns had recognized what Phillips had been arguing a decade earlier, that blacks were a huge potential market. Pepsi would attribute its capture of a large portion of this market to "enlightened attitudes on race," and Coke would soon take the same tack. Coke conducted a program similar to Phillips's when it began to contribute to charitable causes on behalf of the black community, relegating publicity to the black press "far from the eyes of whites in the South and elsewhere, who might be offended." Mark Pendergast, *For God, Country and Coca-Cola* (New York: Charles Scribner's Sons, 1993), 288; Frederick Allen, *Secret Formula: How Brilliant Marketing and Relentless Salesmanship Made Coca-Cola the Best Known Product in the World* (New York: HarperCollins, 1994), 284–90.

78. Typescript report of the Booker T. Washington Sales Agency, 1940, from the collection of Virginia Roney and Bettye Daniels.

79. House Committee meetings, February 2, 1956. Participation in such activities as metal salvage and bond drives were standard "bottler's contribution to the wartime efforts of his community." John A. Riley, *A History of the American Soft Drink Industry* (New York: Arno Press, 1972), 150.

80. Sidney J. Phillips, Booker T. Washington Birthplace, Virginia, to T. H. Stanley, the Nehi Corporation, Columbus Georgia, collection of Virginia Roney and Bettye Daniels.

81. Mackintosh, *Booker T. Washington National Monument*, 15–16.

82. Booker T. Washington, *Up from Slavery* (1900, 1901; reprint, Garden City, N.Y.: Doubleday, 1924), 3–4.

83. According to Mackintosh, the cabin was designed by Richard B. Collins of Tuskegee, based on a photograph of the putative birthplace cabin pictured in Washington's *The Story of My Life and Work* (Napierville, Ill.: n.p., 1900). Mackintosh, *Booker T. Washington National Monument*, 19–22.

84. Max Bennett Thrasher, *Tuskegee: Its Story and Its Work* (1901; reprint, New York:

Negro Universities Press, 1969), 169–73, 263; Thomas Monroe Campbell, *The Movable School Goes to the Negro Farmer* (1936: New York: Arno Press, 1969), 133–46; see also 154–55, 85. The Negro Organization Society that attempted to bid against Nehi in the purchase of the birthplace cabin also had a program emphasizing "clean privies, clean homes, and clean lives." Neverdon-Morton, *Afro-American Women of the South*, 119, 123–32. On slave and tenant housing, see George McDaniel, *Hearth and Home: Preserving a People's Culture* (Philadelphia: Temple University Press, 1982), passim.

85. Campbell, *Movable School*, 149–50.

86. Quoted in Louis R. Harlan, *Booker T. Washington in Perspective*, ed. Raymond W. Smock (Jackson: University Press of Mississippi, 1988), 165.

87. Harlan, *Booker T. Washington in Perspective*, 3.

88. *Southern Letter* 2 (spring 1949); ANP news release, June 1, 1949.

89. See Gerald Horne, *Black and Red: W. E. B. DuBois and the Afro-American Reponse to the Cold War, 1944–1963* (Albany: State University of New York Press, 1986), 57–73.

90. Mackintosh, *Booker T. Washington National Monument*, 51.

91. For the use of this argument in international politics, see Harvard Sitkoff, "The Preconditions for Racial Change," in *A History of Our Time*, ed. William Chafe and Harvard Sitkoff (New York: Oxford University Press, 1987), 155.

92. Phillips to Chester C. Davis, Sacramento, Calif., February 24, 1951.

93. Phillips to D. V. Jemison, president, National Baptist Convention, Oklahoma City, Okla., September 8, 1951; Jemison to Phillips, September 9, 1951.

94. Barnett to Patterson, June 18, 1951, Claude Barnett Papers.

95. Barnett to Basil O'Connor, chairman of Tuskegee Board of Trustees, November 15, 1942, Claude Barnett Papers.

96. Patterson to Barnett, August 9, 1945, Claude Barnett Papers. On Patterson, see *Chronicles of Faith: The Autobiography of Frederick D. Patterson*, ed. Martia Graham Goodson (Tuscaloosa: University of Alabama Press, 1971).

97. Lawrence W. Hogan, *A Black National News Service: The Associated Negro Press and Claude Barnett, 1919–1945* (Rutherford, N.J.: Fairleigh Dickinson University Press, 1984), 40–41.

98. Hogan, *Black National News Service*, 238.

99. Hogan, *Black National News Service*, 68–69.

100. Linda J. Evans, "Claude Barnett and the Associated Negro Press," *Chicago History* 12 (spring 1983): 52.

101. Barnett to Albion Holsey, Tuskegee Institute, April 7, 1948, Claude Barnett Papers. Barnett made a similar point in his official capacity as special advisor to the secretary of agriculture in a September 1951 letter to Wesley McCune, executive assistant to the secretary of agriculture.

102. The appropriation referred to in this release passed late in 1950, which dates this undated clipping from Barnett's ANP file.

103. Phillips said this in a typescript written shortly before his death, now in the possession of his daughter, Virginia Roney.
104. Barnett to Patterson, June 9, 1951, Claude Barnett Papers.
105. The suit was thrown out on the basis that the trustees of the memorial had not known of the contract. See *U.S. District Court for the Western District of Virginia, Booker T. Washington Foundation, and Portia Washington Pittman, Plaintiffs, v. S. J. Phillips, Booker T. Washington Birthplace and Booker T. Washington Birthplace Memorial,* Civil Action No. 635; *Roanoke Times,* February 15 and 20, 1953; ANP news release, January 15, 1953; Roy S. Hill, *Booker T.'s Child: The Life and Times of Portia Marshall Washington Pittman* (Washington, D.C.: Three Continents Press, 1993), 87.
106. *Roanoke Times,* February 15, 1953.
107. From an undated clipping in the collection of Virginia Roney and Bettye Daniels.
108. Mackintosh, *Booker T. Washington National Monument,* 41–44.
109. Phillips to the board of Tuskegee Institute, March 28, 1953.
110. Phillips to Tuskegee trustees, May 16, 1953.
111. Allen Rankin, "Rankin File," *Alabama Journal,* June 2, 1953.
112. Mackintosh, *Booker T. Washington National Monument,* 64–65.
113. Phillips, "Summing Up the Situation," *Roanoke Tribune,* October 24, 1953.
114. Phillips to Thomas B. Stanley, November 4, 1953, Phillips to J. Lindsay Almond, November 6, 1953, Booker T. Washington National Historic Site Archives.
115. Mackintosh, *Booker T. Washington National Monument,* 72.
116. Benjamin Muse, *Virginia's Massive Resistance* (Bloomington: Indiana University Press, 1961), 2–5.
117. Robbins L. Gates, *The Making of Massive Resistance: Virginia's Politics of Public School Desegregation, 1954–1956* (Chapel Hill: University of North Carolina Press, 1962), 14 (quote), 13–27; Numan V. Bartley, *The Rise of Massive Resistance: Race and Politics in the South during the 1950s* (Baton Rouge: Louisiana State University Press, 1969), 47–52.
118. The second was South Carolina. Gates, *Making of Massive Resistance,* xvii, 204; Muse, *Virginia's Massive Resistance,* 11.
119. Gates, *Making of Massive Resistance,* 30.
120. Bartley, *Rise of Massive Resistance,* 54–55, 80; Gates, *Making of Massive Resistance,* 30. The most significant feature of the "Gray Plan" amended the state's compulsory education law such that state support would be forthcoming for students to attend segregated private schools so that no child would have to attend an integrated public school. Gates, 62–72, 109–15; Muse, *Virginia's Massive Resistance,* 15–19; Bloom, *Class, Race, and the Civil Rights Movement,* 106–8.
121. Gates, *Making of Massive Resistance,* 34–35, 62–72, 73–99, 101–36.
122. Bartley, *Rise of Massive Resistance,* 116. The "Manifesto" was written in the winter of 1955–56; the "Warning" was issued in July 1956. See Bartley, 148.

123. Phillips's views on segregation before 1954 can be gleaned from various sources, including an ANP clipping from the *Charleston News and Courier*, July 8, 1953; the *Montgomery Journal*, June 2, 1953; and his "Summing Up the Situation" columns for the *Roanoke Tribune* in 1953. See also Mackintosh, *Booker T. Washington National Monument*, 60–61.

124. Drawn from a typescript of Phillips's address to the seventy-fourth annual meeting of the National Baptist Convention, September 10, 1954, at St. Louis, Mo.

125. Michael J. Klarman, "How Brown Changed Race Relations: The Backlash Thesis," *Journal of American History* 81 (June 1994): 82.

126. Herbert S. Parmet, *Eisenhower and the American Crusades* (New York: Macmillan, 1972), 443, 446; J. W. Anderson, *Eisenhower, Brownell, and the Congress: The Tangled Origins of the Civil Rights Bill of 1956–1957* (University, Ala.: University of Alabama Press, 1964), 19–20, 26–27, 112–39, 45–109.

127. A. E. Demary, acting director, National Park Service, to Oscar Chapman, under secretary of the interior, September 20, 1949, National Park Service Central Classified Files, 1907–49, National Archives, Washington, D.C. This file includes a letter from the National Association of Colored Women, which was operating the Douglass house, rejecting the idea of NPS administration. The NACW, as had Phillips of the Carver and Washington sites, preferred that the memorialization be run "by the Negro people of this country."

128. Harlan, *Booker T. Washington in Perspective*, 3.

129. U.S. House Committee on Interior and Insular Affairs, Subcommittee on Public Lands, *Hearings on Booker T. Washington National Monument*, 84th Cong., 2d session, on H. R. 6904, H. R. 6963, H. R. 7187, H. R. 7242, H. R. 7492, and H. R. 7809, February 3, 1956 (Washington, D.C.: Government Printing Office, 1956).

130. *New York Times*, April 1, 1956, section 4.

131. Sitkoff, "Preconditions," 155.

132. House Committee on Interior and Insular Affairs, Subcommittee on Public Lands, *Booker T. Washington National Monument*.

133. Ibid.

134. Ibid.; "Veto of Monument Plan Urged," *New York Times*, March 29, 1956.

135. House Committee on Interior and Insular Affairs, Subcommittee on Public Lands, *Booker T. Washington National Monument*.

136. Ibid.

137. *Roanoke Tribune*, October 21, 22, 23, 24, 25, 26, and 28, 1957; Mackintosh, *Booker T. Washington National Monument*, 35.

138. *Roanoke Tribune*, October 21, 22, 23, 24, 25, 26, and 28, 1957; Mackintosh, *Booker T. Washington National Monument*, 35, 99–101. From George Washington Carver National Monument, Pilant wrote to Claude Barnett praising the articles. Pilant to Barnett, December 10, 1957, Claude Barnett Papers.

139. Mackintosh, *Booker T. Washington National Monument*, 132–35.

140. Mackintosh, *Booker T. Washington National Monument*, 153–58.

141. Mackintosh, *Booker T. Washington National Monument,* 139–39. The "birthplace cabin" is still considered by key constituencies to be the central feature of site. See George Cantor, *Historic Landmarks of Black America* (Detroit: Gale Research, 1991), 263. When George McDaniel undertook his search for remnants of slave cabins, he was frequently directed to what turned out to be postbellum tenant houses; *Hearth and Home,* xix. On the architecture of slave houses, see McDaniel, 45–102.

142. Mackintosh, *Booker T. Washington National Monument,* 124–25.

143. Mackintosh, *Booker T. Washington National Monument,* 131–32.

144. Dianne Pilgrim, "Inherited from the Past: The American Period Room," *American Art Journal* 10 (May 1978): 14; Germain Bazin, *The Museum Age,* trans. Jan van Nuis Cahill (New York: Universe Books, 1967), 255.

145. Mildred White Wells, *Unity in Diversity: The History of the General Federation of Women's Clubs* (Washington, D.C.: General Federation of Women's Clubs, 1953), 252–53; Martha Strayer, *The D.A.R.: An Informal History* (Washington, D.C.: Public Affairs Press, 1958), 57–66.

Index

LaVergne, TN USA
11 August 2010
192941LV00005B/1/A